Marina Abramović

MARINA ABRAMOVIĆ
The House with the Ocean View

CHARTA

Sean Kelly
October, 2003

"Behold, I do not give lectures or a little charity,
When I give I give myself"

Walt Whitman, "Song of Myself" (1855)

Marina Abramović and I have worked together since 1991. Of course I knew her work before then; her pioneering performances were renowned when I was coming of age as a young curator. Indeed, we had many friends in common, most notably Rebecca Horn, however for some reason our paths had never crossed. I would arrive in Berlin, Paris or Madrid, only to be informed by whichever mutual friend was attempting to facilitate an introduction that everyone seemed to agree was overdue, that "Marina has just left," or, "isn't it a shame that Marina will be arriving a few days after you depart." In fact I was quite comfortable with the status quo. Whilst I was a great admirer of Marina's work, as a curator I harbored the disquieting concern that I would be unable to resist the ineluctable pull that I knew to be at the core of Marina's art and personality. In short, I was concerned that I would fall under Marina's fabled magnetic thrall.

In 1989 I moved to New York to take up a position as director of a Manhattan gallery. One of the first artists I invited to exhibit in the gallery was Julião Sarmento. He had mentioned Marina to me on more than one occasion; I knew them to be close and I understood that he would like to see her in the gallery. However, my concern about meeting with Marina presaged our conversations, and once again somehow the meeting never came to pass.

Some time later Julião was in New York and seemed anxious to have a lunchtime meeting, which, it was resolved, would take place in a SoHo restaurant. I arrived and was ushered to a table at which two people were seated; Julião grinned as he rose to greet me and proceeded to introduce me to…Marina Abramović. I knew instantly I was lost, or perhaps found; one of the defining relationships of my professional career had loomed over the horizon and, as with all such portentous events, could only be rejected by an act of the most base professional cowardice. In any event, it wasn't even a question: within minutes we had unearthed the extensive "six degrees of separation" that existed between us; the only question that remained unanswered was why the meeting had taken so long. Moreover, I found Marina to be extraordinary, vibrant, engaging, seductive, nothing less than a force of nature and certainly not to be denied. We have worked together ever since.

In that time we have made numerous exhibitions together, both in New York and in museums and institutions worldwide. I have had the pleasure of being intimately involved with Marina's creative process and I have watched her produce some of the most memorable works of the last decade of the twentieth century. Notable amongst her rich and prodigious oeuvre during this period are *Cleaning the Mirror #1* (1995), commissioned by Chrissie Iles, Curator of The Museum of Modern Art, Oxford, England; *Cleaning the House* (1995), and *Spirit House* (1997). *Cleaning the House*, a performance originally presented in the basement of our 43 Mercer Street gallery in front of a small audience, subsequently became *Balkan Baroque*, and was presented at the XLVII Venice Biennale in 1997, for which Marina was honored with the Golden Lion Award for Best Artist.

At the beginning of the new millennium, Marina started talking to me about a durational work she wanted to make that would be based upon silence and fasting—the piece that would ultimately become *The House with the Ocean View*. At that early stage, the exact nature of the work and the form it would take was unclear, however it continued to evolve through our many discussions. What became evident was that Marina wanted the piece to encompass her concern that several generations of younger artists had not experienced live performances by influential artists of her generation such as Vito Acconci, Chris Burden, James Lee Byars, Gina Pane and Bruce Nauman. It was also her desire to effect an "energy exchange" with the audience by drawing upon their presence to complete the work. Conceptually, this was a development of her recent work, in which she had insisted upon the audience signing a contract with her, in effect making a reciprocal commitment to the one that she, as the artist, was making.

9/11 changed everything profoundly for us all. The ramifications of that fateful day extended even into Marina's proposal for the new performance being prepared for the gallery. It became important to Marina that the work not only engage the audience at the gallery, but moreover that it should attempt to create a larger resonance for the people of the City of New York.

Having worked with Marina for over a decade, I had become attuned to the moment at which her work would engage us in something "beyond the ordinary" in terms of the scale of its ambition. As the untitled performance became further defined over the months leading up to its opening on November 15th, 2002, it became clear to me that if Marina could achieve her stated intentions for the work, it would, in my opinion, be the most significant performance to take place in New York since Joseph Beuys made *I like America and America likes me* at René Block's gallery in May, 1974.

From the moment Marina confirmed her proposal for *The House with the Ocean View*, I believe we both tacitly understood that we were potentially embarking upon an historic endeavor. However, we both studiously avoided a specific conversation on the topic, as if to do so could potentially jinx the piece. Practicalities and preparations aside, the twelve days that Marina spent in the gallery making *The House with the Ocean View* were unprecedented in my experience. I believe if you ask anyone who was in that room during those twelve memorable days, you would be hard pressed to find that they were not profoundly moved by the piece—it is a rare achievement for an artwork at any point in the history of our culture, but one that seems even more prescient in the age in which we live.

This publication attempts to document, in some small way, those twelve days in November, 2002, and through the insightful essays of five prominent cultural commentators, each of whom spent considerable time with the piece, to record and transmit the importance and impact of… *The House with the Ocean View*.

Marina Abramović's performance *The House with the Ocean View* was presented at Sean Kelly Gallery, New York, from Friday, November 15th to Tuesday, November 26th, 2002.

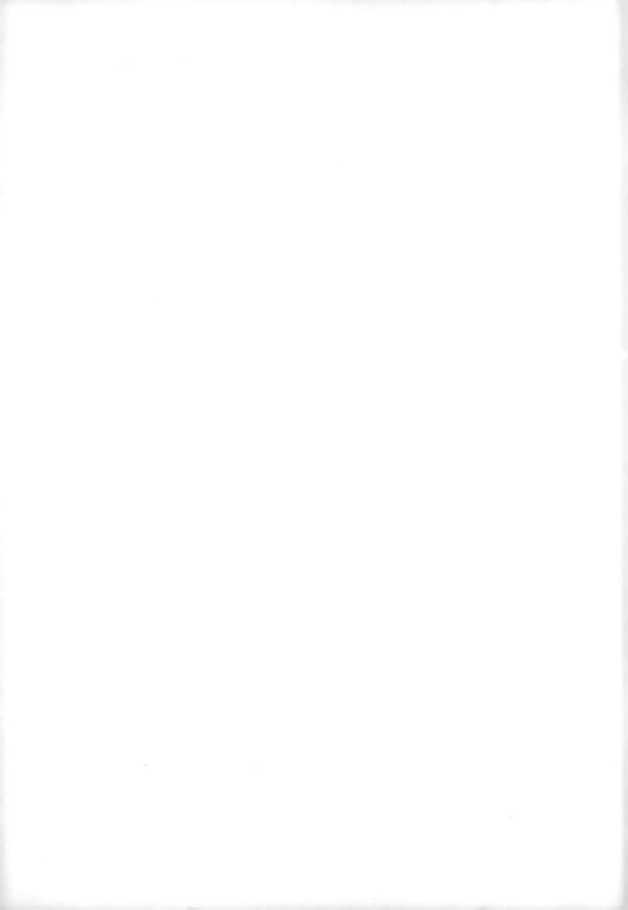

Marina Abramović
The House with the Ocean View: conditions

November 15 – November 26, 2002

THE IDEA:

This performance comes from my desire to see if it is possible to use simple daily discipline, rules and restrictions to purify myself. Can I change my energy field? Can this energy field change the energy field of the audience and the space?

CONDITIONS FOR LIVING INSTALLATION: ARTIST

Duration of the piece	12 days
Food	no food
Water	large quantity of pure mineral water
Talking	no talking
Singing	possible but unpredictable
Writing	no writing
Reading	no reading
Sleeping	7 hours a day
Standing	unlimited
Sitting	unlimited
Lying	unlimited
Shower	3 times a day

CONDITIONS FOR LIVING INSTALLATION: PUBLIC

use telescope
remain silent
establish energy dialogue with the artist

CLOTHES

The clothes for *The House with the Ocean View* were inspired by Alexander Rodchenko. The color of the clothes were selected in accordance with the principles of the Hindu Vedic square. The boots are the ones I used to walk the Great Wall of China in 1987.

STORAGE

1 bottle of pure almond oil
1 bottle rose water
1 bar of soap without perfume
1 wooden comb
12 thin cotton towels
12 cotton underwear
12 cotton t-shirts
7 cotton trousers
7 cotton shirts

The House with the Ocean View

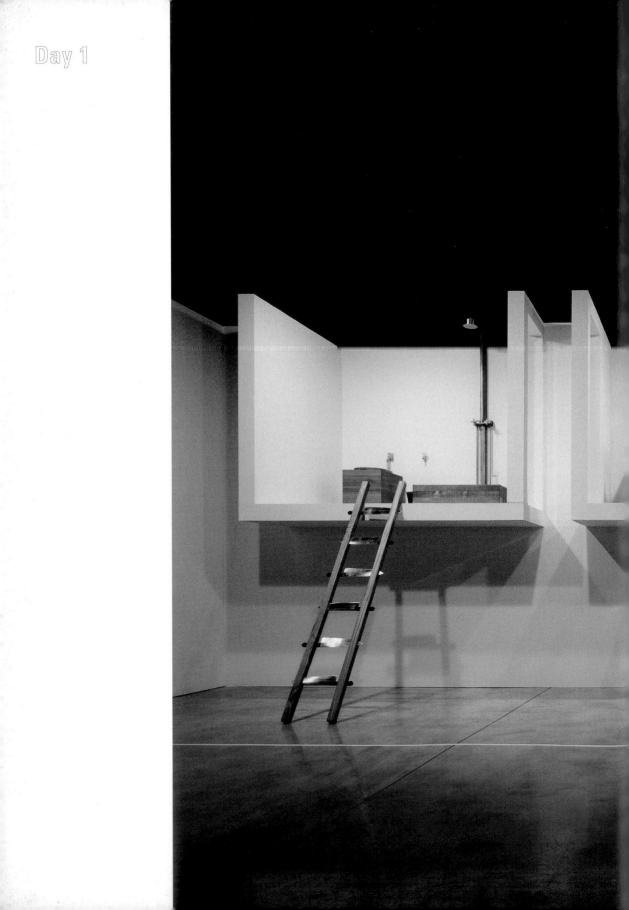

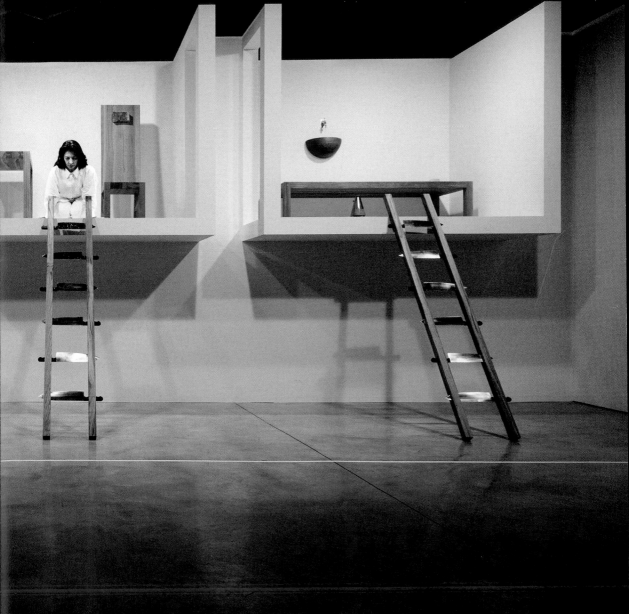

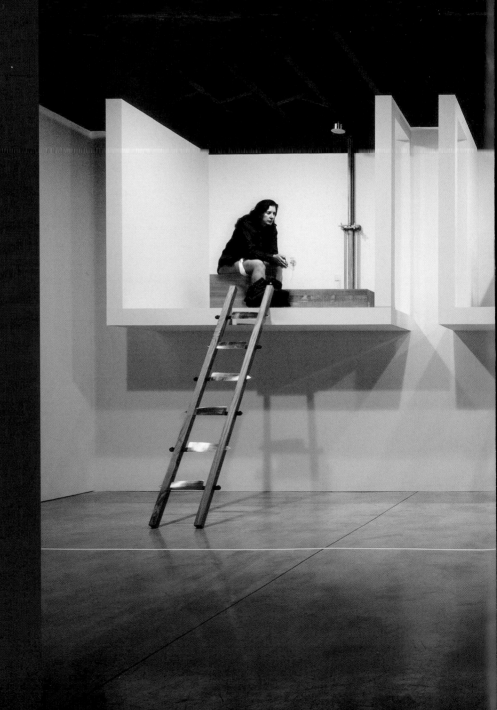

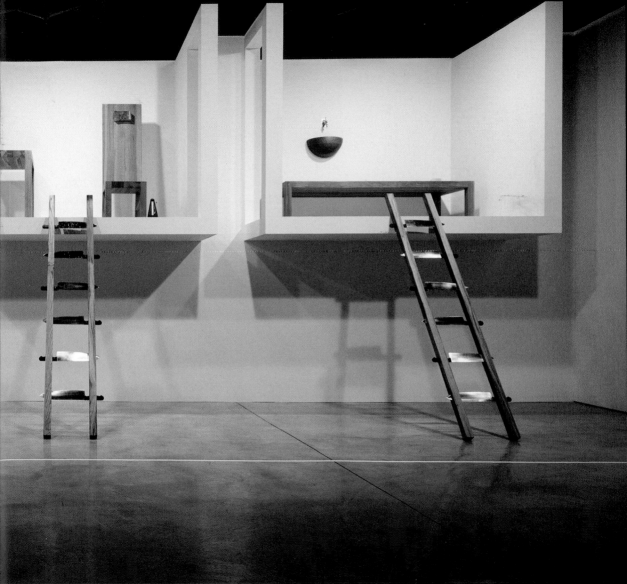

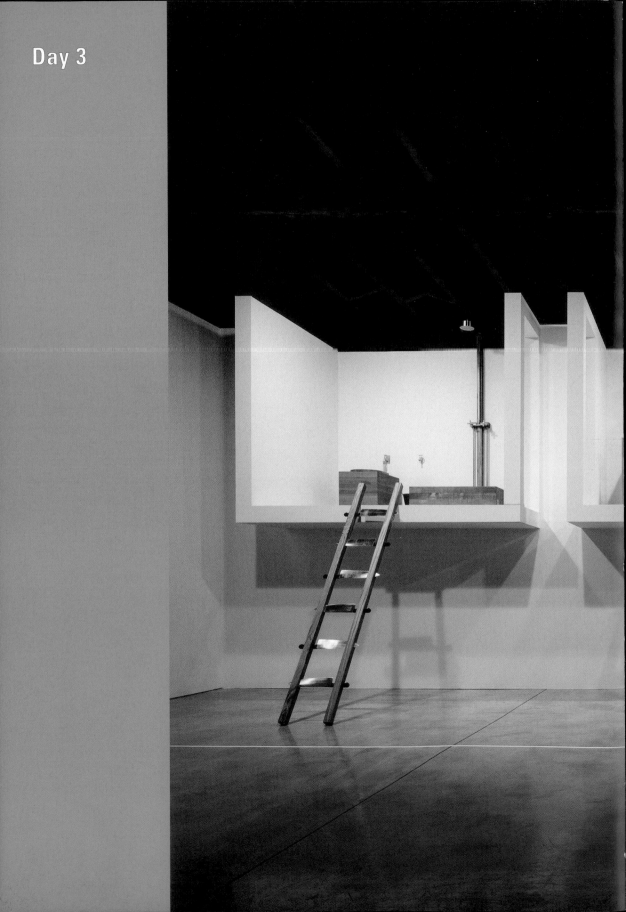

Day 3

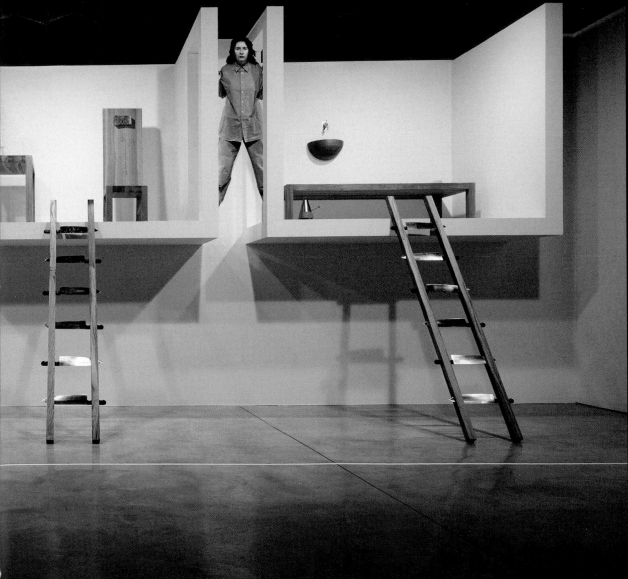

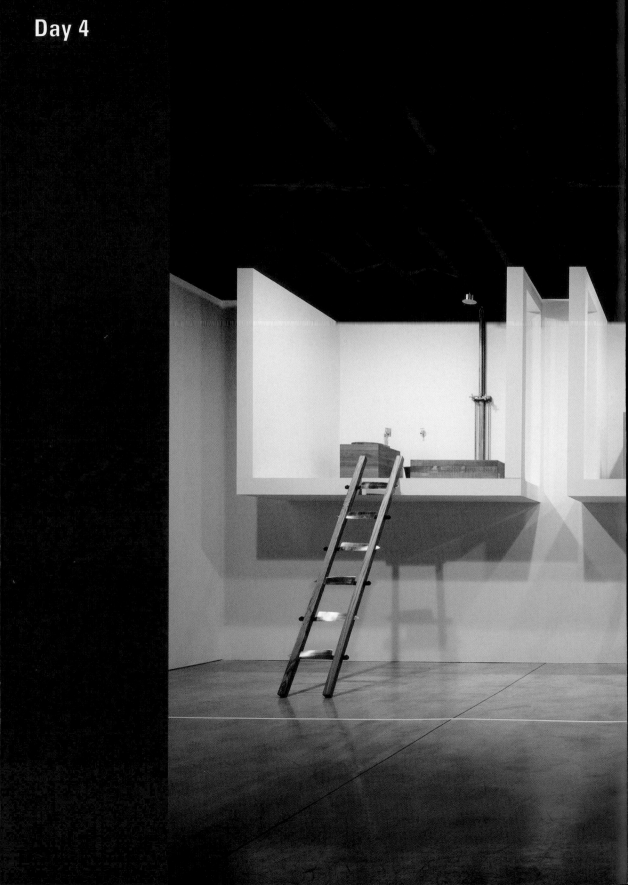

Day 4

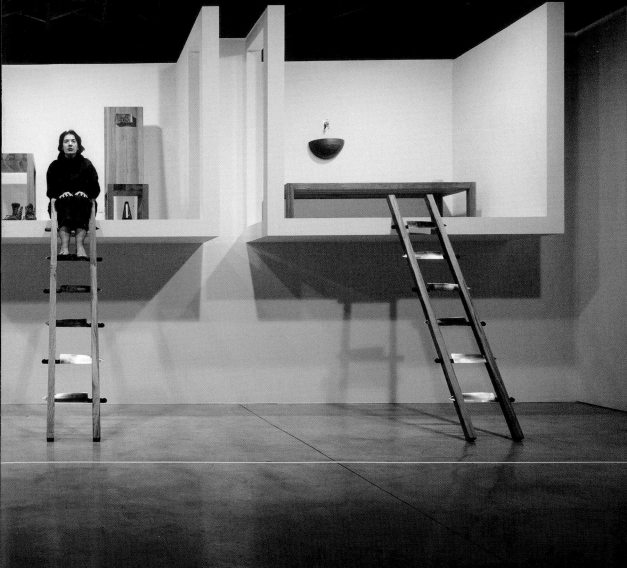

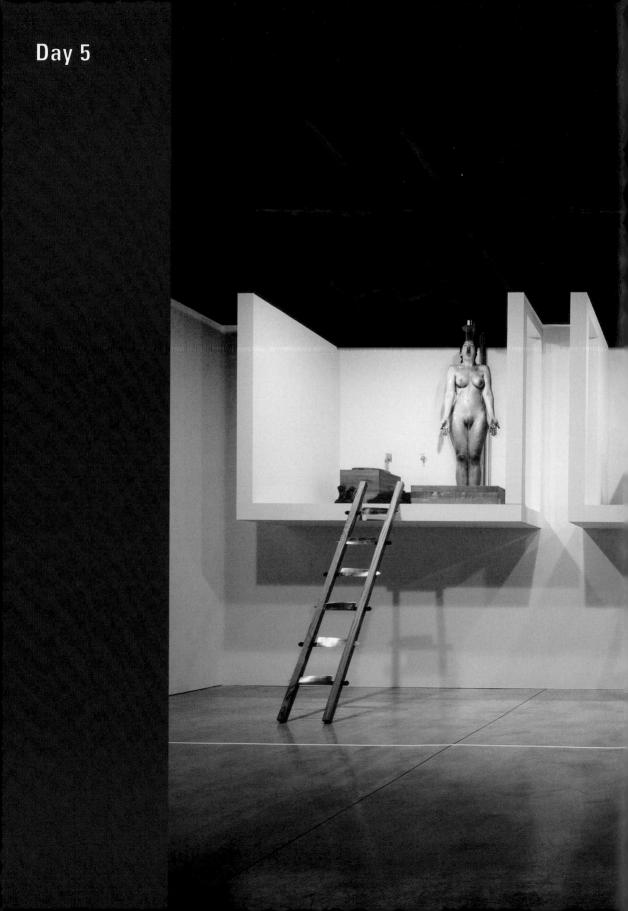

Day 5

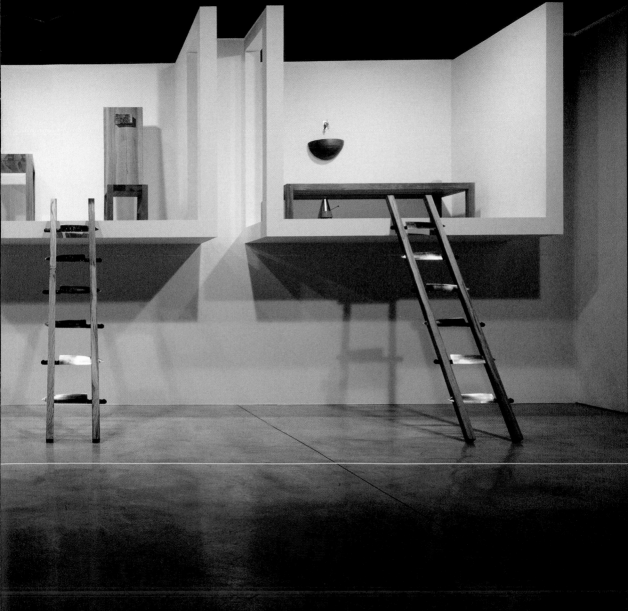

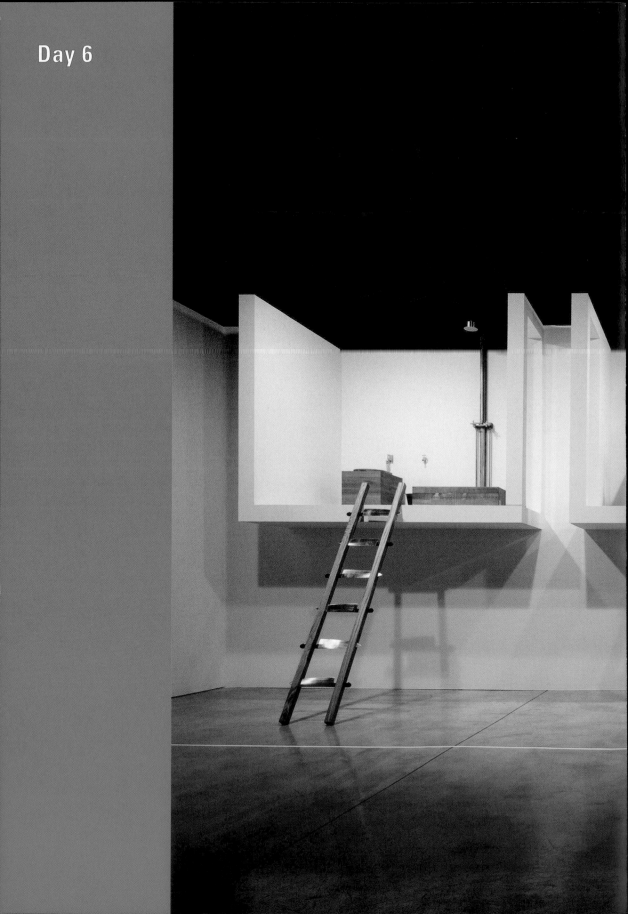

Day 6

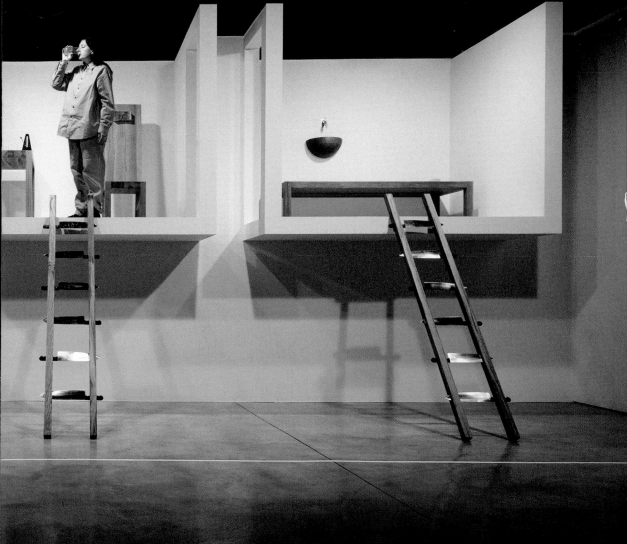

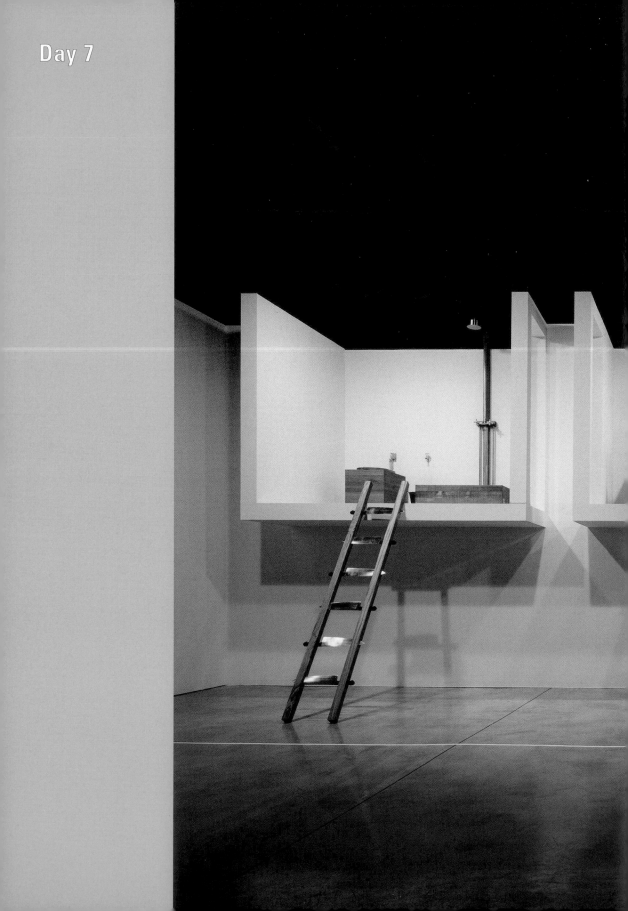

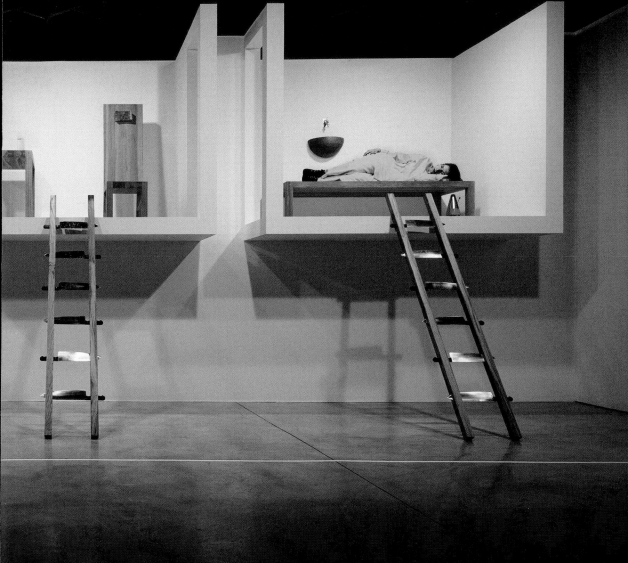

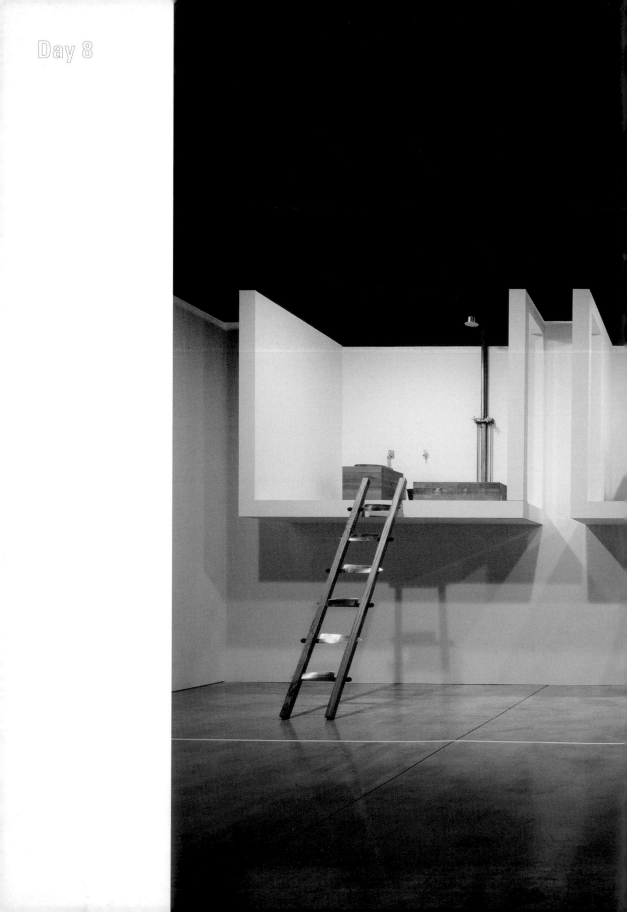

Day 8

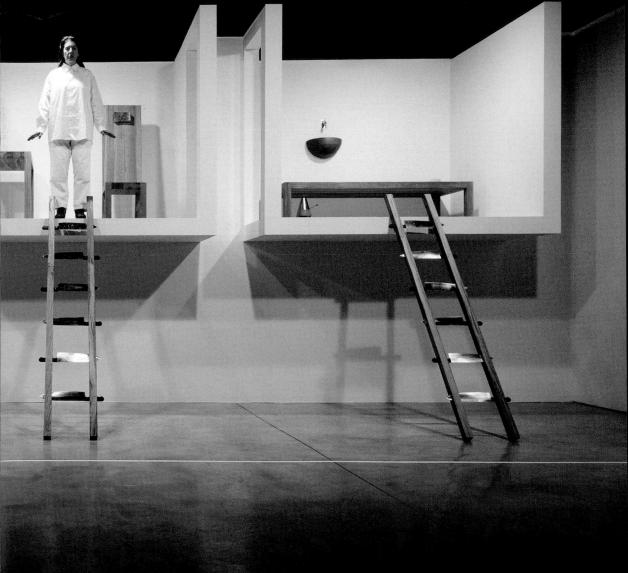

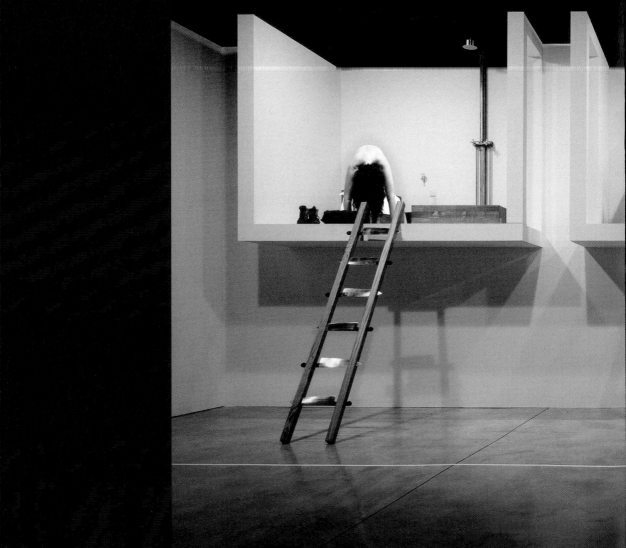

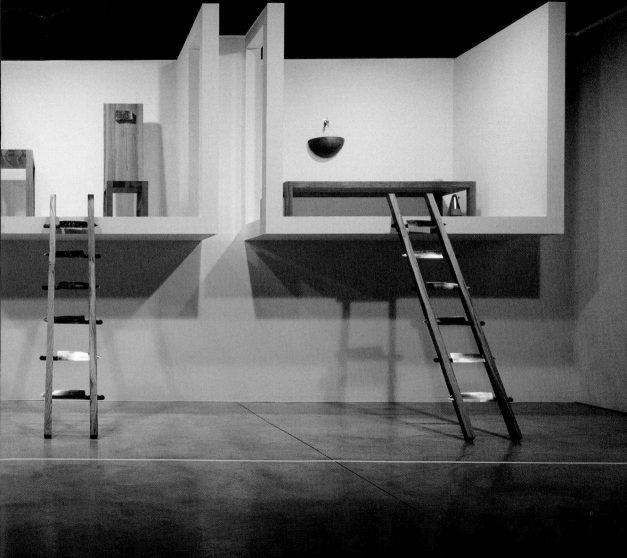

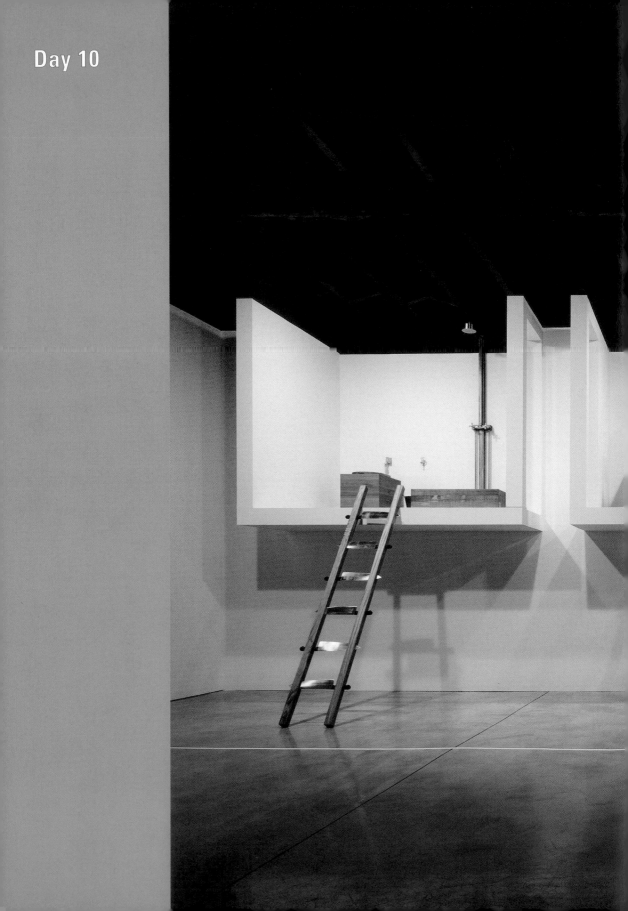

Day 10

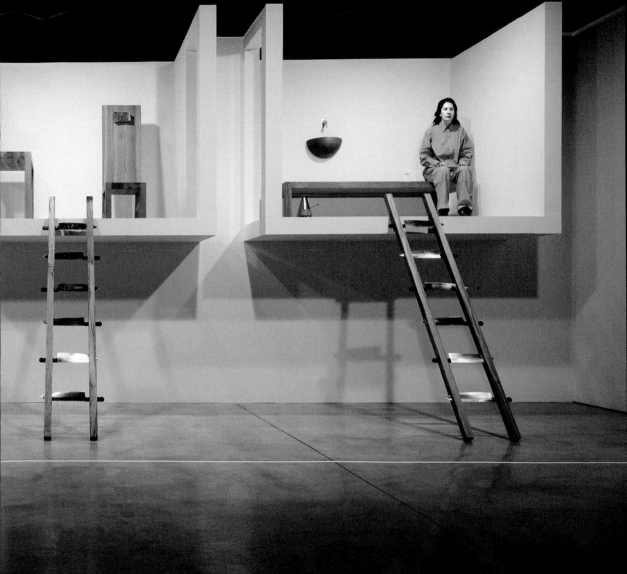

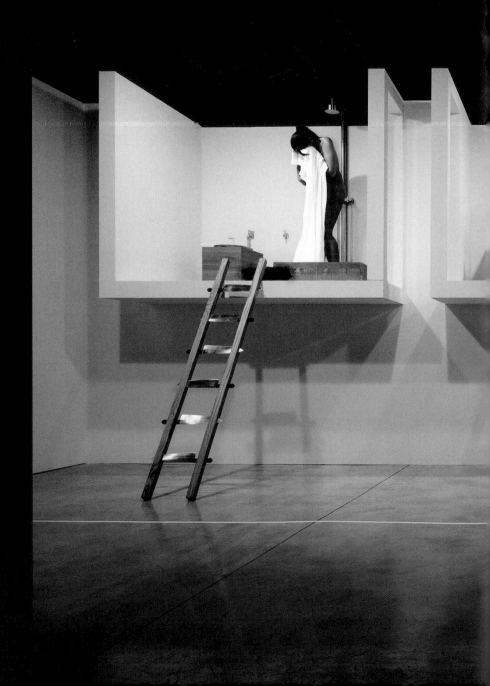

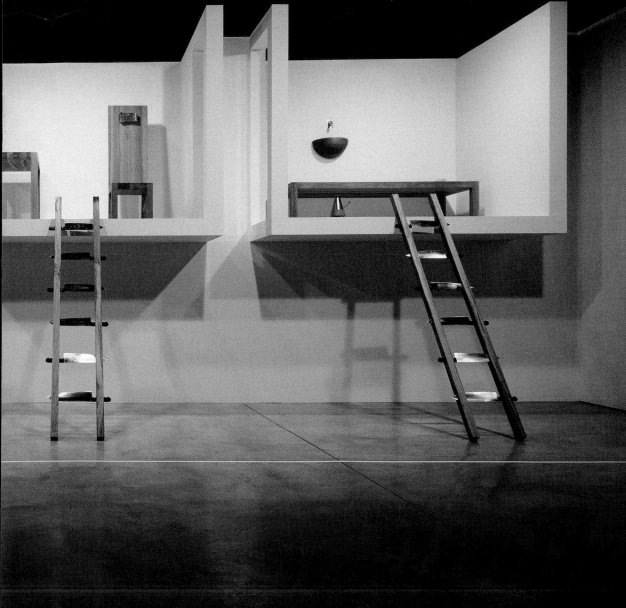

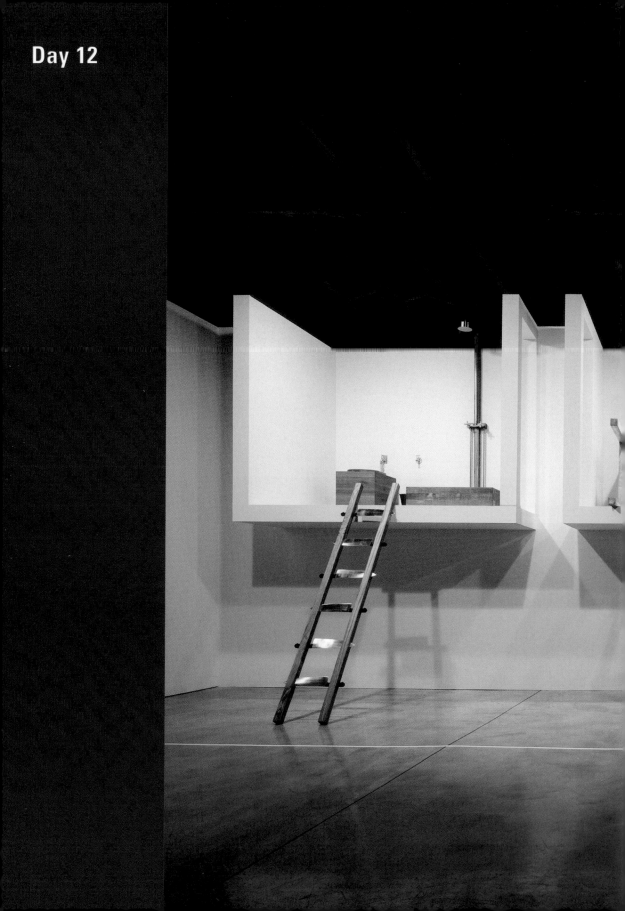

Day 12

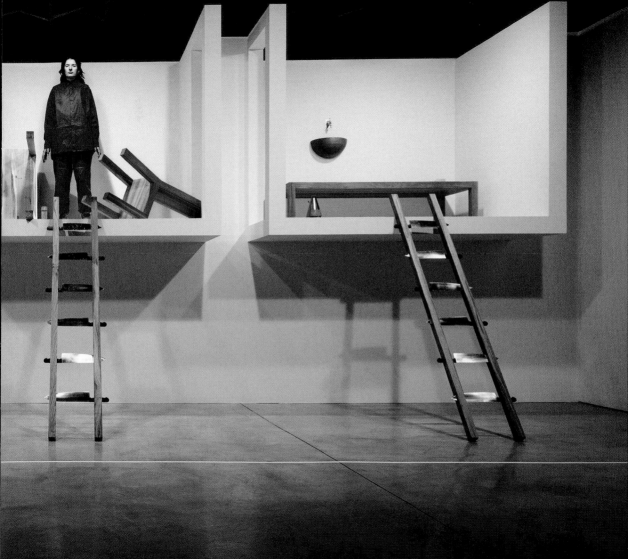

Video documentation of *The House with the Ocean View* was kept
continuously during gallery hours. The following transcript was made
by watching the video recordings and describing every single action
as it happened.

For the reader to have a full sense of the duration of the performance
—which is not possible to achieve by looking only at the photographs—
the text should be read each day for twelve days or all in one sitting.

Friday, November 15th: Day 1

Wearing white

Sitting on the chair

I sit in the chair, shake out my shoulders and push my hair back from my face and forehead with both hands. I shift first my left and then my right buttock back until they touch the back of the chair and I am sitting up perfectly straight. The back of my head is touching the quartz pillow headrest.

I place one hand on each thigh, halfway between my knee and my hip. My fingers are splayed out. The fingers on my right hand are slightly further apart than those on my left hand. The fingers of my left hand curve inward more than the fingers of my right hand.

I take a deep breath and my chest rises. Then it falls. I remain sitting still. The metronome is on the left-hand side of the table and it is ticking. The glass is on the right-hand side of the table and it is full. My feet are flat on the floor and spaced hip-width apart. My back is straight against the chair. I look at the audience. My head does not move, only my eyes. I blink. My mouth is closed. I blink again. When I take deeper breaths my chest rises and falls. The rest of my body is motionless. After I have been sitting for a long time I have to straighten my back up.

Standing at the front

I stand up from sitting down by pushing my hands on my thighs. My elbows point outwards and form two triangle shapes on either side of my body. Using this shape I lever myself up. My hands slide down my thighs as I stand up, then they slide up again. I straighten my shirt. Then I step forward to the edge of the platform in front of the chair. I pull my shirt down again using both my hands so that it is straight. My feet are just wider than hip-width apart. I rock slightly from side to side to make sure that I am evenly balanced. I point my feet outwards slightly and stand still. I let my arms hang down straight by my sides. My fingers curve towards my thighs and there is a gap between them and my thumbs. I stand straight and still and remain looking at the audience. I blink. I breathe.

Drinking water

I point my body towards the glass and put one foot in front of the other until I get to it. It takes three steps. The glass is already full of water. I take the glass with my right hand, curl my fingers around it with my thumb gripping the other side. I cup the glass in the palm of my hand. I raise the glass to my mouth. My left arm is straight and motionless. I tilt my head back and shake my hair away from my face. I tip the water into my open mouth and gulp. To control the flow of water into my mouth, I open and close my lips slowly, and open and close them again. The water waves back and forth in the glass every time I swallow. My neck moves every time I swallow. I drink until half of the glass is empty. Then I place the glass back down on the table.

I press my lips together to suck in the droplets that are left there.

Sitting on the chair

I stand in front of the chair and bend my knees until my body rests on the chair and I am sitting. The back of my head is touching the quartz pillow headrest. I place one hand on each thigh, halfway between my knee and my hip. My fingers are splayed out. The fingers on my right hand are slightly further apart than those on my left hand. The fingers of my left hand curve inward more than the fingers of my right hand.

I look out at the audience.

Drinking water

I point my body towards the glass and put one foot in front of the other until I get to it. It takes three steps. I take the glass with my right hand, curl my fingers around it with my thumb gripping the other side. I cup the glass in the palm of my hand. I raise the glass to my mouth. My left arm is straight and motionless. I tilt my head back and shake my hair away from my face. I tip the water into my open mouth and gulp. To control the flow of water into my mouth, I open and close my lips slowly, and open and close them again. The water waves back and forth in the glass every time I swallow. My neck moves every time I swallow.

I drink until the glass is empty.

Filling the glass

There is no more water in the glass so I have to fill it up. I take the glass to the sink in the bedroom unit. The sink is on the back wall. There is only a small gap between the bed and the back wall. I shuffle past behind the bed to the sink. I hold the glass in my left hand and put it underneath the tap in the sink. I push the tap up and then twist it to the left with my right hand until water trickles out. I tilt my head down towards the tap and watch the water flow. I let the glass fill up slowly. When the glass is full I turn off the tap by pushing it up and then twisting it to the right.

I shuffle past the bed and step over the gap with my right leg first. Now I am in the living unit. I place the glass down on the right-hand side of the table in the living unit. When the glass is resting on the table I release my grip and move my hand away from the glass back towards my body.

Standing at the front

I step forward to the edge of the platform in front of the chair. My feet are just wider than hip-width apart. I rock slightly from side to side to make sure that I am evenly balanced. I point my feet outwards slightly and stand still. I let my arms hang down straight by my sides. My fingers curve towards my thighs and there is a gap between them and my thumbs. I stand straight and still and remain looking at the audience. I blink. I breathe.

Then I twist my wrists so that my palms turn out in front of me. My hands are open and facing the audience. My arms now point out slightly away from my hips.

Every time I breathe in, the bottom of my shirt moves in towards my torso. Every time I breathe out the bottom of my shirt moves outwards away from my torso. Nothing else moves, except the lids of both my eyes. They always move at the same time.

Sitting on the chair

I put my body in front of the chair and bend my knees until my bottom rests on the seat of the chair. I put my hands together in my lap.

I take a deep breath and my chest rises. Then it falls. I remain sitting still. The metronome is on the left-hand side of the table and it is ticking. My feet are flat on the floor and spaced hip-width apart. My back is straight against the chair. I look at the audience. My head does not move, only my eyes. I blink. My mouth is closed. I blink again. When

I take deeper breaths my chest rises and falls. The rest of my body is motionless. After I have been sitting for a long time I have to straighten my back up.

Peeing

I need to pee. I step across the gap to the bathroom unit. When I am in the unit I turn to my right and take the toilet paper from the shelf with my right hand. I take four steps over towards the toilet and turn my body round clockwise. When my back is to the audience I lean over and put the toilet roll on the left front corner of the shower tray. Then I lift the lid of the toilet with my left hand. I push it back until it is resting on the back of the unit. As I turn towards the front I lift up my shirt so I can unfasten my trousers. There are four buttons to unfasten. I tilt my head forward. When I have undone all the buttons I pull my trousers and my slip down to just above my knees and sit on the toilet. I put my feet close together in front of me and cup my hands together in my lap. My two index fingers and thumbs make a triangle shape. My fingertips touch each other.

I look out at the audience. I sit still and wait for the pee to come. It takes a while and there is silence. I am motionless, except for my eyelids, which slide down over my eyes occasionally, and then slide back up.

When I have finished peeing I lean over and take the toilet paper with my left hand. Holding it over my lap I unroll some paper and fold it precisely in half and then in half again and then in half again. I tear the bundle from the roll and place the roll back on the corner of the shower tray. I stand up and wipe myself with my right hand. Then I pull up my slip and my trousers and do up the four buttons. Then I straighten my shirt out.

I push the lid of the toilet down and press the button on the wall to flush the toilet.

I pick up the toilet paper roll and put it back on the shelf where it was before. Then I brush my hair back from my face with both hands. I walk back into the living unit.

Sitting on the chair

I put my body in front of the chair and bend my knees until my bottom rests on the seat of the chair. I put my hands on my thighs.

I take a deep breath and my chest rises. Then it falls. I remain sitting still. The metronome is on the left-hand side of the table and it is ticking. My feet are flat on the floor and spaced hip-width apart. My back is straight against the chair. I look at the audience. My head does not move, only my eyes. I blink. My mouth is closed. I blink again. When I take deeper breaths my chest rises and falls. The rest of my body is motionless.

I look at the audience.

I can hear the sound of traffic passing by outside.

After I have been sitting for a long time I have to straighten my back up.

Drinking water

I point my body towards the glass and put one foot in front of the other until I get to it. It takes three steps. The glass is already full of water. I take the glass with my right hand, curl my fingers around it with my thumb gripping the other side. I cup the glass in the palm of my hand. I raise the glass to my mouth. My left arm is straight and motionless. I tilt my head back and shake my hair away from my face. I tip the water into my open mouth and gulp. To control the flow of water into my mouth, I open and close my lips slowly, and open and close them again. The water waves back and forth in the glass every time I swallow. My neck moves every time I swallow. I drink until half of the glass is empty. Then I place the glass back down on the table. I press my lips together to suck in the droplets that are left there.

Standing at the front

I step forward to the edge of the platform in front of the chair. My feet are just wider than hip-width apart. I point my feet outwards slightly and stand still. I twist my wrists so that my palms turn out in front of me. My hands are open and facing the audience. My arms now point out slightly away from my hips.

Every time I breathe in, the bottom of my shirt moves in towards my torso. Every time I breathe out the bottom of my shirt moves outwards away from my torso. Nothing else moves, except the lids of both my eyes. They always move at the same time.

Winding up the metronome

The metronome has stopped ticking. I am staring at someone but I break the stare to wind up the metronome. I move my body towards it slowly, taking even steps. I pick it up with my right hand and then pass it to my left. I twist the knob clockwise round and round and round and round again until it cannot go round anymore. I do this very slowly. My body is still and only my wrist moves. It takes twenty-two twists to wind up the metronome all the way. I put the metronome back down on the table and then set off the ticker again. It ticks. The metronome faces the audience.

Standing at the front

I step forwards to the edge of the platform in front of the chair. My feet are just wider than hip-width apart. I point my feet outwards slightly and stand still. I twist my wrists so that my palms turn out in front of me. My hands are open and facing the audience. My arms now point out slightly away from my hips.

Every time I breathe in, the bottom of my shirt moves in towards my torso. Every time I breathe out the bottom of my shirt moves outwards away from my torso. Nothing else moves, except the lids of both my eyes. They always move at the same time.

I look at someone in the audience.

I take a deep breath and lift my chest and stand up straighter.

Drinking water

I point my body towards the glass and put one foot in front of the other until I get to it. It takes three steps. The glass is already full of water. I take the glass with my right hand, curl my fingers around it with my thumb gripping the other side. I cup the glass in the palm of my hand. I raise the glass to my mouth. My left arm is straight and motionless. I tilt my head back and shake my hair away from my face. I tip the water into my open mouth and gulp. To control the flow of water into my mouth, I open and close my lips slowly, and open and close them again. The water waves back and forth in the glass every time I swallow. My neck moves every time I swallow. I drink until half of the glass is empty. Then I place the glass back down on the table. I press my lips together to suck in the droplets that are left there.

Filling the glass

There is no more water in the glass so I have to fill it up. I take the glass to the sink in the bedroom unit. The sink is on the back wall. There is only a small gap between the bed and the back wall. I shuffle past behind the bed to the sink. I hold the glass in my left hand and put it underneath the tap in the sink. I push the tap up and then twist it to the left with my right hand until water trickles out. I tilt my head down towards the tap and watch the water flow. I let the glass fill up slowly. When the glass is full I turn off the tap by pushing it up and then twisting it to the right.

I shuffle past the bed and step over the gap with my right leg first. Now I am in the living unit. I place the glass down on the right-hand side of the table in the living unit. When the glass is resting on the table I release my grip and move my hand away from the glass back

towards my body.

Sitting on the chair

I put my body in front of the chair and bend my knees until my bottom rests on the seat of the chair. I put my hands on my thighs.

My feet are flat on the floor and spaced hip-width apart. My back is straight against the chair. I look at the audience. My head does not move, only my eyes. I blink. My mouth is closed. I blink again.

I reach over with my right hand, take the glass from the table and take a gulp from it. Then I put the glass back again. I put my hands back on my thighs.

Standing at the front

I stand up from sitting down by pushing my hands on my thighs. My elbows point outwards and form two triangle shapes on either side of my body. Using this shape I lever myself up. My hands slide down my thighs as I stand up, then they slide up again. I straighten my shirt.

Then I step forward to the edge of the platform in front of the chair. My feet are just wider than hip-width apart. I point my feet outwards slightly and stand still. I let my arms hang down straight by my sides. My fingers curve towards my thighs and there is a gap between them and my thumbs. I stand straight and still and remain looking at the audience. I blink. I breathe.

Drinking water

I pick up the glass with my right hand, curl my fingers around it with my thumb gripping the other side. I cup the glass in the palm of my hand. I raise the glass to my mouth. My left arm is straight and motionless. I tilt my head back and shake my hair away from my face. I tip the water into my open mouth and gulp. To control the flow of water into my mouth, I open and close my lips slowly, and open and close them again. The water waves back and forth in the glass every time I swallow. My neck moves every time I swallow. I drink until half of the glass is empty. Then I place the glass back down on the table. I press my lips together to suck in the droplets that are left there.

Lying on the bed

I stand in front of the bed a third of the way from the bottom end. I turn clockwise so I am facing the audience. Then, in one fluid movement I sit down on the bed, raise up my feet, move my hands back to balance myself and twist round ninety degrees, lower my body down until it is flat and rest my head on the quartz pillow. Then I flick my hair back over the pillow so my head is touching the pillow directly. I lie straight on my back. My hands are resting flat on the bed on either side of my body.

I look up at the ceiling.

Sitting on the bed

I sit up. I rest both feet on the floor and both hands on my thighs. I look at the audience.

I cup my hands together in my lap.

Then I put my elbows on my knees and rest my chin in my hands.

Standing at the front

I walk to the living unit and stand at the front of the platform in front of the chair. My feet are just wider than hip-width apart. I point my feet outwards slightly and stand still. I let my arms hang by my sides.

I stare at the audience.

Then I twist my wrists so that my palms are open, facing the audience.

Drinking water

I pick up the glass from the table. I curl my fingers around it with my thumb gripping the other side. I cup the glass in the palm of my hand.

I raise the glass to my mouth. My left arm is straight and motionless. I tilt my head back and shake my hair away from my face. I tip the water into my open mouth and gulp. To control the flow of water into my mouth, I open and close my lips slowly, and open and close them again. The water waves back and forth in the glass every time I swallow. My neck moves every time I swallow. I drink until the glass is two-thirds empty. Then I place the glass back down on the table. I press my lips together to suck in the droplets that are left there. I put the glass back on the table.

Sitting on the chair

I put my body in front of the chair and bend my knees until my bottom rests on the seat of the chair. I put my hands on my thighs.

I am motionless. I stare at the audience.

Standing at the front

I step forward to the edge of the platform, holding my hair back against my shoulders as I walk. Then I stand at the front, in front of the chair. My feet are just wider than hip-width apart. I point my feet outwards slightly and stand still. I twist my wrists so that my palms turn out in front of me. My hands are open and facing the audience. My arms now point out slightly away from my hips.

I look at the audience.

Drinking water

I pick up the glass from the table. I curl my fingers around it with my thumb gripping the other side. I cup the glass in the palm of my hand. I raise the glass to my mouth. My left arm is straight and motionless. I tilt my head back and shake my hair away from my face. I tip the water into my open mouth and gulp. To control the flow of water into my mouth, I open and close my lips slowly, and open and close them again. The water waves back and forth in the glass every time I swallow. My neck moves every time I swallow. I drink until the glass is two-thirds empty. Then I place the glass back down on the table. I press my lips together to suck in the droplets that are left there.

Filling the glass

There is no more water in the glass so I have to fill it up. I take the glass to the sink in the bedroom unit. The sink is on the back wall. There is only a small gap between the bed and the back wall. I shuffle past behind the bed to the sink. I hold the glass in my left hand and put it underneath the tap in the sink. I push the tap up and then twist it to the left with my right hand until water trickles out. I tilt my head down towards the tap and watch the water flow. I let the glass fill up slowly. My right hand rests on my left arm. When the glass is full I turn off the tap by pushing it up and then twisting it to the right.

I shuffle past the bed and step over the gap with my right leg first. Now I am in the living unit. I place the glass down on the right-hand side of the table in the living unit. When the glass is resting on the table I release my grip and move my hand away from the glass back towards my body.

Sitting on the chair

I stand in front of the chair and bend my knees until my body rests on the chair and I am sitting. The back of my head is touching the quartz pillow headrest. I place one hand on each thigh, halfway between my knee and my hip. My fingers are splayed out. The fingers on my right hand are slightly further apart than those on my left hand. The fingers of my left hand curve inward more than the fingers of my right hand.

I look out at the audience.

Drinking water

I stand up and pick up the glass from the table. I curl my fingers around it with my thumb gripping the other side. I cup the glass in the

palm of my hand. I raise the glass to my mouth. My left arm is straight and motionless. I tilt my head back and shake my hair away from my face. I tip the water into my open mouth and gulp. To control the flow of water into my mouth, I open and close my lips slowly, and open and close them again. The water waves back and forth in the glass every time I swallow. My neck moves every time I swallow. I drink until the glass is two-thirds empty. Then I place the glass back down on the table. I press my lips together to suck in the droplets that are left there. I put the glass back on the table.

Standing at the front

I stand at the front of the living unit over the knife ladder. My hands are by my sides. My fingers are tense and curved. I look at someone in the audience.

Peeing

I need to pee. I step across the gap to the bathroom unit. When I am in the unit I turn to my right and take the toilet paper from the shelf with my right hand. I take four steps over towards the toilet and turn my body round clockwise. When my back is to the audience I lean over and put the toilet roll on the left front corner of the shower tray. Then I lift the lid of the toilet with my left hand. I push it back until it is resting on the back of the unit. As I turn towards the front I lift up my shirt so I can unfasten my trousers. There are four buttons to unfasten. I tilt my head forward. When I have undone all the buttons I pull my trousers and my slip down to just above my knees and sit on the toilet. I put my feet close together in front of me and cup my hands together in my lap. My two index fingers and thumbs make a triangle shape. My fingertips touch each other.

I look down at the floor. I sit still and wait for the pee to come. It takes a while and there is silence. I am motionless, except for my eyelids, which slide down over my eyes occasionally, and then slide back up.

When I have finished peeing I lean over and take the toilet paper with my left hand. Holding it over my lap I unroll some paper and fold it precisely in half and then in half again and then in half again. I tear the bundle from the roll and place the roll back on the corner of the shower tray. I stand up and wipe myself with my right hand. Then I pull up my slip and my trousers and do up the four buttons. Then I straighten my shirt out.

I push the lid of the toilet down and press the button on the wall to flush the toilet.

I pick up the toilet roll and put it back on the shelf where it was before. Then I brush my hair back from my face with both hands. I walk back into the living unit.

Drinking water

I pick up the glass from the table. I curl my fingers around it with my thumb gripping the other side. I cup the glass in the palm of my hand. I raise the glass to my mouth. My left arm is straight and motionless. I tilt my head back and shake my hair away from my face. I tip the water into my open mouth and gulp. To control the flow of water into my mouth, I open and close my lips slowly, and open and close them again. The water waves back and forth in the glass every time I swallow. My neck moves every time I swallow. I drink until the glass is nearly empty. Then I place the glass back down on the table. I press my lips together to suck in the droplets that are left there. I put the glass back on the table.

Sitting on the chair

I put my body in front of the chair and bend my knees until my bottom rests on the seat of the chair. I put my hands on my thighs. I stare at the telescope.

Drinking water

I stand up and pick up the glass from the table. I curl my fingers

around it with my thumb gripping the other side. I cup the glass in the palm of my hand. I raise the glass to my mouth. My left arm is straight and motionless. I tilt my head back and shake my hair away from my face. I tip the water into my open mouth and gulp.

I drink. Then I place the glass back down on the table. I put the glass back on the table.

Standing at the front

I stand at the front of the living unit over the knife ladder. My hands are by my sides. My fingers are tense and curved. I look at someone in the audience.

Sitting on the bed

I sit on the left-hand side of the bed, staring at the audience with my head in my hands.

The metronome stops ticking.

Outside I can hear cars driving past.

Winding up the metronome

I walk to the living unit and pick up the metronome from the table with my right hand and then I pass it to my left. I twist the knob clockwise round and round and round and round again until it cannot go round anymore. I do this very slowly. My body is still and only my wrist moves. It takes twenty-two twists to wind up the metronome all the way. I put the metronome back down on the table and then set off the ticker again. It ticks. The metronome faces the audience.

Sitting on the chair

I put my body in front of the chair and bend my knees until my bottom rests on the seat of the chair. I put my hands on my thighs. I stare at the telescope.

Peeing

I need to pee. I step across the gap to the bathroom unit. When I am in the unit I turn to my right and take the toilet paper from the shelf with my right hand. I take four steps over towards the toilet and turn my body round clockwise. When my back is to the audience I lean over and put the toilet roll on the left front corner of the shower tray. Then I lift the lid of the toilet with my left hand. I push it back until it is resting on the back of the unit. As I turn towards the front I lift up my shirt so I can unfasten my trousers. There are four buttons to unfasten. I tilt my head forward. When I have undone all the buttons I pull my trousers and my slip down to just above my knees and sit on the toilet. I put my feet close together in front of me and cup my hands together in my lap. My two index fingers and thumbs make a triangle shape. My fingers make a cage.

I look out at the floor. I sit still and wait for the pee to come. It takes a while and there is silence. I am motionless, except for my eyelids, which slide down over my eyes occasionally, and then slide back up.

When I have finished peeing I lean over and take the toilet paper with my left hand. Holding it over my lap I unroll some paper and fold it precisely in half and then in half again and then in half again. I tear the bundle from the roll and place the roll back on the corner of the shower tray. I stand up and wipe myself with my right hand. Then I pull up my slip and my trousers and do up the four buttons. Then I straighten my shirt out.

I push the lid of the toilet down and press the button on the wall to flush the toilet.

I pick up the toilet roll and put it back on the shelf where it was before. Then I brush my hair back from my face with both hands. I walk back into the living unit.

Standing at the front

I walk to the living unit and stand at the front of the platform in front of the chair. My feet are just wider than hip-width apart. I point my feet outwards slightly and stand still. I let my arms hang by my sides.

I stare at the audience.

Drinking water

I stand up and pick up the glass from the table. I curl my fingers around it with my thumb gripping the other side. I cup the glass in the palm of my hand. I raise the glass to my mouth. My left arm is straight and motionless. I tilt my head back and shake my hair away from my face. I tip the water into my open mouth and gulp.

I drink until the glass is half empty. Then I place the glass back down on the table.

Sitting on the chair

I put my body in front of the chair and bend my knees until my bottom rests on the seat of the chair. I put my hands on my thighs. I stare at the audience.

The metronome ticks.

I blink.

I reach over with my left hand, pick up the glass and take a gulp from it.

Standing at the front

I get up from the chair and walk to the edge of the platform over the knife ladder. I stand there and stare. I do not move.

Showering

I pick up the bath mat from inside the shower tray and unroll it on the floor in front of the shower. Then I take the towel from the shelf and drape it over the toilet seat. I sit on the edge of the toilet and put my hairband around my left wrist. Then I lean over and untie the laces of my right boot with my left hand. When the laces are loose enough, I take off the boot and then pull off the sock by grabbing the toe. I put the sock in the boot. Then I untie the laces of my left boot with both hands. When the laces are loose enough I take off the boot and then pull off the sock by grabbing the toe. I put the sock in the boot.

Then I undo the buttons on my trousers and stand up so I can pull them down. When I have sat down again, I finish pulling them off, starting with the right leg and finishing with the left leg. Then I fold them in half and then half again and then half again and put them on the floor next to the boots. This I do very slowly.

Then I pull my slip down to my knees and take a pee, since I am sitting on the toilet.

Then I brush the hair from my face and undo the buttons on my collars and the buttons of my shirt, starting at the bottom and working my way up. There are seven buttons to undo. Then I take off my shirt and lay it across my legs. Then I take off my undershirt and fold it up neatly. Then I take off my slip. I put all my clothes on the left-hand side of the unit next to the wall.

I stand up, turn around and press the button on the wall to flush the toilet.

Then I take the hairband off my wrist, pull my hair together behind my head, fold the bundle in half and tie it back with my hairband. I stand on the left of the shower, outside the tray, and turn on the taps. I test the temperature of the water by holding out my left hand under the trickle. I wait for as long as it takes for the water to warm up. I step into the shower and look at the floor.

I need to adjust the temperature and I do that by reaching behind me to the taps with my left hand. When I have finished showering I turn round and twist the taps off with my right hand.

I lean over to pick up the towel. I wrap the towel around my body.

Then I bend down in front of the shower and wipe up the water from the floor with the bath mat.

Then I rub the towel over my arms, then my torso, then my legs. I do not dry myself very thoroughly. Then I lay the towel over the toilet seat and sit down on it.

Then I put my slip back on. Then I put my undershirt back on by putting my head through the head hole and my arms through the armholes. I do the same with my pajama shirt and do up the buttons on my cuffs. I do up the buttons starting at my neck and working my way downward. Then I put my trousers on. I straighten out all of my clothes. I pull my hairband off and put it back on the shelf. I sit back down and put my right sock on followed by my right boot. I tie the laces. Then I put my left sock on followed by my left boot. I tie the laces. I stand up.

I leave the towel hanging on the taps and the bath mat rolled up in the shower tray.

Before I step into the living unit, I stand in front of the shelves and run my fingers through my hair.

Standing at the front

I step forward to the edge of the platform in front of the chair. My feet are just wider than hip-width apart. I rock slightly from side to side to make sure that I am evenly balanced. I point my feet outwards slightly and stand still. I let my arms hang down straight by my sides. My fingers curve towards my thighs and there is a gap between them and my thumbs. I stand straight and still and remain looking at the eyes of someone in the audience. I blink. I breathe.

Sitting on the chair

I stand in front of the chair and bend my knees until my body rests on the chair and I am sitting. The back of my head is touching the quartz pillow headrest. I place one hand on each thigh, halfway between my knee and my hip. My fingers are splayed out. The fingers on my right hand are slightly further apart than those on my left hand. The fingers of my left hand curve inward more than the fingers of my right hand.

I look out at the audience.

Standing at the front

I stand at the front of the living unit over the knife ladder. My hands are by my sides. My fingers are tense and curved. I look at someone in the audience.

Drinking water

I turn around and pick up the glass from the table. I take a sip from the glass and put it back down on the table where it was.

Sitting on the chair

I stand in front of the chair and bend my knees until my body rests on the chair and I am sitting. The back of my head is touching the quartz pillow headrest. I place one hand on each thigh, halfway between my knee and my hip. My fingers are splayed out. The fingers on my right hand are slightly further apart than those on my left hand. The fingers of my left hand curve inward more than the fingers of my right hand.

I look out at the audience.

Peeing

I need to pee. I step across the gap to the bathroom unit. When I am in the unit I turn to my right and take the toilet paper from the shelf with my right hand. I take four steps over towards the toilet and turn my body round clockwise. When my back is to the audience I lean over and put the toilet roll on the left front corner of the shower tray. Then I lift the lid of the toilet with my left hand. I push it back until it is resting on the back of the unit. As I turn towards the front I lift up my shirt

so I can unfasten my trousers. There are four buttons to unfasten. I tilt my head forward. When I have undone all the buttons I pull my trousers and my slip down to just above my knees and sit on the toilet. I put my feet close together in front of me.

I rest my head in my curled up fists under my chin. My elbows rest on my knees.

I look out at the audience. I sit still and wait for the pee to come. It takes a while and there is silence. I am motionless, except for my eyelids, which slide down over my eyes occasionally, and then slide back up.

When I have finished peeing I lean over and take the toilet paper with my left hand. Holding it over my lap I unroll some paper and fold it precisely in half and then in half again and then in half again. I tear the bundle from the roll and place the roll back on the corner of the shower tray. I stand up and wipe myself with my right hand. Then I pull up my slip and my trousers and do up the four buttons. Then I straighten my shirt out.

I push the lid of the toilet down and press the button on the wall to flush the toilet.

I pick up the toilet roll and put it back on the shelf where it was before. Then I brush my hair back from my face with both hands. I walk back into the living unit.

Standing at the front

I step forward to the edge of the platform in front of the chair. My feet are just wider than hip-width apart. I point my feet outwards slightly and stand still. I twist my wrists so that my palms turn out in front of me. My hands are open and facing the audience. My arms now point out slightly away from my hips.

Drinking water

I step back to the table, pick up the glass, and drink a mouthful of water. Then I put the glass back on the table where it was.

Standing at the front

I stand over the knife ladder at the edge of the platform. My arms rest by my sides. My eyes look at someone in the audience.

Drinking water

I step back to the table, pick up the glass, and drink the rest of the water from the glass. Then I carry the glass away.

Filling the glass

There is no more water in the glass so I have to fill it up. I take the glass to the sink in the bedroom unit. The sink is on the back wall. There is only a small gap between the bed and the back wall. I shuffle past behind the bed to the sink. I hold the glass in my left hand and put it underneath the tap in the sink. I push the tap up and then twist it to the left with my right hand until water trickles out. I tilt my head down towards the tap and watch the water flow. I let the glass fill up slowly. My right hand rests on the edge of the sink. I look into the sink. When the glass is full I turn off the tap by pushing it up and then twisting it to the right.

I shuffle past the bed and step over the gap with my right leg first. Now I am in the living unit. I place the glass down on the right-hand side of the table in the living unit. When the glass is resting on the table I release my grip and move my hand away from the glass back towards my body.

Standing at the front

I walk to the living unit and stand at the front of the platform in front of the chair. My feet are just wider than hip-width apart. I point my feet outwards slightly and stand still. I let my arms hang by my sides.

I stare at the audience.

Sitting on the chair

I stand in front of the chair and bend my knees until my body rests on the chair and I am sitting. The back of my head is touching the quartz pillow headrest. I wipe my face with my hands. Then I place one hand on each thigh, halfway between my knee and my hip. My fingers are splayed out. The fingers on my right hand are slightly further apart than those on my left hand. The fingers of my left hand curve inward more than the fingers of my right hand.

I look at someone's eyes.

The metronome ticks.

I reach over and pick up the glass and drink from it.

Dabbing water on my face

I hold the glass in my left hand and dip my fingers from my right hand into the glass. I paint some water under my eyes, down my nose and across my cheeks. I shake off the excess water from my fingers back into the glass. Then I put the glass back on the table.

Drinking water

I stand up and pick up the glass and raise it to my mouth. My left arm is straight and motionless. I tilt my head back and shake my hair away from my face. I tip the water into my open mouth and gulp. To control the flow of water into my mouth, I open and close my lips slowly, and open and close them again. The water waves back and forth in the glass every time I swallow. My neck moves every time I swallow. I drink until half of the glass is empty. Then I place the glass back down on the table. I press my lips together to suck in the droplets that are left there.

I place the glass down on the right-hand side of the table in the living unit. When the glass is resting on the table I release my grip and move my hand away from the glass back towards my body.

Standing at the front

I step forward to the edge of the platform in front of the chair. My feet are just wider than hip-width apart. I rock slightly from side to side to make sure that I am evenly balanced. I point my feet outwards slightly and stand still. I let my arms hang down straight by my sides. My fingers curve towards my thighs and there is a gap between them and my thumbs. I stand straight and still and remain looking at the audience. I blink. I breathe.

Then I twist my wrists so that my palms face the person I am staring at.

Crying

I mouth some words to the person I am staring at. Then I start crying. My chest quivers and my cheeks tighten and my forehead scrunches up. My eyes droop and the tears dribble. A sound comes from the back of my throat as I gasp for air and my chest rocks.

I stay standing up and I stay staring.

Drinking water

I turn around and pick up the glass from the table. I take a sip from the glass and put it back down on the table where it was.

Peeing

I need to pee. I step across the gap to the bathroom unit. When I am in the unit I turn to my right and take the toilet paper from the shelf with my right hand. I take four steps over towards the toilet and turn my body round clockwise. When my back is to the audience I lean over and put the toilet paper roll on the left front corner of the shower tray. Then I lift the lid of the toilet with my left hand. I push it back until it is resting on the back of the unit. As I turn towards the front I lift up my shirt so I can unfasten my trousers. There are four buttons to

unfasten. I tilt my head forward. When I have undone all the buttons I pull my trousers and my slip down to just above my knees and sit on the toilet. I put my feet close together in front of me and cup my hands together in my lap. My two index fingers and thumbs make a triangle shape. My fingertips touch each other.

I look out at the floor.

I cry a little.

I sit still and wait for the pee to come. It takes a while and there is silence. I am motionless, except for my eyelids, which slide down over my eyes occasionally, and then slide back up.

When I have finished peeing I lean over and take the toilet paper with my left hand. I tear off a couple of sheets and wipe my nose. Then I unroll some more paper and fold it precisely in half and then in half again and then in half again. I tear the bundle from the roll and place the roll back on the corner of the shower tray. I stand up and wipe myself with my right hand. Then I pull up my slip and my trousers and do up the four buttons. Then I straighten my shirt out.

I push the lid of the toilet down and press the button on the wall to flush the toilet.

I pick up the toilet roll and put it back on the shelf where it was before. Then I brush my hair back from my face with both hands. I walk back into the living unit.

Winding up the metronome

The metronome has stopped ticking. I walk to the living unit and pick it up with my right hand and then pass it to my left. I twist the knob clockwise round and round and round and round again until it cannot go round anymore. I do this very slowly. My body is still and only my wrist moves. It takes twenty-two twists to wind up the metronome all the way. I put the metronome back down on the table and then set off the ticker again. It ticks. The metronome faces the audience.

Standing at the front

I stand at the front of the living unit over the knife ladder. My hands are by my sides. My fingers are tense and curved. I look at someone in the audience.

Then I twist my wrists so my palms are open facing the person I am staring at.

Sitting on the chair

I put my body in front of the chair and bend my knees until my bottom rests on the seat of the chair. I put my hands on my thighs.

I am motionless. I stare at the audience.

Drinking water

I stand up and pick up the glass from the table. I curl my fingers around it with my thumb gripping the other side. I cup the glass in the palm of my hand. I raise the glass to my mouth. My left arm is straight and motionless. I tilt my head back and shake my hair away from my face. I tip the water into my open mouth and gulp.

I drink all the water in the glass, very slowly. Then I place the glass back down on the table.

Standing at the front

I walk to the living unit and stand at the front of the platform in front of the chair. My feet are just wider than hip-width apart. I point my feet outwards slightly and stand still. I let my arms hang by my sides.

I stare at the audience.

Showering

I pick up the bath mat from inside the shower tray and unroll it on the floor in front of the shower. Then I take the towel from the shelf and drape it over the toilet seat. I sit on the edge of the toilet and lean over and untie the laces of my right boot with my left hand. When the laces are loose enough, I take off the boot and then pull off the sock by grabbing the toe. I put the sock in the boot. Then I untie the laces of my left boot with both hands. When the laces are loose enough I take off the boot and then pull off the sock by grabbing the toe. I put the sock in the boot.

Then I undo the buttons on my trousers and stand up so I can pull them down. When I have sat down again, I finish pulling them off, starting with the right leg and finishing with the left leg. Then I fold them in half and then half again and then half again and put them on the floor next to the boots. This I do very slowly.

Then I brush the hair from my face and undo the buttons on my collars and the buttons of my shirt, starting at the bottom and working my way up. There are seven buttons to undo. Then I take off my shirt and lay it across my legs. Then I take off my undershirt and fold it up neatly. Then I take off my slip. I put all my clothes on the left-hand side of the unit next to the wall.

I stand on the left of the shower, outside the tray, and turn on the taps. I test the temperature of the water by holding out my left hand under the trickle. I wait for as long as it takes for the water to warm up. I step into the shower.

I reach over and take the hairband from the shelf. I tie my hair back.

I stand in the shower and look at the floor.

I need to adjust the temperature and I do that by reaching behind me to the taps with my left hand.

I collect some water in my cupped hands and splash it on my face. Then I wipe my arms with my hands.

I turn round and twist the taps off with my right hand.

I lean over to pick up the towel. I dry myself by wiping the towel all over my body. Then I lay the towel over the toilet seat and sit down on it.

Then I put my slip back on. Then I put my undershirt back on by putting my head through the head hole and my arms through the armholes. Then I put my trousers back on. Then I put my shirt on and do up the buttons on my cuffs. I do up the buttons starting at my neck and working my way downward. I straighten out all of my clothes. I pull my hairband off and put it back on the shelf.

I leave my towel hanging on the right-hand tap so it can dry out.

I get down on my hands and knees and wipe up the water from the floor with the bathmat. Then I wipe the edge of the shower tray. Then I put the bathmat in the shower tray.

I sit back down and put my right sock on followed by my right boot. I tie the laces. Then I put my left sock on followed by my left boot. I tie the laces. I stand up.

Before I step into the living unit, I stand in front of the shelves and run my fingers through my hair.

Standing at the front

I step forward to the edge of the platform in front of the chair. My feet are just wider than hip-width apart. I rock slightly from side to side to make sure that I am evenly balanced. I point my feet outwards slightly and stand still. I let my arms hang down straight by my sides. My fingers curve towards my thighs and there is a gap between them and my thumbs. I stand straight and still and remain looking at the audience. I blink. I breathe.

Then I twist my wrists so that my palms turn out in front of me. My hands are open and facing the audience. My arms now point out

slightly away from my hips.

Filling the glass

There is no more water in the glass so I have to fill it up. I take the glass to the sink in the bedroom unit. The sink is on the back wall. There is only a small gap between the bed and the back wall. I shuffle past behind the bed to the sink. I hold the glass in my left hand and put it underneath the tap in the sink. I push the tap up and then twist it to the left with my right hand until water trickles out. I tilt my head down towards the tap and watch the water flow. I let the glass fill up slowly. My right hand rests on the edge of the sink. I look into the sink. When the glass is full I turn off the tap by pushing it up and then twisting it to the right.

I shuffle past the bed and step over the gap with my right leg first. Now I am in the living unit.

Drinking water

I take a sip of water before I put the glass down on the table.

Standing at the front

I stand at the front of the living unit over the knife ladder. My hands are by my sides. My fingers are tense and curved. I look at someone in the audience.

Then I twist my wrists so that my open palms face the audience. I keep looking.

Stopping the metronome

I step back and hold the ticker between my finger and thumb and then let it rest, still, in the center.

Sitting on the chair

I stand in front of the chair and bend my knees until my body rests on the chair and I am sitting. The back of my head is touching the quartz pillow headrest. I place one hand on each thigh, halfway between my knee and my hip. My fingers are splayed out. The fingers on my right hand are slightly further apart than those on my left hand. The fingers of my left hand curve inward more than the fingers of my right hand.

I look out at the audience.

I blink.

I lean forward a little.

Drinking water

I stand up, take the glass and drink three gulps from it. Then I put the glass back down where it was, on the table.

Peeing

I need to pee. I step across the gap to the bathroom unit with my left leg first and touch the outer wooden frame with my left hand. When I am in the unit I turn to my right and take the toilet paper from the shelf with my right hand. I take four steps over towards the toilet and turn my body round clockwise. When my back is to the audience I lean over and put the toilet roll on the left front corner of the shower tray. Then I lift the lid of the toilet with my right hand. I push it back until it is resting on the back of the unit. As I turn towards the front I lift my shirt so I can unfasten my trousers. There are four buttons to unfasten. I tilt my head forward. When I have undone all the buttons I pull my trousers and my slip down to just above my knees and sit on the toilet. I put my feet close together in front of me.

I rest my head in my hands and look at the floor.

I sit still and wait for the pee to come. It takes a while and there is silence. I am motionless, except for my eyelids, which slide down over my eyes occasionally, and then slide back up.

When I have finished peeing I lean over and take the toilet paper with my left hand. Holding it over my lap I unroll some paper and fold it precisely in half and then in half again and then in half again. I tear the bundle from the roll and place the roll back on the corner of the shower tray. I stand up and wipe myself with my right hand. Then I pull up my slip and my trousers and do up the four buttons. Then I straighten my shirt out.

I lean over and push down the handle of the bucket towards the front, then I turn on the tap on the wall with my left hand. The water falls into the bucket beneath.

I put the toilet paper back on the shelf.

Then I stand and watch the water fall. When the bucket is half full I turn off the tap and lift the bucket. I poor the water down the toilet to flush it, then I put the lid down. I place the bucket back where it was, underneath the tap, and pull the handle up so it is in the middle.

Standing between the units

I stand with one foot in the bathroom unit and the other in the living unit. My body is over the gap. My legs make a triangle shape. Holding my arms at chest height, I rest my hands on the back of the wooden frames. I look at someone in the audience and remain still.

Sitting on the chair

I put my body in front of the chair and bend my knees until my bottom rests on the seat of the chair. I put my hands on my thighs. I look out at the audience.

Standing at the front

I stand up from sitting down by pushing my hands on my thighs. My elbows point outwards and form two triangle shapes on either side of my body. Using this shape I lever myself up. My hands slide down my thighs as I stand up, then they slide up again. I straighten my shirt. Then I step forward to the edge of the platform in front of the chair. I pull my shirt down again using both my hands so that it is straight. My feet are just wider than hip-width apart. I rock slightly from side to side to make sure that I am evenly balanced. I point my feet outwards slightly and stand still. I let my arms hang down straight by my sides. My fingers curve towards my thighs and there is a gap between them and my thumbs. I stand straight and still and remain looking at the audience. I blink. I breathe.

Drinking water

I turn around and pick up the glass from the table. I drink all the water from the glass and then put the glass down.

Sitting on the chair

I put my body in front of the chair and bend my knees until my bottom rests on the seat of the chair. I put my hands on my thighs. I look out at the audience.

Standing at the front

I stand up and walk to the edge of the platform. I stand over the knife ladder and stare down at someone in the audience. I twist my wrists round a little.

Saturday, November 16th: Day 2

Wearing violet

Sitting on the chair

The metronome is not ticking. There is silence.

I sit leaning forward, resting my chin on my knuckles and my elbows on my knees. I blink and look out at the gallery. Then I look at the floor.

I brush the hair back from my forehead.

Then I make motions to someone in the gallery with my hands. I point my finger down. Then I point to my ear and hold my hand out flat and motion downwards.

I stop motioning.

My feet are a hip-width apart, pointing outwards, and I put my hands together with my fingers interlaced, resting in between my legs. Then I rest my head in my hands again.

There is no one in the gallery.

I pick a hair off my pajama trousers.

I lean back in the chair and drum my fingers together.

Peeing

I need to pee. I step across the gap to the bathroom unit. When I am in the unit I turn to my right and take the toilet paper from the shelf with my right hand. I tear off a few sheets and put the toilet roll back on the shelf.

I take four steps over towards the toilet and turn my body round clockwise. Then I lift the lid of the toilet with my left hand. I push it back until it is resting on the back of the unit. As I turn towards the front I lift up my shirt so I can unfasten my trousers. There are four buttons to unfasten. I tilt my head forward. When I have undone all the buttons I pull my trousers and my slip down to just above my knees and sit on the toilet. I put my feet close together in front of me and cup my hands together in my lap. My two index fingers and thumbs make a triangle shape. My fingertips touch each other.

I look out at the empty gallery. I sit still and wait for the pee to come. It takes a while and there is silence. I am motionless, except for my eyelids, which slide down over my eyes occasionally, and then slide back up.

When I have finished peeing I stand up and wipe myself with the bundle of toilet paper. Then I pull up my slip and my trousers and do up the four buttons. Then I straighten my shirt out.

I push the lid of the toilet down and press the button on the wall to flush the toilet.

Hugging the pillar

I stand by the pillar on the right-hand side of the living unit and put my arms around it, linking my hands at the front. I look down. I rest my head against the pillar.

Sitting on the chair

I stand in front of the chair and bend my knees until my body rests on the chair and I am sitting. The back of my head is touching the quartz pillow headrest. I put my hands together in my lap.

Then I look at the floor.

Then I fold my arms and cross my legs, the right leg over the left leg.

Then I rest my head in my hands.

I take the glass from the table and drink from it. I hold it against my mouth. I put it back.

Filling the glass

I pick up the empty glass from the table. I take the glass to the sink in the bedroom unit. I hold the glass in my left hand and put it underneath the tap in the sink. I push the tap up and then twist it to the left with my right hand until water trickles out. I tilt my head down towards the tap and watch the water flow. I let the glass fill up slowly. My right hand rests on the edge of the sink. When the glass is full I turn off the tap by pushing it up and then twisting it to the right. Then I pass the glass from my left to my right hand. I walk to the living unit and put the glass down on the table.

Winding up the metronome

I pick up the metronome with my right hand and then pass it to my left. I twist the knob clockwise round and round. I do this very slowly. My body is still and only my wrist moves. I put the metronome back down on the table and then set off the ticker. It ticks. The metronome faces the audience.

Standing at the front

I step forward to the edge of the platform in front of the chair. My feet are just wider than hip-width apart. I point my feet outwards slightly and stand still. I let my arms hang down straight by my sides. My fingers curve towards my thighs and there is a gap between them and my thumbs. I stand straight and still and remain looking at the audience. I blink. I breathe.

Sitting on the chair

I stand in front of the chair and bend my knees until my body rests on the chair and I am sitting. The back of my head is touching the quartz pillow headrest. I put my hands on my thighs halfway between my knee and my hip. My fingers are splayed out evenly. I look into the eyes someone in the gallery.

Peeing

I need to pee. I step across the gap to the bathroom unit. When I am in the unit I turn to my right and take the toilet paper from the shelf with my right hand. I take four steps over towards the toilet and turn my body round clockwise. When my back is to the audience I lean over and put the toilet roll on the left front corner of the shower tray.
Then I lift the lid of the toilet with my left hand. I push it back until it is resting on the back of the unit. As I turn towards the front I lift up my shirt so I can unfasten my trousers. There are four buttons to unfasten. I tilt my head forward. When I have undone all the buttons I pull my trousers and my slip down to just above my knees and sit on the toilet. I put my feet close together in front of me and cup my hands together in my lap. My two index fingers and thumbs make a triangle shape. My fingers make a cage.

I look at the floor. I sit still and wait for the pee to come. It takes a while and there is silence. I am motionless, except for my eye-

lids, which slide down over my eyes occasionally, and then slide back up.

When I have finished peeing I lean over and take the toilet paper with my left hand. I unroll some more paper and fold it precisely in half and then in half again and then in half again. I tear the bundle from the roll and place the roll back on the corner of the shower tray. I stand up and wipe myself with my right hand. Then I pull up my slip and my trousers and do up the four buttons. Then I straighten my shirt out.

I lean over and push down the handle of the bucket towards the front, then I turn on the tap on the wall with my left hand. The water falls into the bucket beneath.

Then I stand and watch the water fall. When the bucket is half full I turn off the tap and lift the bucket. I poor the water down the toilet to flush it, then I put the lid down. I place the bucket back where it was, underneath the tap, and pull the handle up so it is in the middle.

I put the toilet paper back on the shelf, pause and brush my hair back with my fingers, then walk out of the bathroom unit.

Standing at the front

I stand at the front of the living unit over the knife ladder. My hands are by my sides. My fingers are tense and curved. I look at someone in the audience. I wobble a little bit.

Then I twist my wrists round half way.

I take a deep breath and keep staring.

Then I twist my wrists all the way round so my open palms face the person I am staring at.

Indecision

I walk over to the chair and stand in front of it with my back to the audience. I look down. I do not sit down. I turn around and walk towards the bathroom unit.

Wiping my nose

I step across the gap into the bathroom unit. I reach towards the toilet roll with my right hand and unroll a strip. I fold it up into a pad with both hands and then press the pad against my nose. I blow air and snot hard out of my nose into the paper with two bursts. Then I carry the paper back with me into the living unit. I put the paper into my right pocket on the way.

Sitting on the chair

I stand in front of the chair and bend my knees until my body rests on the chair and I am sitting. The back of my head is touching the quartz pillow headrest. I place one hand on each thigh, halfway between my knee and my hip. My fingers are splayed out. The fingers on my right hand are slightly further apart than those on my left hand. The fingers of my left hand curve inward more than the fingers of my right hand.

I look out at the audience.

I put my hands together in my lap, my fingers interlaced.

I reach over with my left hand and pick up the glass and drink from it. I put the glass down.

Then I reach over and turn the metronome to face me with my right hand. I pinch the ticker in my right hand and balance it in the middle so that it stops ticking. I look at the ticker for a long time after it has stopped. Then I sit back straight again and rest my head in my hands and continue staring.

Then I sit back and cover my face with my hands.

Starting the metronome

I lean across from the chair to the table and push the ticker right over to the left-hand side with the index finger of my right hand. Then I release the ticker and it starts swinging back and forth. I leave my finger resting on the bottom of the metronome and watch the ticker swinging back and forth. Then I sit back straight again. I slouch back in the chair and my neck quivers.

Lying on the bed

I stand in front of the bed a third of the way from the bottom end. I turn clockwise so I am facing the audience. Then, in one fluid movement I sit down on the bed, raise up my feet, move my hands back to balance me and twist round ninety degrees, lower my body down until it is flat and rest my head on the quartz pillow. Then I flick my hair back over the pillow so my head is touching the pillow directly. I lie straight on my back with my right leg over my left leg. My hands are linked together over my belly.

Someone in the audience is singing to me. I listen. Occasionally I wiggle my right foot.

I hunch my legs up.

Showering

I pick up the bath mat from inside the shower tray and unroll it on the floor in front of the shower. Then I take the towel from the shelf and drape it over the toilet seat. I sit on the edge of the toilet and put my hairband around my left wrist. Then I lean over and untie the laces of my right boot with my left hand. When the laces are loose enough, I take off the boot and then pull off the sock by grabbing the toe. I put the sock on the boot. Then I untie the laces of my left boot with both hands. When the laces are loose enough I take off the boot and then pull off the sock by grabbing the toe. I put the sock on the boot.

Then I undo the buttons on my trousers and stand up so I can pull them down. When I have sat down again, I finish pulling them off, starting with the right leg and finishing with the left leg. Then I fold them in half and then half again and then half again and put them on the floor next to the boots. This I do very slowly.

Then I brush the hair from my face and undo the buttons on my collars and the buttons of my shirt, starting at the bottom and working my way up. There are seven buttons to undo. Then I take off my shirt and lay it across my legs. Then I take off my undershirt and fold it up neatly. Then I take off my slip. I put all my clothes on the left-hand side of the unit next to the wall.

Then I take the hairband off my wrist, pull my hair together behind my head, fold the bundle in half and tie it back with my hairband. I stand on the left of the shower, outside the tray, and turn on the taps. I test the temperature of the water by holding out my left hand under the trickle. I wait for as long as it takes for the water to warm up. I step into the shower.

I look straight ahead.

Then I look at the floor.

I wipe my face.

When I have finished showering I turn round and twist the taps off with my right hand.

I lean over to pick up the towel. I rub the towel over my arms, then my torso, then my legs. I do not dry myself very thoroughly. Then I lay the towel over the toilet seat and sit down on it.

Then I put my slip back on. Then I put my undershirt back on by putting my head through the head hole and my arms through the armholes. I do the same with my shirt and do up the buttons on my cuffs. I do up the buttons starting at my neck and working my way down-

ward. Then I put my trousers on. I straighten out all of my clothes. I pull my hairband off and put it back on the shelf.

Then I roll up the bath mat and wipe up the water from the floor. I put the wet bath mat in the shower tray.

I sit back down and put my right sock on followed by my right boot. I tie the laces. Then I put my left sock on followed by my left boot. I tie the laces. I stand up.

I fold up the towel and put it back on the shelf.

Before I step into the living unit, I stand in front of the shelves and run my fingers through my hair.

Standing at the front

I step forward to the edge of the platform in front of the chair. My feet are just wider than hip-width apart. I point my feet outwards slightly and stand still. I let my arms hang down straight by my sides. My fingers curve towards my thighs and there is a gap between them and my thumbs. I stand straight and still and remain looking at the audience. I blink. I breathe.

Drinking water

I turn around and pick up the glass from the table and raise it to my mouth. My left arm is straight and motionless. I tilt my head back and shake my hair away from my face. I tip the water into my open mouth and gulp. To control the flow of water into my mouth, I open and close my lips slowly, and open and close them again. The water waves back and forth in the glass every time I swallow. My neck moves every time I swallow. I drink until half of the glass is empty. Then I place the glass back down on the table. I press my lips together to suck in the droplets that are left there.

Sitting on the chair

I stand in front of the chair and bend my knees until my body rests on the chair and I am sitting. The back of my head is touching the quartz pillow headrest. I place one hand on each thigh, halfway between my knee and my hip. My fingers are splayed out. The fingers on my right hand are slightly further apart than those on my left hand. The fingers of my left hand curve inward more than the fingers of my right hand.

I look out at the audience.

Standing at the front

I stand at the front of the living unit over the knife ladder. My hands are by my sides. My fingers are tense and curved. I look at someone in the audience. I twist my wrists so my palms are open and raise my arms a little from my sides.

Drinking water

I turn around and pick up the glass from the table and raise it to my mouth. My left arm is straight and motionless. I tilt my head back and shake my hair away from my face. I tip the water into my open mouth and gulp. To control the flow of water into my mouth, I open and close my lips slowly, and open and close them again. The water waves back and forth in the glass every time I swallow. My neck moves every time I swallow. I drink until the glass is empty.

Filling the glass

I take the glass to the sink in the bedroom unit. I hold the glass in my left hand and put it underneath the tap in the sink. I push the tap up and then twist it to the left with my right hand until water trickles out. I tilt my head down towards the tap and watch the water flow. I let the glass fill up slowly. My right hand rests on the edge of the sink. When the glass is full I turn off the tap by pushing it up and then twisting it to the right. Then I pass the glass from my left to my right hand. I walk to the living unit and put the glass down on the table.

Standing at the front

I step forward to the edge of the platform in front of the chair. My feet are just wider than hip-width apart. I point my feet outwards slightly and stand still. I let my arms hang down straight by my sides. My fingers curve towards my thighs and there is a gap between them and my thumbs. I stand straight and still and remain looking at the audience.

Some people at the back of the gallery are talking.

Peeing

I need to pee. I step across the gap to the bathroom unit. When I am in the unit I turn to my right and take the toilet paper from the shelf with my right hand. I take four steps over towards the toilet and turn my body round clockwise. When my back is to the audience I lean over and put the toilet roll on the left front corner of the shower tray.

Then I lift the lid of the toilet with my left hand. I push it back until it is resting on the back of the unit. As I turn towards the front I lift up my shirt so I can unfasten my trousers. There are four buttons to unfasten. I tilt my head forward. When I have undone all the buttons I pull my trousers and my slip down to just above my knees and sit on the toilet. I put my feet close together in front of me and cup my hands together in my lap. My two index fingers and thumbs make a triangle shape. My fingers make a cage.

I look at the floor. I sit still and wait for the pee to come. It takes a while and there is silence. I am motionless, except for my eyelids, which slide down over my eyes occasionally, and then slide back up.

When I have finished peeing I lean over and take the toilet paper with my left hand. I unroll some more paper and fold it precisely in half and then in half again and then in half again. I tear the bundle from the roll and place the roll back on the corner of the shower tray. I stand up and wipe myself with my right hand. Then I pull up my slip and my trousers and do up the four buttons. Then I straighten my shirt out.

I lean over and push down the handle of the bucket towards the front, then I turn on the tap on the wall with my left hand. The water falls into the bucket beneath.

Then I stand and watch the water fall. When the bucket is half full I turn off the tap and lift the bucket. I poor the water down the toilet to flush it, then I put the lid down. I place the bucket back where it was, underneath the tap, and pull the handle up so it is in the middle.

I put the toilet paper back on the shelf, pause and brush my hair back with my fingers, then walk out of the bathroom unit.

Standing at the front

I stand at the front of the living unit over the knife ladder. My hands are by my sides. My fingers are tense and curved. I look in the eyes of someone in the audience. I wobble a little bit.

Then I turn my hands around so my palms face the front.

Standing between the units

I stand with one foot in the bedroom unit and the other in the living unit. My body is over the gap. My legs make a triangle shape. Holding my arms at chest height, I rest my hands on the back of the wooden frames. I look at someone's eyes in the audience and remain still.

Sitting on the chair

I stand in front of the chair and bend my knees until my body rests on the chair and I am sitting. The back of my head is touching the quartz pillow headrest. I place one hand on each thigh, halfway between my knee and my hip. My fingers are splayed out. The fingers on my right hand are slightly further apart than those on my left hand. The fingers of my left hand curve inward more than the fingers of my right hand.

I look out at the audience.

I reach over to the table, pick up the glass, raise it to my lips and drink from it, slowly. I drink all the water from the glass. I put the glass back on the table.

Showering

I take the towel from the shelf and drape it over the toilet seat. I sit on the edge of the toilet and put my hairband around my left wrist. Then I lean over and untie the laces of my right boot with my left hand. When the laces are loose enough, I take off the boot and then pull off the sock by grabbing the toe. I put the sock on the boot. Then I untie the laces of my left boot with both hands. When the laces are loose enough I take off the boot and then pull off the sock by grabbing the toe. I put the sock on the boot.

Then I undo the buttons on my trousers and stand up so I can pull them down. When I have sat down again, I finish pulling them off, starting with the right leg and finishing with the left leg. Then I fold them in half and then half again and then half again and put them on the floor next to the boots. This I do very slowly.

Then I brush the hair from my face and undo the buttons on my collars and the buttons of my shirt, starting at the bottom and working my way up. There are seven buttons to undo. Then I take off my shirt and lay it across my legs. Then I take off my undershirt and fold it up neatly. Then I take off my slip. I put all my clothes on the left-hand side of the unit next to the wall.

Then I take the hairband off my wrist, pull my hair together behind my head, fold the bundle in half and tie it back with my hairband. I stand on the left of the shower, outside the tray, and turn on the taps. I test the temperature of the water by holding out my left hand under the trickle. I wait for as long as it takes for the water to warm up.

I step into the shower.

I need to adjust the temperature. I reach behind me and twist the taps.

I look straight ahead.

I open my palms.

When I have finished showering I turn round and twist the taps off with my right hand.

I lean over to pick up the towel. I press it against my face. Then I rub the towel over my arms, then my torso, then my legs. I do not dry myself very thoroughly. Then I lay the towel over the toilet seat and sit down on it.

Then I put my slip back on. Then I put my undershirt back on by putting my head through the head hole and my arms through the armholes. I do the same with my shirt and do up the buttons on my cuffs. I do up the buttons starting at my neck and working my way downward. Then I put my trousers on. I straighten out all of my clothes. I pull my hairband off and put it back on the shelf.

Then I roll up the bath mat and wipe up the water from the floor. I put the wet bath mat in the shower tray.

I sit back down and put my right sock on followed by my right boot. I tie the laces. Then I put my left sock on followed by my left boot. I tie the laces. I stand up.

I fold up the towel and put it back on the shelf.

Before I step into the living unit, I stand in front of the shelves and run my fingers through my hair.

Standing at the front

I stand at the front of the living unit over the knife ladder. My hands are by my sides. My fingers are tense and curved. I look at someone in the audience. I wobble a little bit.

I turn my palms round to face the audience.

Filling the glass

I pick up the empty glass from the table. I take the glass to the sink in the bedroom unit. I hold the glass in my left hand and put it underneath the tap in the sink. I push the tap up and then twist it to the left with my right hand until water trickles out. I tilt my head down towards the tap and watch the water flow. I let the glass fill up slowly. My right hand rests on the edge of the sink. When the glass is full I turn off the tap by pushing it up and then twisting it to the right. Then I pass the glass from my left to my right hand. I walk to the living unit.

Drinking water

I stand between the table and the chair and raise the glass to my mouth. My left arm is straight and motionless. I tilt my head back and shake my hair away from my face. I tip the water into my open mouth and gulp. To control the flow of water into my mouth, I open and close my lips slowly, and open and close them again. The water waves back and forth in the glass every time I swallow. My neck moves every time I swallow. I drink until the glass is empty. Then I place the glass back down on the table. I press my lips together to suck in the droplets that are left there.

Standing between the units

I stand with one foot in the bedroom unit and the other in the living unit. My body is over the gap. My legs make a triangle shape. Holding my arms at chest height, I rest my hands on the back of the wooden frames. I look at the eyes of someone in the audience and remain still.

The metronome stops ticking.

Winding up the metronome

I pick up the metronome from the table with my right hand and then pass it to my left. I twist the knob clockwise round and round. I do this very slowly. My body is still and only my wrist moves. I put the metronome back down on the table and then set off the ticker. It ticks. The metronome faces the audience.

Sitting on the chair

I stand in front of the chair and bend my knees until my body rests on the chair and I am sitting. I place one hand on each thigh, halfway between my knee and my hip. My fingers are splayed out. The fingers on my right hand are slightly further apart than those on my left hand. The fingers of my left hand curve inward more than the fingers of my right hand. My feet are on the floor, and they are hip-width apart.

The metronome ticks and I look out at the audience.

Standing at the front

I stand at the front of the living unit over the knife ladder. My hands are by my sides. My fingers are tense and curved. I look at someone in the audience. I am motionless. Someone speaks at the back of the gallery. I twist my wrists round.

Standing between the units

I stand with one foot in the bedroom unit and the other in the living unit. My body is over the gap. My legs make a triangle shape. Holding my arms at chest height, I rest my hands on the back of the wooden frames. I look at someone in the audience and remain still. Then I turn my head to the right to look at someone else.

Filling the glass

I pick up the empty glass from the table. I take the glass to the sink in the bedroom unit. I hold the glass in my left hand and put it underneath the tap in the sink. I push the tap up and then twist it to the left

with my right hand until water trickles out. I tilt my head down towards the tap and watch the water flow. I let the glass fill up slowly. My right hand rests on the edge of the sink. When the glass is full I turn off the tap by pushing it up and then twisting it to the right. Then I pass the glass from my left to my right hand. I walk to the living unit.

Drinking water

I stand between the table and the chair and raise the glass to my mouth. My left arm is straight and motionless. I tilt my head back and shake my hair away from my face. I tip the water into my open mouth and gulp. To control the flow of water into my mouth, I open and close my lips slowly, and open and close them again. The water waves back and forth in the glass every time I swallow. My neck moves every time I swallow. I drink until the glass is empty. Then I place the glass back down on the table.

Sitting on the chair

I stand in front of the chair and bend my knees until my body rests on the chair and I am sitting. I place one hand on each thigh, halfway between my knee and my hip. My fingers are splayed out. The fingers on my right hand are slightly further apart than those on my left hand. The fingers of my left hand curve inward more than the fingers of my right hand. My feet are on the floor, and they are hip-width apart. I tilt my head back a little and stare at the telescope. Then I brush the hair back from my face.

Standing at the front

I stand up and step forward to the edge of the platform in front of the chair. My feet are hip-width apart. I point my feet outwards slightly and stand still. I let my arms hang down straight by my sides. I turn my wrists so that my open hands face the person I am staring at. I stand straight and still and remain looking. I blink. I breathe.

Filling the glass

I pick up the empty glass from the table. I take the glass to the sink in the bedroom unit. I hold the glass in my left hand and put it underneath the tap in the sink. I push the tap up and then twist it to the left with my right hand until water trickles out. I tilt my head down towards the tap and watch the water flow. I let the glass fill up slowly. My right hand rests on the edge of the sink. When the glass is full I turn off the tap by pushing it up and then twisting it to the right. Then I pass the glass from my left to my right hand. I walk to the living unit.

Drinking water

I stand between the table and the chair and raise the glass to my mouth. My left arm is straight and motionless. I tilt my head back and shake my hair away from my face. I tip the water into my open mouth and gulp. To control the flow of water into my mouth, I open and close my lips slowly, and open and close them again. The water waves back and forth in the glass every time I swallow. My neck moves every time I swallow. I drink until the glass is half empty. Then I place the glass back down on the table.

Sitting on the chair

I stand in front of the chair and bend my knees until my body rests on the chair and I am sitting. I place one hand on each thigh, halfway between my knee and my hip. My fingers are splayed out. The fingers on my right hand are slightly further apart than those on my left hand. The fingers of my left hand curve inward more than the fingers of my right hand. My feet are on the floor, and they are hip-width apart.

Standing at the front

I stand at the front of the living unit over the knife ladder. My hands are by my sides. My fingers are tense and curved. I look at someone in the audience. I wobble a little bit. I look at someone's eyes. I twist my wrists.

Standing between the units

I stand with one foot in the bedroom unit and the other in the living unit. My body is over the gap. My legs make a triangle shape. Holding my arms at chest height, I rest my hands on the back of the wooden frames. I look at someone in the audience and remain still.

Drinking water

I walk to the table, pick up the glass and drink the rest of the water from it. I put the glass back down on the table where it was.

Peeing

I need to pee. I step across the gap to the bathroom unit. When I am in the unit I turn to my right and take the toilet paper from the shelf with my right hand. I take four steps over towards the toilet and turn my body round clockwise. When my back is to the audience I lean over and put the toilet roll on the left front corner of the shower tray.

Then I lift the lid of the toilet with my left hand. I push it back until it is resting on the back of the unit. As I turn towards the front I lift up my shirt so I can unfasten my trousers. There are four buttons to unfasten. I tilt my head forward. When I have undone all the buttons I pull my trousers and my slip down to just above my knees and sit on the toilet. I put my feet close together in front of me and cup my hands together in my lap. My two index fingers and thumbs make a triangle shape. My fingertips touch each other.

I look at the floor. I sit still and wait for the pee to come. It takes a while and there is silence. Then there is a trickling sound. I am motionless, except for my eyelids, which slide down over my eyes occasionally, and then slide back up.

When I have finished peeing I lean over and take the toilet paper with my left hand. I unroll some more paper and fold it precisely in half and then in half again and then in half again. I tear the bundle from the roll and place the roll back on the corner of the shower tray. I stand up and wipe myself with my right hand. Then I pull up my slip and my trousers and do up the four buttons. Then I straighten my shirt out.

I turn on the tap on the wall with my left hand. The water falls into the bucket beneath.

I stand and look at the shelves and listen to the water fall. When the bucket is half full I turn off the tap and lift the bucket. I poor the water down the toilet to flush it, then I put the lid down. I place the bucket back where it was, underneath the tap, and pull the handle up so it is in the middle.

I put the toilet paper back on the shelf, pause and brush my hair back with my fingers, then walk out of the bathroom unit.

Standing at the front

I stand at the front of the living unit over the knife ladder. My hands are by my sides. My fingers are tense and curved. I look at someone in the audience. I am motionless. I twist my wrists round and raise my arms from my sides.

Sitting on the chair

I stand in front of the chair and bend my knees until my body rests on the chair and I am sitting. I place one hand on each thigh, halfway between my knee and my hip. My fingers are splayed out. The fingers on my right hand are slightly further apart than those on my left hand. The fingers of my left hand curve inward more than the fingers of my right hand. My feet are on the floor, and they are hip-width apart. I look. The back of my head is touching the quartz pillow headrest.

I lean forward and rest my elbows on my knees and my chin on my curled up fingers.

Standing between the units

I stand with one foot in the living unit and the other in the bathroom unit. My body is over the gap. My legs make a triangle shape. Holding my arms at chest height, I rest my hands on the back of the wooden frames. I look at someone's eyes and remain still.

Filling the glass

I pick up the empty glass from the table. I take the glass to the sink in the bedroom unit. I hold the glass in my left hand and put it underneath the tap in the sink. I push the tap up and then twist it to the left with my right hand until water trickles out. I tilt my head down towards the tap and watch the water flow. I let the glass fill up slowly. My right hand rests on the edge of the sink. When the glass is full I turn off the tap by pushing it up and then twisting it to the right. Then I pass the glass from my left to my right hand. I walk to the living unit.

Drinking water

I stand between the table and the chair and raise the glass to my mouth. My left arm is straight and motionless. I tilt my head back and shake my hair away from my face. I tip the water into my open mouth and gulp. To control the flow of water into my mouth, I open and close my lips slowly, and open and close them again. The water waves back and forth in the glass every time I swallow. My neck moves every time I swallow. I drink until the glass is empty. Then I place the glass back down on the table.

Showering

I take the towel from the shelf and drape it over the toilet seat. I sit on the edge of the toilet and put my hairband around my left wrist. Then I lean over and untie the laces of my right boot with my left hand. When the laces are loose enough, I take off the boot and then pull off the sock by grabbing the toe. I put the sock on the boot. Then I untie the laces of my left boot with both hands. When the laces are loose enough I take off the boot and then pull off the sock by grabbing the toe. I put the sock on the boot.

Then I undo the buttons on my trousers and stand up so I can pull them down. When I have sat down again, I finish pulling them off, starting with the right leg and finishing with the left leg. Then I fold them in half and then half again and then half again and put them on the floor next to the boots. This I do very slowly.

Then I brush the hair from my face and undo the buttons on my collars and the buttons of my shirt, starting at the bottom and working my way up. There are seven buttons to undo. Then I take off my shirt and lay it across my legs. Then I take off my undershirt and fold it up neatly. Then I take off my slip. I put all my clothes on the left-hand side of the unit next to the wall.

Then I take the hairband off my wrist, pull my hair together behind my head, fold the bundle in half and tie it back with my hairband. I stand on the left of the shower, outside the tray. I take the bath mat out of the shower tray and put it on the floor at the side. It is wet. I do not unroll it.

I turn on the taps. I test the temperature of the water by holding out my left hand under the trickle. I wait for as long as it takes for the water to warm up. I step into the shower.

I look straight ahead. Then I close my eyes.

I adjust the temperature by reaching behind me with my left hand and twisting the tap.

I wipe my face.

Then I let my arms hang by my sides and twist my wrists so my palms are open.

I take gulps of water from the falling water.

When I have finished showering I turn round and twist the taps off with my right hand.

I lean over to pick up the towel. I press the towel against my face. Then I rub the towel over my arms, then my torso, then my legs. I do not dry myself very thoroughly. Then I lay the towel over the toilet seat and sit down on it.

Then I put my slip back on. I pull my hairband off. Then I put my undershirt back on by putting my head through the head hole and my arms through the armholes. I do the same with my shirt and do up the buttons on my cuffs. I do up the buttons starting at my neck and working my way downward. Then I put my trousers on. Then I put my right sock on followed by my right boot. I tie the laces. Then I put my left sock on followed by my left boot. I tie the laces. I stand up.

I fold up the towel and put it back on the shelf.

Then I roll up the bath mat and wipe up the water from the floor. I put the wet bath mat in the shower tray.

I turn on the tap over the bucket and wash my hands. Then I turn off the tap.

Before I step into the living unit, I stand in front of the shelves and run my fingers through my hair.

Standing at the front

I step forward to the edge of the platform in front of the chair. My feet are just wider than hip-width apart. I point my feet outwards slightly and stand still. I let my arms hang down straight by my sides. My fingers curve towards my thighs and there is a gap between them and my thumbs. I stand straight and still and remain looking at the audience. I blink. I breathe. Then I turn my hands around so the palms face the front.

The metronome stops ticking.

Winding up the metronome

I break the stare and turn away and step towards the table. I pick up the metronome from the table with my right hand and then pass it to my left. I twist the knob clockwise round and round. I do this very slowly. My body is still and only my wrist moves. I put the metronome back down on the table and then set off the ticker. It ticks. The metronome faces the audience.

Sitting on the chair

I stand in front of the chair and bend my knees until my body rests on the chair and I am sitting. I place one hand on each thigh, halfway between my knee and my hip. My fingers are splayed out. The fingers on my right hand are slightly further apart than those on my left hand. The fingers of my left hand curve inward more than the fingers of my right hand. My feet are on the floor, and they are hip-width apart.

The metronome stops ticking again.

Starting the metronome

I stand up and prod the ticker to make it tick again. It ticks.

Sitting on the chair

I stand in front of the chair and bend my knees until my body rests on the chair and I am sitting. I place one hand on each thigh, halfway between my knee and my hip. My fingers are splayed out evenly. My feet are on the floor, and they are hip-width apart. I look at people in the audience. The back of my head is touching the quartz pillow headrest.

Standing at the front

I stand up and step forward to the edge of the platform in front of the chair. My feet are hip-width apart. I point my feet outwards slightly

and stand still. I let my arms hang down straight by my sides. I turn my wrists so that my open hands face the person I am staring at. I stand straight and still and remain looking. I blink. I breathe. Some people at the back of the gallery are talking.

Filling the glass

I pick up the empty glass from the table. I take the glass to the sink in the bedroom unit. I hold the glass in my left hand and put it underneath the tap in the sink. I push the tap up and then twist it to the left with my right hand until water trickles out. I tilt my head down towards the tap and watch the water flow. I let the glass fill up slowly. My right hand rests on the edge of the sink. When the glass is full I turn off the tap by pushing it up and then twisting it to the right. Then I pass the glass from my left to my right hand. I walk to the living unit.

Drinking water

I stand between the table and the chair and raise the glass to my mouth. My left arm is straight and motionless. I tilt my head back and shake my hair away from my face. I tip the water into my open mouth and gulp. To control the flow of water into my mouth, I open and close my lips slowly, and open and close them again. The water waves back and forth in the glass every time I swallow. My neck moves every time I swallow. I drink until the glass is empty. Then I place the glass back down on the table.

Standing at the front

I stand at the front of the living unit over the knife ladder. My hands are by my sides. My fingers are tense and curved. I look at someone in the audience. I wobble a little bit.

Sitting on the chair

I stand in front of the chair and bend my knees until my body rests on the chair and I am sitting. I place one hand on each thigh, halfway between my knee and my hip. My fingers are splayed out evenly. My feet are on the floor, and they are hip-width apart. I look at people in the audience. I look out.

Standing between the units

I stand with one foot in the bedroom unit and the other in the living unit. My body is over the gap. My legs make a triangle shape. Holding my arms at chest height, I rest my hands on the back of the wooden frames. I look at someone in the audience and remain still.

Filling the glass

I pick up the empty glass from the table. I take the glass to the sink in the bedroom unit. I hold the glass in my left hand and put it underneath the tap in the sink. I push the tap up and then twist it to the left with my right hand until water trickles out. I tilt my head down towards the tap and watch the water flow. I let the glass fill up slowly. My right hand rests on the edge of the sink. When the glass is full I turn off the tap by pushing it up and then twisting it to the right. Then I pass the glass from my left to my right hand. I walk to the living unit.

Drinking water

I stand between the table and the chair and raise the glass to my mouth. My left arm is straight and motionless. I tilt my head back and shake my hair away from my face. I tip the water into my open mouth and gulp. To control the flow of water into my mouth, I open and close my lips slowly, and open and close them again. The water waves back and forth in the glass every time I swallow. My neck moves every time I swallow. I drink until the glass is empty. Then I place the glass back down on the table.

Peeing

I need to pee. I step across the gap to the bathroom unit. When I am in the unit I turn to my right and take the toilet paper from the shelf with my right hand. I take four steps over towards the toilet and turn my body round clockwise. When my back is to the audience I lean over and put the toilet roll on the left front corner of the shower tray.

Then I lift the lid of the toilet with my left hand. I push it back until it is resting on the back of the unit. As I turn towards the front I lift up my shirt so I can unfasten my trousers. There are four buttons to unfasten. I tilt my head forward. When I have undone all the buttons I pull my trousers and my slip down to just above my knees and sit on the toilet. I put my feet close together in front of me and cup my hands together in my lap. My two index fingers and thumbs make a triangle shape. My fingers make a cage.

I look at the floor. I sit still and wait for the pee to come. It takes a while and there is silence. Then there is the sound of water trickling. I am motionless, except for my eyelids, which slide down over my eyes occasionally, and then slide back up.

When I have finished peeing I lean over and take the toilet paper with my left hand. I unroll some more paper and fold it precisely in half and then in half again and then in half again. I tear the bundle from the roll and place the roll back on the corner of the shower tray. I stand up and wipe myself with my right hand. Then I pull up my slip and my trousers and do up the four buttons. Then I straighten my shirt out.

I turn on the tap on the wall with my left hand. The water falls into the bucket beneath.

I stand and look at the shelves and listen to the water fall. When the bucket is half full I turn off the tap and lift the bucket. I poor the water down the toilet to flush it, then I put the lid down. I place the bucket back where it was, underneath the tap, and pull the handle up so it is in the middle.

I put the toilet paper back on the shelf, pause and brush my hair back with my fingers, then walk out of the bathroom unit.

Sitting on the chair

I stand in front of the chair and bend my knees until my body rests on the chair and I am sitting. I place one hand on each thigh, halfway between my knee and my hip. My fingers are splayed out evenly. My feet are on the floor, and they are hip-width apart. I look at people in the audience. The back of my head is touching the quartz pillow headrest.

The metronome stops ticking.

Winding up the metronome

I pick up the metronome from the table with my right hand and then pass it to my left. I twist the knob clockwise round and round. I do this very slowly. My body is still and only my wrist moves. I put the metronome back down on the table and then set off the ticker. It ticks. The metronome faces the audience.

Standing between the units

I stand with one foot in the bedroom unit and the other in the living unit. My body is over the gap. My legs make a triangle shape. Holding my arms at chest height, I rest my hands on the back of the wooden frames. I look at the eyes of someone in the audience and remain still.

The metronome stops ticking.

Winding up the metronome

I pick up the metronome from the table with my right hand and then pass it to my left. I adjust the weight on the ticker. I put the metronome back down on the table and then set off the ticker. It ticks.

Sitting on the chair

I stand in front of the chair and bend my knees until my body rests on the chair and I am sitting. I place one hand on each thigh, halfway

between my knee and my hip. My fingers are splayed out evenly. My feet are on the floor, and they are hip-width apart. I look at people in the audience.

I turn my hands over on my thighs so my palms face up.

I continue staring.

Filling the glass

I pick up the empty glass from the table. I take the glass to the sink in the bedroom unit. I hold the glass in my left hand and put it underneath the tap in the sink. I push the tap up and then twist it to the left with my right hand until water trickles out. I tilt my head down towards the tap and watch the water flow. I let the glass fill up slowly. My right hand rests on the edge of the sink. When the glass is full I turn off the tap by pushing it up and then twisting it to the right. Then I pass the glass from my left to my right hand. I walk to the living unit.

Drinking water

I stand between the table and the chair and raise the glass to my mouth. My left arm is straight and motionless. I tilt my head back and shake my hair away from my face. I tip the water into my open mouth and gulp. To control the flow of water into my mouth, I open and close my lips slowly, and open and close them again. The water waves back and forth in the glass every time I swallow. My neck moves every time I swallow. I drink until the glass is empty. Then I place the glass back down on the table.

Standing between the units

I stand with one foot in the living unit and the other in the bathroom unit. My body is over the gap. My legs make a triangle shape. Holding my arms at chest height, I rest my hands on the back of the wooden frames. I look at someone in the audience and remain still.

Standing at the front and crying

I stand at the front of the living unit over the knife ladder. My hands are by my sides. My fingers are tense and curved. I look at someone in the audience. I turn my hands around halfway so my thumbs face the front.

My brows tighten and my cheeks tense up and my chest quivers. A sound comes from the back of my throat. The corners of my mouth turn down.

I continue staring.

My shoulders shudder and my head jerks back. Another sound comes from the back of my throat. I gasp. Water streams down my cheeks.

Showering

I take the towel from the shelf and drape it over the toilet seat. I take the bath mat from the shower tray and lay it out in front of the shower tray. I sit on the edge of the toilet and put my hairband around my left wrist. Then I lean over and untie the laces of my right boot with my left hand. When the laces are loose enough, I take off the boot and then pull off the sock by grabbing the toe. I put the sock on the boot. Then I untie the laces of my left boot with both hands. When the laces are loose enough I take off the boot and then pull off the sock by grabbing the toe. I put the sock on the boot.

Then I undo the buttons on my trousers and stand up so I can pull them down. When I have sat down again, I finish pulling them off, starting with the right leg and finishing with the left leg. Then I fold them in half and then half again and then half again and put them on the floor next to the boots. This I do very slowly.

Then I brush the hair from my face and undo the buttons on my collars and the buttons of my shirt, starting at the bottom and working my way up. There are seven buttons to undo. Then I take off my shirt and lay it across my legs. Then I take off my undershirt and fold it up neat-

ly. Then I take off my slip. I put all my clothes on the left-hand side of the unit next to the wall.

Then I take the hairband off my wrist, pull my hair together behind my head, fold the bundle in half and tie it back with my hairband. I stand on the left of the shower, outside the tray, and turn on the taps. I test the temperature of the water by holding out my left hand under the trickle. I wait for as long as it takes for the water to warm up.

I cry.

I step into the shower.

I close my eyes.

I adjust the temperature of the water.

I sigh.

I wipe my face.

I open my palms.

When I have finished showering I turn round and twist the taps off with my right hand.

I lean over to pick up the towel. I press it against my face. Then I rub the towel over my arms, then my torso, then my legs. I do not dry myself very thoroughly. Then I lay the towel over the toilet seat and sit down on it.

Then I put my slip back on. Then I put my undershirt back on by putting my head through the head hole and my arms through the armholes. I do the same with my shirt and do up the buttons on my cuffs. I do up the buttons starting at my neck and working my way downward. Then I put my trousers on. I straighten out all of my clothes. I put my right sock on followed by my right boot. I tie the laces. Then I put my left sock on followed by my left boot. I tie the laces. I stand up.

Then I roll up the bath mat and wipe up the water from the floor. I put the wet bath mat in the shower tray.

I fold up the towel and put it back on the shelf.

Before I step into the living unit, I stand in front of the shelves and run my fingers through my hair.

Sitting on the chair

I stand in front of the chair and bend my knees until my body rests on the chair and I am sitting. I place one hand on each thigh, halfway between my knee and my hip. My fingers are splayed out evenly. My feet are on the floor, and they are hip-width apart. I look at the telescope.

The metronome stops ticking.

Winding up the metronome

I pick up the metronome from the table with my right hand and then pass it to my left. I twist the knob clockwise round and round. I do this very slowly. My body is still and only my wrist moves. I put the metronome back down on the table and then set off the ticker. It ticks. The metronome faces the audience.

Standing at the front

I step forward to the edge of the platform in front of the chair. My feet are just wider than hip-width apart. I point my feet outwards slightly and stand still. I let my arms hang down straight by my sides. My fingers curve towards my thighs and there is a gap between them and my thumbs. I stand straight and still and remain looking at the audience. I blink. I breathe. I turn my wrists round so my open hands face the person I am staring at.

Sitting on the chair

I stand in front of the chair and bend my knees until my body rests on the chair and I am sitting. I place one hand on each thigh, halfway between my knee and my hip. My fingers are splayed out evenly. My feet are on the floor, and they are hip-width apart. I look at the audience.

Filling the glass

I pick up the empty glass from the table. I take the glass to the sink in the bedroom unit. I hold the glass in my left hand and put it underneath the tap in the sink. I push the tap up and then twist it to the left with my right hand until water trickles out. I tilt my head down towards the tap and watch the water flow. I let the glass fill up slowly. My right hand rests on the edge of the sink. When the glass is full I turn off the tap by pushing it up and then twisting it to the right. Then I pass the glass from my left to my right hand. I walk to the living unit.

Drinking water

I stand between the table and the chair and raise the glass to my mouth. My left arm is straight and motionless. I tilt my head back and shake my hair away from my face. I tip the water into my open mouth and gulp. To control the flow of water into my mouth, I open and close my lips slowly, and open and close them again. The water waves back and forth in the glass every time I swallow. My neck moves every time I swallow. I drink until the glass is empty. Then I place the glass back down on the table.

Peeing

I need to pee. I step across the gap to the bathroom unit. When I am in the unit I turn to my right and take the toilet paper from the shelf with my right hand. I take four steps over towards the toilet and turn my body round clockwise. When my back is to the audience I lean over and put the toilet roll on the left front corner of the shower tray.

Then I lift the lid of the toilet with my left hand. I push it back until it is resting on the back of the unit. As I turn towards the front I lift up my shirt so I can unfasten my trousers. There are four buttons to unfasten. I tilt my head forward. When I have undone all the buttons I pull my trousers and my slip down to just above my knees and sit on the toilet. I put my feet close together in front of me and cup my hands together in my lap. My two index fingers and thumbs make a triangle shape. My fingers make a cage.

I look at the floor. I sit still and wait for the pee to come. It takes a while and there is silence. Then there is the sound of water trickling. I am motionless, except for my eyelids, which slide down over my eyes occasionally, and then slide back up.

When I have finished peeing I lean over and take the toilet paper with my left hand. I unroll some more paper and fold it precisely in half and then in half again and then in half again. I tear the bundle from the roll and place the roll back on the corner of the shower tray. I stand up and wipe myself with my right hand. Then I pull up my slip and my trousers and do up the four buttons. Then I straighten my shirt out.

I turn on the tap on the wall with my left hand. The water falls into the bucket beneath.

I stand and look at the shelves and listen to the water fall. When the bucket is half full I turn off the tap and lift the bucket. I poor the water down the toilet to flush it, then I put the lid down. I place the bucket back where it was, underneath the tap, and pull the handle up so it is in the middle.

I put the toilet paper back on the shelf, pause and brush my hair back with my fingers, then walk out of the bathroom unit.

Standing between the units

I stand with one foot in the bedroom unit and the other in the living unit. My body is over the gap. My legs make a triangle shape. Holding my arms at chest height, I rest my hands on the back of the wooden frames. I look at someone in the audience and remain still.

Sitting on the chair

I stand in front of the chair and bend my knees until my body rests on the chair and I am sitting. I place one hand on each thigh, halfway between my knee and my hip. My fingers are splayed out evenly. My feet are on the floor, and they are hip-width apart. I look at the audience.

Standing at the front

I stand at the front of the living unit over the knife ladder. My hands are by my sides. My fingers are tense and curved. I look at the eyes of someone in the audience. I wobble a little bit.

Standing between the units

I stand with one foot in the living unit and the other in the bathroom unit. My body is over the gap. My legs make a triangle shape. Holding my arms at chest height, I rest my hands on the back of the wooden frames. I look at someone in the audience and remain still.

Sitting on the chair

I stand in front of the chair and bend my knees until my body rests on the chair and I am sitting. I place one hand on each thigh, halfway between my knee and my hip. My fingers are splayed out evenly. My feet are on the floor, and they are hip-width apart. I look at the audience. The back of my head is touching the quartz pillow headrest.

Standing at the front

I step forward to the edge of the platform in front of the chair. My feet are just wider than hip-width apart. I point my feet outwards slightly and stand still. I let my arms hang down straight by my sides. My fingers curve towards my thighs and there is a gap between them and my thumbs. I stand straight and still and remain looking at the audience. I raise my arms out from my sides a little.

Filling the glass

I pick up the empty glass from the table. I take the glass to the sink in the bedroom unit. I hold the glass in my left hand and put it underneath the tap in the sink. I push the tap up and then twist it to the left with my right hand until water trickles out. I tilt my head down towards the tap and watch the water flow. I let the glass fill up slowly. My right hand rests on the edge of the sink. When the glass is full I turn off the tap by pushing it up and then twisting it to the right. Then I pass the glass from my left to my right hand. I walk to the living unit.

Drinking water

I stand between the table and the chair and raise the glass to my mouth. My left arm is straight and motionless. I tilt my head back and shake my hair away from my face. I tip the water into my open mouth and gulp. To control the flow of water into my mouth, I open and close my lips slowly, and open and close them again. The water waves back and forth in the glass every time I swallow. My neck moves every time I swallow. I drink until the glass is empty. Then I place the glass back down on the table.

Peeing

I need to pee. I step across the gap to the bathroom unit. When I am in the unit I turn to my right and take the toilet paper from the shelf with my right hand. I take four steps over towards the toilet and turn my body round clockwise. When my back is to the audience I lean over and put the toilet roll on the left front corner of the shower tray.

Then I lift the lid of the toilet with my left hand. I push it back until it is resting on the back of the unit. As I turn towards the front I lift up my shirt so I can unfasten my trousers. There are four buttons to

unfasten. I tilt my head forward. When I have undone all the buttons I pull my trousers and my slip down to just above my knees and sit on the toilet. I put my feet close together in front of me and cup my hands together in my lap. My two index fingers and thumbs make a triangle shape. My fingers make a cage.

I look at the floor. I sit still and wait for the pee to come. It takes a while and there is silence. Then there is the sound of water trickling. I am motionless, except for my eyelids, which slide down over my eyes occasionally, and then slide back up.

When I have finished peeing I lean over and take the toilet paper with my left hand. I unroll some more paper and fold it precisely in half and then in half again and then in half again. I tear the bundle from the roll and place the roll back on the corner of the shower tray. I stand up and wipe myself with my right hand. Then I pull up my slip and my trousers and do up the four buttons. Then I straighten my shirt out.

I push the handle of the bucket down to the front. Then I turn on the tap on the wall with my left hand. The water falls into the bucket beneath.

I stand and look at the shelves and listen to the water fall. When the bucket is half full I turn off the tap and lift the bucket. I poor the water down the toilet to flush it, then I put the lid down. I place the bucket back where it was, underneath the tap, and pull the handle up so it is in the middle.

I put the toilet paper back on the shelf, pause and brush my hair back with my fingers, then walk out of the bathroom unit.

Standing between the units

I stand with one foot in the bedroom unit and the other in the living unit. My body is over the gap. My legs make a triangle shape. Holding my arms at chest height, I rest my hands on the back of the wooden frames. I look in the eyes of someone in the audience and remain still.

The metronome stops ticking.

Winding up the metronome

I break the stare and turn away and step towards the table. I pick up the metronome from the table with my right hand and then pass it to my left. I twist the knob clockwise round and round. I do this very slowly. My body is still and only my wrist moves. I put the metronome back down on the table and then set off the ticker. It ticks.

Sitting on the chair

I stand in front of the chair and bend my knees until my body rests on the chair and I am sitting. I place one hand on each thigh, halfway between my knee and my hip. My fingers are splayed out evenly. My feet are on the floor, and they are hip-width apart. I look at the audience.

Standing at the front

I stand at the front of the living unit over the knife ladder. My hands are by my sides. My fingers are tense and curved. I look into the eyes of someone in the audience. I turn my hands around halfway so my thumbs face the front.

The metronome stops ticking.

Winding up the metronome

I break the stare and turn away and step towards the table. I pick up the metronome from the table with my right hand and then pass it to my left. I twist the knob clockwise round and round. I do this very slowly. My body is still and only my wrist moves. I put the metronome back down on the table and then set off the ticker. It ticks.

Sitting on the chair

I stand in front of the chair and bend my knees until my body rests on the chair and I am sitting. I place one hand on each thigh, halfway between my knee and my hip. My fingers are splayed out evenly. My feet are on the floor, and they are hip-width apart. I look at the audience.

Filling the glass

I stand up and pick up the empty glass from the table. I take the glass to the sink in the bedroom unit. I hold the glass in my left hand and put it underneath the tap in the sink. I push the tap up and then twist it to the left with my right hand until water trickles out. I tilt my head down towards the tap and watch the water flow. I let the glass fill up slowly. My right hand rests on the edge of the sink. When the glass is full I turn off the tap by pushing it up and then twisting it to the right. Then I pass the glass from my left to my right hand. I walk to the living unit.

Drinking water

I stand between the table and the chair and raise the glass to my mouth. My left arm is straight and motionless. I tilt my head back and shake my hair away from my face. I tip the water into my open mouth and gulp. To control the flow of water into my mouth, I open and close my lips slowly, and open and close them again. The water waves back and forth in the glass every time I swallow. My neck moves every time I swallow. I drink until the glass is empty. Then I place the glass back down on the table.

Standing in the middle

I do not move my feet. I turn my body towards the front and look at the audience.

Showering

I take the towel from the shelf and drape it over the toilet seat. I take the bath mat from the shower tray and lay it out in front of the shower tray. Then I lean over and untie the laces of my right boot with my left hand. When the laces are loose enough, I take off the boot and then pull off the sock by grabbing the toe. I put the sock on the boot. Then I untie the laces of my left boot with both hands. When the laces are loose enough I take off the boot and then pull off the sock by grabbing the toe. I put the sock on the boot.

Then I undo the buttons on my trousers and stand up so I can pull them down. When I have sat down again, I finish pulling them off, starting with the right leg and finishing with the left leg. Then I fold them in half and then half again and then half again and put them on the floor next to the boots. This I do very slowly.

Then I brush the hair from my face and undo the buttons on my collars and the buttons of my shirt, starting at the bottom and working my way up. There are seven buttons to undo. Then I take off my shirt and lay it across my legs. Then I take off my undershirt and fold it up neatly. Then I take off my slip. I put all my clothes on the left-hand side of the unit next to the wall.

I do not tie my hair back. I stand on the left of the shower, outside the tray, and turn on the taps. I test the temperature of the water by holding out my left hand under the trickle. I wait for as long as it takes for the water to warm up.

I step into the shower.

I close my eyes.

I wipe my face.

I open my palms.

When I have finished showering I turn round and twist the taps off with my right hand.

I lean over to pick up the towel. I press it against my face. Then I rub the towel over my arms, then my torso, then my legs. I do not dry myself very thoroughly. Then I lay the towel over the toilet seat and sit down on it.

Then I put my slip back on. Then I put my undershirt back on by putting my head through the head hole and my arms through the armholes. I do the same with my shirt and do up the buttons on my cuffs. I do up the buttons starting at my neck and working my way downward. Then I put my trousers on. I straighten out all of my clothes. I put my right sock on followed by my right boot. I tie the laces. Then I put my left sock on followed by my left boot. I tie the laces. I stand up.

Then I roll up the bath mat and wipe up the water from the floor. I put the wet bath mat in the shower tray.

I fold up the towel and put it back on the shelf.

Before I step into the living unit, I stand in front of the shelves and run my fingers through my hair.

Sunday, November 17th: Day 3

Wearing deep orange

Sitting on the chair

I stand in front of the chair and bend my knees until my body rests on the chair and I am sitting. I put my hands in my lap. My feet are on the floor, and they are hip-width apart. I look at the empty gallery.

I stroke my hair and straighten my pajamas.

Bathing my face in the light

I stand on the edge of the platform underneath the light. It lights up my face. I tilt my head back and close my eyes. Then I turn around with my back to the audience. The light lights the top of my head.

Sitting on the bed

I sit on the bed, more to the right than the left. My hands are cupped in my lap. My feet are on the ground. I look out. I scratch my chin.

Standing in the middle

I stand in the middle of the living unit. My hands hold each other and rest in front of me. I look at someone in the audience. The metronome ticks.

I step back and take a sip of water from the glass.

Sitting on the chair

I sit on the chair with my head in my hands. The metronome stops ticking.

Winding up the metronome

I pick up the metronome from the table with my right hand and then pass it to my left. I twist the knob clockwise round and round. I do this very slowly. My body is still and only my wrist moves. I put the metronome back down on the table and then set off the ticker. It ticks very quickly. I adjust the ticker and then it starts ticking very slowly.

Sitting on the chair

I stand in front of the chair and bend my knees until my body rests on the chair and I am sitting. I put my hands in my lap. My feet are on the floor, and they are hip-width apart. I look at the empty gallery.

Pinching the ticker

I stand up and pinch the ticker of the metronome between my thumb and forefinger. Then I release it and it starts ticking again. Then I pinch it. Then release.

Sitting on the chair

I stand in front of the chair and bend my knees until my body rests on the chair and I am sitting. I put my hands in my lap. My feet are on the floor, and they are hip-width apart. I look out. Then I rest my elbows

on my knees and my chin on my curled up fingers.

I lean back in the chair and then take a mouthful of water from the glass. Then I stand up.

Drinking water

I stand between the table and the chair and raise the glass to my mouth. My left arm is straight and motionless. I tilt my head back and shake my hair away from my face. I tip the water into my open mouth and gulp. To control the flow of water into my mouth, I open and close my lips slowly, and open and close them again. The water waves back and forth in the glass every time I swallow. My neck moves every time I swallow. I drink until the glass is empty. Then I carry the glass to the bedroom unit.

Filling the glass

I take the glass to the sink in the bedroom unit. I sit down on the bed and twist round to face the sink. I hold the glass in my left hand and put it underneath the tap in the sink. I push the tap up and then twist it to the left with my right hand until water trickles out. I tilt my head down towards the tap and watch the water flow. I let the glass fill up slowly. My right hand rests on the edge of the sink. When the glass is full I turn off the tap by pushing it up and then twisting it to the right. Then I pass the glass from my left to my right hand. I walk to the living unit and put the glass down on the table.

Peeing

I need to pee. I step across the gap to the bathroom unit. When I am in the unit I turn to my right and take the toilet paper from the shelf with my right hand. I tear off a few sheets and put the toilet paper back on the shelf. I take four steps over towards the toilet and turn my body round clockwise.

Then I lift the lid of the toilet with my left hand. I push it back until it is resting on the back of the unit. As I turn towards the front I lift up my shirt so I can unfasten my trousers. There are four buttons to unfasten. I tilt my head forward. When I have undone all the buttons I pull my trousers and my slip down to just above my knees and sit on the toilet. I put my feet close together in front of me and cup my hands together in my lap. My two index fingers and thumbs make a triangle shape. My fingertips touch each other.

I look at the floor. I sit still and wait for the pee to come. It takes a while and there is silence. Then there is the sound of water trickling. I am motionless, except for my eyelids, which slide down over my eyes occasionally, and then slide back up.

When I have finished peeing I stand up and wipe myself with the bundle of tissue paper. Then I pull up my slip and my trousers and do up the four buttons. Then I straighten my shirt out.

I turn around and press the button on the wall but the toilet does not flush.

I pause and brush my hair back with my fingers, then walk out of the bathroom unit.

Lying on the bed

I stand in front of the bed a third of the way from the bottom end. I turn clockwise so I am facing the audience. Then, in one fluid movement, I sit down on the bed, raise up my feet, move my hands back to balance myself and twist round ninety degrees, lower my body down until it is flat, and rest my head on the quartz pillow. Then I flick my hair back over the pillow so my head is touching the pillow directly. I lie straight on my back. My hands are linked together over my belly.

Sitting on the bed

I sit on the bed halfway between each end. I rest my elbows on my knees and my chin on my curled-up hands.

I lean back and rest my hands on the bed.

Lying on the bed

Then, in one fluid movement, I raise up my feet, move my hands back to balance myself and twist round ninety degrees, lower my body down until it is flat, and rest my head on the quartz pillow. Then I flick my hair back over the pillow so my head is touching the pillow directly. I lie straight on my back. My hands are linked together over my belly.

Reaching up to the heater

I signal that I am too cold by reaching up with both hands to the heater in the ceiling.

Sitting on the chair and fidgeting

I stand in front of the chair and bend my knees until my body rests on the chair and I am sitting. I fold my arms and fold my legs. I look out. I scratch my face. I unfold my legs and then re-fold them with the left leg over the right. Then I unfold them again and rest my elbows on my knees and my chin on my hands. Then I sit back with my hands in my lap. Then I rest my elbows on my knees and my chin on my hands. Then I sit back with my hands in my lap. Then I motion with my hands to someone in the gallery. I move my hands downward.

Then I rest my hands on my thighs.

Drinking water

I stand between the table and the chair and raise the glass to my mouth. My left arm is straight and motionless. I tilt my head back and shake my hair away from my face. I tip the water into my open mouth and gulp. To control the flow of water into my mouth, I open and close my lips slowly, and open and close them again. The water waves back and forth in the glass every time I swallow. My neck moves every time I swallow. I drink until the glass is half empty.

Standing at the front

I step forward to the edge of the platform in front of the chair. My feet are just wider than hip-width apart. I point my feet outwards slightly and stand still. I let my arms hang down straight by my sides. My fingers curve towards my thighs and there is a gap between them and my thumbs. I stand straight and still and keep looking at the audience.

The metronome stops ticking.

Winding up the metronome

I pick up the metronome from the table with my right hand and then pass it to my left. I twist the knob clockwise round and round. I do this very slowly. My body is still and only my wrist moves. I put the metronome back down on the table and then set off the ticker. It ticks.

Sitting on the chair

I stand in front of the chair and bend my knees until my body rests on the chair and I am sitting. I put my hands on my thighs. My feet are on the floor, and they are hip-width apart. I look at the audience.

The metronome stops ticking.

I keep staring at someone.

Then I lean over and prod the ticker. It ticks again.

Standing between the units

I stand with one foot in the bedroom unit and the other in the living unit. My body is over the gap. My legs make a triangle shape. Holding my arms at chest height, I rest my hands on the back of the wooden frames. I look at someone in the audience and remain still.

Drinking water

I stand between the table and the chair and raise the glass to my

mouth. My left arm is straight and motionless. I tilt my head back and shake my hair away from my face. I tip the water into my open mouth and gulp. To control the flow of water into my mouth, I open and close my lips slowly, and open and close them again. The water waves back and forth in the glass every time I swallow. My neck moves every time I swallow. I drink until the glass is empty. I wipe some water from my mouth. Then I carry the glass to the bedroom unit.

Filling the glass

I take the glass to the sink in the bedroom unit. I sit down on the bed and twist round to face the sink. I hold the glass in my left hand and put it underneath the tap in the sink. I push the tap up and then twist it to the left with my right hand until water trickles out. I tilt my head down towards the tap and watch the water flow. I let the glass fill up slowly. My right hand rests on the edge of the sink. When the glass is full I turn off the tap by pushing it up and then twisting it to the right. Then I pass the glass from my left to my right hand. I walk to the living unit and put the glass down on the table.

Sitting on the chair

I stand in front of the chair and bend my knees until my body rests on the chair and I am sitting. I put my hands on my thighs. My feet are on the floor, and they are hip-width apart. I look at the audience.

Standing at the front

I stand at the front of the living unit over the knife ladder. My hands are by my sides. My fingers are tense and curved. I look at someone in the audience. I am breathing. I turn my hands around halfway so my thumbs face the front.

Sitting on the chair

I stand in front of the chair and bend my knees until my body rests on the chair and I am sitting. I put my hands on my thighs. My feet are on the floor, and they are hip-width apart. I look at the audience.

Drinking water

I stand between the table and the chair and raise the glass to my mouth. My left arm is straight and motionless. I tilt my head back and shake my hair away from my face. I tip the water into my open mouth and gulp. To control the flow of water into my mouth, I open and close my lips slowly, and open and close them again. The water waves back and forth in the glass every time I swallow. My neck moves every time I swallow. I drink until the glass is one-third empty.

Somebody is talking in the back of the gallery.

Sitting on the chair

I stand in front of the chair and bend my knees until my body rests on the chair and I am sitting. I put my hands on my thighs. My feet are on the floor, and they are hip-width apart. I look at the audience. The metronome stops ticking.

Winding up the metronome

I pick up the metronome from the table with my right hand and then pass it to my left. I twist the knob clockwise round and round. I do this very slowly. My body is still and only my wrist moves. I put the metronome back down on the table and then set off the ticker. It ticks.

Sitting on the chair

I stand in front of the chair and bend my knees until my body rests on the chair and I am sitting. I put my hands on my thighs. My feet are on the floor, and they are hip-width apart. I look at the audience.

The metronome stops ticking again.

Starting the metronome

I stand up and prod the ticker with my right hand. It starts swinging back and forth again, ticking every time it passes the center.

Standing at the front

I step forward to the edge of the platform in front of the chair. My feet are just wider than hip-width apart. I point my feet outwards slightly and stand still. I let my arms hang down straight by my sides. My fingers curve towards my thighs and there is a gap between them and my thumbs. I stand straight and still and keep looking at the audience. Then I turn my hands round a little so that they are almost open. I am breathing and my shirt rises and falls.

Drinking water

I stand between the table and the chair and raise the glass to my mouth. My left arm is straight and motionless. I tilt my head back and shake my hair away from my face. I tip the water into my open mouth and gulp. To control the flow of water into my mouth, I open and close my lips slowly, and open and close them again. The water waves back and forth in the glass every time I swallow. My neck moves every time I swallow. I drink until the glass is empty. Then I carry the glass to the bedroom unit.

Showering

I pick up the bath mat from inside the shower tray and unroll it on the floor in front of the shower. Then I take the towel from the shelf and drape it over the toilet seat. I sit on the edge of the toilet and put my hairband around my left wrist. Then I lean over and untie the laces of my right boot with my left hand. When the laces are loose enough, I take off the boot and then pull off the sock by grabbing the toe. I put the sock on the boot. Then I untie the laces of my left boot with both hands. When the laces are loose enough I take off the boot and then pull off the sock by grabbing the toe. I put the sock on the boot.

Then I undo the buttons on my trousers and stand up so I can pull them down. When I have sat down again, I finish pulling them off, starting with the right leg and finishing with the left leg. Then I fold them in half and then half again and then half again and put them on the floor next to the boots. This I do very slowly.

Then I brush the hair from my face and undo the buttons on my collars and the buttons of my shirt, starting at the bottom and working my way up. There are seven buttons to undo. Then I take off my shirt and lay it across my legs. Then I tie my hair back with the headband. Then I take off my undershirt and fold it up neatly. Then I take off my slip. I put all my clothes on the left-hand side of the unit next to the wall.

I stand on the left of the shower, outside the tray, and turn on the taps. I test the temperature of the water by holding out my left hand under the trickle. I wait for as long as it takes for the water to warm up. I step into the shower.

I look straight ahead and close my eyes.

I wipe my face and then let my arms hang by my sides with my palms open.

When I have finished showering I turn round and twist the taps off with my right hand.

I lean over to pick up the towel. I press the towel hard against my face for a long time. Then I rub the towel over my arms, then my torso, then my legs. I do not dry myself very thoroughly. Then I lay the towel over the toilet seat and sit down on it.

I take my hairband off.

Then I put my slip back on. Then I put my undershirt back on by putting my head through the head hole and my arms through the armholes. I do the same with my shirt and do up the buttons on my cuffs. I do up the buttons starting at my neck and working my way downward. Then I put my trousers on. I straighten out all of my clothes. I

stand up, take the towel, sit down and dry my feet. Then I put my right sock on followed by my right boot. I tie the laces. Then I put my left sock on followed by my left boot. I tie the laces. I stand up.

I fold up the towel and put it back on the shelf. Then I fold up the bath mat and put it in the shower tray. Then I put the hairband back on the shelf.

Before I step into the living unit, I stand in front of the shelves and run my fingers through my hair.

Standing at the front

I stand at the front of the living unit over the knife ladder. My hands are by my sides. My fingers are tense and curved. I look into the eyes of someone in the audience. I am breathing. I turn my hands around halfway so my thumbs face the front. Then I open my palms completely.

Filling the glass

I take the glass to the sink in the bedroom unit. I sit down on the bed and twist round to face the sink. I hold the glass in my left hand and put it underneath the tap in the sink. I push the tap up and then twist it to the left with my right hand until water trickles out. I tilt my head down towards the tap and watch the water flow. I let the glass fill up slowly. My right hand rests on the edge of the sink. When the glass is full I turn off the tap by pushing it up and then twisting it to the right. Then I pass the glass from my left to my right hand. I walk to the living unit.

Drinking water

I take a little gulp of the water before I put the glass back down on the table.

Sitting on the chair

I stand in front of the chair and bend my knees until my body rests on the chair and I am sitting. I put my hands on my thighs. My feet are on the floor, and they are hip-width apart. I look at the audience.

I lean back so my head rests on the quartz pillow and I shut my eyes.

The metronome stops ticking and there is silence.

I can hear the sound of cars going past outside.

I lean over and prod the ticker so that it starts ticking again.

Then I lean back again and close my eyes.

Lying on the bed

I stand in front of the bed a third of the way from the bottom end. I turn clockwise so I am facing the audience. Then, in one fluid movement, I sit down on the bed, raise up my feet, move my hands back to balance myself and twist round ninety degrees, lower my body down until it is flat, and rest my head on the quartz pillow. Then I flick my hair back over the pillow so my head is touching the pillow directly. I lie straight on my back. My hands are linked together over my belly. My eyes are closed.

The metronome stops ticking.

Winding up the metronome

I get up and walk to the living unit. I pick up the metronome from the table with my right hand and then pass it to my left. I twist the knob clockwise round and round. I do this very slowly. My body is still and only my wrist moves. I put the metronome back down on the table and then set off the ticker. It ticks.

Leaning against the wall

The wall on the right-hand side of the bedroom unit supports me as I lean against it. My feet are together but away from the wall, creating a triangle between where my bottom touches the wall and my feet meet on the ground. I have my hands behind my back. I look out at the audience, then I look away.

The metronome stops ticking.

Starting the metronome

I walk over to the metronome and push the ticker to make it tick again.

Drinking water

I stand between the table and the chair and raise the glass to my mouth. My left arm is straight and motionless. I tilt my head back and shake my hair away from my face. I tip the water into my open mouth and gulp. To control the flow of water into my mouth, I open and close my lips slowly, and open and close them again. The water waves back and forth in the glass every time I swallow. My neck moves every time I swallow. I drink until the glass is empty.

The metronome stops ticking.

I lean over and prod the ticker to make it tick again.

Lying on the bed

I stand in front of the bed a third of the way from the bottom end. I turn clockwise so I am facing the audience. Then, in one fluid movement, I sit down on the bed, raise up my feet, move my hands back to balance myself and twist round ninety degrees, lower my body down until it is flat, and rest my head on the quartz pillow. Then I flick my hair back over the pillow so my head is touching the pillow directly. I lie straight on my back. My hands are linked together over my belly. I rub my face.

I hunch up my legs.

I make a triangle shape with my fingers and thumb. The triangle points diagonally to the ceiling.

Sitting on the bed

I sit up and sit on the bed in the middle. I rest my head in my hands and stare at the floor.

Sitting on the chair

I stand in front of the chair and bend my knees until my body rests on the chair and I am sitting. I put my hands in my lap. My feet are on the floor, and they are hip-width apart. I look at the audience.

Peeing

I need to pee. I step across the gap to the bathroom unit. When I am in the unit I turn to my right and take the toilet paper from the shelf with my right hand. I tear off a few sheets and put the toilet paper back on the shelf. I take four steps over towards the toilet and turn my body round clockwise.

Then I lift the lid of the toilet with my left hand. I push it back until it is resting on the back of the unit. As I turn towards the front I lift up my shirt so I can unfasten my trousers. There are four buttons to unfasten. I tilt my head forward. When I have undone all the buttons I pull my trousers and my slip down to just above my knees and sit on the toilet. I put my feet close together in front of me and cup my hands together in my lap. My two index fingers and thumbs make a triangle shape. My fingers make a cage.

I look at the floor. I sit still and wait for the pee to come. It takes a while and there is silence. Then there is the sound of water trickling. I am motionless, except for my eyelids, which slide down over my eyes occasionally, and then slide back up.

When I have finished peeing I stand up and wipe myself with the bundle of tissue paper. Then I pull up my slip and my trousers and do up the four buttons. Then I straighten my shirt out.

I lean over and push down the handle of the bucket towards the front, then I turn on the tap on the wall with my left hand. The water falls into the bucket beneath.

Then I stand and watch the water fall. When the bucket is half full I turn off the tap and lift the bucket. I pour the water down the toilet to flush it, then I put the lid down. I place the bucket back where it was, underneath the tap, and pull the handle up so it is in the middle.

I pause and brush my hair back with my fingers, then walk out of the bathroom unit.

Filling the glass

I take the empty glass to the sink in the bedroom unit. I sit down on the bed and twist round to face the sink. I hold the glass in my left hand and put it underneath the tap in the sink. I push the tap up and then twist it to the left with my right hand until water trickles out. I tilt my head down towards the tap and watch the water flow. I let the glass fill up slowly. My right hand rests on the edge of the sink. When the glass is full I turn off the tap by pushing it up and then twisting it to the right. Then I pass the glass from my left to my right hand. I walk to the living unit and put the glass down on the table.

Standing at the back

I stand at the back of the living unit leaning against the wall. My hands are clasped together behind my back. My feet are together. I look at someone in the audience.

Standing at the front

I stand at the front of the living unit over the knife ladder. My hands are by my sides. My fingers are tense and curved. I look at someone in the audience. I am breathing. I turn my hands around halfway so my thumbs face the front.

Drinking water

I stand between the table and the chair and raise the glass to my mouth. My left arm is straight and motionless. I tilt my head back and shake my hair away from my face. I tip the water into my open mouth and gulp. To control the flow of water into my mouth, I open and close my lips slowly, one open and close them again. The water waves back and forth in the glass every time I swallow. My neck moves every time I swallow. I drink until the glass is empty.

Sitting on the chair

I stand in front of the chair and bend my knees until my body rests on the chair and I am sitting. I put my hands on my thighs. My feet are on the floor, and they are hip-width apart. I look at the audience.

Wiping my nose

I step across the gap into the bathroom unit. I reach towards the toilet roll with my right hand and unroll a strip. I fold it up into a pad with both hands and then press the pad against my nose, walk to the end of the bathroom unit and then turn around and walk out again. I put the bundle of toilet paper in my pocket.

The metronome stops ticking.

Winding up the metronome

I pick up the metronome from the table with my right hand and then pass it to my left. I twist the knob clockwise round and round. I do this very slowly. My body is still and only my wrist moves. I put the metronome back down on the table and then set off the ticker. It ticks twice and then stops.

Lying on the bed

I stand in front of the bed a third of the way from the bottom end. I turn clockwise so I am facing the audience. Then, in one fluid move-ment, I sit down on the bed, raise up my feet, move my hands back to balance myself and twist round ninety degrees, lower my body down until it is flat, and rest my head on the quartz pillow. Then I flick my hair back over the pillow so my head is touching the pillow directly. I lie straight on my back. My hands are linked together over my belly.

Starting the metronome

I walk over to the metronome and prod the ticker to make it tick.

Sitting on the chair and starting the metronome

I stand in front of the chair and bend my knees until my body rests on the chair and I am sitting. I put my hands in my lap. My feet are on the floor, and they are hip-width apart. I look at the audience. The metronome ticks fourteen times and then stops.

I lean over and push the ticker to make it tick again.

I lean over and pick up the glass and drink all the water from it and put the glass back.

The metronome stops ticking again.

I stand up and push the ticker to make it tick. I stand with my hand on the table and then walk away.

Peeing

I need to pee. I step across the gap to the bathroom unit. When I am in the unit I turn to my right and take the toilet paper from the shelf with my right hand. I tear off a few sheets and put the toilet paper back on the shelf. I take four steps over towards the toilet and turn my body round clockwise.

Then I lift the lid of the toilet with my left hand. I push it back until it is resting on the back of the unit. As I turn towards the front I lift up my shirt so I can unfasten my trousers. There are four buttons to unfasten. I tilt my head forward. When I have undone all the buttons I pull my trousers and my slip down to just above my knees and sit on the toilet. I put my feet close together in front of me and cup my hands together in my lap. My two index fingers and thumbs make a triangle shape. My fingertips touch each other.

I look at the floor. I sit still and wait for the pee to come. It takes a while and there is silence. Then there is the sound of water trickling. I am motionless, except for my eyelids, which slide down over my eyes occasionally, and then slide back up.

When I have finished peeing I stand up and wipe myself with the bundle of tissue paper. Then I pull up my slip and my trousers and do up the four buttons. Then I straighten my shirt out.

I lean over and push down the handle of the bucket towards the front, then I turn on the tap on the wall with my left hand. The water falls into the bucket beneath.

Then I stand and look at the shelves and listen to the water fall. When the bucket is half full I turn off the tap and lift the bucket. I pour the water down the toilet to flush it, then I put the lid down. I place the bucket back where it was, underneath the tap, and pull the handle up so it is in the middle.

I pause and brush my hair back with my fingers, then walk out of the bathroom unit.

Sitting on the chair

I stand in front of the chair and bend my knees until my body rests on the chair and I am sitting. I put my hands on my thighs. My feet are on the floor, and they are hip-width apart. I look at the audience.

Standing at the front

I stand at the front of the living unit over the knife ladder. My hands are by my sides. My fingers are tense and curved. I look at someone

in the audience. I am breathing. I turn my hands around halfway so my thumbs face the front. I wobble a little.

Standing between the units

I stand with one foot in the bathroom unit and the other in the living unit. My body is over the gap. My legs make a triangle shape. Holding my arms at chest height, I rest my hands on the back of the wooden frames. I look at someone in the audience and remain still.

Filling the glass

I take the glass to the sink in the bedroom unit. I sit down on the bed and twist round to face the sink. I hold the glass in my left hand and put it underneath the tap in the sink. I push the tap up and then twist it to the left with my right hand until water trickles out. I tilt my head down towards the tap and watch the water flow. I let the glass fill up slowly. My right hand rests on the edge of the sink. When the glass is full I turn off the tap by pushing it up and then twisting it to the right. Then I pass the glass from my left to my right hand. I walk to the living unit.

Drinking water

I stand between the table and the chair and raise the glass to my mouth. My left arm is straight and motionless. I tilt my head back and shake my hair away from my face. I tip the water into my open mouth and gulp. To control the flow of water into my mouth, I open and close my lips slowly, and open and close them again. The water waves back and forth in the glass every time I swallow. My neck moves every time I swallow. I drink until the glass is empty. Then I put the glass down on the table.

Sitting on the chair

I stand in front of the chair and bend my knees until my body rests on the chair and I am sitting. I put my hands on my thighs. My feet are on the floor, and they are hip-width apart. I look at the telescope.

Filling the glass

I take the glass to the sink in the bedroom unit. I sit down on the bed and twist round to face the sink. I hold the glass in my left hand and put it underneath the tap in the sink. I push the tap up and then twist it to the left with my right hand until water trickles out. I tilt my head down towards the tap and watch the water flow. I let the glass fill up slowly. My right hand rests on the edge of the sink. When the glass is full I turn off the tap by pushing it up and then twisting it to the right. Then I pass the glass from my left to my right hand. I walk to the living unit.

Drinking water

I stand between the table and the chair and raise the glass to my mouth. My left arm is straight and motionless. I tilt my head back and shake my hair away from my face. I tip the water into my open mouth and gulp. To control the flow of water into my mouth, I open and close my lips slowly, and open and close them again. The water waves back and forth in the glass every time I swallow. My neck moves every time I swallow. I drink until the glass is empty.

Standing at the front

I step forward to the edge of the platform in front of the chair. My feet are just wider than hip-width apart. I point my feet outwards slightly and stand still. I let my arms hang down straight by my sides. My fingers curve towards my thighs and there is a gap between them and my thumbs. I stand straight and still and keep looking at the audience. I turn my hands round and keep staring.

Sitting on the chair

I stand in front of the chair and bend my knees until my body rests on the chair and I am sitting. I put my hands on my thighs. My feet are on the floor, and they are hip-width apart. I look at the audience.

Drinking water

I stand between the table and the chair and raise the glass to my mouth. My left arm is straight and motionless. I tilt my head back and shake my hair away from my face. I tip the water into my open mouth and gulp. To control the flow of water into my mouth, I open and close my lips slowly, and open and close them again. The water waves back and forth in the glass every time I swallow. My neck moves every time I swallow. I drink until the glass is empty.

Showering

I pick up the bath mat from inside the shower tray and unroll it on the floor in front of the shower. Then I take the towel from the shelf and drape it over the toilet seat. I sit on the edge of the toilet and put my hairband around my left wrist. Then I lean over and untie the laces of my right boot with my left hand. When the laces are loose enough, I take off the boot and then pull off the sock by grabbing the toe. I put the sock on the boot. Then I untie the laces of my left boot with both hands. When the laces are loose enough I take off the boot and then pull off the sock by grabbing the toe. I put the sock on the boot.

Then I undo the buttons on my trousers and stand up so I can pull them down. When I have sat down again, I finish pulling them off, starting with the right leg and finishing with the left leg. Then I fold them in half and then half again and then half again and put them on the floor next to the boots. This I do very slowly.

Then I brush the hair from my face and undo the buttons on my collars and the buttons of my shirt, starting at the bottom and working my way up. There are seven buttons to undo. Then I take off my shirt and lay it across my legs. Then I take off my undershirt and fold it up neatly. Then I take off my slip. I put all my clothes on the left-hand side of the unit next to the wall. Then I tie my hair back with the headband.

I stand on the left of the shower, outside the tray, and turn on the taps. I test the temperature of the water by holding out my left hand under the trickle. I wait for as long as it takes for the water to warm up. I step into the shower.

I look straight ahead and close my eyes.

I wipe my face and then turn around to adjust the temperature of the water.

Then I stand with my palms open. The water runs over me.

I lean forward and let it run down my back.

When I have finished showering I turn round and twist the taps off with my right hand.

I lean over to pick up the towel. I press the towel hard against my face for a long time. Then I rub the towel over my arms, then my torso, then my legs. I do not dry myself very thoroughly. Then I lay the towel over the toilet seat and sit down on it.

I take my hairband off.

Then I put my slip back on. Then I put my undershirt back on by putting my head through the head hole and my arms through the armholes. I do the same with my shirt and do up the buttons on my cuffs. I do up the buttons starting at my neck and working my way downward. Then I put my trousers on. I straighten out all of my clothes. I stand up, take the towel, sit down and dry my feet. Then I put my right sock on followed by my right boot. I tie the laces. Then I put my left sock on followed by my left boot. I tie the laces. I stand up.

I fold up the towel and put it back on the shelf. Then I fold up the bath mat and put it in the shower tray. Then I put the hairband back on the shelf.

Before I step into the living unit, I stand in front of the shelves and run my fingers through my hair.

Sitting on the chair

I stand in front of the chair and bend my knees until my body rests on the chair and I am sitting. I put my hands on my thighs. My feet are on the floor, and they are hip-width apart. I look at the audience.

The metronome ticks.

Standing at the front

I step forward to the edge of the platform in front of the chair. My feet are just wider than hip-width apart. I point my feet outwards slightly and stand still. I let my arms hang down straight by my sides. My fingers curve towards my thighs and there is a gap between them and my thumbs. I stand straight and still and keep looking at the audience.

Filling the glass

I take the glass to the sink in the bedroom unit. I sit down on the bed and twist round to face the sink. I hold the glass in my left hand and put it underneath the tap in the sink. I push the tap up and then twist it to the left with my right hand until water trickles out. I tilt my head down towards the tap and watch the water flow. I let the glass fill up slowly. My right hand rests on the edge of the sink. When the glass is full I turn off the tap by pushing it up and then twisting it to the right. Then I pass the glass from my left to my right hand. I walk to the living unit.

Drinking water

I stand between the table and the chair and raise the glass to my mouth. My left arm is straight and motionless. I tilt my head back and shake my hair away from my face. I tip the water into my open mouth and gulp. To control the flow of water into my mouth, I open and close my lips slowly, and open and close them again. The water waves back and forth in the glass every time I swallow. My neck moves every time I swallow. I drink until the glass is one-third empty.

Sitting on the chair

I stand in front of the chair and bend my knees until my body rests on the chair and I am sitting. I put my hands on my thighs. My feet are on the floor, and they are hip-width apart. I look at the audience.

Winding up the metronome

I pick up the metronome from the table with my right hand and then pass it to my left. I twist the knob clockwise round and round. I do this very slowly. My body is still and only my wrist moves. I put the metronome back down on the table and then set off the ticker. It ticks.

Standing at the front

I stand at the front of the living unit over the knife ladder. My hands are by my sides. My fingers are tense and curved. I look at the eyes of someone in the audience. I wobble from side to side.

Sitting on the chair

I stand in front of the chair and bend my knees until my body rests on the chair and I am sitting. I put my hands on my thighs. My feet are on the floor, and they are hip-width apart. I look at the audience.

Drinking water

I stand between the table and the chair and raise the glass to my mouth. My left arm is straight and motionless. I tilt my head back and shake my hair away from my face. I tip the water into my open mouth and gulp. To control the flow of water into my mouth, I open and close my lips slowly, and open and close them again. The water waves back and forth in the glass every time I swallow. My neck moves every time I swallow. I drink until the glass is empty.

Peeing

I need to pee. I step across the gap to the bathroom unit. When I am in the unit I turn to my right and take the toilet paper from the shelf with my right hand. I take four steps over towards the toilet and turn my body round clockwise. I put the toilet paper down on the corner of the shower tray.

Then I lift the lid of the toilet with my left hand. I push it back until it is resting on the back of the unit. As I turn towards the front I lift up my shirt so I can unfasten my trousers. There are four buttons to unfasten. I tilt my head forward. When I have undone all the buttons I pull my trousers and my slip down to just above my knees and sit on the toilet. I put my feet close together in front of me and cup my hands together in my lap. My two index fingers and thumbs make a triangle shape. My fingertips touch each other.

I look at the floor. I sit still and wait for the pee to come. It takes a while and there is silence. Then there is the sound of water trickling. I am motionless, except for my eyelids, which slide down over my eyes occasionally, and then slide back up.

When I have finished peeing I take the toilet roll and unroll a few sheets. I fold them into a bundle and stand up and wipe myself. Then I pull up my slip and my trousers and do up the four buttons. Then I straighten my shirt out.

I lean over and turn on the tap on the wall with my left hand. The water falls into the bucket beneath.

Then I stand and watch the water fall. When the bucket is half full I turn off the tap and lift the bucket. I pour the water down the toilet to flush it, then I put the lid down. I place the bucket back where it was, underneath the tap, and pull the handle up so it is in the middle.

I put the toilet paper back on the shelf, pause and brush my hair back with my fingers, then walk out of the bathroom unit.

Sitting on the chair

I stand in front of the chair and bend my knees until my body rests on the chair and I am sitting. I put my hands on my thighs. My feet are on the floor, and they are hip-width apart. I look at the audience.

Standing between the units

I stand with one foot in the bathroom unit and the other in the living unit. My body is over the gap. My legs make a triangle shape. Holding my arms at chest height, I rest my hands on the back of the wooden frames. I look at someone in the audience and remain still.

Standing at the front

I step forward to the edge of the platform in front of the chair. My feet are just wider than hip-width apart. I point my feet outwards slightly and stand still. I let my arms hang down straight by my sides. My fingers curve towards my thighs and there is a gap between them and my thumbs. I stand straight and still and keep looking at the audience.

I turn my hands round. I breathe and the bottom of my shirt rises and falls.

The metronome stops ticking.

Winding up the metronome

I pick up the metronome from the table with my right hand and then pass it to my left. I twist the knob clockwise round and round. I do this very slowly. My body is still and only my wrist moves. I put the metronome back down on the table and then set off the ticker. It ticks.

Filling the glass

I take the glass to the sink in the bedroom unit. I sit down on the bed and twist round to face the sink. I hold the glass in my left hand and put it underneath the tap in the sink. I push the tap up and then twist it to the left with my right hand until water trickles out. I tilt my head down towards the tap and watch the water flow. I let the glass fill up slowly. My right hand rests on the edge of the sink. When the glass is full I turn

off the tap by pushing it up and then twisting it to the right. Then I pass the glass from my left to my right hand. I walk to the living unit.

Drinking water

I stand between the table and the chair and raise the glass to my mouth. My left arm is straight and motionless. I tilt my head back and shake my hair away from my face. I tip the water into my open mouth and gulp. To control the flow of water into my mouth, I open and close my lips slowly, and open and close them again. The water waves back and forth in the glass every time I swallow. My neck moves every time I swallow. I drink until the glass is empty. The metronome stops ticking and I start it again by prodding the ticker.

Sitting on the chair

I stand in front of the chair and bend my knees until my body rests on the chair and I am sitting. I put my hands on my thighs. My feet are on the floor, and they are hip-width apart. I look at the audience.

The metronome stops ticking.

Starting the metronome

I stand up and prod the ticker to make it tick again. Then I start walking to the bathroom unit but I turn around, hold the ticker and then let it go.

Standing at the back

I stand at the back of the living unit leaning against the wall. I hold my hands together behind my back. My feet are together. I look at someone in the audience. The metronome stops ticking.

I walk over and push the ticker. It moves again.

Sitting on the chair

I stand in front of the chair and bend my knees until my body rests on the chair and I am sitting. I put my hands on my thighs. My feet are on the floor, and they are hip-width apart. I look at the audience.

The metronome stops ticking again.

Starting the metronome

I walk over and prod it.

Peeing

I need to pee. I step across the gap to the bathroom unit. When I am in the unit I turn to my right and take the toilet paper from the shelf with my right hand. I tear off a few sheets and put the toilet paper back on the shelf. I take four steps over towards the toilet and turn my body round clockwise.

The metronome stops ticking.

Then I lift the lid of the toilet with my left hand. I push it back until it is resting on the back of the unit. As I turn towards the front I lift up my shirt so I can unfasten my trousers. There are four buttons to unfasten. I tilt my head forward. When I have undone all the buttons I pull my trousers and my slip down to just above my knees and sit on the toilet. I put my feet close together in front of me and cup my hands together in my lap. My two index fingers and thumbs make a triangle shape. My fingers make a cage.

I look at the floor. I sit still and wait for the pee to come. It takes a while and there is silence. Then there is the sound of water trickling. I am motionless, except for my eyelids, which slide down over my eyes occasionally, and then slide back up.

When I have finished peeing I stand up and wipe myself with the bundle of tissue paper. Then I pull up my slip and my trousers and do up the four buttons. Then I straighten my shirt out.

I turn around and press the button on the wall but the toilet does not flush.

I pause and brush my hair back with my fingers, then walk out of the bathroom unit.

Filling the glass

On my way to the glass I prod the metronome back into motion. I take the glass to the sink in the bedroom unit. I sit down on the bed and twist round to face the sink. I hold the glass in my left hand and put it underneath the tap in the sink. I push the tap up and then twist it to the left with my right hand until water trickles out. I tilt my head down towards the tap and watch the water flow. I let the glass fill up slowly. My right hand rests on the edge of the sink. When the glass is full I turn off the tap by pushing it up and then twisting it to the right. Then I pass the glass from my left to my right hand. I walk to the living unit and put the glass down on the table.

Reaching up to the light

I reach up with both hands to the light that lights the living unit. I am standing directly underneath the light and I don't have to stretch my arms all the way for my hands to be bathed in the light. I open out my palms to the light, then I turn my hands over. When they are warm, I cover my face with my hands. Then I rub my hands together and hug myself.

The metronome has stopped ticking again and I poke it again.

I stay standing under the light.

The metronome has stopped ticking again and I poke it again. The ticking sound starts again.

Sitting on the chair

I stand in front of the chair and bend my knees until my body rests on the chair and I am sitting. I put my hands in my lap. My feet are on the floor, and they are hip-width apart. I look at someone in the audience.

Drinking water

I stand between the table and the chair and raise the glass to my mouth. My left arm is straight and motionless. I tilt my head back and shake my hair away from my face. I tip the water into my open mouth and gulp. To control the flow of water into my mouth, I open and close my lips slowly, and open and close them again. The water waves back and forth in the glass every time I swallow. My neck moves every time I swallow. I drink until the glass is empty.

Standing at the front

I stand at the front of the living unit over the knife ladder. My hands are by my sides. My fingers are tense and curved. I look at someone in the audience. I wobble around.

Sitting on the chair

I stand in front of the chair and bend my knees until my body rests on the chair and I am sitting. I put my hands on my thighs. My feet are on the floor, and they are hip-width apart. I look at the audience.

Standing at the front

I stand at the front of the living unit over the knife ladder. My hands are by my sides. I look at someone in the audience. I wobble around. I turn my hands round so my thumbs face the front. Then I turn my hands round even further so my palms are open.

Filling the glass

I take the glass to the sink in the bedroom unit. I sit down on the bed and twist round to face the sink. I hold the glass in my left hand and put it underneath the tap in the sink. I push the tap up and then twist it to the left with my right hand until water trickles out. I tilt my head down towards the tap and watch the water flow. I let the glass fill up

slowly. My right hand rests on the edge of the sink. When the glass is full I turn off the tap by pushing it up and then twisting it to the right. Then I pass the glass from my left to my right hand. I walk to the living unit.

Drinking water

I stand between the table and the chair and raise the glass to my mouth. My left arm is straight and motionless. I tilt my head back and shake my hair away from my face. I tip the water into my open mouth and gulp. To control the flow of water into my mouth, I open and close my lips slowly, and open and close them again. The water waves back and forth in the glass every time I swallow. My neck moves every time I swallow. I drink until the glass is empty.

Sitting on the chair

I stand in front of the chair and bend my knees until my body rests on the chair and I am sitting. I put my hands in my lap. My feet are on the floor, and they are hip-width apart. I look at someone in the audience.

Showering

I take the towel from the shelf and drape it over the toilet seat. I sit on the edge of the toilet and put my hairband around my left wrist. Then I lean over and untie the laces of my right boot with my left hand. When the laces are loose enough, I take off the boot and then pull off the sock by grabbing the toe. I put the sock on the boot. Then I untie the laces of my left boot with both hands. When the laces are loose enough I take off the boot and then pull off the sock by grabbing the toe. I put the sock on the boot.

Then I undo the buttons on my trousers and stand up so I can pull them down. When I have sat down again, I finish pulling them off, starting with the right leg and finishing with the left leg. Then I fold them in half and then half again and then half again and put them on the floor next to the boots. This I do very slowly.

Then I brush the hair from my face and undo the buttons on my collars and the buttons of my shirt, starting at the bottom and working my way up. There are seven buttons to undo. Then I take off my shirt and lay it across my legs. Then I tie my hair back with the headband. Then I take off my undershirt and fold it up neatly. Then I take off my slip. I put all my clothes on the left-hand side of the unit next to the wall.

I take the bath mat from the shower tray and spread it on the floor in front of the shower.

I stand on the left of the shower, outside the tray, and turn on the taps. I test the temperature of the water by holding out my left hand under the trickle. I wait for as long as it takes for the water to warm up. I step into the shower.

I look straight ahead and close my eyes.

I open my mouth wide and let the water flow in.

I wipe my face and then let my arms hang by my sides.

I reach behind me and twist the tap to adjust the temperature.

When I have finished showering I turn round and twist the taps off with my right hand.

I lean over to pick up the towel. I press the towel hard against my face for a long time. Then I rub the towel over my arms, then my torso, then my legs. I do not dry myself very thoroughly. Then I lay the towel over the toilet seat and sit down on it.

I take my hairband off and put it on the edge of the shower tray.

Then I put my slip back on. Then I put my undershirt back on by putting my head through the head hole and my arms through the arm-holes. I do the same with my shirt and do up the buttons on my cuffs. I do up the buttons starting at my neck and working my way down-

ward. Then I put my trousers on. I straighten out all of my clothes. I stand up, take the towel, sit down and dry my feet. Then I put my right sock on followed by my right boot. I tie the laces. Then I put my left sock on followed by my left boot. I tie the laces. I stand up.

I fold up the towel and put it back on the shelf. Then I fold up the bath mat and put it in the shower tray. Then I put the hairband back on the shelf.

Before I step into the living unit, I stand in front of the shelves and run my fingers through my hair.

Standing at the front

I stand at the front of the living unit over the knife ladder. My hands are by my sides. My fingers are tense and curved. I look at someone in the audience. I am breathing. I turn my hands around halfway so my thumbs face the front. I raise my arms out from my sides.

Outside it is raining and I can hear the water falling on the roof of the gallery.

Filling the glass

I take the glass to the sink in the bedroom unit. I sit down on the bed and twist round to face the sink. I hold the glass in my left hand and put it underneath the tap in the sink. I push the tap up and then twist it to the left with my right hand until water trickles out. I tilt my head down towards the tap and watch the water flow. I let the glass fill up slowly. My right hand rests on the edge of the sink. When the glass is full I turn off the tap by pushing it up and then twisting it to the right. Then I pass the glass from my left to my right hand. I walk to the living unit.

Drinking water

I stand between the table and the chair and raise the glass to my mouth. My left arm is straight and motionless. I tilt my head back and shake my hair away from my face. I tip the water into my open mouth and gulp. To control the flow of water into my mouth, I open and close my lips slowly, and open and close them again. The water waves back and forth in the glass every time I swallow. My neck moves every time I swallow. I drink until the glass is empty. Then I put the glass down on the table.

Sitting on the chair

I stand in front of the chair and bend my knees until my body rests on the chair and I am sitting. I put my hands on my thighs. My feet are on the floor, and they are hip-width apart. I look at the audience.

Standing between the units

I stand with one foot in the bedroom unit and the other in the living unit. My body is over the gap. My legs make a triangle shape. Holding my arms at chest height, I rest my hands on the back of the wooden frames. I look at someone in the audience and remain still.

Standing in front of the chair

I stand in front of the chair and stare.

Filling the glass

I take the glass to the sink in the bedroom unit. I sit down on the bed and twist round to face the sink. I hold the glass in my left hand and put it underneath the tap in the sink. I push the tap up and then twist it to the left with my right hand until water trickles out. I tilt my head down towards the tap and watch the water flow. I let the glass fill up slowly. My right hand rests on the edge of the sink. When the glass is full I turn off the tap by pushing it up and then twisting it to the right. Then I pass the glass from my left to my right hand. I walk to the living unit.

Drinking water

I stand between the table and the chair and raise the glass to my

mouth. My left arm is straight and motionless. I tilt my head back and shake my hair away from my face. I tip the water into my open mouth and gulp. To control the flow of water into my mouth, I open and close my lips slowly, and open and close them again. The water waves back and forth in the glass every time I swallow. My neck moves every time I swallow. I drink until the glass is empty. Then I put the glass down on the table.

Sitting on the chair

I stand in front of the chair and bend my knees until my body rests on the chair and I am sitting. I put my hands on my thighs. My feet are on the floor, and they are hip-width apart. I look at the audience.

Peeing

I need to pee. I step across the gap to the bathroom unit. When I am in the unit I turn to my right and take the toilet paper from the shelf with my right hand. I take four steps over towards the toilet and turn my body round clockwise. I put the toilet paper down on the corner of the shower tray.

Then I lift the lid of the toilet with my left hand. I push it back until it is resting on the back of the unit. As I turn towards the front I lift up my shirt so I can unfasten my trousers. There are four buttons to unfasten. I tilt my head forward. When I have undone all the buttons I pull my trousers and my slip down to just above my knees and sit on the toilet. I put my feet close together in front of me and cup my hands together in my lap. My two index fingers and thumbs make a triangle shape. My fingers make a cage.

I look at the floor. I sit still and wait for the pee to come. It takes a while and there is silence. Then there is the sound of water trickling. I am motionless, except for my eyelids, which slide down over my eyes occasionally, and then slide back up.

When I have finished peeing I take the toilet roll and unroll a few sheets. I fold them into a bundle and stand up and wipe myself. Then I pull up my slip and my trousers and do up the four buttons. Then I straighten my shirt out.

I lean over and turn on the tap on the wall with my left hand. The water falls into the bucket beneath.

Then I stand and look at the right-hand wall of the gallery and listen to the water fall. When the bucket is half full I turn off the tap and lift the bucket. I pour the water down the toilet to flush it, then I put the lid down. I place the bucket back where it was, underneath the tap, and pull the handle up so it is in the middle.

I put the toilet paper back on the shelf, pause and brush my hair back with my fingers, then walk out of the bathroom unit.

Winding up the metronome

The metronome has stopped ticking so I pick it up from the table with my right hand and then pass it to my left. I twist the knob clockwise round and round. I do this very slowly. My body is still and only my wrist moves. I put the metronome back down on the table and then set off the ticker. It ticks.

Sitting on the chair

I stand in front of the chair and bend my knees until my body rests on the chair and I am sitting. I put my hands on my thighs. My feet are on the floor, and they are hip-width apart. I look at the audience.

Standing at the back and then moving forward

I stand at the back of the living unit leaning against the wall. My hands are clasped together behind my back. My feet are together. I look at someone in the audience. Then I let my hands hang down and twist my wrists so my open palms face the person I am staring at.

Then I step to the middle, maintaining the stare.

Then I step forward so I am standing over the knife ladder.

Filling the glass

I take the glass to the sink in the bedroom unit. I sit down on the bed and twist round to face the sink. I hold the glass in my left hand and put it underneath the tap in the sink. I push the tap up and then twist it to the left with my right hand until water trickles out. I tilt my head down towards the tap and watch the water flow. I let the glass fill up slowly. My right hand rests on the edge of the sink. When the glass is full I turn off the tap by pushing it up and then twisting it to the right. Then I pass the glass from my left to my right hand. I walk to the living unit.

Drinking water

I stand between the table and the chair and raise the glass to my mouth. I take one mouthful from the glass.

Wiping my nose

I walk to the bathroom unit and tear off a couple of sheets of toilet paper, bundle them up and wipe my nose. I put the bundle in my pocket and walk away.

Sitting on the chair

I sit down on the chair and cover my face with my hands. Then I look.

I turn my hands over on my thighs so my palms face upwards. I lean my head back on the quartz pillow. I look.

Drinking water

I swallow the rest of the water left in the glass by tipping it into my mouth.

Showering

I take the towel from the shelf and drape it over the toilet seat. I sit on the edge of the toilet and put my hairband around my left wrist. Then I lean over and untie the laces of my right boot with my left hand. When the laces are loose enough, I take off the boot and then pull off the sock by grabbing the toe. I put the sock on the boot. Then I untie the laces of my left boot with both hands. When the laces are loose enough I take off the boot and then pull off the sock by grabbing the toe. I put the sock on the boot.

Then I undo the buttons on my trousers and stand up so I can pull them down. When I have sat down again, I finish pulling them off, starting with the right leg and finishing with the left leg. Then I fold them in half and then half again and then half again and put them on the floor next to the boots. This I do very slowly.

Then I brush the hair from my face and undo the buttons on my collars and the buttons of my shirt, starting at the bottom and working my way up. There are seven buttons to undo. Then I take off my shirt and lay it across my legs. Then I take off my undershirt and fold it up neatly. Then I take off my slip. I put all my clothes on the left-hand side of the unit next to the wall.

Then I tie my hair back with the headband.

I take the bath mat from the shower tray and spread it on the floor in front of the shower.

I stand on the left of the shower, outside the tray, and turn on the taps. I test the temperature of the water by holding out my left hand under the trickle. I wait for as long as it takes for the water to warm up. I step into the shower.

I look straight ahead and close my eyes.

I open my mouth wide and let the water flow in and rock my head from side to side.

I cover my eyes with my hands and then let them hang by my side.

I reach behind me and twist the tap to adjust the temperature.

When I have finished showering I turn round and twist the taps off with my right hand.

I lean over to pick up the towel. I press the towel hard against my face for a long time. Then I rub the towel over my arms, then my torso, then my legs. I do not dry myself very thoroughly. Then I lay the towel over the toilet seat and sit down on it.

I take my hairband off and put it on the edge of the shower tray.

Then I put my slip back on. Then I put my undershirt back on by putting my head through the head hole and my arms through the arm-holes. I do the same with my shirt and do up the buttons on my cuffs. I do up the buttons starting at my neck and working my way downward. Then I put my trousers on. I straighten out all of my clothes. I stand up, take the towel, sit down and dry my feet. Then I put my right sock on followed by my right boot. I tie the laces. Then I put my left sock on followed by my left boot. I tie the laces. I stand up.

I fold up the towel and put it back on the shelf. Then I fold up the bath mat and put it in the shower tray. Then I put the hairband back on the shelf.

Before I step into the living unit, I stand in front of the shelves and run my fingers through my hair.

Sitting on the chair

I stand in front of the chair and bend my knees until my body rests on the chair and I am sitting. I put my hands on my thighs. My feet are on the floor, and they are hip-width apart. I look at someone in the audience.

Standing between the units

I stand with one foot in the bathroom unit and the other in the living unit. My body is over the gap. My legs make a triangle shape. Holding my arms at chest height, I rest my hands on the back of the wooden frames. I look at the eyes of someone in the audience and remain still.

Standing at the front

I stand at the front of the living unit over the knife ladder. My hands are by my sides. My fingers are tense and curved. I look at someone in the audience. I am breathing. I turn my hands around halfway so my thumbs face the front.

Outside it is raining very hard and it makes a sound as it falls on the roof of the gallery.

I step backwards, holding out my hands.

Sitting on the chair

I stand in front of the chair and bend my knees until my body rests on the chair and I am sitting. I put my hands on my thighs. My feet are on the floor, and they are hip-width apart. I look into someone's eyes in the audience. I turn my hands over so my palms face up.

Monday, November 18th: Day 4

Wearing blue

Lying on the bed

I lie on the bed with my head resting on the quartz pillow, my hands linked over my belly, and my feet hunched up. I look at the inside of my eyelids.

Then I turn over onto my left side so I am facing the gallery. My hands rest on the quartz pillow. I close my eyes again.

I stroke my hair then sit up.

Stretching and shaking

I sit up from lying on the bed, do a big yawn and then open my mouth as wide as it will go. I roll my chin around and stretch my lips round and round, tensing my cheeks. I stick out my tongue as far as it will go. I shake my hair down over my face and then run my fingers through it to shake it back. I stand up and jig up and down and from side to side, keeping my feet in the same spot but twisting my hips, rolling my shoulders and letting my head sway from side to side. I raise my elbows up and then my both my arms. I stretch up to the ceiling and then bend down to the floor.

Winding up the metronome

I pick up the metronome from the table with my right hand and then pass it to my left. I twist the knob clockwise round and round. I do this very slowly. My body is still and only my wrist moves. I adjust the weight on the ticker and then put the metronome back down on the table. It ticks.

Filling the glass

I pick up the glass and take it to the sink in the bedroom unit. I sit down on the bed and twist round to face the sink. I hold the glass in my left hand and put it underneath the tap in the sink. I push the tap up and then twist it to the left with my right hand until water trickles out. I tilt my head down towards the tap and watch the water flow. I let the glass fill up slowly. My right hand rests on the edge of the sink. When the glass is full I turn off the tap by pushing it up and then twisting it to the right. Then I pass the glass from my left to my right hand. I walk to the living unit.

Drinking water

I stand in front of the chair and raise the glass to my mouth. My left arm is straight and motionless. I tilt my head back. I tip the water into my open mouth and swallow. To control the flow of water into my mouth, I open and close my lips slowly, and open and close them again. The water waves back and forth in the glass every time I swallow. My neck moves every time I swallow. I drink until the glass is empty. Then I look at the floor and then put the glass down on the table.

Peeing

I need to pee. I step across the gap to the bathroom unit. When I am in the unit I turn to my right and take the toilet paper from the shelf with my right hand. I take four steps over towards the toilet and turn my body round clockwise. I put the toilet paper down on the corner of the shower tray.

Then I lift the lid of the toilet with my left hand. I push it back until it is resting on the back of the unit. As I turn towards the front I lift up my shirt so I can unfasten my trousers. There are four buttons to unfasten. I tilt my head forward. When I have undone all the buttons I pull my trousers and my slip down to just above my knees and sit on the toilet. I put my feet close together in front of me and rest my head in my hands.

I look at the floor. I sit still and wait for the pee to come. It takes a while and there is silence. Then there is the sound of water trickling. I am motionless, except for my eyelids, which slide down over my eyes occasionally, and then slide back up.

When I have finished peeing I take the toilet roll and unroll two sheets. I fold them together and stand up and wipe myself. Then I pull up my slip and my trousers and do up the four buttons. Then I straighten my shirt out.

I lean over and turn on the tap on the wall with my left hand. The water falls into the bucket beneath.

Then I stand and look at the right-hand wall of the gallery and listen to the water fall. When the bucket is half full I turn off the tap and lift the bucket. I pour the water down the toilet to flush it, then I put the lid down. I place the bucket back where it was, underneath the tap, and pull the handle up so it is in the middle.

I pause and brush my hair back with my fingers, then walk out of the bathroom unit.

Sitting on the chair

I sit down on the chair and rest my elbows on my knees and my chin on my curled up fingers. My eyes look at the floor. The metronome ticks.

Standing and squatting in the corner

I stand in the left-hand back corner of the living unit, leaning against the back wall and the side wall, with my hands in front of me, holding each other. I stare at someone in the audience. Then I look at the ceiling. Then I cover my face with my hands. Then I rub my hands together and cover my face again. I pull my hair back from my face.

Then I squat down. My elbows are resting on my knees, my head is resting on my hands, my fingers are clenched on my cheeks, my eyes are pointing towards the audience. I blink only when I have to.

Looking in the sink

I sit on the bed with my legs spread flat and my hands behind me for support. I rest my head on the sink. My face touches the edge of the sink between my mouth and my nose. I look into the sink. Then I lift my legs up and around so they are resting flat on the bed. I continue looking in the sink.

Lying on the bed

I lie on the bed with my head resting on the quartz pillow, my hands linked over my belly, and my legs flat. I look at the inside of my eyelids.

Then I turn over onto my left side so I am facing the gallery. My left hand rests on the quartz pillow and my right hand rests on my side.

I stroke my hair and rub my face then lie back on my back. I cross my legs.

Shaking

I sit up from lying on the bed, then stand up and jig up and down and from side to side, keeping my feet in the same spot but twisting my hips, rolling my shoulders and letting my head sway from side to side. Then I roll my head round anti-clockwise then clockwise. I brush my hair back, straighten the collar of my shirt and walk away.

Filling the glass

I pick up the glass and take it to the sink in the bedroom unit. I sit down on the bed and twist round to face the sink. I hold the glass in my left hand and put it underneath the tap in the sink. I push the tap up and then twist it to the left with my right hand until water trickles out. I tilt my head down towards the tap and watch the water flow. I let the glass fill up slowly. My right hand rests on the edge of the sink. When the glass is full I turn off the tap by pushing it up and then twisting it to the right. Then I pass the glass from my left to my right hand. I walk to the living unit.

Drinking water

I stand between the chair and the table and raise the glass to my mouth. My left arm is straight and motionless. I tilt my head back. I tip the water into my open mouth and swallow. To control the flow of water into my mouth, I open and close my lips slowly, and open and close them again. The water waves back and forth in the glass every time I swallow. My neck moves every time I swallow. I drink until the glass is empty. Then I look at the floor and then put the glass down on the table.

Reaching up to the light and hugging myself

I reach up with both hands to the light that lights the living unit. I stand directly underneath the light and I don't have to stretch my arms all the way for my hands to be bathed in the light. I open out my palms to the light, then I hug myself, putting my left hand on my right shoulder and my right hand on my left shoulder.

Peeing

I need to pee. I step across the gap to the bathroom unit. When I am in the unit I turn to my right and take the toilet paper from the shelf with my right hand. I take four steps over towards the toilet and turn my body round clockwise. I put the toilet paper down on the corner of the shower tray.

Then I lift the lid of the toilet with my left hand. I push it back until it is resting on the back of the unit. As I turn towards the front I lift up my shirt so I can unfasten my trousers. There are four buttons to unfasten. I tilt my head forward. When I have undone all the buttons I pull my trousers and my slip down to just above my knees and sit on the toilet. I put my feet close together in front of me and cup my hands together in my lap. My two index fingers and thumbs make a triangle shape. My fingers make a cage.

I look at the floor. I sit still and wait for the pee to come. It takes a while and there is silence. Then there is the sound of water trickling. I am motionless, except for my eyelids, which slide down over my eyes occasionally, and then slide back up.

When I have finished peeing I take the toilet roll and tear off some sheets. I fold them together and stand up and wipe myself. Then I pull up my slip and my trousers and do up the four buttons. Then I straighten my shirt out.

I lean over and turn on the tap on the wall with my left hand. The water falls into the bucket beneath.

Then I stand and look at the right-hand wall of the gallery and listen to the water fall. When the bucket is half full I turn off the tap and lift the bucket. I pour the water down the toilet to flush it. Some water spills on the toilet seat. I place the bucket back where it was, under-

neath the tap, and pull the handle up so it is in the middle. Then I wipe the water around the toilet seat with my hand.

I pause and brush my hair back with my fingers, then walk out of the bathroom unit.

Walking back and forth and starting the metronome when it stops

I walk with even steps very slowly across all three rooms. When I reach the end I turn around, pause with my back against the wall, and then walk back the other way by putting one foot in front of the other. It takes eighteen steps to get from one end to the other. The wooden floor of the units creaks with every step. My spine is curved forward as I walk and I look at the floor in front of me.

As I walk through the living unit, I pause to prod the metronome to make it tick again. Then I continue walking.

It stops again and I stop to prod it, then it starts again and I start walking again.

I continue walking.

The metronome stops again and I stop to prod it, then it starts again and I start walking again.

I walk back and forth three times and then it stops again and I poke it to make it tick again and then continue walking.

Again it stops. I start it on my way past.

It stops. I stop and push the ticker to make it tick. I pause and look at the metronome tick. Then I start walking again.

By the time I come back to the living unit the metronome has stopped ticking again. I poke it with my finger and it ticks again.

Then on my way past I pick up the water glass and take it to the bedroom unit.

Filling the glass

I sit down on the bed and twist round to face the sink. I hold the glass in my left hand and put it underneath the tap in the sink. I push the tap up and then twist it to the left with my right hand until water trickles out. I tilt my head down towards the tap and watch the water flow. I let the glass fill up slowly. My right hand rests on the edge of the sink. When the glass is full I turn off the tap by pushing it up and then twisting it to the right. Then I pass the glass from my left to my right hand. I walk to the living unit.

Drinking water

I stand between the chair and the table and raise the glass to my mouth. My left arm is straight and motionless. I tilt my head back. I tip the water into my open mouth and swallow. To control the flow of water into my mouth, I open and close my lips slowly, and open and close them again. The water waves back and forth in the glass every time I swallow. My neck moves every time I swallow. I drink until the glass is empty. Then I look at the floor and then put the glass down on the table.

Peeing

I need to pee. I step across the gap to the bathroom unit. When I am in the unit I turn to my right and take the toilet paper from the shelf with my right hand. I take four steps over towards the toilet and turn my body round clockwise. I put the toilet paper down on the corner of the shower tray.

Then I lift the lid of the toilet with my left hand. I push it back until it is resting on the back of the unit. As I turn towards the front I lift up my shirt so I can unfasten my trousers. There are four buttons to unfasten. I tilt my head forward. When I have undone all the buttons

I pull my trousers and my slip down to just above my knees and sit on the toilet. I put my feet close together in front of me and rest my head in my hands.

I look at the floor. I sit still and wait for the pee to come. It takes a while and there is silence. Then there is the sound of water trickling. I am motionless, except for my eyelids, which slide down over my eyes occasionally, and then slide back up.

When I have finished peeing I take the toilet roll and tear off some sheets. I fold them together and stand up and wipe myself. Then I pull up my slip and my trousers and do up the four buttons. Then I straighten my shirt out.

I lean over and turn on the tap on the wall with my left hand. The water falls into the bucket beneath.

Then I stand and look at the right-hand wall of the gallery and listen to the water fall. When the bucket is half full I turn off the tap and lift the bucket. I pour the water down the toilet to flush it. I place the bucket back where it was, underneath the tap, making sure the handle is up. Then I wipe the water around the toilet seat with my hand.

I pause and brush my hair back with my fingers, then walk out of the bathroom unit.

Sitting on the chair

I put my body in front of the chair and bend my knees until my bottom rests on the seat of the chair. I hold the front two corners of the chair as I lower myself. Then I put my hands together in my lap. I look at people in the audience.

The metronome stops ticking.

Winding up the metronome

I pick up the metronome from the table with my right hand and then pass it to my left. I twist the knob clockwise round and round. I do this very slowly. My body is still and only my wrist moves. I put the metronome back down on the table and push the ticker. It ticks.

Sitting on the chair

I put my body in front of the chair and bend my knees until my bottom rests on the seat of the chair. I hold the front two corners of the chair as I lower myself. Then I put my hands on my thighs. I look at the telescope.

The metronome stops ticking.

Starting the metronome

I stand up and before I poke the ticker I rest my hand on the top of the glass and look at the metronome. Then I poke the ticker into motion again.

Sitting on the chair

I put my body in front of the chair and bend my knees until my bottom rests on the seat of the chair. I hold the front two corners of the chair as I lower myself. Then I put my hands on my thighs. I look at the telescope.

The metronome stops ticking.

Starting the metronome

I stand up and poke the ticker into motion again.

Sitting on the chair

I put my body in front of the chair and bend my knees until my bottom rests on the seat of the chair. I hold the front two corners of the chair as I lower myself. Then I put my hands on my thighs. I look at someone. Then I turn my hands over so the palms face up.

The metronome stops ticking but I continue the stare.

Starting the metronome

I stand up and poke the ticker into motion again.

Sitting on the chair

I put my body in front of the chair and bend my knees until my bottom rests on the seat of the chair. I hold the front two corners of the chair as I lower myself. Then I put my hands on my thighs. I look at the telescope.

The metronome stops ticking immediately.

Starting the metronome

I stand up and poke the ticker into motion again. I stay standing and staring at the metronome.

Sitting on the chair

I put my body in front of the chair and bend my knees until my bottom rests on the seat of the chair. I hold the front two corners of the chair as I lower myself. Then I put my hands on my thighs. I close my eyes and rest my head back on the quartz pillow.

The metronome stops ticking again. I lean forward slowly in the chair.

Starting the metronome

I stand up and poke the ticker into motion again. I stay standing and staring at the metronome.

Peeing

I need to pee. I step across the gap to the bathroom unit. When I am in the unit I turn to my right and take the toilet paper from the shelf with my right hand. I take four steps over towards the toilet and turn my body round clockwise. I put the toilet paper down on the corner of the shower tray.

Then I lift the lid of the toilet with my left hand. I push it back until it is resting on the back of the unit. As I turn towards the front I lift up my shirt so I can unfasten my trousers. There are four buttons to unfasten. I tilt my head forward. When I have undone all the buttons I pull my trousers and my slip down to just above my knees and sit on the toilet. I put my feet close together in front of me and rest my head in my hands. My hands cup my cheeks.

The metronome stops ticking in the living unit.

I look at the floor. I sit still and wait for the pee to come. It takes a while and there is silence. Then there is the sound of water trickling. I am motionless, except for my eyelids, which slide down over my eyes occasionally, and then slide back up.

When I have finished peeing I take the toilet roll and tear off some sheets. I fold them together and stand up and wipe myself. Then I pull up my slip and my trousers and do up the four buttons. Then I straighten my shirt out.

I lean over and push the handle of the bucket down and then turn on the tap on the wall with my left hand. The water falls into the bucket beneath.

Then I stand and look at the right-hand wall of the gallery and listen to the water fall. When the bucket is half full I turn off the tap and lift the bucket. I pour the water down the toilet to flush it. I place the bucket back where it was, underneath the tap, and pull the handle up so it is in the middle.

I pause and brush my hair back with my fingers, then walk out of the bathroom unit.

Winding up the metronome

I pick up the metronome from the table with my right hand and then pass it to my left. I twist the knob clockwise round and round. I do this

very slowly. My body is still and only my wrist moves. I put the metronome back down on the table and push the ticker. It ticks. I watch the ticker moving from side to side.

Walking back and forth

I walk with even steps very slowly across all three rooms. When I reach the end I turn around, pause with my back against the wall, and then walk back the other way by putting one foot in front of the other. It takes eighteen steps to get from one end to the other. The wooden floor of the units creaks with every step. My spine is curved forward as I walk and I look at the floor in front of me.

Standing at the front

I stand at the front of the living unit over the knife ladder. My hands are by my sides. My fingers are relaxed and curved. I look at the eyes of someone in the audience. I am breathing. I turn my hands around halfway so my thumbs face the front. I wobble a little.

Squatting in the corner

I squat in the left-hand corner of the living unit. My feet are flat on the ground, my bottom rests against the wall, my head rests in my hands and I look at the floor and the metronome ticks. Then I brush the hair back from my face and cover my face with my hands.

Then I shuffle forward a little and sit on the floor. I hunch up my legs and hug them close to my body with my hands linked around my shins.

The metronome stops ticking. I reach up and drag it towards me and prod the ticker into motion again.

Then I move my feet apart and slouch forward between my knees. My face still rests in my hands.

The metronome stops ticking. I reach up and prod the ticker into motion again.

Then I rest my forehead in my hands and close my eyes.

There is silence because the metronome stops ticking again. I prod it again and move back how I was, except with my finger now running through my hair.

It stops ticking again and I poke it again. It ticks eleven times and then stops. I use my middle finger to pull the ticker back and then release it to make it tick again. Then I rest my head in my hands again. It stops. I do nothing. Then I pull the ticker back again. It stops. I get up.

Winding up the metronome

I pick up the metronome from the table with my right hand and then pass it to my left. I twist the knob clockwise round and round. I do this very slowly. My body is still and only my wrist moves. I put the metronome back down on the table and push the ticker. It ticks.

Filling the glass

I sit down on the bed and twist round to face the sink. I hold the glass in my left hand and put it underneath the tap in the sink. I push the tap up and then twist it to the left with my right hand until water trickles out. I tilt my head down towards the tap and watch the water flow. I let the glass fill up slowly.
The metronome stops ticking.

My right hand rests on the edge of the sink. When the glass is full I turn off the tap by pushing it up and then twisting it to the right. Then I pass the glass from my left to my right hand. I walk to the living unit.

Drinking water

I stand between the chair and the table and raise the glass to my mouth. My left arm is straight and motionless. I tilt my head back. I tip the water into my open mouth and swallow. To control the flow of

water into my mouth, I open and close my lips slowly, and open and close them again. The water waves back and forth in the glass every time I swallow. My neck moves every time I swallow. I drink until the glass is empty. Then I look at the floor and then put the glass down on the table.

Starting the metronome

I poke it into motion again.

Sitting on the chair

I put my body in front of the chair and bend my knees until my bottom rests on the seat of the chair. I hold the front two corners of the chair as I lower myself. Then I put my hands on my thighs. I close my eyes and rest my head back on the quartz pillow.

The metronome stops ticking again. I remain sitting.

Starting the metronome

I lean over poke it into motion again. It stops ticking after four ticks.

Standing at the front

I stand at the front of the living unit over the knife ladder. My hands are by my sides. I look into someone's eyes. I am breathing. I wobble a little.

Peeing

I need to pee. I step across the gap to the bathroom unit. When I am in the unit I turn to my right and take the toilet paper from the shelf with my right hand. I take four steps over towards the toilet and turn my body round clockwise. I put the toilet paper down on the corner of the shower tray.

Then I lift the lid of the toilet with my left hand. I push it back until it is resting on the back of the unit. As I turn towards the front I lift up my shirt so I can unfasten my trousers. There are four buttons to unfasten. I tilt my head forward. When I have undone all the buttons I pull my trousers and my slip down to just above my knees and sit on the toilet. I put my feet close together in front of me and rest my head in my hands.

I look at the floor. I sit still and wait for the pee to come. It takes a while and there is silence. Then there is the sound of water trickling. I am motionless, except for my eyelids, which slide down over my eyes occasionally, and then slide back up.

When I have finished peeing I take the toilet roll and tear off some sheets. I fold them together and stand up and wipe myself. Then I pull up my slip and my trousers and do up the four buttons. Then I straighten my shirt out.

I lean over and turn on the tap on the wall with my left hand. The water falls into the bucket beneath.

Then I stand and look at the right-hand wall of the gallery and listen to the water fall. When the bucket is half full I turn off the tap and lift the bucket. I pour the water down the toilet to flush it. I place the bucket back where it was, underneath the tap, and pull the handle up so it is in the middle.

I pause and brush my hair back with my fingers, then walk out of the bathroom unit.

Walking back and forth

I walk with even steps very slowly across all three rooms. When I reach the end I turn around, pause with my back against the wall, and then walk back the other way by putting one foot in front of the other. It takes eighteen steps to get from one end to the other. The wooden floor of the units creaks with every step. My spine is curved forward as I walk and I look at the floor in front of me.

Sitting on the chair

I put my body in front of the chair and bend my knees until my bottom rests on the seat of the chair. I hold the front two corners of the chair as I lower myself. Then I put my hands on my thighs. I look at the telescope. Then I look at someone directly.

I turn my hands over on my thighs.

Filling the glass

I pick up the glass and take it to the sink in the bedroom unit. I sit down on the bed and twist round to face the sink. I hold the glass in my left hand and put it underneath the tap in the sink. I push the tap up and then twist it to the left with my right hand until water trickles out. I tilt my head down towards the tap and watch the water flow. I let the glass fill up slowly. My right hand rests on the edge of the sink. When the glass is full I turn off the tap by pushing it up and then twisting it to the right. Then I pass the glass from my left to my right hand. I walk to the living unit.

Drinking water

I stand between the chair and the table and raise the glass to my mouth. My left arm is straight and motionless. I tilt my head back. I tip the water into my open mouth and swallow. To control the flow of water into my mouth, I open and close my lips slowly, and open and close them again. The water waves back and forth in the glass every time I swallow. My neck moves every time I swallow. I drink until the glass is empty. Then I look at the floor and then put the glass down on the table.

Sitting on the chair

I put my body in front of the chair and bend my knees until my bottom rests on the seat of the chair. I hold the front two corners of the chair as I lower myself. Then I put my hands on my thighs and turn them over.

Standing at the back

I stand at the back of the living unit leaning against the wall. I hold my hands together behind my back. My feet are together. I look at someone in the audience.

Showering

I pick up the bath mat from inside the shower tray and unroll it on the floor in front of the shower. Then I take the towel from the shelf and drape it over the toilet seat. I sit on the edge of the toilet and put my hairband around my left wrist. Then I lean over and untie the laces of my right boot with my left hand. When the laces are loose enough, I take off the boot and then pull off the sock by grabbing the toe. I put the sock on the boot. Then I untie the laces of my left boot with both hands. When the laces are loose enough I take off the boot and then pull off the sock by grabbing the toe. I put the sock on the boot.

Then I undo the buttons on my trousers and stand up so I can pull them down. When I have sat down again, I finish pulling them off, starting with the right leg and finishing with the left leg. Then I fold them in half and then half again and then half again and put them on the floor next to the boots. This I do very slowly.

Then I brush the hair from my face and undo the buttons on my collars and the buttons of my shirt, starting at the bottom and working my way up. There are seven buttons to undo. Then I take off my shirt and lay it across my legs. Then I take off my undershirt and fold it up neatly. Then I take off my slip. I put all my clothes on the left-hand side of the unit next to the wall. Then I tie my hair back with the hairband.

I stand on the left of the shower, outside the tray, and turn on the taps. I test the temperature of the water by holding out my left hand under the trickle. I wait for as long as it takes for the water to warm up. I

step into the shower.

I stand with my hands by my sides and the palms facing out. I open my mouth wide and the water flows in. I rock my head from side to side.

When I have finished showering I turn round and twist the taps off with my right hand.

I lean over to pick up the towel. I press the towel hard against my face for a long time. Then I rub the towel over my arms, then my torso, then my legs. I do not dry myself very thoroughly. Then I lay the towel over the toilet seat and sit down on it.

I take my hairband off.

Then I put my slip back on. Then I put my undershirt back on by putting my head through the head hole and my arms through the arm-holes. I do the same with my shirt and do up the buttons on my cuffs. I do up the buttons starting at my neck and working my way downward. Then I put my trousers on. I straighten out all of my clothes. I stand up, take the towel, sit down and dry my feet. Then I put my right sock on followed by my right boot. I tie the laces. Then I put my left sock on followed by my left boot. I tie the laces. I stand up.

I fold up the towel and put it back on the shelf. Then I fold up the bath mat and put it in the shower tray. Then I put the hairband back on the shelf.

Before I step into the living unit, I stand in front of the shelves and run my fingers through my hair.

Standing at the front

I stand at the front of the living unit over the knife ladder. My hands are by my sides. My fingers are relaxed and curved. I look at someone in the audience. I am breathing. I turn my hands around halfway so my thumbs face the front. I wobble a little.

I turn my head to the left and stare at someone else.

I relax my wrists so my hands lift up.

I step back from the edge slowly.

Filling the glass

I pick up the glass and take it to the sink in the bedroom unit. I sit down on the bed and twist round to face the sink. I hold the glass in my left hand and put it underneath the tap in the sink. I push the tap up and then twist it to the left with my right hand until water trickles out. I tilt my head down towards the tap and watch the water flow. I let the glass fill up slowly. My right hand rests on the edge of the sink. When the glass is full I turn off the tap by pushing it up and then twisting it to the right. Then I pass the glass from my left to my right hand. I walk to the living unit.

Drinking water

I stand between the chair and the table and raise the glass to my mouth. My left arm is straight and motionless. I tilt my head back. I tip the water into my open mouth and swallow. To control the flow of water into my mouth, I open and close my lips slowly, and open and close them again. The water waves back and forth in the glass every time I swallow. My neck moves every time I swallow. I drink until the glass is empty. Then I look at the floor and then put the glass down on the table.

Wiping my nose

I walk to the bathroom unit and tear off a couple of sheets of toilet roll, bundle them up and wipe my nose. I put the bundle in my pocket and walk away.

Sitting on the chair

I put my body in front of the chair and bend my knees until my bottom rests on the seat of the chair. I hold the front two corners of the chair as I lower myself. Then I put my hands on my thighs. I look at the telescope.

Sitting in the corner

I sit in the left-hand corner of the living unit. My feet are hunched up, my hands support my head and my fingers grip my hair and my eyes look ahead. I get up.

Peeing

I need to pee. I step across the gap to the bathroom unit. When I am in the unit I turn to my right and take the toilet paper from the shelf with my right hand. I take four steps over towards the toilet and turn my body round clockwise. I put the toilet paper down on the corner of the shower tray.

Then I lift the lid of the toilet with my left hand. I push it back until it is resting on the back of the unit. As I turn towards the front I lift up my shirt so I can unfasten my trousers. There are four buttons to unfasten. I tilt my head forward. When I have undone all the buttons I pull my trousers and my slip down to just above my knees and sit on the toilet. I put my feet close together in front of me and rest my head in my hands. My fingers touch my cheeks.

I look at the floor. I sit still and wait for the pee to come. It takes a while and there is silence. Then there is the sound of water trickling. I am motionless, except for my eyelids, which slide down over my eyes occasionally, and then slide back up.

When I have finished peeing I take the toilet roll and tear off some sheets. I fold them together and stand up and wipe myself. Then I pull up my slip and my trousers and do up the four buttons. Then I straighten my shirt out.

I lean over and push the handle of the bucket down and then turn on the tap on the wall with my left hand. The water falls into the bucket beneath.

Then I stand and look at the right-hand wall of the gallery and listen to the water fall. When the bucket is half full I turn off the tap and lift the bucket. I pour the water down the toilet to flush it. I place the bucket back where it was, underneath the tap, and pull the handle up so it is in the middle.

I pause and brush my hair back with my fingers, then walk out of the bathroom unit.

Walking back and forth

I walk with even steps very slowly across all three rooms. When I reach the end I turn around, pause with my back against the wall, and then walk back the other way by putting one foot in front of the other. It takes between seventeen and eighteen steps to get from one end to the other. The wooden floor of the units creaks with every step. My spine is curved forward as I walk and I look at the floor in front of me.

Lying on the bed

I lie on the bed on my side, looking out at the gallery. My head rests on the quartz pillow. My left arm rests on my neck and my right arm rests on my side.

Sitting on the bed

I sit on the bed a third of the way from the bottom end. I have my hands in my lap, my feet on the floor and my eyes on a person. My right trouser leg is rumpled up at my ankle. I open my hands in my lap so the tips of my fingers touch.

Lying on the bed

I lie on the bed with my head resting on the quartz pillow, my hands

linked over my belly, and my legs flat and straight. I look at the inside of my eyelids.

The metronome stops ticking so I get up.

Winding up the metronome

I pick up the metronome from the table with my right hand and then pass it to my left. I twist the knob clockwise round and round. I do this very slowly. My body is still and only my wrist moves. I take the metronome to the bedroom unit and put it on the end of the bed near the quartz pillow. I set the ticker ticking.

Lying on the bed

I lie on the bed with my head resting on the quartz pillow, my hands linked over my belly, and my legs flat and straight. I look at the inside of my eyelids. I wiggle my feet. Then I rest my hands flat on the bed, palm up. Then I hunch my feet up and touch my head with my hands. I tilt my head to the left to face the audience. Then I put it straight again and close my eyes.

I bend my left knee and bring my foot further up the bed a little.

Then I get up.

Filling the glass

I pick up the glass from the table in the living unit and take it to the sink in the bedroom unit. I sit down on the bed and twist round to face the sink. I hold the glass in my left hand and put it underneath the tap in the sink. I push the tap up and then twist it to the left with my right hand until water trickles out. I tilt my head down towards the tap and watch the water flow. I let the glass fill up slowly. My right hand rests on the edge of the sink. When the glass is full I turn off the tap by pushing it up and then twisting it to the right. Then I pass the glass from my left to my right hand.

Drinking water

Sitting on the bed, I raise the glass to my mouth. My left hand rests in my lap. I tilt my head back. I tip the water into my open mouth and swallow. To control the flow of water into my mouth, I open and close my lips slowly, and open and close them again. The water waves back and forth in the glass every time I swallow. My neck moves every time I swallow. I drink until the glass is empty. Then I carry the glass to the living unit and put it down on the table.

Peeing

I need to pee. I step across the gap to the bathroom unit. When I am in the unit I turn to my right and take the toilet paper from the shelf with my right hand. I take four steps over towards the toilet and turn my body round clockwise. I put the toilet paper down on the corner of the shower tray.

Then I lift the lid of the toilet with my left hand. I push it back until it is resting on the back of the unit. As I turn towards the front I lift up my shirt so I can unfasten my trousers. There are four buttons to unfasten. I tilt my head forward. When I have undone all the buttons I pull my trousers and my slip down to just above my knees and sit on the toilet. I put my feet close together in front of me and cup my hands together in my lap. My two index fingers and thumbs make a triangle shape. The tips of my fingers touch each other.

I look at the floor. I sit still and wait for the pee to come. It takes a while and there is silence. Then there is the sound of water trickling. I am motionless, except for my eyelids, which slide down over my eyes occasionally, and then slide back up.

When I have finished peeing I take the toilet roll and tear off some sheets. I fold them together and stand up and wipe myself. Then I pull up my slip and my trousers and do up the four buttons. Then I straighten my shirt out.

I lean over and turn on the tap on the wall with my left hand. The water falls into the bucket beneath.

Then I stand and look at the right-hand wall of the gallery and listen to the water fall. When the bucket is half full I turn off the tap and lift the bucket. I pour the water down the toilet to flush it. I place the bucket back where it was, underneath the tap, and pull the handle up so it is in the middle.

I pause and brush my hair back with my fingers, then walk out of the bathroom unit.

Sitting on the chair

I put my body in front of the chair and bend my knees until my bottom rests on the seat of the chair. I hold the front two corners of the chair as I lower myself. Then I put my hands on my thighs. I look at the telescope. Then I look at someone. Then I turn my hands over. Then I look away and turn my hands over again.

Filling the glass

I pick up the glass and take it to the sink in the bedroom unit. I sit down on the bed and twist round to face the sink. I hold the glass in my left hand and put it underneath the tap in the sink. I push the tap up and then twist it to the left with my right hand until water trickles out. I tilt my head down towards the tap and watch the water flow. I let the glass fill up slowly. My right hand rests on the edge of the sink. When the glass Is full I turn off the tap by pushing It up and then twisting it to the right. Then I pass the glass from my left to my right hand. I walk to the living unit.

Drinking water

I stand between the chair and the table and raise the glass to my mouth. My left arm is straight and motionless. I tilt my head back. I tip the water into my open mouth and swallow. To control the flow of water into my mouth, I open and close my lips slowly, and open and close them again. The water waves back and forth in the glass every time I swallow. My neck moves every time I swallow. I drink until the glass is empty. Then I look at the floor and then put the glass down on the table.

Standing at the back

I stand at the back of the living unit leaning against the wall. My arms hang by my sides. My feet are together. I look at someone in the audience. Then I hold my hands together behind my back.

Walking back and forth

I walk with even steps very slowly across all three rooms. When I reach the end I turn around, pause with my back against the wall, and then walk back the other way by putting one foot in front of the other. It takes eighteen steps to get from one end to the other. The wooden floor of the units creaks with every step. My spine is curved forward as I walk and I look at the floor in front of me.

Filling the glass

I pick up the glass and take it to the sink in the bedroom unit. I sit down on the bed and twist round to face the sink. I hold the glass in my left hand and put it underneath the tap in the sink. I push the tap up and then twist it to the left with my right hand until water trickles out. I tilt my head down towards the tap and watch the water flow. I let the glass fill up slowly. My right hand rests on the edge of the sink. When the glass is full I turn off the tap by pushing it up and then twisting it to the right. Then I pass the glass from my left to my right hand. I walk to the living unit.

Drinking water

I stand between the chair and the table and raise the glass to my mouth. My left arm is straight and motionless. I tilt my head back. I tip

the water into my open mouth and swallow. To control the flow of water into my mouth, I open and close my lips slowly, and open and close them again. The water waves back and forth in the glass every time I swallow. My neck moves every time I swallow. I drink until the glass is empty. Then I look at the floor and then put the glass down on the table.

Peeing

I need to pee. I step across the gap to the bathroom unit. When I am in the unit I turn to my right and take the toilet paper from the shelf with my right hand. I take four steps over towards the toilet and turn my body round clockwise. I put the toilet paper down on the corner of the shower tray.

Then I lift the lid of the toilet with my left hand. I push it back until it is resting on the back of the unit. As I turn towards the front I lift up my shirt so I can unfasten my trousers. There are four buttons to unfasten. I tilt my head forward. When I have undone all the buttons I pull my trousers and my slip down to just above my knees and sit on the toilet. I put my feet close together in front of me and rest my head in my hands. My hands cup my cheeks.

The metronome stops ticking in the living unit.

I look at the floor. I sit still and wait for the pee to come. It takes a while and there is silence. Then there is the sound of water trickling. I am motionless, except for my eyelids, which slide down over my eyes occasionally, and then slide back up.

When I have finished peeing I take the toilet roll and tear off some paper. I drop one of the sheets on the floor and have to pick it up. Then I fold the sheets together and stand up and wipe myself. Then I pull up my slip and my trousers and do up the four buttons. Then I straighten my shirt out.

I lean over and push the handle of the bucket down and then turn on the tap on the wall with my left hand. The water falls into the bucket beneath.

Then I stand and look at the right-hand wall of the gallery and listen to the water fall. I glance once at the bucket and then look at the right-hand wall of the gallery again. When the bucket is half full I turn off the tap and lift the bucket. I pour the water down the toilet to flush it. I place the bucket back where it was, underneath the tap. The handle falls to the back but I do not put it back in the middle.

I pause and brush my hair back with my fingers, then walk out of the bathroom unit.

Sitting on the chair

I put my body in front of the chair and bend my knees until my bottom rests on the seat of the chair. I hold the front two corners of the chair as I lower myself. Then I put my hands on my thighs. I look at the telescope.

Standing between the units

I stand with one foot in the bathroom unit and the other in the living unit. My body is over the gap. My legs make a triangle shape. Holding my arms at chest height, I rest my hands on the back of the wooden frames. I look at someone in the audience and remain still.

Lying on the bed

I lie on the bed with my head resting on the quartz pillow, my hands by my sides, and my legs flat. I look at the inside of my eyelids.

The metronome ticks by my head.

I get up and carry the metronome with me to the bathroom unit.

Showering

I put the metronome on the floor at the front on the right-hand side. Then I pick up the bath mat from inside the shower tray and unroll it on the floor in front of the shower. Then I take the hairband and the towel from the shelf. I drape the towel over the toilet seat. I sit on the edge of the toilet and put my hairband around my left wrist. Then I lean over and untie the laces of my right boot with my left hand. When the laces are loose enough, I take off the boot and then pull off the sock by grabbing the toe. I put the sock on the boot. Then I untie the laces of my left boot with both hands. When the laces are loose enough I take off the boot and then pull off the sock by grabbing the toe. I put the sock on the boot.

Then I undo the buttons on my trousers and stand up so I can pull them down. When I have sat down again, I finish pulling them off, starting with the right leg and finishing with the left leg. Then I fold them in half and then half again and then half again and put them on the floor next to the boots. This I do very slowly.

Then I brush the hair from my face and undo the buttons on my collars and the buttons of my shirt, starting at the bottom and working my way up. There are seven buttons to undo. Then I take off my shirt and lay it across my legs. Then I tie my hair back with the hairband. Then I take off my undershirt and fold it up neatly. Then I take off my slip. I put all my clothes on the left-hand side of the unit next to the wall.

I stand on the left of the shower, outside the tray, and turn on the taps. I test the temperature of the water by holding out my left hand under the trickle. I wait for as long as it takes for the water to warm up. I step into the shower.

I stand with my hands by my sides and the palms facing out. I close my eyes. I open my mouth wide and the water flows in. I rock my head from side to side.

When I have finished showering I turn round and twist the taps off with my right hand.

I lean over to pick up the towel. I press the towel hard against my face for a long time. Then I rub the towel over my arms, then my torso, then my legs. I do not dry myself very thoroughly. Then I lay the towel over the toilet seat and sit down on it.

I take my hairband off and put it on the edge of the shower tray.

Then I put my slip back on. Then I put my undershirt back on by putting my head through the head hole and my arms through the armholes. I do the same with my shirt and do up the buttons on my cuffs. I do up the buttons starting at my neck and working my way downward. Then I put my trousers on. I straighten out all of my clothes. I stand up, take the towel, sit down and dry my feet. Then I put my right sock on followed by my right boot. I tie the laces. Then I put my left sock on followed by my left boot. I tie the laces. I stand up.

I fold up the towel and put it back on the shelf. Then I fold up the bath mat and put it in the shower tray. Then I put the hairband back on the shelf.

Before I step into the living unit, I stand in front of the shelves and run my fingers through my hair. Then I pick up the metronome and walk away.

Standing at the front

I put the metronome on the table and then stand at the front of the living unit over the knife ladder. My hands are by my sides. I look at someone in the audience. I am breathing.

The metronome stops ticking.

I keep staring and flare out my fingers from my sides. Then I raise my arms a little from my sides.

I turn around and poke the ticker on the metronome so it starts ticking

again. Then I stand staring into someone's eyes, resting my left hand on the table.

Sitting on the chair

I put my body in front of the chair and bend my knees until my bottom rests on the seat of the chair. I hold the front two corners of the chair as I lower myself. Then I put my hands on my thighs. I look at people in the audience.

The metronome stops ticking.

I stand up and make it tick again and stare at it with my right hand resting on the table, my fingers outstretched. Then I sit down on the chair again.

It stops ticking again. I remain still.

Winding up the metronome

I pick up the metronome from the table with my right hand and then pass it to my left. I twist the knob clockwise round and round. I do this very slowly. My body is still and only my wrist moves. I put the metronome down, push the ticker and it ticks.

Sitting on the chair

I put my body in front of the chair and bend my knees until my bottom rests on the seat of the chair. I hold the front two corners of the chair as I lower myself. Then I put my hands on my thighs. I look at people in the audience.

Then the metronome stops ticking again. I lean over and prod it. I don't prod it hard enough so I have to prod it again. Then it ticks.

I sit back how I was but open my hands in my lap so my palms face up and my fingers are touching.

It stops. I start it again.

I stare out.

It stops. I keep staring.

Then I prod it. It ticks fourteen times then stops.

Winding up the metronome

I reach over and pick up the metronome from the table with my right hand and then pass it to my left. I twist the knob clockwise round and round. I do this very slowly. My body is still and only my wrist moves. I put the metronome down on the floor by my feet, push the ticker and it ticks.

Filling the glass

I pick up the glass from the table in the living unit and take it to the sink in the bedroom unit. I sit down on the bed and twist round to face the sink. I hold the glass in my left hand and put it underneath the tap in the sink. I push the tap up and then twist it to the left with my right hand until water trickles out. I tilt my head down towards the tap and watch the water flow. I let the glass fill up slowly. My right hand rests on the edge of the sink. When the glass is full I turn off the tap by pushing it up and then twisting it to the right. Then I pass the glass from my left to my right hand.

Drinking water

Sitting on the bed, I raise the glass to my mouth. My left hand rests in my lap. I tilt my head back. I tip the water into my open mouth and swallow. To control the flow of water into my mouth, I open and close my lips slowly, and open and close them again. The water waves back and forth in the glass every time I swallow. My neck moves every time I swallow. I drink until the glass is empty. Then I carry the glass to the living unit and put it down on the table.

Peeing

I need to pee. I step across the gap to the bathroom unit. When I am in the unit I turn to my right and take the toilet paper from the shelf with my right hand. I take four steps over towards the toilet and turn my body round clockwise. I put the toilet paper down on the corner of the shower tray.

Then I lift the lid of the toilet with my left hand. I push it back until it is resting on the back of the unit. As I turn towards the front I lift up my shirt so I can unfasten my trousers. There are four buttons to unfasten. I tilt my head forward. When I have undone all the buttons I pull my trousers and my slip down to just above my knees and sit on the toilet. I put my feet close together in front of me and cup my hands together in my lap. My two index fingers and thumbs make a triangle shape. My fingers make a cage.

I look at the floor. I sit still and wait for the pee to come. It takes a while and there is silence. Then there is the sound of water trickling. I am motionless, except for my eyelids, which slide down over my eyes occasionally, and then slide back up.

When I have finished peeing I take the toilet roll and unroll some paper and tear it off. I fold it up into a bundle and stand up and wipe myself. Then I pull up my slip and my trousers and do up the four buttons. Then I straighten my shirt out.

I lean over and push the handle of the bucket down to the front then turn on the tap on the wall with my left hand. The water falls into the bucket beneath.

Then I stand and look at the right-hand wall of the gallery and listen to the water fall. When the bucket is half full I turn off the tap and lift the bucket. I pour the water down the toilet to flush it. I place the bucket back where it was, underneath the tap, and pull the handle up so it is in the middle.

I pause and brush my hair back with my fingers, then walk out of the bathroom unit.

Standing at the back

I stand at the back of the living unit leaning against the wall. I hold my hands together behind my back. My feet are together. I look at someone in the audience.

Sitting on the chair

I put my body in front of the chair and bend my knees until my bottom rests on the seat of the chair. I hold the front two corners of the chair as I lower myself. Then I put my hands on my thighs. I look at people in the audience, then at the floor.

Then I run my fingers through my hair and cup my hands together in my lap.

Then I lean forward and rest my elbows on my knees and my chin in my curled-up fingers.

Then I lean back and rest my head against the quartz pillow and put my hands together in my lap.

Then I lean forward and rest my elbows on my knees and my chin in my curled-up fingers.

Then I lean back and rest my head against the quartz pillow and put my hands together in my lap. I stroke my hair.

Peeing

I need to pee. I step across the gap to the bathroom unit. When I am in the unit I turn to my right and take the toilet paper from the shelf with my right hand. I take four steps over towards the toilet and turn my body round clockwise. I put the toilet paper down on the corner of the shower tray.

Then I lift the lid of the toilet with my left hand. I push it back until it is resting on the back of the unit. As I turn towards the front I lift up my shirt so I can unfasten my trousers. There are four buttons to unfasten. I tilt my head forward. When I have undone all the buttons I pull my trousers and my slip down to just above my knees and sit on the toilet. I put my feet close together in front of me and cup my hands together in my lap. My fingers are interlaced and close together.

I sit up straight but look at the floor. I sit still and wait for the pee to come. It takes a while and there is silence. Then there is the sound of water trickling. I am motionless, except for my eyelids, which slide down over my eyes occasionally, and then slide back up.

When I have finished peeing I take the toilet roll and tear off some sheets. I fold them together and stand up and wipe myself. Then I pull up my slip and my trousers and do up the four buttons. Then I straighten my shirt out.

I lean over and push the handle of the bucket to the front and then turn on the tap on the wall with my left hand. The water falls into the bucket beneath.

Then I stand and look at the right-hand wall of the gallery and listen to the water fall. When the bucket is half full I turn off the tap and lift the bucket. I pour the water down the toilet to flush it. I place the bucket back where it was, underneath the tap, and pull the handle up so it is in the middle.

I pause and brush my hair back with my fingers, then walk out of the bathroom unit.

Filling the glass

I pick up the glass and take it to the sink in the bedroom unit. I sit down on the bed and twist round to face the sink. I hold the glass in my left hand and put it underneath the tap in the sink. I push the tap up and then twist it to the left with my right hand until water trickles out. I tilt my head down towards the tap and watch the water flow. I let the glass fill up slowly. My right hand rests on the edge of the sink. When the glass is full I turn off the tap by pushing it up and then twisting it to the right. Then I pass the glass from my left to my right hand. I walk to the living unit.

Drinking water

I stand between the chair and the table and raise the glass to my mouth. My left arm is straight and motionless. I tilt my head back. I tip the water into my open mouth and swallow. To control the flow of water into my mouth, I open and close my lips slowly, and open and close them again. The water waves back and forth in the glass every time I swallow. My neck moves every time I swallow. I drink until the glass is empty. Then I look at the floor and then put the glass down on the table.

Sitting on the chair

I put my body in front of the chair and bend my knees until my bottom rests on the seat of the chair. I hold the front two corners of the chair as I lower myself. Then I put my hands on my thighs. Then I rest my head in my hands. Then I sit back again and put my hands on my thighs.

Standing at the back

I stand at the back of the living unit leaning against the wall. I hold my hands together behind my back. My feet are together. I look at someone's eyes in the audience.

I rub my shirt and then put my hands back behind my back.

Standing at the front

I stand at the front of the living unit over the knife ladder. My hands are by my sides. My fingers are relaxed and curved. I look at someone in the audience on the right-hand side of the gallery. I am breathing. I turn my hands around halfway so my thumbs face the front. I wobble a little. Then I look straight ahead. Then to the left, and I open out my hands.

Sitting on the chair

I put my body in front of the chair and bend my knees until my bottom rests on the seat of the chair. I hold the front two corners of the chair as I lower myself. Then I put my hands on my thighs.

Tuesday, November 19th: Day 5

Wearing red

Sitting naked on the bed

I sit naked on the bed, still wet from my first shower of the day. I stare at the ground. I am sitting on my towel. My hands are resting flat on the bed, perpendicular to my wrists and pointing outwards. On the towel are laid out two bottles—almond oil and rose water—with the lids off. I pick up the almond oil, empty some of the fluid into my cupped hands and rub it over my face. Then I pick up the bottle of rose water, empty some of the fluid out into my cupped hands and rub it over my body, right down to my toes. I hold my toes and stretch forward for a long time, with my head hanging loose from my neck, drooping down towards the floor. My face is touching my legs.

Then I sit up and take a comb from the bed. I comb my wet hair. Then I put the comb down and shake my hair with both hands. Then I rest my hands on the side of the bed. I look down at the floor.

The metronome stops ticking.

Winding up the metronome

I walk to the living unit, still naked, and pick up the metronome from the table with my right hand and then pass it to my left. I twist the knob clockwise round and round. I do this very slowly. My body is still and only my wrist moves. I put the metronome back down on the table and push the ticker. It ticks.

Sitting naked on the bed

I lift my legs up onto the bed and lean against the wall with my knees against my chest and my hands flopped over my knees. I curl my toes over the edge of the bed. Then I fold my arms over the top of my knees.

I brush my hair again. Then I sit back against the wall and fold my arms across my knees. I hide my face behind my arms.

I sit up and take away the towel I was sitting on. I roll it up and roll up the bath mat too and put them next to me on the bed. My clothes are folded in a pile on my right-hand side. I sit back how I was and cover my face with my hands.

Getting dressed

I pick up my slip, think about putting them on but put them back down on the bed. Instead I stretch forward again, holding my toes with my fingers. I massage each toe individually—the same toe on each foot at the same time—by twiddling it between my index finger and thumb. Then I squeeze all my toes together with my fingers.

Then I sit up, take my slip and put it on, followed by my two under-shirts. Then I have to unfold and unbutton my shirt of the day. I put my left arm through the left armhole first, then my right arm through the right armhole second. I do the buttons up again, starting at the top.

Then I take my pajama bottoms, unfold them, stand up and put my right leg in the right leg hole and my left leg in the left leg hole. I pull up the pajama bottoms to my waist and fasten the button.

Then I take my left sock and put it on, followed by my left boot. Then I take my right sock and put it on, followed by my right boot.

I brush my hair again.

Then I gather the bundle of folded towel and bath mat and walk to the bathroom unit and put them back on the shelf.

Filling the glass

I pick up the glass from the table in the living unit and take it to the sink in the bedroom unit. I sit down on the bed and twist round to face the sink. I hold the glass in my left hand and put it underneath the tap in the sink. I push the tap up and then twist it to the left with my right hand until water trickles out. I tilt my head down towards the tap and watch the water flow. I let the glass fill up slowly. My right hand rests on the tap. When the glass is full I turn off the tap by pushing it up and then twisting it to the right. Then I pass the glass from my left to my right hand and carry it to the living unit.

Drinking water

Standing between the table and the chair, I raise the glass to my mouth. My left arm hangs by my side. I tilt my head back. I tip the water into my open mouth and swallow. To control the flow of water into my mouth, I open and close my lips slowly, and open and close them again. The water waves back and forth in the glass every time I swallow. My neck moves every time I swallow. I drink until the glass is empty. Then I put the glass down on the table.

Sitting on the chair

I bend my knees until my bottom rests on the seat of the chair. I hold the front two corners of the chair as I lower myself. Then I put my hands together in my lap. I look out. I get up almost immediately.

Lying on the bed

I lie on the bed with my head resting on the quartz pillow. I flick my hair back so my head touches the pillow directly. Then I link my hands over my belly. My legs lay flat. I look at the inside of my eyelids. The metronome ticks.

I bend my left knee and raise my left foot up the bed. I touch my head with my hands.

Sitting on the bed

I sit up so I am sitting on the bed. I look out.

Walking back and forth

Starting at the end of the bedroom unit, I walk with even steps very slowly across all three rooms. When I reach the end of the bathroom unit I turn around, pause with my back against the wall, and then walk back the other way by putting one foot in front of the other. It takes twenty steps to get from one end to the other. The wooden floor of the units creaks with every step. My spine is curved forward as I walk and I look at the floor in front of me.

I walk back and forth thirty-four times.

Filling the glass

I pick up the glass from the table in the living unit and take it to the sink in the bedroom unit. I sit down on the bed and twist round to face the sink. I hold the glass in my left hand and put it underneath the tap in the sink. I push the tap up and then twist it to the left with my right hand until water trickles out. I tilt my head down towards the tap and watch the water flow. I let the glass fill up slowly. My right hand rests on the tap. When the glass is full I turn off the tap by pushing it up

and then twisting it to the right. Then I pass the glass from my left to my right hand and carry it to the living unit.

Drinking water

Standing in front of the chair, I raise the glass to my mouth. My left arm hangs by my side. I tilt my head back. I tip the water into my open mouth and swallow. To control the flow of water into my mouth, I open and close my lips slowly, and open and close them again. The water waves back and forth in the glass every time I swallow. My neck moves every time I swallow. I drink until the glass is empty. Then I put the glass down on the table.

Walking back and forth

Staring at the end of the bedroom unit, I walk with even steps very slowly across all three rooms. When I reach the end of the bathroom unit I turn around, pause with my back against the wall, and then walk back the other way by putting one foot in front of the other. It takes twenty steps to get from one end to the other. The wooden floor of the units creaks with every step. My spine is curved forward as I walk and I look at the floor in front of me.

Filling the glass

On my way through the living unit I pick up the glass from the table in the living unit and take it to the sink in the bedroom unit. I sit down on the bed and twist round to face the sink. I hold the glass in my left hand and put it underneath the tap in the sink. I push the tap up and then twist it to the left with my right hand until water trickles out. I tilt my head down towards the tap and watch the water flow. I let the glass fill up slowly. My right hand rests on the tap. When the glass is full I turn off the tap by pushing it up and then twisting it to the right. Then I pass the glass from my left to my right hand and carry it to the living unit.

Drinking water

Standing in front of the chair, I raise the glass to my mouth. My left arm hangs by my side. I tilt my head back. I tip the water into my open mouth and swallow. To control the flow of water into my mouth, I open and close my lips slowly, and open and close them again. The water waves back and forth in the glass every time I swallow. My neck moves every time I swallow. I drink until the glass is empty. Then I put the glass down on the table.

Walking back and forth

Staring at the end of the bedroom unit, I walk with even steps very slowly across all three rooms. When I reach the end of the bathroom unit I turn around, pause with my back against the wall, and then walk back the other way by putting one foot in front of the other. It takes twenty steps to get from one end to the other. The wooden floor of the units creaks with every step. My spine is curved forward as I walk and I look at the floor in front of me.

Sitting on the chair

I bend my knees until my bottom rests on the seat of the chair. I hold the front two corners of the chair as I lower myself. Then I put my hands on my thighs, halfway between my knees and my hips. My fingers are splayed out evenly. I look straight ahead.

Standing at the back

I stand at the back of the living unit leaning against the wall. I hold my hands together behind my back. My feet are together. I look at someone in the audience. I look at their eyes.

The metronome ticks.

Filling the glass

I pick up the glass from the table in the living unit and take it to the

sink in the bedroom unit. I sit down on the bed and twist round to face the sink. I hold the glass in my left hand and put it underneath the tap in the sink. I push the tap up and then twist it to the left with my right hand until water trickles out. I tilt my head down towards the tap and watch the water flow. I let the glass fill up slowly. My right hand rests on the tap. When the glass is full I turn off the tap by pushing it up and then twisting it to the right. Then I pass the glass from my left to my right hand and carry it to the living unit.

Drinking water

Standing between the table and the chair, I raise the glass to my mouth. My left arm hangs by my side. I tilt my head back. I tip the water into my open mouth and swallow. To control the flow of water into my mouth, I open and close my lips slowly, and open and close them again. The water waves back and forth in the glass every time I swallow. My neck moves every time I swallow. I drink until the glass is empty. Then I put the glass down on the table.

Standing at the back

I stand at the back of the living unit leaning against the wall. I hold my hands together behind my back. My feet are together. I look at the telescope.

Peeing

I need to pee. I step across the gap to the bathroom unit. When I am in the unit I turn to my right and take the toilet paper from the shelf with my right hand. I take four steps over towards the toilet and turn my body round clockwise. I put the toilet paper down on the corner of the shower tray.

Then I lift the lid of the toilet with my left hand. I push it back until it is resting on the back of the unit. As I turn towards the front I lift up my shirt so I can unfasten my trousers. There are four buttons to unfasten. I tilt my head forward. When I have undone all the buttons I pull my trousers and my slip down to just above my knees and sit on the toilet. I put my feet close together in front of me and cup my hands together in my lap. My two index fingers and thumbs make a triangle shape. The tips of my fingers on my left hand touch the tips of my fingers on my right hand.

I look at the floor. I sit still and wait for the pee to come. It takes a while and there is silence. Then there is the sound of water trickling. I am motionless, except for my eyelids, which slide down over my eyes occasionally, and then slide back up.

When I have finished peeing I take the toilet roll and unroll some paper and tear it off. I fold it up into a bundle and stand up and wipe myself. Then I pull up my slip and my trousers and do up the four buttons. Then I straighten my shirt out.

I lean over and turn on the tap on the wall with my left hand. The water falls into the bucket beneath.

Then I stand and look at the right-hand wall of the gallery and listen to the water fall. When the bucket is half full I turn off the tap and lift the bucket. I pour the water down the toilet to flush it. I place the bucket back where it was, underneath the tap, and pull the handle up so it is in the middle.

I pause and brush my hair back with my fingers, then walk out of the bathroom unit.

Standing at the back

I stand at the back of the living unit leaning against the wall. I hold my hands together behind my back. My feet are together. I look at the eyes of someone in the audience.

Filling the glass

I pick up the glass from the table in the living unit and take it to the

sink in the bedroom unit. I sit down on the bed and twist round to face the sink. I hold the glass in my left hand and put it underneath the tap in the sink. I push the tap up and then twist it to the left with my right hand until water trickles out. I tilt my head down towards the tap and watch the water flow. I let the glass fill up slowly. My right hand rests on the tap. When the glass is full I turn off the tap by pushing it up and then twisting it to the right. Then I pass the glass from my left to my right hand and carry it to the living unit.

Drinking water

Standing between the table and the chair, I raise the glass to my mouth. My left arm hangs by my side. I tilt my head back. I tip the water into my open mouth and swallow. To control the flow of water into my mouth, I open and close my lips slowly, and open and close them again. The water waves back and forth in the glass every time I swallow. My neck moves every time I swallow. I drink until the glass is empty. Then I go to put the glass down on the table, hesitate and then put it down.

The metronome has stopped ticking.

Winding up the metronome

I pick up the metronome from the table with my right hand and then pass it to my left. I twist the knob clockwise round and round. I do this very slowly. My body is still and only my wrist moves. I put the metronome back down on the table and push the ticker. It ticks.

Standing at the front

I stand at the front of the living unit over the knife ladder. My hands are by my sides. My fingers are relaxed and curved. I look at someone in the audience. I am breathing. I turn my hands around halfway so my thumbs face the front. I wobble a little. I tense up my fingers and they lift a little.

Showering

I pick up the bath mat from inside the shower tray and unroll it on the floor in front of the shower. Then I sit on the toilet seat. I look at the shelf and stand up and walk over to it. I take the towel from the shelf and drape it over the toilet seat. I sit on the edge of the toilet and put my hairband around my left wrist. Then I lean over and untie the laces of my right boot with my left hand. When the laces are loose enough, I take off the boot and then pull off the sock by grabbing the toe. I put the sock on the boot. Then I untie the laces of my left boot with both hands. When the laces are loose enough I take off the boot and then pull off the sock by grabbing the toe. I put the sock on the boot.

Then I undo the buttons on my trousers and stand up so I can pull them down. When I have sat down again, I finish pulling them off, starting with the right leg and finishing with the left leg. Then I fold them in half and then half again and then half again and put them on the floor next to the boots. This I do very slowly.

Then I brush the hair from my face and undo the buttons on my collars and the buttons of my shirt, starting at the bottom and working my way up. There are seven buttons to undo. Then I take off my shirt and lay it across my legs. Then I take off my undershirt and fold it up neatly. Then I take off my slip. I put all my clothes on the left-hand side of the unit next to the wall. Then I tie my hair back with the hairband.

I stand on the left of the shower, outside the tray, and turn on the taps. I test the temperature of the water by holding out my left hand under the trickle. I wait for as long as it takes for the water to warm up. I step into the shower.

I stand with my hands by my sides and the palms facing out. I close my eyes and open my mouth wide and the water flows in. I rock my head from side to side.

When I have finished showering I turn round and twist the taps off with my right hand.

I lean over to pick up the towel. I press the towel hard against my face for a long time. Then I rub the towel over my arms, then my torso, then my legs. I do not dry myself very thoroughly. Then I lay the towel over the toilet seat and sit down on it.

I take my hairband off and put it on the edge of the shower tray.

Then I put my slip back on. Then I put my undershirt back on by putting my head through the head hole and my arms through the arm-holes. I do the same with my shirt and do up the buttons on my cuffs. I do up the buttons starting at my neck and working my way downward. Then I put my trousers on. I straighten out all of my clothes. I stand up, take the towel, sit down and dry my feet. Then I put my right sock on followed by my right boot. I tie the laces. Then I put my left sock on followed by my left boot. I tie the laces. I stand up.

I fold up the towel and put it back on the shelf. Then I fold up the bath mat and put it in the shower tray. Then I put the hairband back on the shelf.

Before I step into the living unit, I stand in front of the shelves and run my fingers through my hair.

Standing at the front

I stand at the front of the living unit over the knife ladder. My hands are by my sides. I look into the eyes of someone in the audience. I am breathing. I turn my hands around halfway so my thumbs face the front. I wobble a little. I tense up my fingers and they lift a little. My fingers are together and they flare out even further. I continue staring. Then I look at someone else. I take a deep breath and walk away.

Filling the glass

I pick up the glass from the table in the living unit and take it to the sink in the bedroom unit. I sit down on the bed and twist round to face the sink. I hold the glass in my left hand and put it underneath the tap in the sink. I push the tap up and then twist it to the left with my right hand until water trickles out. I tilt my head down towards the tap and watch the water flow. I let the glass fill up slowly. My right hand rests on the tap. When the glass is full I turn off the tap by pushing it up and then twisting it to the right. Then I pass the glass from my left to my right hand and carry it to the living unit.

Drinking water

Standing between the table and the chair, I raise the glass to my mouth. My left arm hangs by my side. I tilt my head back. I tip the water into my open mouth and swallow. To control the flow of water into my mouth, I open and close my lips slowly, and open and close them again. The water waves back and forth in the glass every time I swallow. My neck moves every time I swallow. I drink until the glass is empty. Then I put the glass down on the table.

Wiping my nose

I unroll some paper from the toilet roll from the shelf in the bathroom unit. I tear it off. Then I fold it up and wipe my nose with it. I put it in my pocket and walk out.

Sitting on the chair

I bend my knees until my bottom rests on the seat of the chair. I hold the front two corners of the chair as I lower myself. Then I put my hands on my thighs, halfway between my knees and my hips. My fingers are splayed out evenly. I look straight ahead.

Standing at the back

I stand at the back of the living unit leaning against the wall. I straighten out my shirt and then I hold my hands together behind my back. My

feet are together. I look at someone in the audience. Then I look away.

Standing at the front

I stand at the front of the living unit over the knife ladder. My hands are by my sides. My fingers are relaxed and curved. I look at a person. I am breathing. I turn my hands around halfway so my thumbs face the front. I wobble a little. I tense up my fingers and they lift a little. I stand up straighter.

Sitting on the bed

I sit on the bed. I look out. My hands grip the edge of the bed. My feet are together and they are on the floor.

Lying on the bed

In one fluid movement I raise up my feet, move my hands back to balance myself and twist round ninety degrees, lower my body down until it is flat, and rest my head on the quartz pillow. Then I flick my hair back over the pillow so my head is touching the pillow directly. I lie straight on my back with my legs flat. My hands are linked together over my belly.

Then I I bend my left knee and lift up my left foot.

Sitting on the bed

I sit up so I am sitting on the bed. I look out. My hands grip the edge of the bed. My feet are together and they are on the floor.

Showering

I take the towel from the shelf and drape it over the toilet seat. Then I pick up the bath mat from inside the shower tray and unroll it on the floor in front of the shower. Then I sit on the toilet seat. I put my hairband around my left wrist. Then I lean over and untie the laces of my right boot with my left hand. When the laces are loose enough, I take off the boot and then pull off the sock by grabbing the toe. I put the sock on the boot. Then I untie the laces of my left boot with both hands. When the laces are loose enough I take off the boot and then pull off the sock by grabbing the toe. I put the sock on the boot.

Then I undo the buttons on my trousers and stand up so I can pull them down. When I have sat down again, I finish pulling them off, starting with the right leg and finishing with the left leg. Then I fold them in half and then half again and then half again and put them on the floor next to the boots. This I do very slowly.

Then I brush the hair from my face and undo the buttons on my collars and the buttons of my shirt, starting at the bottom and working my way up. There are seven buttons to undo. Then I take off my shirt and lay it across my legs. Then I take off my undershirt and fold it up neatly. Then I take off my slip. I put all my clothes on the left-hand side of the unit next to the wall. Then I tie my hair back with the hairband.

I stand on the left of the shower, outside the tray, and turn on the taps. I test the temperature of the water by holding out my left hand under the trickle. I wait for as long as it takes for the water to warm up. I step into the shower.

I close my eyes. Then I reach behind me and adjust the temperature.

I stand with my hands by my sides and the palms facing out. I open my mouth wide and the water flows in and dribbles out.

I reach behind me and adjust the temperature again.

When I have finished showering I turn round and twist the taps off with my right hand.

I lean over to pick up the towel. I press the towel hard against my face for a long time. Then I rub the towel over my arms, then my torso, then my legs. I do not dry myself very thoroughly. Then I lay the towel over the toilet seat and sit down on it.

I take my hairband off and put it on the edge of the shower tray.

Then I put my slip back on. Then I put my undershirt back on by putting my head through the head hole and my arms through the arm-holes. I do the same with my shirt and do up the buttons on my cuffs. I do up the buttons starting at my neck and working my way down. Then I put my trousers on. I straighten out all of my clothes. I stand up, take the towel, sit down and dry my feet. Then I put my right sock on followed by my right boot. I tie the laces. Then I put my left sock on followed by my left boot. I tie the laces. I stand up.

I fold up the towel and put it back on the shelf. Then I fold up the bath mat and put it in the shower tray. Then I put the hairband back on the shelf.

Before I step into the living unit, I stand in front of the shelves and run my fingers through my hair.

The metronome has stopped ticking.

Winding up the metronome

I pick up the metronome from the table with my right hand and then pass it to my left. I twist the knob clockwise round and round. I do this very slowly. My body is still and only my wrist moves. I put the metronome back down on the table and push the ticker. It ticks.

Standing at the front

I stand at the front of the living unit over the knife ladder. My hands are by my sides. I look at a person. I am breathing. I tense up my fingers and they lift a little. My fingers are together but they flare out from my sides. I step back from the edge.

Filling the glass

I pick up the glass from the table in the living unit and take it to the sink in the bedroom unit. I sit down on the bed and twist round to face the sink. I hold the glass in my left hand and put it underneath the tap in the sink. I push the tap up and then twist it to the left with my right hand until water trickles out. I tilt my head down towards the tap and watch the water flow. I let the glass fill up slowly. My right hand rests on the tap. When the glass is full I turn off the tap by pushing it up and then twisting it to the right. Then I pass the glass from my left to my right hand and carry it to the living unit.

Drinking water

Standing between the table and the chair, I raise the glass to my mouth. My left arm hangs by my side. I tilt my head back. I tip the water into my open mouth and swallow. To control the flow of water into my mouth, I open and close my lips slowly, and open and close them again. The water waves back and forth in the glass every time I swallow. My neck moves every time I swallow. I drink until the glass is empty. Then I put the glass down on the table.

Standing at the back

I stand at the back of the living unit leaning against the wall. I hold my hands together behind my back. My feet are together. I look at the telescope. Then I look at someone to my left.

I stand up straight so I am no longer leaning against the wall.

Filling the glass

I pick up the glass from the table in the living unit and take it to the sink in the bedroom unit. I sit down on the bed and twist round to face the sink. I hold the glass in my left hand and put it underneath the tap in the sink. I push the tap up and then twist it to the left with my right hand until water trickles out. I tilt my head down towards the tap and watch the water flow. I let the glass fill up slowly. My right hand rests on the tap. When the glass is full I turn off the tap by pushing it up and then twisting it to the right. Then I pass the glass from my left to

my right hand and carry it to the living unit.

Drinking water

Standing between the table and the chair, I raise the glass to my mouth. My left arm hangs by my side. I tilt my head back. I tip the water into my open mouth and swallow. To control the flow of water into my mouth, I open and close my lips slowly, and open and close them again. The water waves back and forth in the glass every time I swallow. My neck moves every time I swallow. I drink until the glass is empty. Then I put the glass down on the table.

Wiping my nose

I unroll some paper from the toilet roll from the shelf in the bathroom unit. I tear it off. Then I fold it up and wipe my nose with it. I walk over to the toilet, lift the lid and throw the paper down.

The metronome has stopped ticking.

Winding up the metronome

I pick up the metronome from the table with my right hand and then pass it to my left. I twist the knob clockwise round and round. I do this very slowly. My body is still and only my wrist moves. When the winder will not wind round any more I stop winding and adjust the weight on the ticker. I put the metronome back down on the table and push the ticker. It ticks.

Sitting on the chair

I bend my knees until my bottom rests on the seat of the chair. I hold the front two corners of the chair as I lower myself. Then I put my hands on my thighs, halfway between my knees and my hips. My fingers are splayed out and point towards the gap between my thighs. I look straight ahead.

Then I look to my left, meet someone's eyes and stand up.

Standing at the front

I step to the front of the living unit over the knife ladder. My hands are by my sides. My fingers are relaxed and curved. I look at the same person. I am breathing. I turn my hands around halfway so my thumbs face the front. I wobble a little. I tense up my fingers and they lift a little.

I keep staring.

Then I stop.

Showering

I pick up the bath mat from inside the shower tray and unroll it on the floor in front of the shower. Then I take the towel from the shelf and drape it over the toilet seat. I sit on the toilet seat. I put my hairband around my left wrist. Then I lean over and untie the laces of my right boot with my left hand. When the laces are loose enough, I take off the boot and then pull off the sock by grabbing the toe. I put the sock on the boot. Then I untie the laces of my left boot with both hands. When the laces are loose enough I take off the boot and then pull off the sock by grabbing the toe. I put the sock on the boot.

Then I undo the buttons on my trousers and stand up so I can pull them down. When I have sat down again, I finish pulling them off, starting with the right leg and finishing with the left leg. Then I fold them in half and then half again and then half again and put them on the floor next to the boots. This I do very slowly.

Then I brush the hair from my face and undo the buttons on my collars and the buttons of my shirt, starting at the bottom and working my way up. I have to undo seven buttons. When they are undone I take off my shirt and lay it across my legs. Then I take off my undershirt and fold it up. Then I take off my slip. I put all my clothes on the left-hand side of the unit next to the wall. Then I tie my hair back

with the hairband.

I stand on the left of the shower, outside the tray, and turn on the taps. I test the temperature of the water by holding out my left hand under the trickle. I wait for as long as it takes for the water to warm up. I step into the shower.

I close my eyes.
I stand with my hands by my sides and the palms facing out. I open my mouth wide and the water flows in and dribbles out.

Then I reach behind me and adjust the temperature.

I reach behind me and adjust the temperature again.

I open my mouth wider.

When I have finished showering I turn round and twist the taps off with my right hand.

I lean over to pick up the towel. I press the towel hard against my face for a long time. Then I rub the towel over my arms, then my torso, then my legs. I do not dry myself very thoroughly. Then I lay the towel over the toilet seat and sit down on it.

I take my hairband off and put it on the edge of the shower tray.

Then I put my slip back on. Then I put my undershirt back on by putting my head through the head hole and my arms through the armholes. I do the same with my shirt and do up the buttons on my cuffs. I do up the buttons starting at my neck and working my way down. Then I put my trousers on. I straighten out all of my clothes. Then I put my right sock on followed by my right boot. I tie the laces. Then I put my left sock on followed by my left boot. I tie the laces. I stand up.

I fold up the towel and put it back on the shelf. Then I roll up the bath mat and put it in the shower tray. Then I put the hairband back on the shelf.

Before I step into the living unit, I stand in front of the shelves and run my fingers through my hair.

Standing at the back

I stand at the back of the living unit leaning against the wall. I hold my hands together behind my back. My feet are together. I look at someone in the audience.

Filling the glass

I pick up the glass from the table in the living unit and take it to the sink in the bedroom unit. I sit down on the bed and twist round to face the sink. I hold the glass in my left hand and put it underneath the tap in the sink. I push the tap up and then twist it to the left with my right hand until water trickles out. I tilt my head down towards the tap and watch the water flow. I let the glass fill up slowly. My right hand rests on the tap. When the glass is full I turn off the tap by pushing it up and then twisting it to the right. Then I pass the glass from my left to my right hand.

Drinking water

Standing in front of the bed, I raise the glass to my mouth. My left arm hangs by my side. I tilt my head back. I tip the water into my open mouth and swallow. To control the flow of water into my mouth, I open and close my lips slowly, and open and close them again. The water waves back and forth in the glass every time I swallow. My neck moves every time I swallow. I drink until the glass is empty. Then I carry the glass to the living unit and put it down on the table.

Sitting on the chair

I bend my knees until my bottom rests on the seat of the chair. I hold the front two corners of the chair as I lower myself. Then I put my hands on my thighs, halfway between my knees and my hips. My fin-

gers are splayed out and point towards the gap between my thighs. I look straight ahead.

Standing at the front

I stand at the front of the living unit over the knife ladder. My hands are by my sides. My fingers are curved. I look at someone's eyes and raise my fingers out from my sides even more.

Sitting on the chair

I bend my knees until my bottom rests on the seat of the chair. I hold the front two corners of the chair as I lower myself. Then I put my hands on my thighs, halfway between my knees and my hips. My fingers are splayed out evenly and point towards each other. I look at someone in the gallery.

Filling the glass

I pick up the glass from the table in the living unit and take it to the sink in the bedroom unit. I sit down on the bed and twist round to face the sink. I hold the glass in my left hand and put it underneath the tap in the sink. I push the tap up and then twist it to the left with my right hand until water trickles out. I tilt my head down towards the tap and watch the water flow. I let the glass fill up slowly. My right hand rests on the tap. When the glass is full I turn off the tap by pushing it up and then twisting it to the right. Then I pass the glass from my left to my right hand and carry it to the living unit.

Drinking water

Standing between the table and the chair, I raise the glass to my mouth. My left arm hangs by my side. I tilt my head back. I tip the water into my open mouth and swallow. To control the flow of water into my mouth, I open and close my lips slowly, and open and close them again. The water waves back and forth in the glass every time I swallow. My neck moves every time I swallow. I drink until the glass is empty. Then I put the glass down on the table.

Standing between the units

I stand with one foot in the bathroom unit and the other in the living unit. My body is over the gap. My legs make a triangle shape. Holding my arms at chest height, I rest my hands on the back of the wooden frames. I look down at someone in the audience. I look into their eyes. I am motionless.

Standing at the back

I stand at the back of the living unit leaning against the wall. I hold my hands together behind my back. My feet are together. I look at someone in the audience.

Filling the glass

I pick up the glass from the table in the living unit and take it to the sink in the bedroom unit. I sit down on the bed and twist round to face the sink. I hold the glass in my left hand and put it underneath the tap in the sink. I push the tap up and then twist it to the left with my right hand until water trickles out. I tilt my head down towards the tap and watch the water flow. I let the glass fill up slowly. My right hand rests on the tap. When the glass is full I turn off the tap by pushing it up and then twisting it to the right. Then I pass the glass from my left to my right hand and carry it to the living unit.

Drinking water

Standing between the table and the chair, I raise the glass to my mouth. My left arm hangs by my side. I tip the water into my open mouth and swallow. To control the flow of water into my mouth, I open and close my lips slowly, and open and close them again. My neck moves every time I swallow and I tilt my head back as the glass empties. I drink until the glass is empty. Then I put the glass down on the table.

Sitting on the chair

I sit down on the chair but stand up immediately.

Peeing

I need to pee. I step across the gap to the bathroom unit. When I am in the unit I turn to my right and take the toilet paper from the shelf with my right hand. I take four steps over towards the toilet and turn my body round clockwise. I put the toilet paper down on the corner of the shower tray.

Then I lift the lid of the toilet with my left hand. I push it back until it is resting on the back of the unit. As I turn towards the front I lift up my shirt so I can unfasten my trousers. There are four buttons to unfasten. I tilt my head forward. When I have undone all the buttons I pull my trousers and my slip down to just above my knees and sit on the toilet. I put my feet close together in front of me and cup my hands together in my lap. My two index fingers and thumbs make a triangle shape. The tips of my fingers on my left hand touch the tips of my fingers on my right hand.

I look at the floor. I sit still and wait for the pee to come. It takes a while and there is silence. Then there is the sound of water trickling. I am motionless.

When I have finished peeing I take the toilet roll and unroll some paper and tear it off. I fold it up into a bundle and stand up and wipe myself. Then I pull up my slip and my trousers and do up the four buttons. Then I straighten my shirt out.

I lean over and touch the bucket and then turn on the tap on the wall with my left hand. The water falls into the bucket beneath.

Then I stand and look at the right-hand wall of the gallery and listen to the water fall. When the bucket is half full I turn off the tap and lift the bucket. I pour the water down the toilet to flush it. I place the bucket back where it was, underneath the tap, and pull the handle up so it is in the middle.

I pause and brush my hair back with my fingers, then walk out of the bathroom unit.

Standing at the front

I stand at the front of the living unit over the knife ladder. My hands are by my sides. My fingers are relaxed and curved. I look at someone and raise my finger out from my sides even more. I wobble as I stare.

The metronome stops ticking.

Winding up the metronome

I pick up the metronome from the table with my right hand and then pass it to my left. I twist the knob clockwise round and round. I do this very slowly. My body is still and only my wrist moves. When the knob will not wind round any more I stop winding. Then I adjust the weight on the ticker. I put the metronome back down on the table and push the ticker. It ticks.

Sitting on the chair

I bend my knees until my bottom rests on the seat of the chair. I hold the front two corners of the chair as I lower myself. Then I put my hands on my thighs, halfway between my knees and my hips. My fingers are splayed out evenly and point towards each other. I look at someone in the gallery. I look into their eyes.

Showering

I pick up the bath mat from inside the shower tray and unroll it on the floor in front of the shower. Then I take the towel from the shelf and drape it over the toilet seat. Then I get up again and take the hairband from the shelf. I sit on the edge of the toilet and put my hairband around my left wrist. Then I lean over and untie the laces of my right

boot with my left hand. When the laces are loose enough, I take off the boot and then pull off the sock by grabbing the toe. I put the sock on the boot. Then I untie the laces of my left boot with both hands. When the laces are loose enough I take off the boot and then pull off the sock by grabbing the toe. I put the sock on the boot.

Then I undo the buttons on my trousers and stand up so I can pull them down. When I have sat down again, I finish pulling them off, starting with the right leg and finishing with the left leg. Then I fold them in half and then half again and then half again and put them on the floor next to the boots. This I do very slowly.

Then I brush the hair from my face and undo the buttons on my collars and the buttons of my shirt, starting at the bottom and working my way up. There are seven buttons to undo. Then I take off my shirt and lay it across my legs. Then I take off my undershirt and fold it up neatly. I pick a hair off it. Then I take off my slip. I put all my clothes on the left-hand side of the unit next to the wall. Then I tie my hair back with the hairband.

I stand on the left of the shower, outside the tray, and turn on the taps. I test the temperature of the water by holding out my left hand under the trickle. I wait for as long as it takes for the water to warm up. I turn the tap a little to adjust the temperature and then I step into the shower.

I stand with my hands by my sides and the palms facing out. I close my eyes and open my mouth wide and the water flows in.

I reach behind me with my left hand to adjust the temperature.

I again reach behind me with my left hand to adjust the temperature.

I again reach behind me with my left hand to adjust the temperature.

When I have finished showering I turn round and twist the taps off with my right hand.

I lean over to pick up the towel. I press the towel hard against my face for a long time. Then I rub the towel over my arms, then my torso, then my legs. I do not dry myself very thoroughly. Then I lay the towel over the toilet seat and sit down on it.

I take my hairband off and put it on the edge of the shower tray.

Then I put my slip back on. Then I put my undershirt back on by putting my head through the head hole and my arms through the armholes. I do the same with my shirt and do up the buttons on my cuffs. I do up the buttons starting at my neck and working my way downward. Then I put my trousers on. I straighten out all of my clothes. I stand up, take the towel, sit down and dry my feet. Then I put my right sock on followed by my right boot. I tie the laces. Then I put my left sock on followed by my left boot. I tie the laces. I stand up.

I fold up the towel and put it back on the shelf. Then I fold up the bath mat and put it in the shower tray. Then I put the hairband back on the shelf.

Before I step into the living unit, I stand in front of the shelves and run my fingers through my hair.

Standing at the front

I stand at the front of the living unit over the knife ladder. My hands are by my sides. I wobble. I look down directly in front of me into someone's eyes.

Sitting on the chair

I bend my knees until my bottom rests on the seat of the chair. I hold the front two corners of the chair as I lower myself. Then I put my hands on my thighs, halfway between my knees and my hips. My fingers are splayed out evenly. I look at someone. I keep looking. I blink.

My eyes close.

My head droops forward.

The metronome stops ticking.

I remain motionless.

Then I sit back.

Then I sit up.

Winding up the metronome

I pick up the metronome from the table with my right hand and then pass it to my left. I twist the knob clockwise round and round. I do this very slowly. My body is still and only my wrist moves. I wind the knob until it won't go around anymore. Then I put the metronome back down on the table and push the ticker. It ticks.

Showering

I pick up the bath mat from inside the shower tray and unroll it on the floor in front of the shower. Then I take the towel from the shelf and drape it over the toilet seat. Then I take the hairband from the shelf. I sit on the toilet seat. I put my hairband on the floor. Then I lean over and untie the laces of my right boot with my left hand. When the laces are loose enough, I take off the boot and then pull off the sock by grabbing the toe. I put the sock on the boot. Then I untie the laces of my left boot with both hands. When the laces are loose enough I take off the boot and then pull off the sock by grabbing the toe. I put the sock on the boot.

Then I undo the buttons on my trousers and stand up so I can pull them down. When I have sat down again, I finish pulling them off, starting with the right leg and finishing with the left leg. Then I fold them in half and then half again and then half again and put them on the floor next to the boots. This I do very slowly.

Then I brush the hair from my face and undo the buttons on my collar and the buttons of my shirt, starting at the bottom and working my way up. I have to undo seven buttons. When they are undone I take off my shirt and lay it across my legs. Then I take off my undershirt and fold it up. Then I take off my slip. I put all my clothes on the left-hand side of the unit next to the wall. Then I tie my hair back with the hairband.

I stand on the left of the shower, outside the tray, and turn on the taps. I test the temperature of the water by holding out my left hand under the trickle. I wait for as long as it takes for the water to warm up. I step into the shower.

I step to the left away from the water and turn the tap to adjust the temperature.

I close my eyes.

I stand with my hands by my sides and the palms facing out. I open my mouth wide and the water flows in and dribbles out.

I open my mouth wider.

When I have finished showering I turn round and twist the taps off with my right hand.

I lean over to pick up the towel. I press the towel hard against my face for a long time. Then I rub the towel over my arms, then my torso, then my legs. I do not dry myself very thoroughly. Then I lay the towel over the toilet seat and sit down on it.

I take my hairband off and put it on the edge of the shower tray.

Then I put my slip back on. Then I put my undershirt back on by putting my head through the head hole and my arms through the armholes. I do the same with my shirt and do up the buttons on my cuffs. I do up the buttons starting at my neck and working my way down. Then I put my trousers on. I straighten out all of my clothes.

Then I put my right sock on followed by my right boot. I tie the laces. Then I put my left sock on followed by my left boot. I tie the laces. I stand up.

I fold up the towel and put it back on the shelf. Then I roll up the bath mat and put it in the shower tray. Then I put the hairband back on the shelf.

Before I step into the living unit, I stand in front of the shelves and run my fingers through my hair.

D a y 6

Wednesday, November 20th: Day 6

Wearing green

Sitting naked on the bed

The metronome is not ticking. There is no one in the gallery yet. There is silence.

I sit naked on the bed. I stare at the ground. I am sitting on my towel. My feet are on the bath mat, which is on the floor. My hands are resting flat on the bed, perpendicular to my wrists and pointing outwards. On the towel are laid out two bottles with the lids off.

I lean forward and touch my toes. I am bent double. My hair hangs down and my face touches my legs.

Getting the comb

I stand up and walk to the bathroom unit and take the comb from the self and carry it back to the bedroom unit.

Sitting naked on the bed and combing my hair

I sit naked on the bed and comb my hair. Then I put the comb down and shake my hair and ruffle my hair with my fingers. Then I comb my hair again.

I put the comb down on the bed and lean forward and hold my toes.

Then I sit up and comb my hair again. I hold the comb with my right hand and hold locks of my hair with my left hand.

Putting on lotion

I pick up one of the bottles on the bed, empty some of the fluid into my cupped hands and rub it over my face. Then I rub it over my body. I pour out some more lotion and rub it over my legs, right down to my toes.

Then I tie my hair back with the hairband.

I take the other bottle and pour some fluid into my cupped hands. I rub my hands over my face and my arms. Then I pour out some more and rub it under my arms, on my back, and across my belly. I pour some fluid directly onto my thighs and then rub it in. Then I pour out some more and rub it into my shins.

Getting dressed

My clothes are folded up next to me on the bed. I pick up my slip and put it on, followed by my two undershirts. Then I have to unfold and unbutton my shirt of the day. I undo all the buttons and then I put my left arm through the left armhole first, then my right arm through the right armhole second. I do the buttons up again, starting at the top. Then I take my pajama bottoms, unfold them, stand up and put my right leg in the right leg hole and my left leg in the left leg hole. I pull up the pajama bottoms to my waist and fasten the button.

Then I take my right sock and put it on, followed by my right boot.

Then I take my left sock and put it on, followed by my left boot.

I stand up and fold up the towel I was sitting on and roll up the bath mat my feet were resting on.

Then I gather the bundle of folded towel and bath mat and walk to the bathroom unit and put them back on the shelf.

Winding up the metronome

In the night I turned the table upside down. Now the glass is on the end of the upturned table leg and the metronome is on the floor. I pick up the metronome from the floor with my right hand and then pass it to my left. I twist the knob clockwise round and round. I do this very slowly. My body is still and only my wrist moves. I put the metronome back down on the floor in front of the chair and push the ticker. It ticks.

Filling the glass

I pick up the glass from the end of the table leg and take it to the sink in the bedroom unit. I sit down on the bed and twist round to face the sink. I hold the glass in my left hand and put it underneath the tap in the sink. I push the tap up and then twist it to the left with my right hand until water trickles out. I tilt my head down towards the tap and watch the water flow. I let the glass fill up slowly. My right hand rests on the tap. When the glass is full I turn off the tap by pushing it up and then twisting it to the right. Then I pass the glass from my left to my right hand and carry it to the living unit.

Drinking water

Standing between the table and the chair, I raise the glass to my mouth. My left arm hangs by my side. I tip the water into my open mouth and swallow. To control the flow of water into my mouth, I open and close my lips slowly, and open and close them again. My neck moves every time I swallow and I tilt my head back as the glass empties. I drink very slowly until the glass is empty. Then I put the glass down on the end of the table leg.

Sitting on the chair

I bend my knees until my bottom rests on the seat of the chair. I hold the front two corners of the chair as I lower myself. Then I put my hands on my thighs, halfway between my knees and my hips. My fingers are splayed out evenly. I look at someone off to my left. I keep looking. I blink.

The metronome stops ticking.

I keep looking.

I turn my hands over on my thighs so my palms face up.

I keep looking at the same person.

Then I look down.

Starting the metronome

I lean forward in the chair and prod the ticker on the metronome. It ticks six times then stops. So I pick it up and adjust the weight on the ticker. Then I put the metronome down on the underside of the table-top. I push the ticker to set it in motion. It ticks.

Walking back and forth

I walk with even steps very slowly across all three rooms. When I reach the end of the bathroom unit I turn around, pause with my back against the wall, and then walk back the other way by putting one foot in front of the other. It takes twenty steps to get from one end to the other. The wooden floor of the units creaks with every step. My spine is curved forward as I walk and I look at the floor in front of me. I try to walk in time with the ticks of the metronome.

I stop in the bathroom unit and stare at someone. I wobble a little. The bottom of my shirt moves every time I breathe. I turn my hands round so my thumbs face the front.

Then I turn away and lean against the wall.

Then I walk away.

Sitting on the chair

I bend my knees until my bottom rests on the seat of the chair. I hold the front two corners of the chair as I lower myself. Then I put my hands on my thighs, halfway between my knees and my hips. My fingers are splayed out evenly and point towards each other. I look straight ahead.

Walking back and forth

I walk with even steps very slowly across all three rooms. When I reach the end of the bathroom unit I turn around, pause with my back against the wall, and then walk back the other way by putting one foot in front of the other. It takes twenty steps to get from one end to the other. The wooden floor of the units creaks with every step. My spine is curved forward as I walk and I look at the floor in front of me. I try to walk in time with the ticks of the metronome. Someone walks into the gallery with very loud shoes clicking on the floor and they are talking. Then there is silence again, except for the ticking metronome.

I walk back and forth eight times.

I stop in the bathroom unit again to stare at someone. I lean against the side wall, facing the front, as I stare. I blink.

Then I stand up straight and move my feet wider apart and turn my hands round so my thumbs face the front. I keep looking.

I turn away and lean my back on the wall and rub my neck. Then I walk away.

Filling the glass

I pick up the glass from the end of the table leg and take it to the sink in the bedroom unit. I sit down on the bed and twist round to face the sink. I hold the glass in my left hand and put it underneath the tap in the sink. I push the tap up and then twist it to the left with my right hand until water trickles out. I tilt my head down towards the tap and watch the water flow. I let the glass fill up slowly. My right hand rests on the tap. When the glass is full I turn off the tap by pushing it up and then twisting it to the right. Then I pass the glass from my left to my right hand and carry it to the living unit.

Drinking water

Standing between the table and the chair, I raise the glass to my mouth. My left arm hangs by my side. I tip the water into my open mouth and swallow. To control the flow of water into my mouth, I open and close my lips slowly, and open and close them again. My neck moves every time I swallow and I tilt my head back as the glass empties. I drink very slowly until the glass is empty. Then I put the glass down on the end of the table leg.

Sitting on the bed

I sit on the bed with my feet on the floor and my hands gripping the edge of the bed. I look straight ahead at someone. Then I stand up.

Standing at the front

I stand at the front of the bedroom unit over the knife ladder. My hands are by my sides. My fingers relax and curve. I keep looking at the same person. I am breathing. I turn my hands around halfway so my thumbs face the front. I wobble a little.

Sitting on the chair

I bend my knees until my bottom rests on the seat of the chair. I hold the front two corners of the chair as I lower myself. Then I put my

hands on my thighs, halfway between my knees and my hips. My fingers are splayed out evenly and point towards each other. I look at the telescope.

Standing at the front

I step forward to the edge of the platform in front of the chair. My feet are just wider than hip-width apart. I point my feet outwards slightly and stand still. I let my arms hang down straight by my sides. My fingers curve towards my thighs and there is a gap between them and my thumbs. I stand straight and still and keep looking at the audience.

Walking back and forth

I walk with even steps very slowly across all three rooms. When I reach the end of the bathroom unit I turn around, pause with my back against the wall, and then walk back the other way by putting one foot in front of the other. It takes twenty steps to get from one end to the other. The wooden floor of the units creaks with every step. My spine is curved forward as I walk and I look at the floor in front of me. I try to walk in time with the ticks of the metronome.

I walk back and forth five times.

Sitting on the bed

I sit on the bed with my feet on the floor and my hands in my lap. I look out.

Lying on the bed

In one fluid movement I raise up my feet, move my hands back to balance myself and twist round ninety degrees, lower my body down until it is flat, and rest my head on the quartz pillow. Then I flick my hair back over the pillow so my head is touching the pillow directly. I lie straight on my back with my legs flat. My hands are linked together over my belly.

Sitting on the bed

Then I sit up so I am sitting on the bed, looking, with my hands flat on the bed.

Standing at the front

Then I stand up and step to the edge of the bedroom unit. I stand over the knife ladder and stare at someone. My hands are by my sides. My fingers relax and curve. I keep looking at the same person. I am breathing. I turn my hands around halfway so my thumbs face the front. I wobble a little. I tense up my fingers and they lift a little.

Filling the glass

I pick up the glass from the end of the table leg and take it to the sink in the bedroom unit. I sit down on the bed and twist round to face the sink. I hold the glass in my left hand and put it underneath the tap in the sink. I push the tap up and then twist it to the left with my right hand until water trickles out. I tilt my head down towards the tap and watch the water flow. I let the glass fill up slowly. My right hand rests on the tap. When the glass is full I turn off the tap by pushing it up and then twisting it to the right. Then I pass the glass from my left to my right hand and carry it to the living unit.

Drinking water

Standing between the upside-down table and the chair, I raise the glass to my mouth. My left arm hangs by my side. I tip the water into my open mouth and swallow. To control the flow of water into my mouth, I open and close my lips slowly, and open and close them again. My neck moves every time I swallow and I tilt my head back as the glass empties. I drink very slowly until the glass is empty. Then I put the glass down on the end of the table leg.

Peeing

I need to pee. I step across the gap to the bathroom unit. When I am in the unit I turn to my right and take the toilet paper from the shelf with my right hand. I take four steps over towards the toilet and turn my body round clockwise. I put the toilet paper down on the corner of the shower tray.

Then I lift the lid of the toilet with my left hand. I push it back until it is resting on the back of the unit. As I turn towards the front I lift up my shirt so I can unfasten my trousers. There are four buttons to unfasten. I tilt my head forward. When I have undone all the buttons I pull my trousers and my slip down to just above my knees and sit on the toilet. I put my feet close together in front of me and cup my hands together in my lap. My two index fingers and thumbs make a triangle shape. The tips of the fingers on my left hand touch the tips of the fingers on my right hand.

I look at the floor. I sit still and wait for the pee to come. It takes a while and there is silence. Then there is the sound of water trickling. I am motionless.

When I have finished peeing I take the toilet roll and unroll some paper and tear it off. I fold it up into a bundle and stand up and wipe myself. Then I pull up my slip and my trousers and do up the four buttons. Then I straighten my shirt out.

I lean over and touch the bucket and then turn on the tap on the wall with my left hand. The water falls into the bucket beneath.

Then I stand and look at the right-hand wall of the gallery and listen to the water fall. When the bucket is half full I turn off the tap and lift the bucket. I pour the water down the toilet to flush it. I place the bucket back where it was, underneath the tap, and pull the handle up so it is in the middle.

I pause and brush my hair back with my fingers, then walk out of the bathroom unit.

Sitting on the chair

I bend my knees until my bottom rests on the seat of the chair. I hold the front two corners of the chair as I lower myself. Then I put my hands together in my lap. I look at the telescope.

Standing at the front

I stand at the front of the bedroom unit over the knife ladder. My hands are by my sides. My fingers relax and curve. I keep looking at the same person. I am breathing. I turn my hands around halfway so my thumbs face the front.

Filling the glass

I pick up the glass from the end of the table leg and take it to the sink in the bedroom unit. I sit down on the bed and twist round to face the sink. I hold the glass in my left hand and put it underneath the tap in the sink. I push the tap up and then twist it to the left with my right hand until water trickles out. I tilt my head down towards the tap and watch the water flow. I let the glass fill up slowly. My right hand rests on the tap. When the glass is full I turn off the tap by pushing it up and then twisting it to the right. Then I pass the glass from my left to my right hand and carry it to the living unit.

Drinking water

Standing between the upside-down table and the chair, I raise the glass to my mouth. My left arm hangs by my side. I tip the water into my open mouth and swallow. To control the flow of water into my mouth, I open and close my lips slowly, and open and close them again. My neck moves every time I swallow and I tilt my head back as the glass empties. I drink very slowly until the glass is empty. Then I put the glass down on the end of the table leg.

The metronome has stopped ticking.

Winding up the metronome

I pick up the metronome from the underside of the tabletop with my right hand and then pass it to my left. I twist the knob clockwise round and round. I do this very slowly. My body is still and only my wrist moves. I twist the knob until it will not turn round any more. I put the metronome on the end of the table leg opposite the table leg that the glass is on. I push the ticker. It ticks.

Showering

I pick up the bath mat from inside the shower tray and unroll it on the floor in front of the shower. Then I take the towel from the shelf and drape it over the toilet seat. Then I take the hairband from the shelf. I sit on the toilet seat. I put my hairband on the floor. Then I lean over and untie the laces of my right boot with my left hand. When the laces are loose enough, I take off the boot and then pull off the sock by grabbing the toe. I put the sock on the boot. Then I untie the laces of my left boot with both hands. When the laces are loose enough I take off the boot and then pull off the sock by grabbing the toe. I put the sock on the boot.

Then I undo the buttons on my trousers and stand up so I can pull them down. When I have sat down again, I finish pulling them off, starting with the right leg and finishing with the left leg. Then I fold them in half and then half again and then half again and put them on the floor next to the boots. This I do very slowly.

Then I brush the hair from my face and undo the buttons on my collars and the buttons of my shirt, starting at the bottom and working my way up. I have to undo seven buttons. When they are undone I take off my shirt and lay it across my legs. Then I take off my undershirt and fold it up. Then I take off my slip. I put all my clothes on the left-hand side of the unit next to the wall. Then I tie my hair back with the hairband.

I stand on the left of the shower, outside the tray, and turn on the taps. I test the temperature of the water by holding out my left hand under the trickle. I wait for the water to warm up. I step into the shower.

I close my eyes.

I stand with my hands by my sides and the palms facing out. I open my mouth wide and the water flows in and dribbles out.

I reach behind me with my left hand and adjust the temperature of the water by turning the tap.

I rock my head from side to side.

When I have finished showering I turn round and twist the taps off with my right hand.

I lean over to pick up the towel. I press the towel hard against my face for a long time. Then I rub the towel over my arms, then my torso, then my legs. I do not dry myself very thoroughly. Then I lay the towel over the toilet seat and sit down on it.

I take my hairband off and put it on the floor.

Then I put my slip back on. Then I put my undershirt back on by putting my head through the head hole and my arms through the armholes. I do the same with my shirt and do up the buttons on my cuffs. I do up the buttons starting at my neck and working my way down. Then I put my trousers on. I straighten out all of my clothes. Then I put my right sock on followed by my right boot. I tie the laces. Then I put my left sock on followed by my left boot. I tie the laces. I stand up.

I fold up the towel and put it back on the shelf. Then I roll up the bath mat and put it in the shower tray. Then I put the hairband back on the shelf.

Before I step into the living unit, I stand in front of the shelves and run my fingers through my hair.

Standing at the front

I stand at the front of the living unit over the knife ladder. My hands are by my sides. My fingers relax and curve. I keep looking at the same person. I am breathing. I turn my hands around halfway so my thumbs face the front. I flare my fingers out further.

Filling the glass

I pick up the glass from the end of the table leg and take it to the sink in the bedroom unit. I sit down on the bed and twist round to face the sink. I hold the glass in my left hand and put it underneath the tap in the sink. I push the tap up and then twist it to the left with my right hand until water trickles out. I tilt my head down towards the tap and watch the water flow. I let the glass fill up slowly. My right hand rests on the tap. When the glass is full I turn off the tap by pushing it up and then twisting it to the right. Then I pass the glass from my left to my right hand and carry it to the living unit.

Drinking water

Standing between the upside-down table and the chair, I raise the glass to my mouth. My left arm hangs by my side. I tip the water into my open mouth and swallow. To control the flow of water into my mouth, I open and close my lips slowly, and open and close them again. My neck moves every time I swallow and I tilt my head back as the glass empties. I drink very slowly until the glass is empty. Then I put the glass down on the end of the table leg.

Standing at the back

I stand at the back of the living unit leaning against the wall. I hold my hands together behind my back. My feet are together. I look at someone in the audience.

The metronome is ticking.

The metronome stops ticking.

Winding up the metronome

I pick up the metronome from the end of the table leg with my right hand and then pass it to my left. I twist the knob clockwise round and round. I do this very slowly. My body is still and only my wrist moves. I twist the knob until it will not turn round any more. I put the metronome on the end of the table leg opposite the table leg that the glass is on. I push the ticker. It ticks.

Sitting on the edge

I sit on the chair, lean down and take off my shoes and socks. I put my socks in my shoes. Then I take the metronome off the end of the table leg and put it on the floor. Then I sit on the edge with my legs between the rails of the knife ladder. My bare feet rest on the second knife blade.

I sit with my hands on my thighs and my eyes on the audience.

I breathe deeply.

Then I lift my feet up and rest them on the first knife blade. I hold my knees with my hands.

Then I shuffle back a little and rest my feet on the edge of the living unit. I link my hands under my legs.

Then I get up.

Sitting on the chair

I bend my knees until my bottom rests on the seat of the chair. I hold the front two corners of the chair as I lower myself. Then I put my hands together in my lap. I look at the telescope.

Standing at the back

I stand at the back of the living unit leaning against the wall. I hold my

hands together behind my back. My feet are together. I look at someone in the audience.

The metronome is ticking.

Lying on the bed

I lie down on the bed. Then I flick my hair back over the pillow so my head is touching the pillow directly. My knees are bent so my legs are hunched up a little. My hands are linked together over my belly. I look at the ceiling and listen to the metronome.

Sitting on the bed

I sit on the bed with my feet on the floor and my hands in my lap. I look out.

Putting my shoes back on

I walk to the living unit and pick up my shoes and carry them to the bedroom unit. I sit on the bed, bend down and put on my right sock. Then I put on my right shoes and tie the laces. Then I take my left sock from my left shoes and put it on. Then I put my left shoe on and tie the laces.

Peeing

I need to pee. I step across the gap to the bathroom unit. When I am in the unit I turn to my right and take the toilet paper from the shelf with my right hand. I take four steps over towards the toilet and turn my body round clockwise. I put the toilet paper down on the corner of the shower tray.

Then I lift the lid of the toilet with my left hand. I push it back until it is resting on the back of the unit. As I turn towards the front I lift up my shirt so I can unfasten my trousers. There are four buttons to unfasten. I tilt my head forward. When I have undone all the buttons I pull my trousers and my slip down to just above my knees and sit on the toilet. I put my feet close together in front of me and cup my hands together in my lap. My two index fingers and thumbs make a triangle shape. The tips of the fingers on my left hand touch the tips of the fingers on my right hand.

I look at the floor. I sit still and wait for the pee to come. It takes a while and there is silence. Then there is the sound of water trickling. I am motionless.

When I have finished peeing I take the toilet roll and unroll some paper and tear it off. I fold it up into a bundle and stand up and wipe myself. Then I pull up my slip and my trousers and do up the four buttons. Then I straighten my shirt out.

I lean over and push the handle of the bucket to the front and then turn on the tap on the wall with my left hand. The water falls into the bucket beneath.

I stand and look at the right-hand wall of the gallery and listen to the water fall. The water starts to overflow. It spreads across the floor of the bathroom unit. I look at the bucket and then turn off the tap.

I lift the bucket with both hands and pour the water down the toilet to flush it. I place the bucket back where it was, underneath the tap, and pull the handle up so it is in the middle.

I pause and brush my hair back with my fingers, then walk out of the bathroom unit.

Sitting on the chair

I bend my knees until my bottom rests on the seat of the chair. I hold the front two corners of the chair as I lower myself. Then I put my hands on my thighs, halfway between my knees and my hips. My fingers are splayed out wider on my left hand than on my right hand. I look at someone off to my left. I keep looking. I blink.

I can hear the water falling from the platform in the bathroom unit onto the floor of the gallery.

Filling the glass

I pick up the glass from the end of the table leg and take it to the sink in the bedroom unit. I sit down on the bed and twist round to face the sink. I hold the glass in my left hand and put it underneath the tap in the sink. I push the tap up and then twist it to the left with my right hand until water trickles out. I tilt my head down towards the tap and watch the water flow. I let the glass fill up slowly. My right hand rests on the tap. When the glass is full I turn off the tap by pushing it up and then twisting it to the right. Then I pass the glass from my left to my right hand and carry it to the living unit.

Drinking water

Standing between the upside-down table and the chair, I raise the glass to my mouth. My left arm hangs by my side. I tip the water into my open mouth and swallow. To control the flow of water into my mouth, I open and close my lips slowly, and open and close them again. My neck moves every time I swallow and I tilt my head back as the glass empties. I drink very slowly until the glass is empty. Then I put the glass down on the end of the table leg.

Standing at the front

I stand at the front of the living unit over the knife ladder. My hands are by my sides. I look at the audience. I sway slowly from side to side.

Then I tense my fingers.

I keep looking at one person in the audience.

Then I step back from the edge.

Standing at the back

I stand at the back of the living unit leaning against the wall. I hold my hands together behind my back. My feet are together. I look at the audience. Outside, a car goes past and makes a sound.

Standing between the units

I stand with one foot in the bathroom unit and the other in the living unit. My body is over the gap. My legs make a triangle shape. Holding my arms at chest height, I rest my hands on the back of the wooden frames. I look down at someone in the audience. I am motionless.

Sitting on the chair

I bend my knees until my bottom rests on the seat of the chair. I hold the front two corners of the chair as I lower myself. Then I put my hands on my thighs, halfway between my knees and my hips. My fingers are splayed out evenly. I look straight ahead. Then I put my hands together in my lap. My palms touch each other and my fingers are interlaced. I blink.

Showering

I pick up the bath mat from inside the shower tray and unroll it on the floor in front of the shower. Then I take the towel from the shelf and drape it over the toilet seat. Then I take the hairband from the shelf. I sit on the toilet seat. I put my hairband on the floor. Then I lean over and untie the laces of my right boot with my left hand. When the laces are loose enough, I take off the boot and then pull off the sock by grabbing the toe, only using my left hand. I put the sock on the boot. Then I untie the laces of my left boot with my left hand. When the laces are loose enough I take off the boot and then pull off the sock by grabbing the toe, only using my left hand. I put the sock on the boot.

Then I undo the buttons on my trousers and stand up so I can pull them down. When I have sat down again, I finish pulling them off, starting with the right leg and finishing with the left leg. Then I fold them in half and then half again and then half again and put them on

the floor next to the boots. This I do very slowly.

Then I brush the hair from my face and undo the buttons on my collars and the buttons of my shirt, starting at the bottom and working my way up. I have to undo seven buttons. When they are undone I take off my shirt and lay it across my legs. Then I take off my undershirt and fold it up. Then I take off my slip. I put all my clothes on the left-hand side of the unit next to the wall. Then I pick up the hairband from the floor and put it on my knee. I pull my hair back and then tie my hair back with the hairband.

I stand on the left of the shower, outside the tray, and turn on the taps. I test the temperature of the water by holding out my left hand under the trickle. I wait for the water to warm up. I step into the shower.

I close my eyes.

I reach behind me with my left hand and adjust the temperature of the water by turning the tap.

I stand with my hands by my sides and the palms facing out. I open my mouth wide and the water flows in and dribbles out.

I rock my head from side to side.

I open my mouth wider. I fill it up with water and I spit the water out.

When I have finished showering I turn round and twist the taps off with my right hand.

I lean over to pick up the towel. I press the towel hard against my face for a long time. Then I rub the towel over my arms, then my torso, then my legs. I do not dry myself very thoroughly. Then I lay the towel over the toilet seat and sit down on it.

I take my hairband off and put it on the floor.

Then I put my slip back on. Then I put my undershirt back on by putting my head through the head hole and my arms through the arm-holes. I do the same with my shirt and do up the buttons on my cuffs. I do up the buttons starting at my neck and working my way down. Then I put my trousers on. I straighten out all of my clothes. Then I put my right sock on followed by my right boot. I tie the laces. Then I put my left sock on followed by my left boot. I tie the laces. I stand up.

I fold up the towel and put it back on the shelf. Then I roll up the bath mat and put it in the shower tray. Then I put the hairband back on the shelf.

Before I step into the living unit, I stand in front of the shelves and run my fingers through my hair.

Standing at the front

I stand at the front of the living unit over the knife ladder and stare someone in the eye. My hands are by my sides. My fingers relax and curve. I turn my hands around halfway so my thumbs face the front. I flare my fingers out further so they poke out at an angle of forty-five degrees from my sides.

The metronome stops ticking.

Starting the metronome

I turn around and step over to the metronome. I pick it up and adjust the weight on the ticker. Then I put it down again on the end of the table leg and set it ticking. It ticks. I look at it.

Wiping my nose

While I am looking at the metronome I take a bundle of tissue paper from my pocket and wipe my nose. Then I put the tissue paper back in my pocket.

Filling the glass

I pick up the glass from the end of the table leg and take it to the sink in the bedroom unit. I sit down on the bed and twist round to face the sink. I hold the glass in my left hand and put it underneath the tap in the sink. I push the tap up and then twist it to the left with my right hand until water trickles out. I tilt my head down towards the tap and watch the water flow. I let the glass fill up slowly. My right hand rests on the tap. When the glass is full I turn off the tap by pushing it up and then twisting it to the right. Then I pass the glass from my left to my right hand and carry it to the living unit.

Drinking water

Standing between the upside-down table and the chair, I raise the glass to my mouth. My left arm hangs by my side. I tip the water into my open mouth and swallow. To control the flow of water into my mouth, I open and close my lips slowly, and open and close them again. My neck moves every time I swallow and I tilt my head back as the glass empties. I drink very slowly until the glass is empty. Then I put the glass down on the end of the table leg.

Sitting on the chair

I bend my knees until my bottom rests on the seat of the chair. I hold the front two corners of the chair as I lower myself. Then I put my hands in my lap and look out.

The metronome stops ticking.

Starting the metronome

I stand up and step over to the metronome. I pick it up and adjust the weight on the ticker. Then I put it down again on the end of the table leg and set it ticking. It ticks. I look at it.

Sitting on the chair

I bend my knees until my bottom rests on the seat of the chair. I hold the front two corners of the chair as I lower myself. Then I put my hands in my lap and look out.

The metronome stops ticking.

Winding up the metronome

I pick up the metronome from the end of the table leg with my right hand and then pass it to my left.

Then I sit down on the chair and twist the knob clockwise round and round. I do this very slowly. My body is still and only my wrist moves. I twist the knob until it will not turn round any more. I put the metronome on my lap. I push the ticker. It ticks.

Lying on the bed

I stand up and carry the metronome to the bedroom unit. I put it down on the bed right at the end, near the quartz pillow. I lie down on the bed. Then I flick my hair back over the pillow so my head is touching the pillow directly. My legs rest flat on the bed. My hands are linked together over my belly. I look at the inside of my eyelids and listen to the metronome.

Reaching out for the metronome

I sit on the bed staring at someone in the audience. The metronome is by the quartz pillow. It stops ticking. I lean over to my left and wave my arm, trying to push the ticker into motion again, all the while still looking at the person in the audience. I cannot reach far enough to touch the metronome. I slide my bottom across the bed to my right and reach out again, still maintaining eye contact. But still I cannot reach far enough. I slide even further to my left and finally I can reach the metronome and push the ticker so it starts ticking again. Then I slide back into a central position. I never break eye contact.

Peeing

I need to pee. I step across the gap to the bathroom unit. When I am in the unit I turn to my right and take the toilet paper from the shelf with my right hand. I take four steps over towards the toilet and turn my body round clockwise. I put the toilet paper down on the corner of the shower tray.

Then I lift the lid of the toilet with my left hand. I push it back until it is resting on the back of the unit. As I turn towards the front I lift up my shirt so I can unfasten my trousers. There are four buttons to unfasten. I tilt my head forward. When I have undone all the buttons I pull my trousers and my slip down to just above my knees and sit on the toilet. I put my feet close together in front of me and cup my hands together in my lap. My two index fingers and thumbs make a triangle shape. The tips of the fingers on my left hand touch the tips of the fingers on my right hand.

I look at the floor. I sit still and wait for the pee to come. It takes a while and there is silence. Then there is the sound of water trickling. I am motionless.

When I have finished peeing I take the toilet roll and unroll some paper and tear it off. I fold it up into a bundle and stand up and wipe myself. Then I pull up my slip and my trousers and do up the four buttons. Then I straighten my shirt out.

I lean over and push the handle of the bucket to the front and then turn on the tap on the wall with my left hand. The water falls into the bucket beneath.

I stand and look at the right-hand wall of the gallery and listen to the water fall. The water starts to overflow. It spreads across the floor of the bathroom unit. I look at the bucket and then turn off the tap.

I lift the bucket with both hands and pour the water down the toilet to flush it. Some water spills on the toilet seat. I place the bucket back where it was, underneath the tap, and pull the handle up so it is in the middle. I wipe the spilled water from the toilet seat with my hand.

I pause by the shelf and brush my hair back with my fingers, then walk out of the bathroom unit.

Standing at the back

I stand at the back of the living unit leaning against the wall. I hold my hands together behind my back. My feet are together. I look at the eyes of someone in the audience.

I can hear the metronome ticking in the bedroom unit and water falling from the bathroom unit. Someone steps across the gallery in loud clicking shoes.

Standing at the front

I step to the front of the living unit and stand over the knife ladder. I keep my hands behind my back. I keep looking at someone in the audience. I sway slowly from side to side. Then I release my hands and let them hang by my sides. I tense my fingers together and bend them back. I take a deep breath.

Sitting on the chair

I bend my knees until my bottom rests on the seat of the chair. I hold the front two corners of the chair as I lower myself. Then I put my hands on my thighs. I look out at the ground, then I close my eyes.

Filling the glass

I pick up the glass from the end of the table leg and take it to the sink in the bedroom unit. I sit down on the bed and twist round to face the sink. I hold the glass in my left hand and put it underneath the tap in the sink. I push the tap up and then twist it to the left with my right hand until water trickles out. I tilt my head down towards the tap and watch the water flow. I let the glass fill up slowly. My right hand rests

on the tap. When the glass is full I turn off the tap by pushing it up and then twisting it to the right. Then I pass the glass from my left to my right hand and carry it to the living unit.

Drinking water

Standing between the upside-down table and the chair, I raise the glass to my mouth. My left arm hangs by my side. I tip the water into my open mouth and swallow. To control the flow of water into my mouth, I open and close my lips slowly, and open and close them again. My neck moves every time I swallow and I tilt my head back as the glass empties. I drink very slowly until the glass is empty. Then I put the glass down on the chair.

Turning the table over

I turn the table from upside down to the right way up by first taking the two legs at the end and tipping it over so that it is on its side. Then I rotate the table around. I use both hands. I push it round until it is in the right position. Then I lift it up so all four table legs are on the ground in the normal way. I have to straighten the table. Then I put the glass back on the table.

I rest my hand on the table and bend over.

Then I walk to the bedroom unit and pick up the metronome from the bed. I carry it to the living unit and put it down on the table, in the back right-hand corner behind the glass.

Sitting on the chair

I bend my knees until my bottom rests on the seat of the chair. I hold the front two corners of the chair as I lower myself. Then I put my hands on my thighs, halfway between my knees and my hips. My fingers are splayed out evenly. I look straight ahead. Then I look at someone on my left.

The metronome stops ticking. I keep looking.

Then I lean back in the chair and close my eyes.

I reach over and pull the ticker back to set the metronome ticking again.

Filling the glass

I pick up the glass from the table and take it to the sink in the bedroom unit. I sit down on the bed and twist it round to face the sink. I hold the glass in my left hand and put it underneath the tap in the sink. I push the tap up and then twist it to the left with my right hand until water trickles out. I tilt my head down towards the tap and watch the water flow. I let the glass fill up slowly. My right hand rests on the tap. When the glass is full I turn off the tap by pushing it up and then twisting it to the right. Then I pass the glass from my left to my right hand and carry it to the living unit.

Drinking water

Standing between the table and the chair, I raise the glass to my mouth. My left arm hangs by my side. I tip the water into my open mouth and swallow. To control the flow of water into my mouth, I open and close my lips slowly, and open and close them again. My neck moves every time I swallow and I tilt my head back as the glass empties. I drink very slowly until the glass is empty. Then I put the glass down on the chair.

Wiping my nose

I walk to the bathroom unit and take the toilet roll from the shelf. I tear off some paper, fold it up and wipe my nose. I put the paper in my pocket and walk away.

Standing at the back

I stand at the back of the living unit leaning against the wall. I hold my hands together behind my back. My feet are together. I look into the

eyes of someone in the audience.

The metronome stops ticking. I make it tick again.

I look at the audience.

The metronome stops ticking. I make it tick again.

I look at the metronome.

Then I look up again.

Standing between the units

I stand with one foot in the bathroom unit and the other in the living unit. My body is over the gap. My legs make a triangle shape. Holding my arms at chest height, I rest my hands on the back of the wooden frames. I look down at someone in the audience. I am motionless.

The metronome stops ticking.

Thursday, November 21st: Day 7

Wearing yellow

Sitting naked on the bed

There is no one in the gallery yet. There is silence, except for the ticking of the metronome.

I sit naked on the bed. I stare at the ground. I am sitting on my towel, leaning against the back wall, with my legs hunched up on the bed. My hands are linked around my shins. I am hugging my leg.

I am humming a song.

On the towel are laid out two bottles with the lids off.

I take the comb from the bed and comb my hair. I comb it down over my face. I lean forward and comb, pulling hard to smooth out the tangles. Some hair has fallen in my lap. I pick it off and drop it on the floor.

I lean forward and touch my toes. I am bent double. My hair hangs down and my face touches my legs.

I start singing rather than humming.

I sit up and stand up and then sit down again immediately. I lean forward, resting my elbows on my knees, allowing my head to droop, and holding my hands together with my fingers interlaced. I continue singing. It is five descending notes. I sing them over and over.

The metronome stops ticking.

Starting the metronome

I stand up and step over to the metronome in the living unit. I poke the ticker to make it tick again.

Sitting on the bed

Then I walk back to the bedroom unit and sit down on the bed with my head drooping down and my hands together. I keep singing.

The metronome stops ticking.

Moving the metronome

I stand up and step over to the metronome in the living unit. I pick up the metronome and carry it to the bedroom unit. I put it on the floor and set it ticking again.

Putting on almond oil

I pick up one of the bottles on the bed, empty some of the fluid into my cupped hands and rub it over my face. Then I rub it over my body.

The metronome stops ticking and I bend down to poke the ticker. It ticks.

I pour out some more almond oil and rub it over my legs.

The metronome stops ticking and I bend down to poke the ticker. It ticks.

I rub some almond oil round and round my hands then wipe it over my arms and my face.

Someone walks into the gallery and I look at them.

I take the other bottle and pour some fluid into my cupped hands. I rub my hands over my face and my arms. Then I pour out some more and rub it under my arms, on my back, and across my belly. I pour some fluid directly onto my thighs then rub it in. Then I pour out some more and rub it into my shins.

Then I tie my hair back with the hairband.

I pour out some more almond oil from the bottle into my left hand. I rub it into my neck. I pour out some more and stand up and rub it into my lower back and shoulders. I pour out some more and rub it into the side of my legs.

Then I sit down again on the bed and pour out some more almond oil, lift my right leg up onto the bed and rub the almond oil into my shin and calf muscle and my foot and my toes. I keep singing. Then I bring my left leg up onto the bed too and pour out some more almond oil and rub the almond oil into my shin and calf muscle and my foot and my toes. I keep singing.

Then I pour out some more almond oil and use both hands to rub it into my face and shoulders and chest. I put the bottle to one side and pick up a corner of the towel and wipe my face with it.

Then I sit back on the bed, leaning against the back wall. My legs are hunched up on the bed and my hands hug my legs.

I sing and look out at the gallery. Now I am singing words, not just a tune.

The metronome stops ticking and I bend down to poke the ticker. It ticks.

Getting dressed

My clothes are folded up next to me on the bed. I pick up my slip and put it on, followed by my undershirt.

The metronome stops ticking and I bend down to poke the ticker. It ticks.

Then it stops immediately. I pick it up and adjust the weight on the ticker and put it on the floor and prod it so it ticks again.

I put the lids on the bottles of rose water and almond oil and put them back on the shelf in the bedroom unit.

Then I sit down and comb my hair.

The metronome stops ticking. I pick it up and adjust the weight on the ticker and put it on the bed and prod it so it ticks again.

I continue combing my hair and singing. Then I unfold and unbutton my shirt of the day. It is yellow. I undo all the buttons and then I put my left arm through the left armhole first, then my right arm through the right armhole second. I do the buttons up again, starting at the top. Then I take my pajama bottoms, unfold them, stand up and put my right leg in the right leg hole and my left leg in the left leg hole. I pull up the pajama bottoms to my waist and fasten the button.

I stand up and fold up the towel I was sitting on. I put it on the bed behind the metronome.

Then I take my right sock and put it on, followed by my right boot. Then I take my left sock and put it on, followed by my left boot.

Then I roll up the bath mat my feet were resting on.

Then I gather the bundle of folded towel and bath mat and walk to the bathroom unit and put them back on the shelf.

Filling the glass

I pick up the glass from the table and take it to the sink in the bedroom unit. I sit down on the bed and twist round to face the sink. I hold the glass in my left hand and put it underneath the tap in the sink. I push the tap up and then twist it to the left with my right hand until

water trickles out. I tilt my head down towards the tap and watch the water flow. I let the glass fill up slowly. My right hand rests on the tap. When the glass is two-thirds full I turn off the tap by pushing it up and then twisting it to the right. Then I pass the glass from my left to my right hand and carry it to the living unit.

Drinking water

Standing in front of the chair, I raise the glass to my mouth. My left arm hangs by my side. I tip the water into my open mouth and swallow. I open and close my lips slowly, and open and close them again. My neck moves every time I swallow and I tilt my head back as the glass empties. I drink very slowly until the glass is empty. Then I put the glass down on the table.

Sitting on the chair

I bend my knees until my bottom rests on the seat of the chair. I hold the front two corners of the chair as I lower myself. I brush my hair back. I look at someone. My hands are in my lap with the palms face up.

The metronome stops ticking.

Sitting on the bed

I sit on the bed with my feet on the floor and my hands gripping the edge of the bed. I prod the metronome to make it tick again. I look straight ahead at someone. Then I lean forward and rest my elbows on my knees and my chin in my curled up fingers and stare at the floor.

The metronome stops ticking and I prod the ticker. It ticks.

I look out.

Walking back and forth

Starting at the end of the bedroom unit, I walk with even steps very slowly across all three rooms. When I reach the end of the bathroom unit I turn around, pause with my back against the wall, and then walk back the other way by putting one foot in front of the other. It takes eighteen steps to get from one end to the other. The wooden floor of the units creaks with every step. My spine is curved forward as I walk and I look at the floor in front of me.

The metronome stops ticking. I prod the ticker as I walk past to make it tick again.

I walk back and forth seven times.

Standing at the front

I stand at the front of the living unit over the knife ladder. My hands are by my sides. I look at someone. My fingers are curved. I keep looking at the same person. I am breathing.

Filling the glass

I pick up the glass from the table and take it to the sink in the bedroom unit. I sit down on the bed and twist round to face the sink. I hold the glass in my left hand and put it underneath the tap in the sink. I push the tap up and then twist it to the left with my right hand until water trickles out. I tilt my head down towards the tap and watch the water flow. I let the glass fill up slowly. My right hand rests on the tap. When the glass is two-thirds full I turn off the tap by pushing it up and then twisting it to the right. Then I pass the glass from my left to my right hand.

Drinking water

Standing in front of the bed, I raise the glass to my mouth. My left arm hangs by my side. I tip the water into my open mouth and swallow. I open and close my lips slowly, and open and close them again. My neck moves every time I swallow and I tilt my head back as the glass empties. I drink very slowly until the glass is empty. Then I carry the empty glass to the living unit and put it down on the table.

Standing at the back

I stand at the back of the living unit leaning against the wall. I hold my hands together behind my back. My feet are together. I look at someone in the audience.

Crouching at the back

I crouch down at the back of the living unit, my chin resting on my folded up fingers, my elbows resting on my knees. I look at the audience.

Filling the glass

I pick up the glass from the table and take it to the sink in the bedroom unit. I sit down on the bed and twist round to face the sink. I hold the glass in my left hand and put it underneath the tap in the sink. I push the tap up and then twist it to the left with my right hand until water trickles out. I tilt my head down towards the tap and watch the water flow. I let the glass fill up slowly. My right hand rests on the tap. When the glass is two-thirds full I turn off the tap by pushing it up and then twisting it to the right. Then I pass the glass from my left to my right hand.

Drinking water

Standing in front of the bed, I raise the glass to my mouth. My left arm hangs by my side. I tip the water into my open mouth and swallow. I open and close my lips slowly, and open and close them again. My neck moves every time I swallow and I tilt my head back as the glass empties. I drink very slowly until the glass is empty. Then I carry the empty glass to the living unit and put it down on the table.

Peeing

I need to pee. I step across the gap to the bathroom unit. When I am in the unit I turn to my right and take the toilet paper from the shelf with my right hand. I take four steps over towards the toilet and turn my body round clockwise. I put the toilet paper down on the corner of the shower tray.

Then I lift the lid of the toilet with my left hand. I push it back until it is resting on the back of the unit. As I turn towards the front I lift up my shirt so I can unfasten my trousers. There are four buttons to unfasten. I tilt my head forward. When I have undone all the buttons I pull my trousers and my slip down to just above my knees and sit on the toilet. I put my feet close together in front of me and cup my hands together in my lap. My two index fingers and thumbs make a triangle shape. The tips of the fingers on my left hand touch the tips of the fingers on my right hand.

I look at the floor. I sit still and wait for the pee to come. It takes a while and there is silence. Then there is the sound of water trickling. I am motionless.

When I have finished peeing I take the toilet roll and unroll some paper and tear it off. I fold it up into a bundle and stand up and wipe myself. I drop the paper into the toilet. Then I pull up my slip and my trousers and do up the four buttons. Then I straighten my shirt out.

I lean over and push the handle of the bucket to the front and then turn on the tap on the wall with my left hand. The water falls into the bucket beneath.

I stand and look at the right-hand wall of the gallery and listen to the water fall. When the bucket is half full I look at the bucket and then turn off the tap.

I lift the bucket with one hand and pour the water down the toilet to flush it. I place the bucket back where it was, underneath the tap, and pull the handle up so it is in the middle.

I pause by the shelf and brush my hair back with my fingers, then walk out of the bathroom unit.

Sitting on the chair

I bend my knees until my bottom rests on the seat of the chair. I hold the front two corners of the chair as I lower myself. I look at someone. My hands are in my lap. My fingertips touch each other.

The metronome stops ticking.

I look down at someone on my left.

Standing at the front

I stand up and step to the edge of the platform. I lean my side against the door frame and stare down at the same person. My hands rest by my sides. I breathe.

Then I straighten my body and stop leaning. I sway from side to side.

Blowing my nose

I walk to the bathroom unit and take the toilet roll from the shelf. I tear off some paper, fold it up and blow my nose. I put the paper in my pocket and walk away.

Sitting on the bed and singing

I walk to the bedroom unit and sit down on the bed. I prod the metronome to make it tick again. Then I sit and stare at the audience with my hands gripping the edge of the bed.

Then I lean forward and rest my arms on my thighs. I link my hands together in front of me and I start singing. I sing the same song I always sing.

Filling the glass

I pick up the glass from the table and take it to the sink in the bedroom unit. I sit down on the bed and twist round to face the sink. I hold the glass in my left hand and put it underneath the tap in the sink. I keep singing. I push the tap up and then twist it to the left with my right hand until water trickles out. I tilt my head down towards the tap and watch the water flow. I let the glass fill up slowly. My right hand rests on the tap. When the glass is two-thirds full I turn off the tap by pushing it up and then twisting it to the right. Then I pass the glass from my left to my right hand.

Drinking water

Sitting on the bed, I raise the glass to my mouth. My left arm hangs by my side. I tip the water into my open mouth and swallow. I open and close my lips slowly, and open and close them again. My neck moves every time I swallow and I tilt my head back as the glass empties. I drink very slowly until the glass is empty. Then I carry the empty glass to the living unit and put it down on the table.

Peeing and singing

I need to pee. I step across the gap to the bathroom unit. When I am in the unit I turn to my right and take the toilet paper from the shelf with my right hand. I take four steps over towards the toilet and turn my body round clockwise. I put the toilet paper down on the corner of the shower tray. I keep singing.

Then I lift the lid of the toilet with my left hand. I push it back until it is resting on the back of the unit. As I turn towards the front I lift up my shirt so I can unfasten my trousers. There are four buttons to unfasten. I tilt my head forward. When I have undone all the buttons I pull my trousers and my slip down to just above my knees and sit on the toilet. I put my feet close together in front of me and cover my face with my hands.

I sit still and wait for the pee to come. It takes a while and there is silence. Then there is the sound of water trickling. I am motionless.

When I have finished peeing I take the toilet roll and unroll some paper and tear it off. I fold it up into a bundle and stand up and wipe myself. I drop the paper in the toilet. Then I pull up my slip and my trousers and do up the four buttons. Then I straighten my shirt out.

I lean over and push the handle of the bucket to the front and then turn on the tap on the wall with my left hand. The water falls into the bucket beneath.

I stand and look at the right-hand wall of the gallery and listen to the

water fall. When the bucket is half full I look at the bucket and then turn off the tap.

I lift the bucket with one hand and pour the water down the toilet to flush it. I place the bucket back where it was, underneath the tap, and pull the handle up so it is in the middle.

I pause by the shelf and brush my hair back with my fingers, then walk out of the bathroom unit.

Walking back and forth

I walk with even steps very slowly across all three rooms. When I reach the end of the bathroom unit I turn around, pause with my back against the wall, and then walk back the other way by putting one foot in front of the other. It takes eighteen steps to get from one end to the other. The wooden floor of the units creaks with every step. My spine is curved forward as I walk and I look at the floor in front of me.

I walk back and forth seventeen times.

Standing at the back and singing

I stand at the back of the living unit leaning against the wall. I hold my hands together behind my back. My feet are together. I look at someone in the audience. I sing quietly. I sing the same song I always sing.

Blowing my nose

I walk to the bathroom unit and take the toilet roll from the shelf. I tear off some paper, fold it up and blow my nose. I put the paper in my pocket and walk away. I put the toilet roll on the corner of the shower unit and get ready to pee.

Peeing and singing

I take four steps over towards the toilet and turn my body round clockwise. I put the toilet paper down on the corner of the shower tray. I keep singing.

Then I lift the lid of the toilet with my left hand. I push it back until it is resting on the back of the unit. As I turn towards the front I lift up my shirt so I can unfasten my trousers. There are four buttons to unfasten. I tilt my head forward. When I have undone all the buttons I pull my trousers and my slip down to just above my knees and sit on the toilet. I put my feet close together in front of me and cover my face with my hands.

I sit still and wait for the pee to come. It takes a while. I sing. Then there is the sound of water trickling. I am motionless.

When I have finished peeing I take the toilet roll and unroll some paper and tear it off. I fold it up into a bundle and stand up and wipe myself. Then I pull up my slip and my trousers and do up the four buttons. Then I straighten my shirt out.

I lean over and push the handle of the bucket to the front and then turn on the tap on the wall with my left hand. The water falls into the bucket beneath.

I stand and look at the right-hand wall of the gallery and listen to the water fall. When the bucket is half full I look at the bucket and then turn off the tap.

I lift the bucket with one hand and pour the water down the toilet to flush it. I place the bucket back where it was, underneath the tap, and pull the handle up so it is in the middle. Then it falls to the front.

I pause by the shelf and brush my hair back with my fingers, then walk out of the bathroom unit.

Walking back and forth

I walk with even steps very slowly across all three rooms. When I reach the end of the bathroom unit I turn around, pause with my back against the wall, and then walk back the other way by putting one foot in front of the other. It takes eighteen steps to get from one end to the other. The wooden floor of the units creaks with every step. My spine is curved forward as I walk and I look at the floor in front of me.

I sing as I walk.

The metronome stops ticking.

I walk back and forth eleven times.

Sitting on the chair

I bend my knees until my bottom rests on the seat of the chair. I hold the front two corners of the chair as I lower myself. I look at someone. My hands are in my lap. My fingertips touch each other.

I look down at someone on my left. I turn my hands over in my lap so my palms face up.

There is silence. I stare.

Filling the glass

I pick up the glass from the table and take it to the sink in the bedroom unit. I sit down on the bed and twist round to face the sink. I hold the glass in my left hand and put it underneath the tap in the sink. I push the tap up and then twist it to the left with my right hand until water trickles out. I tilt my head down towards the tap and watch the water flow. I let the glass fill up slowly. My right hand rests on the tap. When the glass is two-thirds full I turn off the tap by pushing it up and then twisting it to the right. Then I pass the glass from my left to my right hand.

Drinking water

Standing in front of the bed, I raise the glass to my mouth. My left arm hangs by my side. I tip the water into my open mouth and swallow. I open and close my lips slowly, and open and close them again. My neck moves every time I swallow and I tilt my head back as the glass empties. I drink very slowly until the glass is empty. I leave the glass on the bed.

Winding up the metronome

I pick up the metronome from the bed and carry it to the living unit. Standing between the table and the chair, I twist the knob clockwise round and round. I do this very slowly. My body is still and only my wrist moves. I twist the knob until it will not turn round any more. I put the metronome on the table. I push the ticker. It ticks.

Standing at the back

I stand at the back of the living unit leaning against the wall. I hold my hands together behind my back. My feet are together. I look at someone in the audience.

Showering

I take the towel from the shelf and drape it over the toilet seat. Then I pick up the bath mat from inside the shower tray and unroll it on the floor in front of the shower. I take the hairband from the shelf. I sit on the toilet seat. I put my hairband on the floor. Then I lean over and untie the laces of my right boot with my right hand. When the laces are loose enough, I take off the boot and then pull off the sock by grabbing the toe. I put the sock on the boot. Then I untie the laces of my left boot with my right hand. When the laces are loose enough I take off the boot and then pull off the sock by grabbing the toe. I put the sock on the boot.

Then I undo the buttons on my trousers and stand up so I can pull them down. When I have sat down again, I finish pulling them off, starting with the right leg and finishing with the left leg. Then I fold them in half and then half again and then half again and put them on the floor next to the boots. This I do very slowly.

Then I stand up and take a red cloth from the shower tray and crouch down in front of the toilet and wipe up some water from the floor. I put the red cloth back in the shower tray.

Then I brush the hair from my face and undo the buttons on my collar

and the buttons of my shirt, starting at the bottom and working my way up. I have to undo seven buttons. When they are undone I take off my shirt and lay it across my legs. Then I take off my undershirt. I pick some hairs off it and fold it up. Then I take off my slip. I put all my clothes on the left-hand side of the unit next to the wall. Then I tie my hair back with the hairband.

I stand on the left of the shower, outside the tray, and turn on the taps. I test the temperature of the water by holding out my left hand under the trickle. I wait for the water to warm up. I step into the shower.

I close my eyes.

I reach behind me with my left hand and adjust the temperature of the water by turning the tap.

I stand with my hands by my sides and the palms facing out. I open my mouth wide and the water flows in and dribbles out.

I rock my head from side to side slowly.

I open my mouth wider.

When I have finished showering I turn round and twist the taps off with my right hand.

I lean over to pick up the towel. I press the towel hard against my face for a long time. Then I rub the towel over my arms, then my torso, then my legs. I do not dry myself very thoroughly. Then I lay the towel over the toilet seat and sit down on it.

I take my hairband off and put it on the floor.

Then I put my slip back on. Then I put my undershirt back on by putting my head through the head hole and my arms through the armholes. I do the same with my shirt and do up the buttons on my cuffs. I do up the buttons starting at my neck and working my way down. Then I put my trousers on. I straighten out all of my clothes. Then I put my right sock on followed by my right boot. I tie the laces. Then I put my left sock on followed by my left boot. I tie the laces. I stand up.

I fold up the towel and put it back on the shelf. Then I roll up the bath mat and put it in the shower tray. Then I put the hairband back on the shelf.

Before I step into the living unit, I stand in front of the shelves and run my fingers through my hair.

Standing at the front

I stand at the front of the living unit over the knife ladder. My hands are by my sides. I look at a person in the audience. My fingers are curved. I keep looking at the same person. I am breathing. I wobble. My fingers twitch. I step back from the edge.

Standing at the back

I stand at the back of the living unit leaning against the wall. I hold my hands together behind my back. My feet are together. I look at someone in the audience.

Filling the glass

I walk to the bedroom unit and pick up the glass from the bed. I sit down on the bed and twist round to face the sink. I hold the glass in my left hand and put it underneath the tap in the sink. I push the tap up and then twist it to the left with my right hand until water trickles out. I tilt my head down towards the tap and watch the water flow. I let the glass fill up slowly. My right hand rests on the tap. When the glass is two-thirds full I turn off the tap by pushing it up and then twisting it to the right. Then I pass the glass from my left to my right hand.

Drinking water

Standing in front of the bed, I raise the glass to my mouth. My left arm hangs by my side. I tip the water into my open mouth and swallow. I open and close my lips slowly, and open and close them again. My

neck moves every time I swallow and I tilt my head back as the glass empties. I drink very slowly until the glass is empty. Then I carry the empty glass to the living unit and put it down on the table.

Lying on the bed

I walk to the bedroom unit. I sit on the bed and then I raise up my feet, move my hands back to balance myself and twist round ninety degrees, lower my body down until it is flat, and rest my head on the quartz pillow. Then I flick my hair back over the pillow so my head is touching the pillow directly. I lie with my knees bent and my legs hunched up. My hands are linked together over my belly.

Sitting on the bed

Then I sit up so I am sitting on the bed. My feet are on the floor and my hands are linked together in my lap. I look into someone's eyes.

Standing at the back

I stand at the back of the living unit leaning against the wall. I hold my hands together behind my back. My feet are together. I look at someone in the audience.

Standing at the front

I step forward to the edge of the platform in front of the chair and stare. My feet are just wider than hip-width apart. I point my feet outwards slightly and stand still. I let my arms hang down straight by my sides. My fingers curve towards my thighs and there is a gap between them and my thumbs. I stand straight and still and keep looking at the same person.

Sitting on the chair

I bend my knees until my bottom rests on the seat of the chair. I hold the front two corners of the chair as I lower myself. I look into someone's eyes. My hands are on my thighs.

Walking back and forth

I walk with even steps very slowly across all three rooms. When I reach the end of the bathroom unit I turn around, pause with my back against the wall, and then walk back the other way by putting one foot in front of the other. It takes twenty steps to get from one end to the other. The wooden floor of the units creaks with every step. My spine is curved forward as I walk and I look at the floor in front of me.

I sing as I walk.

I walk back and forth seven times.

Standing at the front and singing

I stand at the front of the living unit over the knife ladder. My hands are by my sides. I look at someone. My fingers are curved. I keep looking at the same person. I am singing.

The metronome stops ticking.

Winding up the metronome

I turn around and pick up the metronome from the table. I twist the knob clockwise round and round. I do this very slowly. My body is still and only my wrist moves. I twist the knob until it will not turn round any more. I put the metronome on the table. I push the ticker. It ticks.

Walking back and forth

I walk with even steps very slowly across all three rooms. When I reach the end of the bathroom unit I turn around, pause with my back against the wall, and then walk back the other way by putting one foot in front of the other. It takes twenty steps to get from one end to the other. The wooden floor of the units creaks with every step. My spine is curved forward as I walk and I look at the floor in front of me.

I sing as I walk.

Peeing and singing

I need to pee. I step across the gap to the bathroom unit. When I am in the unit I turn to my right and take the toilet paper from the shelf with my right hand. I take four steps over towards the toilet and turn my body round clockwise. I put the toilet paper down on the corner of the shower tray. I keep singing.

Then I lift the lid of the toilet with my left hand. I push it back until it is resting on the back of the unit. As I turn towards the front I lift up my shirt so I can unfasten my trousers. There are four buttons to unfasten. I tilt my head forward. When I have undone all the buttons I pull my trousers and my slip down to just above my knees and sit on the toilet. I put my feet close together in front of me and cup my hands together in my lap. My two index fingers and thumbs make a triangle shape. The tips of the fingers on my left hand touch the tips of the fingers on my right hand.

I look at the floor. I sit still and wait for the pee to come. Then there is the sound of water trickling. I am motionless.

When I have finished peeing I take the toilet roll and unroll some paper and tear it off. I put the toilet roll in my lap. I wipe my nose with the bundle of tissue. Then I tear off some more. I put the toilet roll back on the corner of the shower tray. Then I fold up the paper into a bundle and stand up and wipe myself. Then I pull up my slip and my trousers and do up the four buttons. Then I straighten my shirt out.

I lean over and turn on the tap on the wall with my left hand. The water falls into the bucket beneath.

I stand and look at the right-hand wall of the gallery and listen to the water fall. When the bucket is half full I look at the bucket and then turn off the tap.

I lift the bucket with one hand and pour the water down the toilet to flush it. I place the bucket back where it was, underneath the tap, and pull the handle up so it is in the middle.

I pause by the shelf and brush my hair back with my fingers, then walk out of the bathroom unit.

Standing at the back

I stand at the back of the living unit leaning against the wall. I hold my hands together behind my back. My feet are together. I look at the telescope.

I release my hands and let my arms hand by my sides. I stand up straight so I am no longer leaning against the wall. I sway from side to side.

The metronome stops ticking.

Winding up the metronome

I step forward and pick up the metronome from the table. I twist the knob clockwise round and round. I do this very slowly. My body is still and only my wrist moves. I twist the knob until it will not turn round any more. I put the metronome on the table. I pull the ticker down by touching it with my index finger and bending my index finger. The metronome ticks.

Sitting on the chair

I bend my knees until my bottom rests on the seat of the chair. I hold the front two corners of the chair as I lower myself. I look at someone's eyes. My hands are on my thighs and my fingers are splayed out evenly.

Standing between the units

I stand with one foot in the bedroom unit and the other in the living unit. My body is over the gap. My legs make a triangle shape. Holding my arms at chest height, I rest my hands on the back of the wooden frames. I look down at someone in the audience. I am motionless.

Filling the glass

I pick up the glass from the table and take it to the sink in the bedroom unit. I sit down on the bed and twist round to face the sink. I hold the glass in my left hand and put it underneath the tap in the sink. I push the tap up and then twist it to the left with my right hand until water trickles out. I tilt my head down towards the tap and watch the water flow. I let the glass fill up slowly. My right hand rests on the tap. The metronome stops ticking. When the glass is two-thirds full I turn off the tap by pushing it up and then twisting it to the right. Then I pass the glass from my left to my right hand and carry it to the living unit.

Drinking water

Standing in front of the chair, I raise the glass to my mouth. My left arm hangs by my side. I tip the water into my open mouth and swallow. I open and close my lips slowly, and open and close them again. My neck moves every time I swallow and I tilt my head back as the glass empties. I drink very slowly until the glass is empty. Then I put the glass down on the table. I prod the ticker on the metronome to make it tick again.

Sitting on the chair

I bend my knees until my bottom rests on the seat of the chair. I hold the front two corners of the chair as I lower myself. I look into someone's eyes. My hands are together in my lap. The metronome stops ticking.

Winding up the metronome

I stand up and pick up the metronome from the table. I twist the knob clockwise round. I do this very slowly. My body is still and only my wrist moves. I put the metronome on the table. I pull the ticker down by touching it with my index finger and bending my index finger. The metronome ticks.

Showering

I take the towel from the shelf and drape it over the toilet seat. Then I pick up the bath mat from inside the shower tray and unroll it on the floor in front of the shower. I take the hairband from the shelf. I sit on the toilet seat. I put my hairband on the floor. Then I lean over and untie the laces of my right boot with both hands. When the laces are loose enough, I take off the boot and then pull off the sock by grabbing the toe. I put the sock on the boot. Then I untie the laces of my left boot with both hands. When the laces are loose enough I take off the boot and then pull off the sock by grabbing the toe. I put the sock on the boot.

Then I undo the buttons on my trousers and stand up so I can pull them down. When I have sat down again, I finish pulling them off, starting with the right leg and finishing with the left leg. Then I fold them in half and then half again and then half again and put them on the floor next to the boots. This I do very slowly.

Then I brush the hair from my face and undo the buttons on my collars and the buttons of my shirt, starting at the bottom and working my way up. I have to undo seven buttons. When they are undone I take off my shirt and lay it across my legs. Then I take off my undershirt. I pick some hairs off it and fold it up. Then I take off my slip. I put all my clothes on the left-hand side of the unit next to the wall. Then I tie my hair back with the hairband.

I stand on the left of the shower, outside the tray, and turn on the taps. I test the temperature of the water by holding out my left hand under the trickle. I wait for the water to warm up. I step into the shower.

I close my eyes.

I stand with my hands by my sides and the palms facing out. I open my mouth wide and the water flows in and dribbles out.

I reach behind me with my left hand and adjust the temperature of the water by turning the tap.

I open my mouth wider.

When I have finished showering I turn round and twist the taps off with my right hand.

I lean over to pick up the towel. I press the towel hard against my face for a long time. Then I rub the towel over my arms, then my torso, then my legs. I do not dry myself very thoroughly. Then I lay the towel over the toilet seat and sit down on it.

I take my hairband off and put it on the floor.

Then I put my slip back on. Then I put my undershirt back on by putting my head through the head hole and my arms through the armholes. I do the same with my shirt and do up the buttons on my cuffs. I do up the buttons starting at my neck and working my way down. Then I put my trousers on. I straighten out all of my clothes. Then I put my right sock on followed by my right boot. I tie the laces. Then I put my left sock on followed by my left boot. I tie the laces. I stand up.

I fold up the towel and put it back on the shelf. Then I roll up the bath mat and put it in the shower tray. Then I put the hairband back on the shelf.

Before I step into the living unit, I stand in front of the shelves and run my fingers through my hair.

Standing at the front and then singing

I stand at the front of the living unit over the knife ladder. My hands are by my sides. I look at someone. My fingers are curved. I am almost motionless. The metronome is not ticking. I tense my fingers and they bend out. I start singing as I stare.

I step back from the edge.

Starting the metronome

I pick up the metronome, adjust the weight on the ticker, put it back down on the table and push the ticker to make it tick again. It ticks.

Wiping my nose

I walk to the bathroom unit and take the toilet roll from the shelf. I tear off some paper, fold it up and wipe my nose. I put the paper in my pocket and walk away.

Filling the glass

I pick up the glass from the table and take it to the sink in the bedroom unit. I sit down on the bed and twist round to face the sink. I hold the glass in my left hand and put it underneath the tap in the sink. I push the tap up and then twist it to the left with my right hand until water trickles out. I tilt my head down towards the tap and watch the water flow. I let the glass fill up slowly. My right hand rests on the tap. When the glass is two-thirds full I turn off the tap by pushing it up and then twisting it to the right. Then I pass the glass from my left to my right hand.

Drinking water

Standing in front of the bed, I raise the glass to my mouth. My left arm hangs by my side. I tip the water into my open mouth and swallow. I open and close my lips slowly, and open and close them again. My neck moves every time I swallow and I tilt my head back as the glass empties. I drink very slowly until the glass is empty. Then I carry the glass to the living unit and put it down on the table.

Sitting on the chair

I bend my knees until my bottom rests on the seat of the chair. I hold the front two corners of the chair as I lower myself. My hands rest on my thighs. My eyes close.

Then they open and I blink.

Standing at the front

I stand at the front of the living unit over the knife ladder. My hands are by my sides. I look at someone to my right. My fingers are curved. I keep looking at the same person.

Standing between the units

I stand with one foot in the bathroom unit and the other in the living unit. My body is over the gap. My legs make a triangle shape. Holding my arms at chest height, I rest my hands on the back of the wooden frames. I look down at someone in the audience. I am breathing and staring at the same time. The ticker on the metronome swings back and forth and ticks every time it passes the middle. Then the metronome stops ticking. I lean my head forward and keep staring.

Starting the metronome

I walk to the metronome and pull the ticker back with my index finger. Then I release it and it starts ticking again.

Showering

I take the towel from the shelf and drape it over the toilet seat. Then I pick up the bath mat from inside the shower tray and unroll it on the floor in front of the shower. I take the hairband from the shelf. I sit on the toilet seat. I put my hairband on the floor. Then I lean over and untie the laces of my right boot with my right hand. When the laces are loose enough, I take off the boot and then pull off the sock by grabbing the toe. I put the sock on the boot. Then I untie the laces of my left boot with my left hand. When the laces are loose enough I take off the boot and then pull off the sock by grabbing the toe. I put the sock on the boot.

Then I undo the buttons on my trousers and stand up so I can pull them down. When I have sat down again, I finish pulling them off, starting with the right leg and finishing with the left leg. Then I fold them in half and then half again and then half again and put them on the floor next to the boots. This I do very slowly.

Then I stand up and take a red cloth from the shower tray and crouch down in front of the toilet and wipe up some water from the floor. I put the red cloth back in the shower tray.

Then I brush the hair from my face and undo the buttons on my collars and the buttons of my shirt, starting at the bottom and working my way up. I have to undo seven buttons. When they are undone I take off my shirt and lay it across my legs.

Then I wrap my arms around my head and squeeze. My hands hold the back of my head and my arms cover the side of my head. I stay in this position.

Then I take off my undershirt. I pick some hairs off it and fold it up. Then I take off my slip. I put all my clothes on the left-hand side of the unit next to the wall. Then I tie my hair back with the hairband.

I stand on the left of the shower, outside the tray, and turn on the taps. I test the temperature of the water by holding out my left hand under the trickle. I wait for the water to warm up. I step into the shower.

I close my eyes.

I stand with my hands by my sides and the palms facing out. I open my mouth wide and the water flows in. Then I spit it out.

I open my mouth wider.

I cover my face with my hands.

I reach behind me with my left hand and adjust the temperature of the water by turning the tap.

I cover my face with my hands.

When I have finished showering I turn round and twist the taps off with my right hand.

I lean over to pick up the towel. I press the towel hard against my face for a long time. Then I rub the towel over my arms, then my torso, then my legs. I do not dry myself very thoroughly. Then I lay the towel over the toilet seat and sit down on it.

I take my hairband off and put it on the floor.

Then I lean forward and touch my toes. My hair hangs down. My head

droops down.

Then I put my slip back on. Then I put my undershirt back on by putting my head through the head hole and my arms through the armholes. I do the same with my shirt and do up the buttons on my cuffs. I do up the buttons starting at my neck and working my way down. Then I put my trousers on. I straighten out all of my clothes. Then I put my right sock on followed by my right boot. I tie the laces. Then I put my left sock on followed by my left boot. I tie the laces. I stand up.

I fold up the towel and put it back on the shelf. Then I roll up the bath mat and put it in the shower tray. Then I put the hairband back on the shelf.

Before I step into the living unit, I stand in front of the shelves and run my fingers through my hair.

Filling the glass

I pick up the glass from the table and take it to the sink in the bedroom unit. I sit down on the bed and twist round to face the sink. I hold the glass in my left hand and put it underneath the tap in the sink. I push the tap up and then twist it to the left with my right hand until water trickles out. I tilt my head down towards the tap and watch the water flow. I let the glass fill up slowly. My right hand rests on the tap. When the glass is two-thirds full I turn off the tap by pushing it up and then twisting it to the right. Then I pass the glass from my left to my right hand.

Drinking water

Standing in front of the bed, I raise the glass to my mouth. My left arm hangs by my side. I tip the water into my open mouth and swallow. I open and close my lips slowly, and open and close them again. My neck moves every time I swallow and I tilt my head back as the glass empties. I drink very slowly until the glass is empty. Then I carry the empty glass to the living unit and put it down on the table.

Winding up the metronome

I pick up the metronome from the table. I twist the knob clockwise round and round. I do this very slowly. My body is still and only my wrist moves. I twist the knob until it will not turn round any more. I put the metronome on the table. I push the ticker. It ticks.

Standing at the back

I stand at the back of the living unit leaning against the wall. I hold my hands together behind my back. My feet are together. I look at someone in the audience.

Standing at the front and singing

I step forward to the edge of the platform in front of the chair and stare. My feet are just wider than hip-width apart. I point my feet outwards slightly and stand still. I let my arms hang down straight by my sides. My fingers curve towards my thighs and there is a gap between them and my thumbs. I stand straight and still and keep looking at the same person.

Then I step over to the center of the living unit and stand over the knife ladder. I look straight ahead. Then I start singing. I sing the same song I always sing. I sway from side to side as I sing.

I look at someone else, off to my right.

Then I look straight ahead again and continue singing and swaying.

Filling the glass

I pick up the glass from the table and take it to the sink in the bedroom unit. I sit down on the bed and twist round to face the sink. I hold the glass in my left hand and put it underneath the tap in the sink. I push the tap up and then twist it to the left with my right hand until water trickles out. I tilt my head down towards the tap and watch the water flow. I let the glass fill up slowly. My right hand rests on the tap. When the glass is two-thirds full I turn off the tap by pushing it up and then twist-

ing it to the right. Then I pass the glass from my left to my right hand.

Drinking water

Standing in front of the bed, I raise the glass to my mouth. My left arm hangs by my side. I tip the water into my open mouth and swallow. I open and close my lips slowly, and open and close them again. My neck moves every time I swallow and I tilt my head back as the glass empties. I drink very slowly until the glass is empty. Then I carry the glass to the living unit and put it down on the table.

Standing at the back

I stand at the back of the living unit leaning against the wall. I hold my hands together behind my back. My feet are together. I look at someone in the audience.

Standing

I stand on the left-hand side of the bedroom unit pointing to the right. I stare down at someone.

Filling the glass

I pick up the glass from the table and take it to the sink in the bedroom unit. I stand in front of the sink and hold the glass in my left hand and put it underneath the tap in the sink. I push the tap up and then twist it to the left with my right hand until water trickles out. I tilt my head down towards the tap and watch the water flow. I let the glass fill up slowly. My right hand rests on the tap. When the glass is two-thirds full I turn off the tap by pushing it up and then twisting it to the right. Then I pass the glass from my left to my right hand and carry it to the living unit.

Drinking water

Standing in front of the chair, I raise the glass to my mouth. My left arm hangs by my side. I tip the water into my open mouth and swallow. I open and close my lips slowly, and open and close them again. My neck moves every time I swallow and I tilt my head back as the glass empties. I drink very slowly until the glass is empty. Then I put it down on the table.

Standing

After I put the glass down, I do not move my feet. I look at someone in the gallery.

Sitting on the chair

I bend my knees until my bottom rests on the seat of the chair. I hold the front two corners of the chair as I lower myself. I look at someone. My hands are together in my lap. The metronome stops ticking. I pull the ticker back with my finger and it starts ticking again.

Moving the chair forward

I stand up and reach behind me and pull the chair forward. Then move around to the back of the chair and push it forward. It makes a noise as it moves. Then I take the metronome from the table and put it on the chair.

Peeing

I need to pee. I step across the gap to the bathroom unit. When I am in the unit I turn to my right and take the toilet paper from the shelf with my right hand. The metronome stops ticking.

Starting the metronome then moving it

Carrying the toilet roll in my hand, I walk back to the living unit. I poke the ticker of the metronome to make it tick again. I stare at it and it ticks five times. I turn away and begin walking back to the bathroom unit. It ticks once more then stops. I turn around and pick up the metronome and carry it with the toilet paper back to the bathroom unit.

Peeing

I step across the gap into the bathroom unit. I put the metronome down on the corner of the shower tray and set it ticking. I put the toi-

let paper down behind it.

Then I lift the lid of the toilet with my left hand. I push it back until it is resting on the back of the unit. As I turn towards the front I lift up my shirt so I can unfasten my trousers. There are four buttons to unfasten. I tilt my head forward. When I have undone all the buttons I pull my trousers and my slip down to just above my knees and sit on the toilet. I put my feet close together in front of me and cup my hands together in my lap. My two index fingers and thumbs make a triangle shape. The tips of the fingers on my left hand touch the tips of the fingers on my right hand.

I look at the floor. I sit still and wait for the pee to come. It takes a while. The metronome stops ticking and there is silence. Then there is the sound of water trickling. I am motionless.

When I have finished peeing I take the toilet roll and unroll some paper and tear it off. I fold it up into a bundle and stand up and wipe myself. I drop the paper into the toilet. Then I pull up my slip and my trousers and do up the four buttons. Then I straighten my shirt out.

I lean over and push the handle of the bucket to the front and then turn on the tap on the wall with my left hand. The water falls into the bucket beneath.

I lean forward to prod the ticker of the metronome again. It starts ticking again.

I stand and look at the right-hand wall of the gallery and listen to the water fall. When the bucket is half full I look at the bucket and then turn off the tap.

I slide the bucket along the floor then lift it with one hand and pour the water down the toilet to flush it. I place the bucket back where it was, underneath the tap, and pull the handle up so it is in the middle.

I pause by the shelf and brush my hair back with my fingers, then walk out of the bathroom unit.

Sitting and singing on the chair

I bend my knees until my bottom rests on the seat of the chair. I hold the front two corners of the chair as I lower myself. I look down at someone. My hands are together in my lap. The ends of my shoes poke out over the edge of the platform. The metronome stops ticking.

I start singing. I sing the same song I always sing, but I sing it slower and more softly. I look at someone down on my left as I sing.

I turn my hands over in my lap so my palms face up.

I lean over and put my arms around the pillar and pull myself up and out of the chair.

Winding up the metronome

I walk to the bathroom unit and pick up the metronome from the corner of the shower tray. I twist the knob clockwise round. I do this very slowly. My body is still and only my wrist moves. I put the metronome on the floor at the front next to the left-hand wall. I pull the ticker down by touching it with my index finger and bending my index finger. The metronome ticks.

Peeing

I lift the lid of the toilet with my left hand. I push it back until it is resting on the back of the unit. Then I take the toilet roll from the shelf and put it down on the corner of the shower tray. As I turn towards the front I lift up my shirt so I can unfasten my trousers. There are four buttons to unfasten. I tilt my head forward. When I have undone all the buttons I pull my trousers and my slip down to just above my knees and sit on the toilet. I put my feet close together in front of me. I rest my arms on my legs and put my hands together. My two index fingers and thumbs make a triangle shape. The tips of the fingers on my left hand touch the tips of the fingers on my right hand.

I look at the floor. I sit still and wait for the pee to come. It takes a

while. I sing. Then there is the sound of water trickling. I am motionless.

When I have finished peeing I take the toilet roll and unroll some paper and tear it off. I fold it up into a bundle and stand up and wipe myself. Then I pull up my slip and my trousers and do up the four buttons. Then I straighten my shirt out.

I lean over and turn on the tap on the wall with my left hand. The water falls into the bucket beneath.

I stand and look at the right-hand wall of the gallery and listen to the water fall. The water starts to overflow. It spreads across the floor of the bathroom unit and falls over the edge.

I look at the bucket and then turn off the tap.

I slide the bucket along the floor and then lift it with both hands and rest it on the toilet seat. Then I pour the water down the toilet to flush it. I place the bucket back where it was, underneath the tap, and pull the handle up so it is in the middle.

I pause by the shelf and brush my hair back with my fingers. Then I pick up the metronome and walk out of the bathroom unit.

Lying on the bed

I walk to the bedroom unit. I put the metronome down on the floor and set it ticking. I sit on the bed and then I raise up my feet, move my hands back to balance myself and twist round ninety degrees, lower my body down until it is flat, and rest my head on the quartz pillow. Then I flick my hair back over the pillow so my head is touching the pillow directly. The metronome stops ticking. I lie with my knees bent and my legs hunched up. My hands are linked together over my belly. I close my eyes.

I cover my face with my hands.

Filling the glass

I walk to the living unit and pick up the glass from the table. Then I walk to the bedroom unit. I sit down on the bed and twist round to face the sink. I hold the glass in my left hand and put it underneath the tap in the sink. I push the tap up and then twist it to the left with my right hand until water trickles out. I tilt my head down towards the tap and watch the water flow. I let the glass fill up slowly. My right hand rests on the tap. When the glass is two-thirds full I turn off the tap by pushing it up and then twisting it to the right. Then I pass the glass from my left to my right hand.

Drinking water

Standing in front of the bed, I raise the glass to my mouth. My left arm hangs by my side. I tip the water into my open mouth and swallow. I open and close my lips slowly, and open and close them again. My neck moves every time I swallow and I tilt my head back as the glass empties. I drink very slowly until the glass is empty. Then I put the empty glass down on the bed.

Sitting on the bed

I sit on the bed with my feet on the floor and my hands in my lap. I lean down and prod the metronome to make it tick again. I look at someone. The metronome stops ticking. I keep looking.

Then I lean down and prod the metronome to make it tick again.

The metronome stops ticking.

Friday, November 22nd: Day 8

Wearing white

Sitting naked on the bed

I sit naked on the bed, still wet from my first shower of the day. I am sitting on my towel. I stare at the ground. My back is resting against the wall, my knees are hunched up and my arms are cuddling my legs. I look up, out at someone in the audience. I shuffle forward to the edge of the bed and put my feet on the floor. On the towel are laid out two bottles with the lids off. I pick one bottle up, empty some of the fluid into my cupped hands and rub it over my face. Then I pick up the other bottle, empty some of the fluid out into my cupped hands and rub it over my body, right down to my toes.

Getting dressed in the morning

I pick up my slip, put my feet through the holes and lift them up. Then I put on my two undershirts. Then I have to unfold and unbutton my white shirt. I put my left arm through the left armhole first, then my right arm through the right armhole second. I do the buttons up again, starting at the top. Then I take my pajama bottoms, unfold them, stand up and put my right leg in the right leg hole and my left leg in the left leg hole. I pull up the pajama bottoms to my waist and fasten the button.

Then I take my left sock and put it on, followed by my left boot. Then I take my right sock and put it on, followed by my right boot.

I stand up.

Standing at the front

I stand in the middle of the living unit. I point my body to the right so I can face the person I am staring at.

Every time I breathe in, the bottom of my shirt moves in towards my torso. Every time I breathe out, the bottom of my shirt moves out away from my torso. Nothing else moves, except the lids of both my eyes. They always move at the same time.

Filling the glass

I pick up the empty glass from the table. I take the glass to the sink in the bedroom unit and sit down on the bed, twisting round to face the sink. I hold the glass in my left hand and put it underneath the tap in the sink. I push the tap up and then twist it to the left with my right hand until water trickles out. I tilt my head down towards the tap and watch the water flow. I let the glass fill up slowly. My right hand rests on the edge of the sink. When the glass is full I turn off the tap by pushing it up and then twisting it to the right. As I stand up from the bed I support myself with my left hand on the edge of the sink. Then I pass the glass from my left to my right hand. I stand up from the bed and walk to the living unit.

Drinking water

I raise the glass to my mouth. My left arm is straight and motionless. I tilt my head back and shake my hair away from my face. I tip the water into my open mouth and gulp. To control the flow of water into my mouth, I open and close my lips slowly, and open and close them again. The water waves back and forth in the glass every time I swallow. My neck moves every time I swallow. I drink until the glass is empty. I press my lips together to suck in the droplets that are left there.

I place the glass down on the right-hand side of the table in the living unit. When the glass is resting on the table I release my grip and move my hand away from the glass back towards my body.

Walking back and forth

I walk back and forth across all the units. I walk with even steps very slowly. I take a big step to cross the gap and my body lurches forward. When I reach the end of the bedroom unit I turn around, pause with my back against the wall, and then walk back the other way by putting one foot in front of the other. When I reach the end of the bathroom unit I turn around, pause with my back against the wall, and then walk back the other way by putting one foot in front of the other. It takes nineteen steps to get from one end to the other. I go back and forth for as long as I have to. The wooden floor of the units creaks with every step. My spine is curved forward as I walk and I look at the floor in front of me. I keep walking back and forth for as long as I have to.

Winding up the metronome

The metronome stops ticking and I need to wind it up. I move my body towards it slowly, taking even steps. I pick it up with my right hand and then pass it to my left. I twist the knob clockwise round and round and round and round again until it cannot go round anymore. I do this very slowly. My body is still and only my wrist moves. It takes twenty-two twists to wind up the metronome all the way. I put the metronome back down where it was and then set off the ticker again. It ticks. The metronome faces the audience.

Sitting on the chair

I put my body in front of the chair and bend my knees until my bottom rests on the seat of the chair. I put my hands together in my lap.

I take a deep breath and my chest rises. Then it falls. I remain sitting still. The metronome is on the left-hand side of the table and it is ticking. My feet are flat on the floor and spaced hip-width apart. My back is straight against the chair. I look at the audience. My head does not move, only my eyes. I blink. My mouth is closed. I blink again. When I take deeper breaths my chest rises and falls. The rest of my body is motionless. After I have been sitting for a long time I have to straighten my back up. I remain sitting until I need to stand up.

Filling the glass

I pick up the empty glass from the table. I take the glass to the sink in the bedroom unit and sit down on the bed, twisting round to face the sink. I hold the glass in my left hand and put it underneath the tap in the sink. I push the tap up and then twist it to the left with my right hand until water trickles out. I tilt my head down towards the tap and watch the water flow. I let the glass fill up slowly. My right hand rests on the tap. When the glass is full I turn off the tap by pushing it up and then twisting it to the right. As I stand up from the bed I support myself with my left hand on the edge of the sink. Then I pass the glass from my left to my right hand.

Drinking water

I raise the glass to my mouth. My left arm is straight and motionless. I tilt my head back and shake my hair away from my face. I tip the water into my open mouth and gulp. To control the flow of water into my mouth, I open and close my lips slowly, and open and close them again. The water waves back and forth in the glass every time I swallow. My

neck moves every time I swallow. I drink until the glass is empty. I press my lips together to suck in the droplets that are left there.

I place the glass down on the right-hand side of the table in the living unit. When the glass is resting on the table I release my grip and move my hand away from the glass back towards my body.

Standing at the back

I stand at the back of the living unit leaning against the wall. My hands are clasped together behind my back. My feet are together. I look at someone in the audience.

Standing at the front

I stand at the front of the living unit over the knife ladder. My hands are by my sides. My fingers are curved. I look at someone in the audience.

Every time I breathe in, the bottom of my shirt moves in towards my torso. Every time I breathe out, the bottom of my shirt moves out away from my torso. Nothing else moves, except the lids of both my eyes. They always move at the same time.

Sitting on the chair

I put my body in front of the chair and bend my knees until my bottom rests on the seat of the chair. I put my hands together in my lap.

I take a deep breath and my chest rises. Then it falls. I remain sitting still. The metronome is on the left-hand side of the table and it is ticking. My feet are flat on the floor and spaced hip-width apart. My back is straight against the chair. I look at the audience. My head does not move, only my eyes. I blink. My mouth is closed. I blink again. When I take deeper breaths my chest rises and falls. The rest of my body is motionless.

Starting the metronome

I lean across from the chair to the table and push the ticker right over to the left-hand side with the index finger of my right hand. Then I release the ticker and it starts swinging back and forth.

Filling the glass

I pick up the empty glass from the table. I take the glass to the sink in the bedroom unit and sit down on the bed, twisting round to face the sink. I hold the glass in my left hand and put it underneath the tap in the sink. I push the tap up and then twist it to the left with my right hand until water trickles out. I tilt my head down towards the tap and watch the water flow. I let the glass fill up slowly. My right hand rests on the tap. When the glass is full I turn off the tap by pushing it up and then twisting it to the right. As I stand up from the bed I support myself with my left hand on the edge of the sink. Then I pass the glass from my left to my right hand.

Drinking water

I raise the glass to my mouth. My left arm is straight and motionless. I tilt my head back and shake my hair away from my face. I tip the water into my open mouth and gulp. To control the flow of water into my mouth, I open and close my lips slowly, and open and close them again. The water waves back and forth in the glass every time I swallow. My neck moves every time I swallow. I drink until the glass is empty. I press my lips together to suck in the droplets that are left there.

Peeing

I need to pee. I step across the gap to the bathroom unit with my left leg first and touch the outer wooden frame with my left hand. When I am in the unit I turn to my right and take the toilet paper from the shelf with my right hand. I take four steps over towards the toilet and turn my body round clockwise. When my back is to the audience I lean over and put the toilet roll on the left front corner of the shower tray. Then I lift the lid of the toilet with my right hand. I push it back until it is resting on the back of the unit. As I turn towards the front I lift up my shirt so I

can unfasten my trousers. There are four buttons to unfasten. I tilt my head forward. When I have undone all the buttons I pull my trousers and my slip down to just above my knees and sit on the toilet. I put my feet close together in front of me and cup my hands together in my lap. My two index fingers and thumbs make a triangle shape. The tips of the fingers on my left hand touch the tips of the fingers on my right hand.

I look down. I sit still and wait for the pee to come. It takes a while and there is silence. I am motionless, except for my eyelids, which slide down over my eyes occasionally, and then slide back up.

When I have finished peeing I lean over and take the toilet paper with my left hand. Holding it over my lap I unroll some paper and fold it precisely in half and then in half again and then in half again. I tear the bundle from the roll and place the roll back on the corner of the shower tray. I stand up and wipe myself with my right hand. Then I pull up my slip and my trousers and do up the four buttons. Then I straighten my shirt out.

I lean over and push down the handle of the bucket towards the front, then I turn on the tap on the wall with my left hand. The water falls into the bucket beneath. I stand still with my hands behind my back and listen to the sound. When the bucket is half full I turn off the tap and lift the bucket. I pour the water down the toilet to flush it, then I put the lid down. I place the bucket back where it was, underneath the tap, and pull the handle up so it is in the middle.

I pick up the toilet roll and put it back on the shelf where it was before. Then I brush my hair back from my face with both hands.

Standing at the back

I stand at the back of the living unit leaning against the wall. My hands are clasped together behind my back. My feet are together. I look at someone in the audience. The metronome stops and I lean forward and tap it into motion again. Then I lean back and continue looking at the audience. The metronome stops again and I lean forward to prod the ticker. Then I stand up straight again and stare at the public. The metronome stops again. I leave it silent.

Standing at the front

I stand at the front of the living unit over the knife ladder. My hands are by my sides. My fingers are curved. I look at someone in the audience.

Every time I breathe in, the bottom of my shirt moves in towards my torso. Every time I breathe out, the bottom of my shirt moves out away from my torso. Nothing else moves, except the lids of both my eyes. They always move at the same time.

The metronome stops ticking. I turn around and tap the ticker. It starts ticking. I stare at the metronome.

Sitting on the chair

I put my body in front of the chair and bend my knees until my bottom rests on the seat of the chair. I hold the front two corners of the chair as I lower myself. Then I put my hands together in my lap.

I take a deep breath and my chest rises. Then it falls. I remain sitting still. The metronome is on the left-hand side of the table and it is ticking. The glass is in the center of the table and is empty. My feet are flat on the floor and spaced hip-width apart. My back is straight against the chair. I look at the audience. My head does not move, only my eyes. I blink. My mouth is closed. I blink again. When I take deeper breaths my chest rises and falls. The rest of my body is motionless.

I place one hand on each thigh, halfway between my knee and my hip. My fingers are splayed out. The fingers on my right hand are slightly further apart than those on my left hand. The fingers of my left hand curve inward more than the fingers of my right hand.

The metronome stops ticking. I push the ticker and it ticks again, eleven times. Then it stops.

Filling the glass

I pick up the empty glass from the table. I take the glass to the sink in the bedroom unit and sit down on the bed, twisting round to face the sink. I hold the glass in my left hand and put it underneath the tap in the sink. I push the tap up and then twist it to the left with my right hand until water trickles out. I tilt my head down towards the tap and watch the water flow. I let the glass fill up slowly. My right hand rests on the tap. When the glass is full I turn off the tap by pushing it up and then twisting it to the right. As I stand up from the bed I support myself with my left hand on the edge of the sink. Then I pass the glass from my left to my right hand.

Drinking water

I raise the glass to my mouth. My left arm is straight and motionless. I tilt my head back and shake my hair away from my face. I tip the water into my open mouth and gulp. To control the flow of water into my mouth, I open and close my lips slowly, and open and close them again. The water waves back and forth in the glass every time I swallow. My neck moves every time I swallow. I drink until the glass is empty. I press my lips together to suck in the droplets that are left there. I carry the glass back into the living unit and place the glass on the table.

Standing at the back

I stand at the back of the living unit leaning against the wall. My hands are clasped together behind my back. My feet are together. I look at someone in the audience.

Standing at the front

I walk to the front and stand still there. The knife ladder is beneath me. My wrists are tensed so that my hands point outwards. Outside a truck goes by and makes a sound.

Standing between the units

I stand with one foot in the living unit and one foot in the bedroom unit, so that my body is over the gap. My legs make a triangle. Holding my arms at chest height, I rest my hands on the back of the wooden frames. I look at someone in the audience and remain still.

Trying to start the metronome

The ticking has stopped. I walk over to the table where the metronome is and pull the ticker down with the index finger of my right hand. Then I release the ticker. It swings back and forth and ticks nine times. Then it stops. I pull the ticker down and release. It ticks nine times. Then it stops. I pull the ticker down and release. This time it ticks nineteen times and then stops. I pull the ticker down and release. It ticks nine times. Stops. Pull. Release. Nine. Stop. Pull. Release. Twenty-two ticks then it stops. My finger is hovering over the ticker all the time. Pull and let go. Just seven ticks then stop. Extend bent finger, touch ticker and pull it down by bending finger. Lift finger and let go. Seven ticks this time. Stop. Pull then release, using index finger. Now five ticks. Silence. I walk away. The metronome starts ticking by itself. Then stops.

Peeing

I need to pee. I step across the gap to the bathroom unit with my left leg first and touch the outer wooden frame with my left hand. When I am in the unit I turn to my right and take the toilet paper from the shelf with my right hand. I take four steps over towards the toilet and turn my body round clockwise. When my back is to the audience I lean over and put the toilet roll on the left front corner of the shower tray. Then I lift the lid of the toilet with my right hand. I push it back until it is resting on the back of the unit. As I turn towards the front I lift up my shirt so I can unfasten my trousers. There are four buttons to unfasten. I tilt my head forward. When I have undone all the buttons I pull my trousers and my slip down to just above my knees and sit on the toilet. I put my feet close together in front of me and cup my hands together in my lap.

My two index fingers and thumbs make a triangle shape. The tips of the fingers on my left hand touch the tips of the fingers on my right hand.

I look at the floor. I sit still and wait for the pee to come. It takes a while and there is silence. I am motionless, except for my eyelids, which slide down over my eyes occasionally, and then slide back up.

When I have finished peeing I lean over and take the toilet paper with my left hand. Holding it over my lap I unroll some paper and fold it precisely in half and then in half again and then in half again. I tear the bundle from the roll and put the roll on my lap. I wipe my nose with the bundle. Then I tear off another bundle. I stand up and wipe myself with my right hand. Then I pull up my slip and my trousers and do up the four buttons. Then I straighten my shirt out. Then I push my hair back from my face.

I lean over and push down the handle of the bucket towards the front, then I turn on the tap on the wall with my left hand. The water falls into the bucket beneath. I stand still with my hands behind my back and listen to the sound. When the bucket is half full I turn off the tap and lift the bucket. I pour the water down the toilet to flush it, then I put the lid down. I place the bucket back where it was, underneath the tap, and pull the handle up so it is in the middle.

I pick up the toilet roll and put it back on the shelf where it was before. I walk away.

Standing at the front

I stand in the middle of the living unit. I stare at somebody. I am motionless. Then I tense my fingers. I turn my head to stare at someone else.

Filling the glass

I pick up the empty glass from the table. I take the glass to the sink in the bedroom unit and sit down on the bed, twisting round to face the sink. I hold the glass in my left hand and put it underneath the tap in the sink. I push the tap up and then twist it to the left with my right hand until water trickles out. I tilt my head down towards the tap and watch the water flow. I let the glass fill up slowly. My right hand rests on the tap. When the glass is full I turn off the tap by pushing it up and then twisting it to the right. As I stand up from the bed I support myself with my left hand on the edge of the sink. Then I pass the glass from my left to my right hand.

Drinking water

I raise the glass to my mouth. My left arm is straight and motionless. I tilt my head back and shake my hair away from my face. I tip the water into my open mouth and gulp. To control the flow of water into my mouth, I open and close my lips slowly, and open and close them again. The water waves back and forth in the glass every time I swallow. My neck moves every time I swallow. I drink until the glass is empty. I press my lips together to suck in the droplets that are left there. I carry the glass back in to the living unit and place the glass on the table.

Sitting on the chair

I put my body in front of the chair and bend my knees until my bottom rests on the seat of the chair. I push my hair back and then I put my hands together in my lap.

I take a deep breath and my chest rises. Then it falls. I remain sitting still.

Standing at the back

I stand at the back of the living unit leaning against the wall. My hands are clasped together behind my back. My feet are together. I look into the eyes of someone in the audience.

Sitting on the bed

I slouch on the bed, leaning my back against the back wall. My hands are cupped in my lap. My feet are on the ground. My eyes are on

someone in the audience. Then I lean forward and stand up, pressing my hands against my thighs. I walk to the metronome, pick up the metronome and bring the metronome to the bed and put the metronome down on the bed and sit down on the bed and set the metronome ticking and stare at the metronome.

Filling the glass

I walk to the table and pick up the empty glass from the table. I take the glass to the sink in the bedroom unit and sit down on the bed, twisting round to face the sink. I hold the glass in my left hand and put it underneath the tap in the sink. I push the tap up and then twist it to the left with my right hand until water trickles out. I tilt my head down towards the tap and watch the water flow. I let the glass fill up slowly. My right hand rests on the tap. When the glass is full I turn off the tap by pushing it up and then twisting it to the right. As I stand up from the bed I support myself with my left hand on the edge of the sink. Then I pass the glass from my left to my right hand.

Drinking water

I raise the glass to my mouth. My left arm is straight and motionless. I tilt my head back and shake my hair away from my face. I tip the water into my open mouth and gulp. To control the flow of water into my mouth, I open and close my lips slowly, and open and close them again. The water waves back and forth in the glass every time I swallow. My neck moves every time I swallow. I drink until the glass is empty. I press my lips together to suck in the droplets that are left there. I carry the glass back into the living unit and place the glass on the table.

Standing at the back

I stand at the back of the living unit leaning against the wall. My hands are clasped together behind my back. My feet are together. I look at someone in the audience.
Then I walk to the front.

Standing at the front

I stand in the middle of the living unit at the front over the knife ladder. I stare at somebody. I am motionless. Then I walk to the back.

Standing at the back

I stand at the back of the living unit leaning against the wall. I hold my hands together behind my back. My feet are together. I look at the eyes of someone in the audience. The metronome stops ticking.

Peeing

I need to pee. I step across the gap to the bathroom unit with my left leg first and touch the outer wooden frame with my left hand. When I am in the unit I turn to my right and take the toilet paper from the shelf with my right hand. I take four steps over towards the toilet and turn my body round clockwise. When my back is to the audience I lean over and put the toilet roll on the left front corner of the shower tray. Then I lift the lid of the toilet with my right hand. I push it back until it is resting on the back of the unit. As I turn towards the front I lift up my shirt so I can unfasten my trousers. There are four buttons to unfasten. I tilt my head forward. When I have undone all the buttons I pull my trousers and my slip down to just above my knees and sit on the toilet. I put my feet close together in front of me and cup my hands together in my lap. My two index fingers and thumbs make a triangle shape. The tips of the fingers on my left hand touch the tips of the fingers on my right hand.

I look at the floor. I sit still and wait for the pee to come. It takes a while and there is silence. I am motionless, except for my eyelids, which slide down over my eyes occasionally, and then slide back up.

When I have finished peeing I lean over and take the toilet paper with my left hand. Holding it over my lap I unroll some paper, tear it off and fold it precisely in half and then in half again and then in half again. I stand up and wipe myself with my right hand. Then I pull up my slip

and my trousers and do up the four buttons. Then I straighten my shirt out. Then I push my hair back from my face.

I lean over and push down the handle of the bucket towards the front, then I turn on the tap on the wall with my left hand. The water falls into the bucket beneath. I stand still with my hands behind my back and listen to the sound. When the bucket is half full I turn off the tap and lift the bucket. I struggle to lift the bucket but I do lift it. Then I pour the water down the toilet to flush it, then I put the lid down. I place the bucket back where it was, underneath the tap, and pull the handle up so it is in the middle.

I pick up the toilet roll and put it back on the shelf where it was before. I walk away.

Winding up the metronome

The metronome stops ticking. I move my body towards it slowly, taking even steps. I pick it up with my right hand and then pass it to my left. I twist the knob clockwise round and round and round and round again until it cannot go round anymore. I do this very slowly. My body is still and only my wrist moves. I put the metronome back down where it was and then set off the ticker again. It ticks. Then it stops ticking. Then I set it into motion again by prodding the ticker with the index finger on my right hand.

Sitting on the chair

I put my body in front of the chair and bend my knees until my bottom rests on the seat of the chair. I push my hair back and then I put my hands together in my lap.

I turn my head slowly, looking for someone to stare at. I find someone and stare at them and remain sitting still until I get up.

Standing at the front

I stand in the middle of the living unit at the front over the knife ladder. I stare at somebody. Then I turn round and walk to the back.

Standing at the back

I stand at the back of the living unit leaning against the wall. I hold my hands together behind my back. My feet are together. I look at someone in the audience. The metronome stops ticking.

Standing between the units

I stand with one foot in the living unit and one foot in the bathroom unit, so that my body is over the gap. My legs make a triangle. Holding my arms at chest height, I rest my hands on the back of the wooden frames. I look at the eyes of someone in the audience. Then I turn my head to look at someone else.

Sitting on the chair

I put my body in front of the chair and bend my knees until my bottom rests on the seat of the chair. I push my hair back and then I put my hands together in my lap. My back is slouched forward. I look at someone in the audience.

Standing at the back

I stand at the back of the living unit, between the chair and the table, and I lean against the wall. I hold my hands together behind my back. My feet are together. I look at someone in the audience. The metronome stops ticking. There is silence.

Trying to start the metronome

I take the ticker between my finger and thumb and pull it down towards me and release it and it starts ticking. I look at it and it ticks nine times. It stops. I pull the ticker down with my finger then rest my hand in a cage shape on the table. The ticker ticks nine times and then stops. I pull the ticker down with my finger and it starts swinging back and forth again. It ticks seven times. Then it stops. Then I walk away.

Showering

I take the towel from the shelf and lay it on the toilet seat. Then I pick up the bath mat from inside the shower tray and unroll it on the floor in front of the shower. Then I pick up my hairband from the shelf. Then I sit on the edge of the toilet and put my hairband on the floor. Then I sit on the toilet seat, lean over and untie the laces of my right boot, trying to use only one hand. When the laces are loose enough, I take off the boot and then pull off the sock by grabbing the toe. I put the sock in the boot. Then I untie the laces of my left boot. When the laces are loose enough I take off the boot and then pull off the sock by grabbing the toe. I put the sock in the boot. The boots are next to each other by the wall.

Then I undo the buttons on my trousers and stand up so I can pull them down. When I have sat down again, I finish pulling them off, starting with the right leg and finishing with the left leg. Then I fold them in half and then half again and then half again and put them on the floor next to the boots.

I brush the hair from my face and undo the buttons on my collar and the buttons of my shirt, starting at the bottom. There are seven buttons to undo. Then I take off my shirt and lay it across my legs. Then I take off my undershirt and fold it up neatly. Then I take off my slip. I put all my clothes on the floor next to my boots.

Then I pick up the hairband off the floor, pull my hair together behind my head and tie it back with my hairband. I stand on the left of the shower, outside the tray, and turn on the taps. I test the temperature of the water by holding out my left hand under the trickle. I wait for the water to warm up. I step into the shower and face the audience. My hands are open, palms out and fingers straight, beside me. I open my mouth very wide very quickly and hold it wide open for a long time. I let it fill up with water. Then I spit it out. I rock my head from side to side, slowly. Then I open my mouth wide again.

Then I cover my face with my hands.

I reach behind me and turn off the taps.

I lean over to pick up the towel. I press the towel hard against my face for a long time, leaning forward. When I am ready, I move the towel away and then rub the towel over my arms, then my torso, then my legs. I do not dry myself very thoroughly. I lay the towel over the toilet seat and sit down on it.

I cover my face with my hands.

Then I take off my hairband and put it on the floor.

Then I lean forward and touch my toes and stretch my back.

Then I put my slip back on. Then I put my undershirt back on by putting my head through the head hole and my arms through the armholes. I do the same with my shirt and do up the buttons on my cuffs. I do up the buttons starting at my neck and working my way downward. Then I put on my trousers. I straighten out all of my clothes. I pull my hairband off and put it back on the shelf. I sit back down and put my right sock on followed by my right boot. I tie the laces. Then I put my left sock on followed by my left boot. I tie the laces. I stand up.

Before I step into the living unit, I stand in front of the shelves and run my fingers through my hair.

Standing at the front

I stand in the middle of the living unit at the front over the knife ladder. I stare at somebody. My hands are taut, my fingers together, my knuckles raised.

Starting the metronome

The metronome has stopped so I start it again. I take the ticker between my fingers and push it gently to one side. Then I release it and it starts ticking again. I rest my hand on the table.

Filling the glass

I walk to the table and pick up the empty glass from the table. I take the glass to the sink in the bedroom unit and sit down on the bed, twisting round to face the sink. I hold the glass in my left hand and put it underneath the tap in the sink. I push the tap up and then twist it to the left with my right hand until water trickles out. I tilt my head down towards the tap and watch the water flow. I let the glass fill up slowly. My right hand rests on the tap. When the glass is full I turn off the tap by pushing it up and then twisting it to the right. As I stand up from the bed I support myself with my left hand on the edge of the sink. Then I pass the glass from my left to my right hand.

Drinking water

I raise the glass to my mouth. My left arm is straight and motionless. I tilt my head back and shake my hair away from my face. I tip the water into my open mouth and gulp. To control the flow of water into my mouth, I open and close my lips slowly, and open and close them again. The water waves back and forth in the glass every time I swallow. My neck moves every time I swallow. I drink until the glass is empty. I press my lips together to suck in the droplets that are left there. I carry the glass back into the living unit and place the glass on the table.

Peeing

I need to pee. I sit on the wooden toilet and pee.

Then I blow my nose with tissue paper. Then I unroll some more tissue paper, fold it up and wipe myself with the bundle. I stand up and pull up my slip and trousers and fasten the buttons.

As I bend down to turn the tap on to fill the bucket my right hand is behind my back.

While the water falls into the bucket I stand facing the audience diagonally. I have both hands behind my back. Behind my back my hands are holding each other.

I turn off the tap and lift up the bucket with both hands. Then I hold the bucket over the toilet and tilt it until the water flows out and washes away the pee that is in the toilet.

I close the lid.

I put back the bucket, return the toilet paper to the shelf and walk away.

Standing at the back

I stand at the back of the living unit with my hands behind my back touching the wall behind me. I look at the audience. I breathe. The metronome ticks.

Standing between the units

I stand with one foot in the living unit and one foot in the bedroom unit, so that my body is over the gap. My legs make a triangle. I rest my arms on the back of the wooden frames, at chest level. I look at the audience and remain still. The metronome stops.

Moving the chair and sitting on the moved chair

I push the chair forward to the front of the living unit and sit on it. I put my hands together in my lap and look out at the audience. The ends of my feet stick out over the edge.

Filling the glass

I grip the glass in my right hand and lift it up from the table. I walk towards the sink, sit on the bed, twist round and then turn the tap on. The glass is underneath the tap and the water falls into it.

Drinking water

When the glass is full I stand up and pour the water into my open mouth. When the glass is empty I hold it under my nose and look into it.

Standing between the units

One foot is in the living unit; the other is in the bathroom unit. My legs make a triangle. My arms hold the pillars to balance. My head points forward. My eyes meet with the audience. The metronome ticks.

Peeing

I need to pee. I lift up the toilet seat, pull down my trousers and slip, and sit over the hole. My hands are cupped together in my lap. I look at the floor. I pee.

Then I pick up the toilet roll from the corner of the shower tray, rip off a length of it, fold it into a bundle and wipe myself. Then I pull up my slip and trousers again. I straighten my shirt.

I twist the tap on the wall until water pours out into the bucket below. I stand and listen to the water falling with my hands behind my back.

I lift up the bucket and rest it on the corner of the toilet. Then I lift it up again, hold it over the hole and pour the water down into the toilet until there is no more water left in the bucket. Then I put the bucket back where it was. Then I put the toilet paper back where it was. Then I walk away.

Sitting on the chair

I sit on the chair.

Standing at the front

I stand at the front. I look at one person then at another person.

Moving the chair back

I tilt the chair back and wiggle it backwards from one leg to another. Then I try to lift it but I can't. I leave it in the middle of the living unit.

Standing at the back

I stand at the back of the living unit with my hands behind my back. I lean against the wall. I look at a person in the audience. The metronome stops ticking again.

Starting the metronome

I walk to the metronome and prod it with the index finger on my right hand. It starts to tick again. I walk away.

Walking back and forth

I walk back and forth twice between all the units by putting one foot in front of the other. Then I stop in the living unit to look at someone. I stand in the middle, my head tilting forwards, my eyes focused on a person in the audience. Then I break the stare and continue walking back and forth. It takes seventeen steps to walk across all three units. On my way through the living unit I pause to start the metronome again. It stops again. On my way back through I start it again. It stops again.

Standing between the units

One foot is in the living unit; the other is in the bathroom unit. My legs make a triangle. My arms hold the pillars to balance. My head points forward. My eyes meet with the audience.

Moving the metronome to the bedroom unit and sitting on the bed

I pick up the metronome from the table and carry it into the bedroom unit. I put it on the floor and set it going. I sit on the bed, listen to the ticking and I stare at the audience. The metronome stops ticking after four ticks. I lean forward and put my elbows on my knees and my chin in my hands. I stare. I get up and take the hairband from the shelf and walk away.

Showering

I put the hairband on the floor between the shower tray and the toilet. I take the towel from the shelf and spread it on the toilet seat. I take the bathmat from the shelf and spread it on the floor in front of the shower tray. I sit on the toilet, lean forward and remove first my right boot and then my left. I pull my socks off and put them in my boots.

Then I stand up and pull down my trousers. As they get to knee level I sit down and remove them completely. Then I fold them up. Then I put them on the floor. Then I undo the buttons of my pajama top, starting from the bottom, and take it off. Then I fold it up and put it on the floor, on top of my trousers. Then I take off my undershirt. Then I fold it up and put it on the pile of clothes. Then I take off my slip, straighten it out, fold it and put it on the pile.

Then I pick up the hairband from the floor, pull my hair back and tie it up.

I stand up and twist on the taps with my right hand. I feel the temperature of the water and stand still. I turn on the other tap. I step into the shower. I open my palms and close my eyes.

I scream but don't make a sound.

The water runs over me.

I turn the taps off, pick up the towel and bury my face in it.

Then I wipe my body with the towel.

I sit back down on the toilet seat and bend over and touch my toes and stretch my back. My back rises when I breathe in and falls when I breathe out.

Then I put all my clothes back on, one by one, very slowly.

I roll up the bath mat by pulling it towards me with each roll. I leave it in the shower tray. Then I fold up my towel and put it back on the shelf. Then I pick up the hairband from the floor.

I do not put my shoes on. I pick them up and carry them in one hand to the living unit.

Sitting on the edge

I stand over the knife ladder in the living unit, lean over the edge and look down. Then I sit with my legs between the rails of the knife ladder and my bare feet resting on the blade of the second knife. I sit with my palms resting on the platform edge.

I sing.

I stare at the audience.

Then I hunch my legs up and rest my feet on the platform. I hug my legs together with my hands and arms. I stop singing. I stare.

The metronome is silent so I lean over and make it tick again by pulling the ticker. It ticks. It stops. I make it tick again. It stops. I leave it.

Then I put my feet back on the knife-blade and start singing again. I rest my hands on the top of the ladder. I cover my face with hands, brush my hair back and continue singing. Then I cover my face again and shake my head.

Sitting inside the table

I turn the table up on its end and push it to the front of the platform so that the ends of the table legs are hanging over the edge. I climb into the table and sit between the legs. My legs dangle over the edge. I put my hands in my lap and upturn them while I stare at somebody in the audience.

Peeing

I need to pee. I lift up the toilet seat, pull down my trousers and slip, and sit over the hole. I put the tips of my fingers together and a circle shape is created. I look down. My hands are cupped together in my lap. I look at the floor. I pee.

Then I pick up the toilet roll from the corner of the shower tray, rip off a length of it, fold it into a bundle and wipe myself. Then I pull up my

slip and trousers again. I straighten my shirt.

I do not flush the toilet.

Kneeling

I stand at the front of the living unit staring at somebody with my hands flared out. I take a step backwards and bend my knees until they touch the floor. I put my hands out on the floor to support myself. I lean forward and I point my head forward as I kneel and remain staring at the person.

Checking the shower taps are turned off

I step from the living unit into the bathroom unit. I stand by the shower as I do when I'm about to take a shower, but my clothes are still on. I look up at the shower head and I turn the taps in the opposite direction that I usually turn them in. The taps are turned all the way off. No water was dribbling from the shower head before and no water dribbles from the shower head now. I walk away.

Laughing

I sit on the bed with hands cupped in my lap and my feet apart. I look into the audience. Somebody does something and my face tenses up, the corners of my mouth widen and upturn, my chest convulses and a sound comes up from my belly. My forehead creases and I cover my face with my hands. Still the high-pitched sound comes in spasms from my belly. Then it stops. Then it starts again as I look down and squeeze my cheeks without touching them and rock back and forth a little.

Then I sing the same song I always sing.

Sitting on the edge

I stand over the knife ladder in the living unit, lean over the edge and look down. Then I sit down and take my shoes and socks off. I sit with my legs between the rails of the knife ladder and my bare feet resting on the blade of the second knife. I sit with my hands on the ends of the ladder, singing.

I sing.

I stare at the audience.

Filling the glass

I walk to the table and pick up the empty glass from the table. I take the glass to the sink in the bedroom unit and sit down on the bed, twisting round to face the sink. I hold the glass in my left hand and put it underneath the tap in the sink. I push the tap up and then twist it to the left with my right hand until water trickles out. I tilt my head down towards the tap and watch the water flow. I let the glass fill up slowly. My right hand rests on the tap. When the glass is full I turn off the tap by pushing it up and then twisting it to the right. As I stand up from the bed I support myself with my left hand on the edge of the sink. Then I pass the glass from my left to my right hand.

Drinking water

I raise the glass to my mouth. My left arm is straight and motionless. I tilt my head back and shake my hair away from my face. I tip the water into my open mouth and gulp. To control the flow of water into my mouth, I open and close my lips slowly, and open and close them again. The water waves back and forth in the glass every time I swallow. My neck moves every time I swallow. I drink until the glass is empty. I press my lips together to suck in the droplets that are left there. I carry the glass back into the living unit and place the glass on the upturned table leg.

Peeing

I need to pee. I lift up the toilet seat, pull down my trousers and slip, and sit over the hole. I put the tips of my fingers together and a circle shape is created. I look down. My hands are cupped together in my lap. I look at the floor. I pee.

Then I pick up the toilet roll from the corner of the shower tray, rip off a length of it, fold it into a bundle and wipe myself. Then I pull up my slip and trousers again. I straighten my shirt.

I do not flush the toilet.

Kneeling

I stand at the front of the living unit in front of the chair. I stare at somebody. My hands are flared out. I take a step backwards and bend my knees until they touch the floor. I put my hands out on the floor to support myself. I lean forward and I point my head forward as I kneel and remain staring at the person. My hand grasps the edge of the platform.

Putting the table back up the right way

I drag the table from the edge into the middle of the living unit. I look at the table. I grip the legs and pull it towards me. I pause and look at the table. Then I stand on the bottom legs and hold the top legs and try to lift the table by rocking back and forth. It doesn't work. I walk round to the other side of the table and lift it up by the tabletop. I make a sound.

Showering

I put the hairband on the floor between the shower tray and the toilet. I take the towel from the shelf and spread it on the toilet seat. I take the bathmat from the shelf and spread it on the floor in front of the shower tray. I sit on the toilet, lean forward and remove first my right boot and then my left. I pull my socks off and put them in my boots.

Then I stand up and pull down my trousers. As they get to knee level I sit down and remove them completely. Then I fold them up. Then I put them on the floor. Then I undo the buttons of my pajama top, starting from the bottom, and take it off. Then I fold it up and put it on the floor, on top of my trousers. Then I take off my undershirt. Then I fold it up and put it on the pile of clothes. Then I take off my slip, straighten it out, fold it and put it on the pile.

Then I pick up the hairband from the floor and put it on my naked knee as I pull my hair back. Then I tie my hair up with the hairband.

I stand up and twist on the taps with my right hand. I feel the temperature of the water and stand still. I turn on the other tap. As I stand waiting for the water to warm up, I laugh at somebody in the audience. Then I step into the shower. I open my palms and close my eyes.

I scream but don't make a sound.

The water runs over me.

I turn the taps off, pick up the towel and bury my face in it.

Then I wipe my body with the towel.

I sit back down on the toilet seat and bend over and touch my toes and stretch my back. My back rises when I breathe in and falls when I breathe out.

Then I put all my clothes back on, one by one, very slowly.

I roll up the bath mat by pulling it towards me with each roll. I leave it in the shower tray. Then I fold up my towel and put it back on the shelf. Then I pick up the hairband from the floor and walk away.

Filling the glass

I take the glass to the sink in the bedroom unit and sit down on the bed, twisting round to face the sink. I hold the glass in my left hand and put it underneath the tap in the sink. I push the tap up and then twist it to the left with my right hand until water trickles out. I tilt my head down towards the tap and watch the water flow. I let the glass fill up slowly. My right hand rests on the tap. When the glass is full I turn off the tap by pushing it up and then twisting it to the right. As I stand up from the bed I support myself with my left hand on the edge of the sink. Then I pass the glass from my left to my right hand.

Drinking water

I raise the glass to my mouth. My left arm is straight and motionless. I tilt my head back and shake my hair away from my face. I tip the water into my open mouth and gulp. To control the flow of water into my mouth, I open and close my lips slowly, and open and close them again. The water waves back and forth in the glass every time I swallow. My neck moves every time I swallow. I drink until the glass is empty. I press my lips together to suck in the droplets that are left there.

Sitting on the bed

I sit on the bed, more to the right than the left. My hands are cupped in my lap. My feet are on the ground. My eyes are on someone in the audience.

Standing at the front

I stand at the front of the bedroom unit, in front of the knife ladder. I do not open my palms as I stare at someone. I flare my fingers away from my hips and raise my wrists.

Kneeling

I kneel in the bathroom unit, near the entrance. My hands are resting flat on the floor, pointing outwards. Then I move them. I grasp the edge of the platform and lean further forward so that I am almost bent double.

Sitting on chair

I move the chair to the front and sit on it.

Shower

I put the hairband on the floor between the shower tray and the toilet. I take the towel from the shelf and spread it on the toilet seat. I take the bathmat from the shelf and spread it on the floor in front of the shower tray. I sit on the toilet, lean forward and remove first my right boot and then my left. I pull my socks off and put them in my boots.

I sing as I undress.

I stand up and pull down my trousers. As they get to knee level I sit down and remove them completely. Then I fold them up. Then I put them on the floor. Then I undo the buttons of my pajama top, starting from the bottom, and take it off. Then I fold it up and put it on the floor, on top of my trousers. Then I take off my undershirt. Then I fold it up and put it on the pile of clothes. Then I take off my slip, straighten it out, fold it and put it on the pile.

Then I pick up the hairband from the floor and put it on my naked knee as I pull my hair back. Then I tie my hair up with the hairband.

I stand up and twist on the taps with my right hand. I feel the temperature of the water and stand still. I turn on the other tap. As I stand waiting for the water to warm up, I laugh at somebody in the audience. Then I step into the shower. I open my palms and close my eyes.

I scream but don't make a sound.

The water runs over me.

I turn the taps off, pick up the towel and bury my face in it.

Then I wipe my body with the towel.

I sit back down on the toilet seat and bend over and touch my toes and stretch my back. My back rises when I breathe in and falls when I breathe out.

Then I put all my clothes back, one by one, very slowly.

I roll up the bath mat by pulling it towards me with each roll. I leave it in the shower tray. Then I fold up my towel and put it back on the shelf. Then I pick up the hairband from the floor and walk away.

Standing at the back

I stand at the back of the living unit leaning against the wall. My hands are clasped together behind my back. My feet are together. I look at someone in the audience.

Standing between the units

I stand with one foot in the living unit and one foot in the bedroom unit, so that my body is over the gap. My legs make a triangle. I rest my arms on the back of the wooden frames, at chest level. I look at the audience and remain still.

Sitting on bed

I sit on the bed and stare.

Then I shuffle across the bed to get a better look at somebody.

Winding up the metronome

The metronome is not ticking. I move my body towards it slowly, taking even steps. I pick it up with my right hand and then pass it to my left. I twist the knob clockwise round and round and round and round again until it cannot go round anymore. I do this very slowly. My body is still and only my wrist moves. It takes twenty-two twists to wind up the metronome all the way. I put the metronome back down where it was and then set off the ticker again. It ticks. The metronome faces the audience.

Lying on the bed

I stand in front of the bed a third of the way from the bottom end. I turn clockwise so I am facing the audience. Then, in one fluid movement I sit down on the bed, raise up my feet, move my hands back to balance myself and twist round ninety degrees, lower my body down until it is flat, and rest my head on the quartz pillow. Then I flick my hair back over the pillow so my head is touching the pillow directly. I lie straight on my back with my right leg over my left leg. My hands are linked together over my belly.

Peeing

I need to pee. I lift up the toilet seat, pull down my trousers and slip, and sit over the hole. I put the tips of my fingers together and a circle shape is created. I look down. My hands are cupped together in my lap. I look at the floor. I pee.

Then I pick up the toilet roll from the corner of the shower tray, rip off a length of it, fold it into a bundle and wipe myself. Then I pull up my slip and trousers again. I straighten my shirt.

I twist the tap on the wall until water pours out into the bucket below. I stand and listen to the water falling with my hands behind my back.

I lift up the bucket and rest it on the corner of the toilet. Then I lift it up again, hold it over the hole and pour the water down into the toilet until there is no more water left in the bucket. Then I put the bucket back where it was. Then I put the toilet paper back where it was. Then I walk away.

Sitting on the edge

I sit on the edge of the platform in the living unit, in front of the chair. My legs hang down. My hands are cupped in my lap. I look down at someone in the audience. Then I open my legs a little and my cupped hands flop down between them. After a long stare I cover my face with my hands and then brush my hair back. Then I look at someone else.

Standing at front

I stand at the front over the knife ladder. I stare. I cover my face with my hands. I stare.

Sitting on chair

I sit on the chair and stare.

My hands are between my legs.

Filling the glass

I take the glass to the sink in the bedroom unit and sit down on the bed, twisting round to face the sink. I hold the glass in my left hand and put it underneath the tap in the sink. I push the tap up and then twist it to the left with my right hand until water trickles out. I tilt my head down towards the tap and watch the water flow. I let the glass fill up slowly. My right hand rests on the tap. When the glass is full I turn off the tap by pushing it up and then twisting it to the right. As I stand up from the bed I support myself with my left hand on the edge of the sink. Then I pass the glass from my left to my right hand.

Drinking water

I raise the glass to my mouth. My left arm is straight and motionless. I tilt my head back and shake my hair away from my face. I tip the water into my open mouth and gulp. To control the flow of water into my mouth, I open and close my lips slowly, and open and close them again. The water waves back and forth in the glass every time I swallow. My neck moves every time I swallow. I drink until the glass is empty. I press my lips together to suck in the droplets that are left there.

Sitting on the chair

I sit on the chair and stare. My hands are in my lap. Then I get up.

Standing at front

I stand at the front of the living unit, over the knife ladder. I stare at someone for a long time. Then I cover my face with my hands. I wobble. Then I step back from the edge. I hold my hands out to balance

Sitting on chair

I sit on the chair and stare. My hands are in my lap.

I cover my face with both hands

Filling the glass

I take the glass to the sink in the bedroom unit and sit down on the bed, twisting round to face the sink. I hold the glass in my left hand and put it underneath the tap in the sink. I push the tap up and then twist it to the left with my right hand until water trickles out. I tilt my head down towards the tap and watch the water flow. I let the glass fill up slowly. My right hand rests on the tap. When the glass is full I turn off the tap by pushing it up and then twisting it to the right. As I stand up from the bed I support myself with my left hand on the edge of the sink. Then I pass the glass from my left to my right hand.

Drinking water

I raise the glass to my mouth. My left arm is straight and motionless. I tilt my head back and shake my hair away from my face. I tip the water into my open mouth and gulp. To control the flow of water into my mouth, I open and close my lips slowly, and open and close them again. The water waves back and forth in the glass every time I swallow. My neck moves every time I swallow. I drink until the glass is empty. I press my lips together to suck in the droplets that are left there.

Standing at the front

I stand at the front. I stare. Then I cover my face with my hands. I sigh.

Saturday, November 23rd: Day 9

Wearing violet

Walking back and forth

I walk back and forth across all the units. I walk with even steps very slowly. I take a big step to cross the gap and my body lurches forward. When I reach the end of the bedroom unit I turn around, pause with my back against the wall, then walk back the other way by putting one foot in front of the other. When I reach the end of the bathroom unit I turn around, pause with my back against the wall, and then walk back the other way by putting one foot in front of the other. It takes seventeen steps to get from one end to the other. The wooden floor of the units creaks with every step. My spine is curved forward as I walk and I look at the floor in front of me.

As I walk, I sing.

I stop and brush my hair back from my face.

I continue walking.

The metronome ticks.

Sitting in the chair

I put my body in front of the chair and bend my knees until my bottom rests on the seat of the chair. I put my hands together in my lap. My fingers are interlaced.

I take a deep breath and my chest rises. Then it falls. I remain sitting still. The metronome is on the left-hand side of the table and it is not ticking. The glass is on the right-hand side of the table and it is not full. My feet are flat on the floor and spaced hip-width apart. My back is straight against the chair. I look at the audience. My head does not move, only my eyes. I blink. My mouth is closed. I blink again. When I take deeper breaths my chest rises and falls. The rest of my body is motionless.

Standing

I stand up from the chair and stare. My wrists are tense and my arms are straight. I am pointing a little to the left to look at someone. The metronome starts ticking and then stops again by itself.

I take two steps forward and stand over the knife ladder. I am still looking at the same person. My chest rises and falls when I breathe, which is all the time, and slowly.

Starting the metronome

The metronome has stopped so I start it again. I take the ticker between my fingers and push it gently to one side. Then I release it and it starts ticking again. I rest my hand on the table. Then I raise my hand and my finger hovers over the ticker. I do not touch it. I walk away and it stops ticking.

Filling the glass

I pick up the empty glass from the table. I take the glass to the sink in the bedroom unit and sit down on the bed, twisting round to face the sink. I hold the glass in my left hand and put it underneath the tap in the sink. I push the tap up and then twist it to the left with my right hand until water trickles out. I tilt my head down towards the tap and watch the water flow. I let the glass fill up slowly. My right hand rests on the tap. When the glass is full I turn off the tap by pushing it up and then twisting it to the right. As I stand up from the bed I support myself with my left hand on the edge of the sink. Then I pass the glass from my left to my right hand.

Drinking water

I raise the glass to my mouth. My left arm is straight and motionless. I tilt my head back and shake my hair away from my face. I tip the water into my open mouth and gulp. To control the flow of water into my mouth, I open and close my lips slowly, and open and close them again. The water waves back and forth in the glass every time I swallow. My neck moves every time I swallow. I drink until the glass is empty. I press my lips together to suck in the droplets that are left there. I carry the glass back into the living unit and place the glass on the table.

Moving the metronome to the bedroom unit and sitting on the bed

I pick up the metronome from the table and carry it into the bedroom unit. I put it on the bed and set it ticking. I sit on the bed, listen to the ticking and I stare at the audience. The ticking stops. My hands are holding each other in my lap and I am staring at someone in the audience.

Then I move my hand to the metronome and set it ticking. It swings back and forth and ticks six times before it stops. I push the ticker again and it ticks three times then stops. Then twice and stops. Then I place the tip of my index finger again on the ticker, bend my finger back and then release the ticker so that it ticks again. It ticks six times and then stops. I stare back at the audience.

Standing

I stand up from the bed and stare.

Filling the glass

I walk to the living unit and pick up the empty glass from the table. I take the glass to the sink in the bedroom unit and sit down on the bed, twisting round to face the sink. I hold the glass in my left hand and put it underneath the tap in the sink. I push the tap up and then twist it to the left with my right hand until water trickles out. I tilt my head down towards the tap and watch the water flow. I let the glass fill up slowly. My right hand rests on the tap. When the glass is full I turn off the tap by pushing it up and then twisting it to the right. As I stand up from the bed I support myself with my left hand on the edge of the sink. Then I pass the glass from my left to my right hand.

Drinking water

I raise the glass to my mouth with my right hand. My left arm is straight and motionless. I tilt my head back and shake my hair away from my face. I tip the water into my open mouth and gulp. To control the flow of water into my mouth, I open and close my lips slowly, and open and close them again. The water waves back and forth in the glass every time I swallow. My neck moves every time I swallow. I drink until the glass is empty. I press my lips together to suck in the droplets that are left there. I carry the glass back into the living unit and place the glass on the table.

Sitting on the bed

I sit on the bed and set the metronome ticking and stare at the audience.

The metronome stops ticking. I pick it up, wind it up, and put it on the floor next to my right foot.

Standing at the back

I stand at the back of the living unit leaning against the wall. My hands are clasped together behind my back. My feet are together. I look at someone in the audience.

Peeing

I need to pee. I step across the gap to the bathroom unit with my left leg first. I touch the outer wooden frame with my left hand. When I am in the unit I turn to my right and take the toilet paper from the shelf with my right hand. I keep my left hand behind my back. I take four steps over towards the toilet and turn my body round clockwise. When my back is to the audience I lean over and put the toilet roll on the left front corner of the shower tray. Then I lift the lid of the toilet with my right hand. I push it back until it is resting on the back of the unit. As I turn towards the front I lift up my shirt so I can unfasten my trousers. There are four buttons to unfasten. I tilt my head forward. When I have undone all the buttons I pull my trousers and my slip down to just above my knees and sit on the toilet. I put my feet close together in front of me and cup my hands together in my lap. My two index fingers and thumbs make a triangle shape. The tips of the fingers on my left hand touch the tips of the fingers on my right hand.

I look down, I sit still and wait for the pee to come. It takes a while and there is silence. I am motionless. Then the pee comes.

When I have finished peeing I lean over and take the toilet paper with my left hand. Holding it over my lap I unroll some paper and fold it precisely in half and then in half again and then in half again. I tear the bundle from the roll and place the roll back on the corner of the shower tray. I stand up and wipe myself with my right hand. Then I pull up my slip and my trousers and do up the four buttons. Then I straighten my shirt out.

I lean over and push down the handle of the bucket towards the front, then I turn on the tap on the wall with my left hand. The water falls into the bucket beneath. I stand still with my hands behind my back and listen to the sound. When the bucket is half full I turn off the tap and lift the bucket. I pour the water down the toilet to flush it, then I put the lid down. I place the bucket back where it was, underneath the tap, and pull the handle up so it is in the middle.

I pick up the toilet roll and put it back on the shelf where it was before. Then I brush my hair back from my face with both hands.

Standing at the back

I stand at the back of the living unit leaning against the wall. My hands are clasped together behind my back. My feet are together. I look at someone in the audience.

Kneeling

I walk to the edge, bend my knees and kneel down on the floor at the front of the living unit, to the left of the knife ladder. I put my hands out flat on the floor, pointing outwards, and stare at someone in the audience.

Sitting in the chair

I put my body in front of the chair and bend my knees until my bottom rests on the seat of the chair. I put my hands together in my lap. My fingers are interlaced.

I take a deep breath and my chest rises. Then it falls. I remain sitting still. The metronome is on the left-hand side of the table and it is not ticking. The glass is on the right-hand side of the table and it is not full. My feet are flat on the floor and spaced hip-width apart. My back is straight against the chair. I look at the audience. My head does not

move, only my eyes. I blink. My mouth is closed. I blink again. When I take deeper breaths my chest rises and falls. The rest of my body is motionless.

Standing between the units

I stand with one foot in the living unit and one foot in the bedroom unit, so that my body is over the gap. My legs make a triangle. I rest my arms on the back of the door frames. I look at the audience and remain still.

Kneeling on the floor

I kneel on the floor of the bedroom unit, on the left-hand side. My hands grip the edge of the platform and I stare at somebody. The metronome ticks next to me on the floor. I get up.

Sitting on the bed

I sit on the bed and look at the floor. My hands are cupped together in my lap. My feet are hip-width apart, resting flat on the floor. My head hangs down slightly.

Filling the glass

I pick up the empty glass from the table. I take the glass to the sink in the bedroom unit and sit down on the bed, twisting round to face the sink. I hold the glass in my left hand and put it underneath the tap in the sink. I push the tap up and then twist it to the left with my right hand until water trickles out. I tilt my head down towards the tap and watch the water flow. I let the glass fill up slowly. My right hand rests on the tap. When the glass is full I turn off the tap by pushing it up and then twisting it to the right. As I stand up from the bed I support myself with my left hand on the edge of the sink. Then I pass the glass from my left to my right hand.

Drinking water

Before I raise the glass to my mouth I wipe my mouth. My left arm is straight and motionless. I tilt my head back and tip the water into my open mouth and gulp. To control the flow of water into my mouth, I open and close my lips slowly, and open and close them again. The water waves back and forth in the glass every time I swallow. My neck moves every time I swallow. I drink until the glass is empty. When I have finished I stand still for a long time holding the glass next to my chest. I stare at the floor. Then I carry the glass back into the living unit and place the glass on the table.

Standing at the back

I stand at the back of the living unit leaning against the wall. My hands are clasped together behind my back. My feet are together. I look at someone in the audience. I turn my head and stare at someone else.

Standing at the front

I stand at the front of the living unit over the knife ladder. My hands are by my sides. My fingers are curved. I look at someone in the audience.

Every time I breathe in, the bottom of my shirt moves in towards my torso. Every time I breathe out, the bottom of my shirt moves out away from my torso. Nothing else moves, except the lids of both my eyes. They always move at the same time.

Then I twitch my wrists.

I sing and I sway from side to side.

Showering

I take the towel from the shelf and lay it on the toilet seat. Then I pick up the bath mat from inside the shower tray and unroll it on the floor in front of the shower. I take the hairband from the shelf and sit on the edge of the toilet and put my hairband on the floor. Then I sit on the toilet seat and lean over and untie the laces of my right boot using my

right hand. When the laces are loose enough, I take off the boot and then pull off the sock by grabbing the toe. I put the sock in the boot. Then I untie the laces of my left boot using my left hand. When the laces are loose enough I take off the boot and then pull off the sock by grabbing the toe. I put the sock in the boot. The boots are next to each other by the wall.

Then I stand up and undo the buttons on my trousers. Then I pull them down. When I have sat down again, I finish pulling them off, starting with the right leg and finishing with the left leg. Then I fold them in half and then half again and then half again and put them on the floor next to the boots.

Then I undo the buttons of my shirt, starting at the bottom. There are seven buttons to undo. Then I take off my shirt and lay it across my legs and fold it up. Then I take off my undershirt and fold it up neatly. Then I take off my slip. I put all my clothes on the floor next to my boots.

Then I pick up the hairband off the floor, pull my hair together behind my head, and tie it back with my hairband. I stand on the left of the shower, outside the tray, and turn on the taps. I test the temperature of the water by holding out my left hand under the trickle. I keep my hand there and wait for the water to warm up.

I step into the shower and face the audience. My hands are open, palms out and fingers straight, beside me. I open my mouth very wide very quickly and hold it wide open for a long time. I let it fill up with water. Then I spit it out. I rock my head from side to side, slowly. Then I open my mouth wide again.

I reach behind me and adjust one of the taps.

Then I put my arms down in front of me again.

I rock my head from side to side.

Then I reach behind me with both hands and turn off both taps.

I lean over to pick up the towel. I press the towel hard against my face for a long time, leaning forward. When I am ready, I move the towel away and then rub the towel over my arms, then my torso, then my legs. I do not dry myself very thoroughly. I lay the towel over the toilet seat and sit down on it.

Then I take off my hairband and put it on the floor.

Then I lean forward and touch my toes and stretch my back.

Then I put my slip back on. Then I put my undershirt back on by putting my head through the head hole and my arms through the armholes. I do the same with my shirt and do up the buttons on my cuffs. I do up the buttons starting at my neck and working my way downward. Then I put on my trousers. I straighten out all of my clothes. I pull my hairband off and put it back on the shelf. I sit back down and put my right sock on followed by my right boot. I tie the laces. Then I put my left sock on followed by my left boot. I tie the laces. I stand up.

I roll up the bath mat and put it in the shower tray. I pick up the towel and fold it and put it back on the shelf.

I pick up the hairband from the floor, gripping it between my thumb and index finger, and carry it away with me.

Putting the hairband back on the shelf

I carry the hairband from the bathroom unit to the bedroom unit, holding it between my thumb and forefinger, out in front of me. I put the hairband back on the shelf in the bedroom unit and walk away.

Standing at the front

I stand at the front of the living unit over the knife ladder. My hands are by my sides. I look at someone in the audience.

I turn my head to look at someone else.

Kneeling

I take a step back from the edge, bend my knees and kneel down on the floor over the knife ladder. My hands grip the edge of the platform. I stare at somebody.

Filling the glass

I pick up the empty glass from the table. I take the glass to the sink in the bedroom unit and sit down on the bed, twisting round to face the sink. I hold the glass in my left hand and put it underneath the tap in the sink. I push the tap up and then twist it to the left with my right hand until water trickles out. I tilt my head down towards the tap and watch the water flow. I let the glass fill up slowly. My right hand rests on the tap. When the glass is full I turn off the tap by pushing it up and then twisting it to the right. As I stand up from the bed I support myself with my left hand on the edge of the sink. Then I pass the glass from my left to my right hand.

Drinking water

I raise the glass to my mouth. My left arm is straight and motionless. I tilt my head back and shake my hair away from my face. I tip the water into my open mouth and gulp. To control the flow of water into my mouth, I open and close my lips slowly, and open and close them again. The water waves back and forth in the glass every time I swallow. My neck moves every time I swallow. I drink until the glass is empty. I press my lips together to suck in the droplets that are left there. I carry the glass back into the living unit and place the glass on the table.

Sitting on the bed

I smile and sit on the bed and stare at someone in the audience. Then I unlink my fingers and hold my hands out on my lap, palms up.

Blowing my nose

I tear off a length of toilet paper from the roll. I fold it into a bundle and press it against my nose. I blow hard out of my nose so that air and snot comes out. I take the bundle away from nose, fold it in half and put it in my pocket.

Winding up the metronome

I pick up the metronome from the floor in the bedroom unit and wind the winder. Then I put the metronome back on the floor and set the ticker ticking. I sit on the bed and stare.

Standing at the back

I stand at the back of the living unit leaning against the wall. My hands are clasped together behind my back. My feet are together. I look at someone in the audience.

Standing at the front

I move to the front of the living unit. I stand in front of the chair, point my body to the right a little, and stare down at someone.

My wrists tense up and my hands lift a little by my sides.

Standing between the units

I stand with one foot in the living unit and one foot in the bedroom unit, so that my body is over the gap. My legs make a triangle. I rest my arms on the back of the wooden frames, at chest level. I look at the audience and remain still.

Filling the glass

I pick up the empty glass from the table. I take the glass to the sink in the bedroom unit and sit down on the bed, twisting round to face the sink. I hold the glass in my left hand and put it underneath the tap in the sink. I push the tap up and then twist it to the left with my right hand until water trickles out. I tilt my head down towards the tap and watch the water flow. I let the glass fill up slowly. My right hand rests on the tap. When the glass is full I turn off the tap by pushing it up and then twisting it to the right. As I stand up from the bed I support myself with my left hand on the edge of the sink. Then I pass the glass from my left to my right hand.

Drinking water

I raise the glass to my mouth. My left arm is straight and motionless. I tilt my head back and shake my hair away from my face. I tip the water into my open mouth and gulp. To control the flow of water into my mouth, I open and close my lips slowly, and open and close them again. The water waves back and forth in the glass every time I swallow. My neck moves every time I swallow. I drink until the glass is empty. I press my lips together to suck in the droplets that are left there. Then I stare at the floor. Then I carry the glass back into the living unit and place the glass on the table.

Peeing

I need to pee. I step across the gap to the bathroom unit with my left leg first. I touch the outer wooden frame with my left hand. When I am in the unit I turn to my right and take the toilet paper from the shelf with my right hand. I keep my left hand behind my back. I take four steps over towards the toilet and turn my body round clockwise. When my back is to the audience I lean over and put the toilet roll on the left front corner of the shower tray. Then I lift the lid of the toilet with my right hand. I push it back until it is resting on the back of the unit. As I turn towards the front I lift up my shirt so I can unfasten my trousers. There are four buttons to unfasten. I tilt my head forward. When I have undone all the buttons I pull my trousers and my slip down to just above my knees and sit on the toilet. I put my feet close together in front of me and cup my hands together in my lap. My two index fingers and thumbs make a triangle shape. The tips of the fingers on my left hand touch the tips of the fingers on my right hand.

I look down. I sit still and wait for the pee to come. It takes a while and there is silence. I am motionless. Then the pee comes.

The metronome is ticking.

When I have finished peeing I lean over and take the toilet paper with my left hand. Holding it over my lap I unroll some paper and fold it precisely in half and then in half again and then in half again. I tear the bundle from the roll and place the roll back on the corner of the shower tray. I stand up and wipe myself with my right hand. Then I pull up my slip and my trousers and do up the four buttons. Then I straighten my shirt out.

I lean over and push down the handle of the bucket towards the front, then I turn on the tap on the wall with my left hand. My right hand is behind my back. The water falls into the bucket beneath. I stand still with my hands behind my back and listen to the sound. When the bucket is half full I turn off the tap and lift the bucket. I pour the water down the toilet to flush it, then I put the lid down. I place the bucket back where it was, underneath the tap, and pull the handle up so it is in the middle.

I pick up the toilet roll and put it back on the shelf where it was before. Then I brush my hair back from my face with both hands.

Standing at the front

I move to the front of the living unit. I stand in front of the chair, point my body to the right a little, and stare down at someone.

My wrists tense up and my hands lift a little by my sides.

Kneeling

I walk to the edge, bend my knees and kneel down on the floor at the front of the living unit, to the left of the knife ladder. I put my hands together in front of me, lean forward and stare into the eyes of someone in the audience. Then I sit back on my heels. Then I put my hands

on the edge of the unit, move my feet back and stand up.

Sitting in the chair

I put my body in front of the chair and bend my knees until my bottom rests on the seat of the chair. I put my hands together in my lap. My fingers are interlaced.

I take a deep breath and my chest rises. Then it falls. I remain sitting still. The metronome is in the living unit and it is still ticking. The glass is on the right-hand side of the table and it is not full. My feet are flat on the floor and spaced hip-width apart. My back is straight against the chair. I look at the audience. My head does not move, only my eyes. I blink. My mouth is closed. I blink again. When I take deeper breaths my chest rises and falls. The rest of my body is motionless. My hands are together in my lap.

Standing at the back

I stand at the back of the living unit leaning against the wall. My hands are clasped together behind my back. My feet are together. I look into someone's eyes.

Standing at the front

I move to the front of the living unit and stand over the knife ladder. My wrists tense up and my hands flare out as I stare at someone.

Then I cover my face with my hands and step away.

Filling the glass

I pick up the empty glass from the table. I take the glass to the sink in the bedroom unit and sit down on the bed, twisting round to face the sink. I hold the glass in my left hand and put it underneath the tap in the sink. I push the tap up and then twist it to the left with my right hand until water trickles out. I tilt my head down towards the tap and watch the water flow. I let the glass fill up slowly. My right hand rests on the tap. When the glass is full I turn off the tap by pushing it up and then twisting it to the right. As I stand up from the bed I support myself with my left hand on the edge of the sink. Then I pass the glass from my left to my right hand.

Drinking water

I raise the glass to my mouth. My left arm is straight and motionless. I tilt my head back and shake my hair away from my face. I tip the water into my open mouth and gulp. To control the flow of water into my mouth, I open and close my lips slowly, and open and close them again. The water waves back and forth in the glass every time I swallow. My neck moves every time I swallow. I drink until the glass is empty. I press my lips together to suck in the droplets that are left there. I carry the glass back into the living unit and place the glass on the table.

Walking back and forth

I walk back and forth across all the units. I walk with even steps very slowly. I take a big step to cross the gap and my body lurches forward. When I reach the end of the bedroom unit I turn around, pause with my back against the wall, and then walk back the other way by putting one foot in front of the other. When I reach the end of the bathroom unit I turn around, pause with my back against the wall, and then walk back the other way by putting one foot in front of the other. It takes twenty steps to get from one end to the other. The wooden floor of the units creaks with every step. My spine is curved forward as I walk and I look at the floor in front of me.

As I walk, I sing. I sing the same song I always sing.

I walk back and forth eight times.

Then I pause in the bedroom unit and stare at someone.

Then I continue walking.

Standing at the front

I stand at the front of the living unit over the knife ladder. My hands are by my sides. My fingers are curved. I look in the eyes of someone in the audience.

Every time I breathe in, the bottom of my shirt moves in towards my torso. Every time I breathe out, the bottom of my shirt moves out away from my torso. Nothing else moves, except the lids of both my eyes. They always move at the same time.

Kneeling

I take a step back from the edge and kneel down. My hands are together in front of me. I am leaning forward over the knife ladder and staring in someone's eyes.

Then I move my hands to grip the edge of the platform on either side of the knife ladder.

Then I cover my face with my hands and stand up.

Filling the glass

I pick up the empty glass from the table. I take the glass to the sink in the bedroom unit and sit down on the bed, twisting round to face the sink. I hold the glass in my left hand and put it underneath the tap in the sink. I push the tap up and then twist it to the left with my right hand until water trickles out. I tilt my head down towards the tap and watch the water flow. The glass fills up slowly. My right hand rests on the tap. When the glass is full I turn off the tap by pushing it up and then twisting it to the right. As I stand up from the bed I support myself with my left hand on the edge of the sink. Then I pass the glass from my left to my right hand.

Drinking water

I raise the glass to my mouth. My left arm is straight and motionless. I tilt my head back. I tip the water into my open mouth and gulp. To control the flow of water into my mouth, I open and close my lips slowly, and open and close them again. The water waves back and forth in the glass every time I swallow. My neck moves every time I swallow. I drink the water until the glass is empty. I press my lips together to suck in the droplets that are left there. I carry the glass back into the living unit and place the glass on the table.

Showering

I take the towel from the shelf and lay it on the toilet seat. Then I pick up the bath mat from inside the shower tray and unroll it on the floor in front of the shower. Then I sit on the toilet seat, lean over and untie the laces of my right boot using my right hand. When the laces are loose enough, I take off the boot and then pull off the sock by grabbing the toe. I put the sock in the boot. Then I untie the laces of my left boot using my left hand. When the laces are loose enough I take off the boot and then pull off the sock by grabbing the toe. I put the sock in the boot. The boots are next to each other by the wall.

Then I stand up and undo the buttons on my trousers. Then I pull them down. When I have sat down again, I finish pulling them off, starting with the right leg and finishing with the left leg. Then I fold them in half and then half again and then half again and put them on the floor next to the boots.

Then I undo the buttons of my shirt, starting at the bottom. There are seven buttons to undo. Then I take off my shirt and lay it across my legs and fold it up. Then I take off my undershirt and fold it up neatly. Then I take off my slip. I put all my clothes on the floor next to my boots.

Then I pick up the hairband off the floor, pull my hair together behind my head, and tie it back with my hairband. I stand on the left of the shower, outside the tray, and turn on the taps. I test the temperature of the water by holding out my left hand under the trickle of water. I

keep my hand there and wait for the water to warm up.

I step into the shower and face the audience. My hands are open, palms out and fingers straight, beside me. My eyes are closed. I open my mouth very wide very quickly and hold it wide open for a long time. I let it fill up with water. Then I spit it out. I rock my head from side to side, slowly. Then I open my mouth wide again.

I rock my head from side to side.

Then I open my mouth wide again.

Then I reach behind me with both hands and turn off both taps.

I lean over to pick up the towel. I press the towel hard against my face for a long time, leaning forward. When I am ready, I move the towel away and then rub the towel over my arms, then my torso, then my legs. I do not dry myself very thoroughly. I lay the towel over the toilet seat and sit down on it.

Then I take off my hairband and put it on the floor.

Then I lean forward and touch my toes and stretch my back. Then I sit up and cover my face with my hands.

Then I put my slip back on. Then I put my undershirt back on by putting my head through the head hole and my arms through the arm-holes. I do the same with my shirt and do up the buttons on my cuffs. I do up the buttons starting at my neck and working my way down-ward. Then I brush my hair back from my face. Then I put my trousers on. I stand up and straighten out all of my clothes. I sit back down and put my right sock on followed by my right boot. I tie the laces. Then I put my left sock on followed by my left boot. I tie the laces. I stand up.

I roll up the bath mat and put it in the shower tray. I pick up the towel and fold it and put it back on the shelf.

I pick up the hairband from the floor, gripping it between my thumb and index finger, and carry it away with me.

Putting the hairband back on the shelf in the living unit

I walk across the units holding the hairband between my thumb and index finger. I hold it at chest height. I put it back on the shelf in the living unit.

Moving the table

I grip the table from one end and lift it up and lay it on its side. I shift it so it lies in the corner of the living unit, diagonally between the back wall and the side wall. I put the glass on the side of the table leg.

Standing at the back

I stand at the back of the living unit leaning against the wall. My hands are clasped together behind my back. My feet are together. I look at someone in the audience.

Standing at the front

I stand at the front of the living unit over in front of the chair. My hands are by my sides. My fingers are curved. I look at someone in the audience. I face diagonally to the right.

Sitting on the bed

I sit on the bed halfway between each end with my hands together in my lap. I stare at someone's eyes.

Standing at the front

I stand up and walk to the front and stand at the front, on the left-hand side of the bedroom unit. I stare at someone.

Kneeling

I kneel down in front of the knife ladder. My hands grip the edge of the platform and my eyes look at someone. I lean forward. The

metronome is still ticking.

Filling the glass

I walk to the living unit and pick up the empty glass from the side of the table leg. I take the glass to the sink in the bedroom unit and sit down on the bed, twisting round to face the sink. I hold the glass in my left hand and put it underneath the tap in the sink. I push the tap up and then twist it to the left with my right hand until water trickles out. I tilt my head down towards the tap and watch the water flow. I let the glass fill up slowly. My right hand rests on the tap. When the glass is full I turn off the tap by pushing it up and then twisting it to the right. As I stand up from the bed I support myself with my left hand on the edge of the sink. Then I pass the glass from my left to my right hand.

Drinking water

I face the left, diagonally. I raise the glass to my mouth. My left arm is straight and motionless. I tilt my head back and shake my hair away from my face. I tip the water into my open mouth and gulp. To control the flow of water into my mouth, I open and close my lips slowly, and open and close them again. The water waves back and forth in the glass every time I swallow. My neck moves every time I swallow. I drink until the glass is empty. I press my lips together to suck in the droplets that are left there. I carry the glass back into the living unit and place the glass back on the side of the table leg.

Peeing

I need to pee. I step across the gap to the bathroom unit with my left leg first. I touch the outer wooden frame with my left hand. When I am in the unit I turn to my right and take the toilet paper from the shelf with my right hand. I keep my left hand behind my back. I take four steps over towards the toilet and turn my body round clockwise. When my back is to the audience I lean over and put the toilet roll on the left front corner of the shower tray. Then I lift the lid of the toilet with my right hand. I push it back until it is resting on the back of the unit. As I turn towards the front I lift up my shirt so I can unfasten my trousers. There are four buttons to unfasten. I tilt my head forward. When I have undone all the buttons I pull my trousers and my slip down to just above my knees and sit on the toilet. I put my feet close together in front of me and cup my hands together in my lap. My two index fingers and thumbs make a triangle shape. The tips of the fingers on my left hand touch the tips of the fingers on my right hand.

I look down. I sit still and wait for the pee to come. It takes a while and there is silence. I am motionless. Then the pee comes.

When I have finished peeing I lean over and take the toilet paper with my left hand. Holding it over my lap I unroll some paper and fold it precisely in half and then in half again and then in half again. I tear the bundle from the roll and place the roll back on the corner of the shower tray. I stand up and wipe myself with my right hand. Then I pull up my slip and my trousers and do up the four buttons. Then I straighten my shirt out.

I lean over and push down the handle of the bucket towards the front, then I turn on the tap on the wall with my left hand. The water falls into the bucket beneath. I stand still with my hands behind my back and listen to the sound. When the bucket is half full I turn off the tap and lift the bucket. I rest it on the edge of the toilet and then I pour the water down the toilet to flush it, then I put the lid down. I place the bucket back where it was, underneath the tap, and pull the handle up so it is in the middle.

I pick up the toilet roll and put it back on the shelf where it was before. Then I brush my hair back from my face with both hands.

Rearranging the furniture

I pull the chair forward to the front. Then I take the glass off the side of the table leg. Then I push the table right into the corner and put the

glass back. Then I pull the chair to the middle, so it is over the knife ladder.

Then I sit on the chair with my hands in my lap, palms upturned, and my eyes on the audience.

Then I put my hands together again, palms together. I lean forward and stare at someone.

Kneeling

I stand up from the chair, push the chair back with my hands and kneel down over the knife ladder. My hands grip the edge of the platform and I continue staring at the same person.

I close my eyes and bow my head and hug myself.

Rearranging the furniture

I lift up the chair and lay it first on its side and then on its front, so the quartz pillow and the front edge of the seat are the only points touching the floor.

Sitting on the bed

I sit on the bed near the quartz pillow and stare at someone. My hands are holding each other in my lap. The metronome is still ticking.

I cover my face with my hands.

Filling the glass

I walk to the living unit and pick up the empty glass from the side of the table leg. I take the glass to the sink in the bedroom unit and sit down on the bed, twisting round to face the sink. I hold the glass in my left hand and put it underneath the tap in the sink. I push the tap up and then twist it to the left with my right hand until water trickles out. I tilt my head down towards the tap and watch the water flow. I let the glass fill up slowly. My right hand rests on the tap. When the glass is full I turn off the tap by pushing it up and then twisting it to the right. As I stand up from the bed I support myself with my left hand on the edge of the sink. Then I pass the glass from my left to my right hand.

Drinking water

I face the left, diagonally. I raise the glass to my mouth. My left arm is straight and motionless. I tilt my head back and shake my hair away from my face. I tip the water into my open mouth and gulp. To control the flow of water into my mouth, I open and close my lips slowly, and open and close them again. The water waves back and forth in the glass every time I swallow. My neck moves every time I swallow. I drink until the glass is empty. I press my lips together to suck in the droplets that are left there. I carry the glass back into the living unit and place the glass back on the side of the table leg.

Taking the hairband from the shelf

I pick up the hairband from the shelf and hold it between my thumb and index finger. I carry it at chest height to the bathroom unit.

Showering

I take the towel from the shelf and lay it on the toilet seat. I put the hairband on the floor. Then I pick up the bath mat from inside the shower tray and unroll it on the floor in front of the shower. Then I sit on the toilet seat, lean over and untie the laces of my right boot using my right hand. When the laces are loose enough, I take off the boot and then pull off the sock by grabbing the toe. I put the sock in the boot. Then I untie the laces of my left boot using my left hand. When the laces are loose enough I take off the boot and then pull off the sock by grabbing the toe. I put the sock in the boot. The boots are next to each other by the wall.

Then I stand up and undo the buttons on my trousers. Then I pull them down. When I have sat down again, I finish pulling them off, starting with the right leg and finishing with the left leg. Then I fold them in half and then half again and then half again and put them on the floor next to the boots.

Then I undo the buttons of my shirt, starting at the bottom. There are seven buttons to undo. Then I take off my shirt and lay it across my legs and fold it up. Then I take off my undershirt and fold it up neatly. Then I take off my slip. I put all my clothes on the floor next to my boots.

Then I pick up the hairband off the floor, pull my hair together behind my head, and tie it back with my hairband. I stand on the left of the shower, outside the tray, and turn on the taps. I test the temperature of the water by holding out my left hand under the trickle of water. I keep my hand there and wait for the water to warm up.

I step into the shower and face the audience. My hands are open, palms out and fingers straight, beside me. My eyes are closed. I open my mouth very wide very quickly and hold it wide open for a long time. I let it fill up with water. Then I spit it out. I rock my head from side to side, slowly. Then I open my mouth wide again.

I rock my head from side to side.

Then I open my mouth wide again.

Then I reach behind me with both hands and turn off both taps.

I lean over to pick up the towel. I press the towel hard against my face for a long time, leaning forward. When I am ready, I move the towel away and then rub the towel over my arms, then my torso, then my legs. I do not dry myself very thoroughly. I lay the towel over the toilet seat and sit down on it.

Then I take off my hairband and put it on the floor.

Then I lean forward and touch my toes and stretch my back. Then I sit up and cover my face with my hands.

Then I put my slip back on. Then I put my undershirt back on by putting my head through the head hole and my arms through the armholes. I do the same with my shirt and do up the buttons on my cuffs. I do up the buttons starting at my neck and working my way downward. Then I brush my hair back from my face. Then I put my trousers on. I stand up and straighten out all of my clothes. I sit back down and put my right sock on followed by my right boot. I tie the laces. Then I put my left sock on followed by my left boot. I tie the laces. I stand up.

I roll up the bath mat and put it in the shower tray. I pick up the towel and fold it and put it back on the shelf.

I pick up the hairband from the floor, gripping it between my thumb and index finger, and carry it away with me.

Rearranging the furniture

I shift the chair over to the right a little.

Standing at the back

I stand at the back of the living unit leaning against the wall. My hands are clasped together behind my back. My feet are together. I look at someone in the audience.

Winding up the metronome

I pick up the metronome with my left hand and wind it up with my right hand. I wind it 15 times. Then I put it back on the floor and set it ticking.

I brush my hair from my face and walk away.

Standing at the front

I move to the front of the living unit and stand over the knife ladder. My wrists tense up and my hands flare out as I stare at someone. I turn my head and stare at someone else. I tense my wrists even more and my hands rise up at my sides to an angle of 45 degrees.

I take a deep breath and my chest rises and I stand up straighter.

Then my arms rise from my sides.

Filling the glass

I walk to the living unit and pick up the empty glass from the side of the table leg. I take the glass to the sink in the bedroom unit and sit down on the bed, twisting round to face the sink. I hold the glass in my left hand and put it underneath the tap in the sink. I push the tap up and then twist it to the left with my right hand until water trickles out. I tilt my head down towards the tap and watch the water flow. I let the glass fill up slowly. My right hand rests on the tap. When the glass is full I turn off the tap by pushing it up and then twisting it to the right. As I stand up from the bed I support myself with my left hand on the edge of the sink. Then I pass the glass from my left to my right hand.

Drinking water

I face the left, diagonally. I raise the glass to my mouth. My left arm is straight and motionless. I tilt my head back and shake my hair away from my face. I tip the water into my open mouth and gulp. To control the flow of water into my mouth, I open and close my lips slowly, and open and close them again. The water waves back and forth in the glass every time I swallow. My neck moves every time I swallow. I drink until the glass is empty. I press my lips together to suck in the droplets that are left there. I carry the glass back into the living unit and place the glass back on the side of the table leg.

Standing at the front

I move to the front of the living unit and stand over the knife ladder. My wrists tense up and my hands flare out as I stare at someone.

Standing at the back

I move to the back of the living unit leaning against the wall. My hands are clasped together behind my back. My feet are together. I look at someone in the audience. I blink.

Sitting on the bed

I sit on the bed, halfway between each end, and stare at someone in the audience. My hands are linked together and are resting in my lap.

Then I slide up next to the quartz pillow by pressing my hands against the edge of the bed and pushing myself along. I stare at someone.

The metronome is ticking.

Standing at the front

I stand up and walk to the front of the living unit and stand over the knife ladder. My wrists tense up and my hands flare out as I stare at someone. The metronome keeps ticking.

Peeing

I need to pee. I step across the gap to the bathroom unit with my left leg first. I touch the outer wooden frame with my left hand. When I am in the unit I turn to my right and take the toilet paper from the shelf with my right hand. I keep my left hand behind my back. I take four steps over towards the toilet and turn my body round clockwise. When my back is to the audience I lean over and put the toilet roll on the left front corner of the shower tray. Then I lift the lid of the toilet with my right hand. I push it back until it is resting on the back of the unit. As I turn towards the front I lift up my shirt so I can unfasten my trousers. There are four buttons to unfasten. I tilt my head forward. When I have undone all the buttons I pull my trousers and my slip down to just above my knees and sit on the toilet. I put my feet close together in front of me and cup my hands together in my lap. My two index fingers and thumbs make a triangle shape. The tips of the fingers on my left hand touch the tips of the fingers on my right hand.

I look down. I sit still and wait for the pee to come. It takes a while

and there is silence. I am motionless. Then the pee comes.

When I have finished peeing I lean over and take the toilet paper with my left hand. Holding it over my lap I unroll some paper and fold it precisely in half and then in half again and then in half again. I tear the bundle from the roll and place the roll back on the corner of the shower tray. I stand up and wipe myself with my right hand. Then I pull up my slip and my trousers and do up the four buttons. Then I straighten my shirt out.

I lean over and push down the handle of the bucket towards the front, then I turn on the tap on the wall with my left hand. The water falls into the bucket beneath. I stand still with my hands behind my back and listen to the sound.

The bucket starts to overflow. The pool of water spreads over the floor. I turn off the tap. The water starts to fall off the edge of the unit and splashes on the floor of the gallery.

I lift the bucket with both hands. I rest it on the edge of the toilet and then I pour the water down the toilet to flush it. Then I put the lid down. I place the bucket back where it was, underneath the tap, and pull the handle up so it is in the middle.

I pick up the toilet roll and put it back on the shelf where it was before. Then I brush my hair back from my face with both hands.

Standing between the units

I stand with one foot in the bathroom unit and one foot in the living unit, so that my body is over the gap. My legs make a triangle. I rest my arms on the back of the door frames. I look at the audience and remain still.

Standing at the front

I move to the front of the living unit and stand over the knife ladder. I brush the hair back from my face. My wrists tense up and my hands flare out as I stare at someone. I take a deep breath and my chest rises and I stand up straighter.

I lift my hands up to my chest, sway, and step back from the edge.

Filling the glass

I pick up the empty glass from the side of the table leg. I step over the overturned chair, crouching as I go. I take the glass to the sink in the bedroom unit and sit down on the bed, twisting round to face the sink. I hold the glass in my left hand and put it underneath the tap in the sink. I push the tap up and then twist it to the left with my right hand until water trickles out. I tilt my head down towards the tap and watch the water flow. I let the glass fill up slowly. My right hand rests on the tap. When the glass is full I turn off the tap by pushing it up and then twisting it to the right. As I stand up from the bed I support myself with my left hand on the edge of the sink. Then I pass the glass from my left to my right hand.

Drinking water

I face the left, diagonally. I raise the glass to my mouth. My left arm is straight and motionless. I tilt my head back and shake my hair away from my face. I tip the water into my open mouth and gulp. To control the flow of water into my mouth, I open and close my lips slowly, and open and close them again. The water waves back and forth in the glass every time I swallow. My neck moves every time I swallow. I drink until the glass is empty. I press my lips together to suck in the droplets that are left there. I carry the glass back into the living unit and place the glass back on the side of the table leg.

Sitting on the bed

I sit on the bed near the quartz pillow. I stare at someone in the audience. My hands are linked together and are resting in my lap. I lean forward and rest my elbows on my thighs and stare at someone else.

Then I sit up straighter and put my hands on my thighs, palms down.

Standing at the back

I move to the living unit and stand at the back leaning against the wall. My hands are clasped together behind my back. My feet are together. I look at someone in the audience.

Showering

I take the towel from the shelf and lay it on the toilet seat. I have forgotten the hairband.

Taking the hairband from the shelf

I pick up the hairband from the shelf in the bedroom unit and hold it between my thumb and index finger. I carry it at chest height to the bathroom unit.

Showering

I walk back to the bathroom unit and put the hairband on the floor. Then I pick up the bath mat from inside the shower tray and unroll it on the floor in front of the shower. Then I sit on the toilet seat, lean over and untie the laces of my right boot using my right hand. When the laces are loose enough, I take off the boot and then pull off the sock by grabbing the toe. I put the sock in the boot. Then I untie the laces of my left boot using my left hand. When the laces are loose enough I take off the boot and then pull off the sock by grabbing the toe. I put the sock in the boot. The boots are next to each other by the wall.

Then I stand up and undo the buttons on my trousers. Then I pull them down. When I have sat down again, I finish pulling them off, starting with the right leg and finishing with the left leg. Then I fold them in half and then half again and then half again and put them on the floor next to the boots.

Then I undo the buttons of my shirt, starting at the bottom. There are seven buttons to undo. Then I take off my shirt and lay it across my legs and fold it up. Then I take off my undershirt and fold it up neatly. Then I take off my slip. I put all my clothes on the floor next to my boots.

Then I pick up the hairband off the floor, pull my hair together behind my head, and tie it back with the hairband. I stand on the left of the shower, outside the tray, and turn on the taps. I test the temperature of the water by holding out my left hand under the trickle of water. I keep my hand there and wait for the water to warm up.

I step into the shower and face the audience. My hands are open, palms out and fingers straight, beside me. My eyes are closed. I open my mouth very wide very quickly and hold it wide open for a long time. I let it fill up with water. Then I spit it out. I rock my head from side to side, slowly. Then I open my mouth wide again.

I rock my head from side to side.

Then I open my mouth wide again.

Then I reach behind me with both hands and turn off both taps.

I lean over to pick up the towel. I press the towel hard against my face for a long time, leaning forward. When I am ready, I move the towel away and then rub the towel over my arms, then my torso, then my legs. I do not dry myself very thoroughly. I lay the towel over the toilet seat and sit down on it.

Then I take off my hairband and put it on the floor.

Then I lean forward and touch my toes and stretch my back. Then I sit up and cover my face with my hands.

Then I put my slip back on. Then I put my undershirt back on by putting my head through the head hole and my arms through the armholes. I do the same with my shirt and do up the buttons on my cuffs. I do up the buttons starting at my neck and working my way down-

ward. Then I brush my hair back from my face. Then I put my trousers on. I stand up and straighten out all of my clothes. I sit back down and put my right sock on followed by my right boot. I tie the laces. Then I put my left sock on followed by my left boot. I tie the laces. I stand up.

I roll up the bath mat and put it in the shower tray. I pick up the towel and fold it and put it back on the shelf.

I pick up the hairband from the floor, gripping it between my thumb and index finger, and carry it away with me.

Putting the hairband back on the shelf in the living unit

I walk across the units holding the hairband between my thumb and index finger. I hold it at chest height. I put it back on the shelf in the living unit. The metronome is still ticking.

Filling the glass

I walk to the living unit and pick up the empty glass from the side of the table leg. I take the glass to the sink in the bedroom unit and sit down on the bed, twisting round to face the sink. I hold the glass in my left hand and put it underneath the tap in the sink. I push the tap up and then twist it to the left with my right hand until water trickles out. I tilt my head down towards the tap and watch the water flow. I let the glass fill up slowly. My right hand rests on the tap. When the glass is full I turn off the tap by pushing it up and then twisting it to the right. As I stand up from the bed I support myself with my left hand on the edge of the sink. Then I pass the glass from my left to my right hand.

Drinking water

I face the left, diagonally. I raise the glass to my mouth. My left arm is straight and motionless. I tilt my head back and shake my hair away from my face. I tip the water into my open mouth and gulp. To control the flow of water into my mouth, I open and close my lips slowly, and open and close them again. The water waves back and forth in the glass every time I swallow. My neck moves every time I swallow. I drink until the glass is empty. I press my lips together to suck in the droplets that are left there. I carry the glass back into the living unit and place the glass back on the side of the table leg.

Standing at the front

I stand at the front of the living unit over the knife ladder. My hands are by my sides. I look at someone in the audience. I take a deep breath and my chest rises and stays there.

Day 10

Sunday, November 24th: Day 10

Wearing deep orange

Lying on the bed

I lie on the bed on my left-hand side, facing the audience. My eyes are not closed. My head rests on my hands and my hands rest on the quartz pillow. My legs are on top of each other. The metronome is near the edge of the bed, next to the quartz pillow. It is ticking.

Filling the glass

I get up and walk to the living unit and pick up the empty glass from the side of the table leg. I take the glass to the sink in the bedroom unit and sit down on the bed, twisting round to face the sink. I hold the glass in my left hand and put it underneath the tap in the sink. I push the tap up and then twist it to the left with my right hand until water trickles out. I tilt my head down towards the tap and watch the water flow. I let the glass fill up slowly. My right hand rests on the tap. When the glass is full I turn off the tap by pushing it up and then twisting it to the right. Then I pass the glass from my left to my right hand.

Drinking water

I do not stand up. I stay sitting down on the bed and I raise the glass to my mouth. My left arm is straight and motionless. I tilt my head back and shake my hair away from my face. I tip the water into my open mouth and gulp. To control the flow of water into my mouth, I open and close my lips slowly, and open and close them again. The water waves back and forth in the glass every time I swallow. My neck moves every time I swallow. I drink until the glass is empty. I press my lips together to suck in the droplets that are left there. I put the glass on the floor in front of the bed and look at it.

Lying on the bed

Then I lie on the bed again on my left-hand side, facing the audience. My eyes are not closed. My head rests on the quartz pillow. My right arm is bent at the elbow and my hand rests near my cheek. My left arm is out straight and my hand hangs off the edge of the bed. My legs are on top of each other. The metronome is near the edge of the bed, next to the quartz pillow. It is ticking.

Sitting on the bed

I sit on the bed leaning against the back wall, facing the audience. My feet are on the edge of the bed and my arms are hugging my legs together, close to my chest. My hands are locked together around my shins. I look at the audience.

The metronome stops ticking.

Winding up the metronome

I pick up the metronome and wind the winder until it will not go round any more. Then I put the metronome back, next to the quartz pillow,

and set the ticker ticking.

Sitting on the bed

I sit on the bed with my feet on the floor and my hands in my lap. I am slouching. I look at the floor.

I lean forward and look at someone in the audience. Then I rest my head in my hands.

Kneeling

I kneel on the floor in front of the knife ladder and stare down at the same person. My hands are flat on the floor, pointing outwards. The metronome ticks.

I lean forward so that my head hangs down over the edge and my face is next to the first knife on the knife ladder. My hands grip the edge of the platform.

Sitting on the bed

I sit on the bed with my feet on the floor and push my hair back from my face.

Filling the glass

I lean over and pick up the empty glass from the floor. I twist round to face the sink. I hold the glass in my left hand and put it underneath the tap in the sink. I push the tap up and then twist it to the left with my right hand until water trickles out. I tilt my head down towards the tap and watch the water flow. I let the glass fill up slowly. My right hand rests on the tap. When the glass is full I turn off the tap by pushing it up and then twisting it to the right. Then I pass the glass from my left to my right hand.

Drinking water

I stand up and walk to the living unit. I raise the glass to my mouth. My left arm is straight and motionless. I tip the water into my open mouth and gulp. To control the flow of water into my mouth, I open and close my lips slowly, and open and close them again. The water waves back and forth in the glass every time I swallow. My neck moves every time I swallow. I drink until the glass is empty. I press my lips together to suck in the droplets that are left there. I put the glass on the side of the table leg.

Walking back and forth

I walk back and forth across all the units. I walk with even steps very slowly. I take a big step to cross the gap and my body lurches forward. When I reach the end of the bathroom unit I turn around, pause with my back against the wall, and then walk back the other way by putting one foot in front of the other. I hold my hair away from my face. When I reach the end of the bedroom unit I turn around, pause with my back against the wall, and then walk back the other way by putting one foot in front of the other. It takes twenty-one steps to get from one end to the other. The wooden floor of the units creaks with every step. My spine is curved forward as I walk and I look at the floor in front of me. I walk back and forth three times.

Sitting on the bed

I sit on the bed with my feet on the floor and my hands in my lap. I face the right and stare at someone for a long time.

Then I cover my face with my hands.

Filling the glass

I walk to the living unit and pick up the empty glass from the side of the table leg. I take it to the bedroom unit, sit on the bed and twist round to face the sink. I hold the glass in my left hand and put it underneath the tap in the sink. I push the tap up and then twist it to the left with my right hand until water trickles out. I tilt my head down towards the tap and watch the water flow. I let the glass fill up slowly. My right hand rests on the tap. When the glass is full I turn off the

tap by pushing it up and then twisting it to the right. Then I pass the glass from my left to my right hand.

Drinking water

I stand up and raise the glass to my mouth. My left arm is straight and motionless. I tip the water into my open mouth and gulp. To control the flow of water into my mouth, I open and close my lips slowly, and open and close them again. The water waves back and forth in the glass every time I swallow. My neck moves every time I swallow. I drink until the glass is empty. I press my lips together to suck in the droplets that are left there. I put the glass on the side of the table leg.

Winding up the metronome

I pick up the metronome and wind the winder until it will not go round any more. Then I put the metronome back, next to the quartz pillow, and set the ticker ticking.

Sitting on the bed

I sit on the bed with my feet on the floor and my hands together with my fingers interlaced. My elbows rest on my knees and I lean forward and stare at someone.

The metronome stops ticking.

I reach out with my right hand and pull the ticker back with my index finger and release it. It starts ticking again.

Rearranging the furniture

I push the chair along the ground. Then I walk round to the back of the chair and try to lift it from the top. Then I walk back round to the front and step on the chair leg to try to lever the chair up. I can't. I rest both hands on the top two chair legs. Then I pull the chair along the ground towards the middle of the living unit. Then I walk around the back and lift the chair up by the back. I hesitate halfway though. Then I lift it all the way up and shuffle it along the floor until it is back in its original position.

I take the glass off the side of the table leg and put it on the chair. Then I pull the table out from the corner of the living unit. I put my foot on the table leg and try to lever it up. I can't. I step inside the table so the two legs are on either side of my hips. Then I hold the tabletop and lift it up and put it back up the right way. Then I shuffle the table back to its original position. Then I put the glass back on the table.

Peeing

I need to pee. I put one foot in front of the other until I get to the bathroom unit. When I am in the unit I turn to my right and take the toilet paper from the shelf with my right hand. I keep my left hand behind my back. I take four steps over towards the toilet and turn my body round clockwise. When my back is to the audience I lean over and put the toilet roll on the left front corner of the shower tray. Then I lift the lid of the toilet with my right hand. I push it back until it is resting on the back of the unit. As I turn towards the front I lift up my shirt so I can unfasten my trousers. There are four buttons to unfasten. I tilt my head forward. When I have undone all the buttons I pull my trousers and my slip down to just above my knees and sit on the toilet. I put my feet close together in front of me and cup my hands together in my lap. My two index fingers and thumbs make a triangle shape. The tips of the fingers on my left hand touch the tips of the fingers on my right hand.

I look down. I sit still and wait for the pee to come. It takes a while and there is silence. I am motionless. Then the pee comes.

When I have finished peeing I lean over and take the toilet paper with my left hand. Holding it over my lap I unroll some paper and fold it precisely in half and then in half again and then in half again. I tear the bundle from the roll and place the roll back on the corner of the shower tray. I stand up and wipe myself with my right hand. Then I pull up my slip and my trousers and do up the four buttons. Then I straighten my shirt out.

I lean over and push down the handle of the bucket towards the front, then I turn on the tap on the wall with my left hand. The water falls into the bucket beneath. I stand still with my hands behind my back and listen to the sound.

When the bucket is half full I lift the bucket with both hands. I rest it on the edge of the toilet and then I pour the water down the toilet to flush it. Then I put the lid down. I place the bucket back where it was, underneath the tap, and pull the handle up so it is in the middle.

I pick up the toilet roll and put it back on the shelf where it was before. Then I brush my hair back from my face with both hands.

Standing at the back

I move to the living unit and stand at the back leaning against the wall. My hands are clasped together behind my back. My feet are together. I look at someone in the audience.

Kneeling

I walk to the edge, bend my knees and kneel down on the floor at the front of the living unit, to the left of the knife ladder. I put my hands together and stare down at someone in the audience.

Filling the glass

I take the empty glass from the table and take it to the sink in the bedroom unit. I sit down on the bed, twisting round to face the sink. I hold the glass in my left hand and put it underneath the tap in the sink. I push the tap up and then twist it to the left with my right hand until water trickles out. I tilt my head down towards the tap and watch the water flow. I let the glass fill up slowly. My right hand rests on the tap. When the glass is full I turn off the tap by pushing it up and then twisting it to the right. Then I pass the glass from my left to my right hand.

Drinking water

I stand up and raise the glass to my mouth. My left arm is straight and motionless. I tilt my head back and shake my hair away from my face. I tip the water into my open mouth and gulp. To control the flow of water into my mouth, I open and close my lips slowly, and open and close them again. The water waves back and forth in the glass every time I swallow. My neck moves every time I swallow. I drink until the glass is empty. I press my lips together to suck in the droplets that are left there. I take the glass back to the living unit and put it on the table.

Sitting on the chair

I put my body in front of the chair and bend my knees until my bottom rests on the seat of the chair. I put my hands together in my lap. My fingers are interlaced. I look at the audience.

I lean forward and rest my elbows on my knees. I stare at someone.

Filling the glass

I take the empty glass from the table and take it to the sink in the bedroom unit. I sit down on the bed, twisting round to face the sink. I hold the glass in my left hand and put it underneath the tap in the sink. I push the tap up and then twist it to the left with my right hand until water trickles out. I tilt my head down towards the tap and watch the water flow. I let the glass fill up slowly. My right hand rests on the tap. When the glass is full I turn off the tap by pushing it up and then twisting it to the right. Then I pass the glass from my left to my right hand.

Drinking water

I stand up and raise the glass to my mouth. My left arm is straight and motionless. I tilt my head back and shake my hair away from my face. I tip the water into my open mouth and gulp. To control the flow of water into my mouth, I open and close my lips slowly, and open and close them again. The water waves back and forth in the glass every time I swallow. My neck moves every time I swallow. I drink until the

glass is empty. I press my lips together to suck in the droplets that are left there. I take the glass back to the living unit and put it on the table.

Winding up the metronome

The metronome is not ticking. I pick up the metronome from the bed and wind the winder until it will not go round any more. Then I put the metronome back on the bed next to the quartz pillow, and set the ticker ticking.

Sitting on the bed

I sit on the bed with my feet on the floor and my hands in my lap. I stare.

Standing at the front

I stand up and move to the front of the bedroom unit and stand over the knife ladder.

I stare at someone in the audience.

I sing. I sing the same song I always sing.

My wrists tense and my hands flare out at my sides.

In the audience a baby makes gurgling noises.

Walking back and forth

I walk back and forth across all the units. I walk with even steps very slowly. I take a big step to cross the gap and my body lurches forward. When I reach the end of the bathroom unit I turn around, pause with my back against the wall, and then walk back the other way by putting one foot in front of the other. I hold my hair away from my face. When I reach the end of the bedroom unit I turn around, pause with my back against the wall, and then walk back the other way by putting one foot in front of the other. It takes twenty-one steps to get from one end to the other. The wooden floor of the units creaks with every step. My spine is curved forward as I walk and I look at the floor in front of me. I walk back and forth three times.

Showering

I walk back to the bathroom unit and pick up the bath mat from inside the shower tray and unroll it on the floor in front of the shower. Then I lay the towel out on the toilet seat. I have forgotten the hairband.

Taking the hairband from the shelf

I walk to the bedroom unit and pick up the hairband from the shelf in the bedroom unit and hold it between my thumb and index finger. I carry it at chest height to the bathroom unit.

Showering

I put the hairband on the floor and sit on the toilet seat and lean over and untie the laces of my right boot using my right hand. When the laces are loose enough, I take off the boot and then pull off the sock by grabbing the toe. I put the sock in the boot. Then I untie the laces of my left boot using my left hand. When the laces are loose enough I take off the boot and then pull off the sock by grabbing the toe. I put the sock in the boot. The boots are next to each other by the wall.

Then I stand up and undo the buttons on my trousers. Then I pull them down. When I have sat down again, I finish pulling them off, starting with the right leg and finishing with the left leg. Then I fold them in half and then half again and then half again and put them on the floor next to the boots.

Then I undo the buttons of my shirt, starting at the bottom. There are seven buttons to undo. Then I take off my shirt and lay it across my legs and fold it up. Then I take off my undershirt and fold it up neatly. Then I take off my slip. I put all my clothes on the floor next to my boots.

Then I pick up the hairband off the floor, pull my hair together behind my head, and tie it back with my hairband. I stand on the left of the shower, outside the tray, and turn on the taps. I test the temperature of the water by holding out my left hand under the trickle of water. I

keep my hand there and wait for the water to warm up.

I step into the shower and face the audience. My hands are open, palms out and fingers straight, beside me. My eyes are closed.

I open my mouth very wide very quickly and hold it wide open for a long time. I let it fill up with water. Then I spit it out. I rock my head from side to side, slowly. Then I open my mouth wide again.

I rock my head from side to side.

Then I open my mouth wide again.

Then I reach behind me with both hands and turn off both taps.

I lean over to pick up the towel. I press the towel hard against my face for a long time, leaning forward. When I am ready, I move the towel away and then rub the towel over my arms, then my torso, then my legs. I do not dry myself very thoroughly. I lay the towel over the toilet seat and sit down on it.

Then I take off my hairband and put it on the floor.

Then I lean forward and touch my toes and stretch my back. Then I sit up and cover my face with my hands.

Then I put my slip back on. Then I put my undershirt back on by putting my head through the head hole and my arms through the armholes. I do the same with my shirt and do up the buttons on my cuffs. I do up the buttons starting at my neck and working my way downward. Then I brush my hair back from my face. Then I put my trousers on. I stand up and straighten out all of my clothes. I sit back down and put my right sock on followed by my right boot. I tie the laces. Then I put my left sock on followed by my left boot. I tie the laces. I stand up.

I roll up the bath mat and put it in the shower tray. I pick up the towel and fold it and put it back on the shelf.

I pick up the hairband from the floor, gripping it between my thumb and index finger, and carry it away with me.

Standing at the back

I move to the living unit and stand at the back leaning against the wall. My hands are clasped together behind my back. My feet are together. I look at someone in the audience.

My back comes off the wall as I stop leaning and stand up straight to stare harder at someone. My feet do not move.

I close my eyes and cover my face with my hands. Then I squat down on the floor, still with my face in my hands.

Filling the glass

I take the empty glass from the table and take it to the sink in the bedroom unit. I sit down on the bed and twist round to face the sink. I hold the glass in my left hand and put it underneath the tap in the sink. I push the tap up and then twist it to the left with my right hand until water trickles out. I tilt my head down towards the tap and watch the water flow. I let the glass fill up slowly. My right hand rests on the tap. When the glass is full I turn off the tap by pushing it up and then twisting it to the right. Then I pass the glass from my left to my right hand.

Drinking water

I stand up and raise the glass to my mouth. My left arm is straight and motionless. I tip the water into my open mouth and gulp. To control the flow of water into my mouth, I open and close my lips slowly, and open and close them again. The water waves back and forth in the glass every time I swallow. My neck moves every time I swallow. I tilt my head back and drink until the glass is empty. I press my lips together to suck in the droplets that are left there. I take the glass back to the living unit and put it on the table.

The metronome starts ticking by itself. It ticks four times then stops.

Winding up the metronome

I pick up the metronome and wind the winder until it will not go round any more. Then I put the metronome back, next to the quartz pillow, and set the ticker ticking.

Rearranging the furniture

I tilt the table to the side so two legs are on the ground and two are in the air. The two legs that are in the air are on either side of my hips. My hands hold the tabletop and I lower it until the table is resting on the floor on its side. Then I shift the table around so the ends of the table legs point towards the audience. The table is on the left-hand side of the living unit at the front.

Picking up the metronome and moving it to the living unit

I pick up the metronome from the bed and carry it to the living unit.

Sitting inside the table

I sit on the floor next to the table and shuffle myself under the table legs. I have to duck my head. Then I sit inside the table. Two legs are on either side of my bottom. The other two legs are on either side of my head. My knees are hunched up against my chest.

I move the metronome next to my right foot and set it ticking. I rest my right hand on the metronome.

It stops ticking.

I prod the ticker to make it tick again.

It stops ticking.

I hold the ticker between my thumb and forefinger and pull it to the side to make it tick.

It ticks then stops.

I prod the ticker again.

Stops.

I pick up the metronome and put it on the other side of the table. I turn it around.

Winding up the metronome

I get out of the table and pick up the metronome and carry it to the bedroom unit. I sit on the bed. I wind the winder of the metronome until it will not go round any more. Then I put the metronome next to the quartz pillow, and set the ticker ticking.

Lying on the bed

I lie on the bed on my left-hand side, facing the audience. My eyes are not closed. My head rests on my hands and my hands rest on the quartz pillow. My legs are on top of each other. The metronome is near the edge of the bed, next to the quartz pillow. It is ticking.

Sitting on the bed

I sit on the bed with my feet on the floor and my hands together with my fingers interlaced. I stare at someone.

The metronome stops ticking.

I reach out with my left hand and pull the metronome towards me. I pull the ticker down and set it ticking again. I keep staring.

The metronome stops ticking.

I set it ticking again.

Then it stops.

I hold the ticker between my thumb and forefingers. Then I release it. It ticks. I hold my hand over the top of the metronome.

It keeps ticking.

Filling the glass

I get up and put one foot in front of the other until I get to the table in the living unit. I pick up the empty glass from the table and take it to the sink in the bedroom unit. I sit down on the bed and twist round to face the sink. I hold the glass in my left hand and put it underneath the tap in the sink. I push the tap up and then twist it to the left with my right hand until water trickles out. I tilt my head down towards the tap and watch the water flow. I let the glass fill up slowly. My right hand rests on the tap. When the glass is full I turn off the tap by pushing it up and then twisting it to the right. Then I pass the glass from my left to my right hand.

Drinking water

I stand up and raise the glass to my mouth. My left arm is straight and motionless. I tip the water into my open mouth and gulp. To control the flow of water into my mouth, I open and close my lips slowly, and open and close them again. The water waves back and forth in the glass every time I swallow. My neck moves every time I swallow. I tilt my head back and drink until the glass is empty. I press my lips together to suck in the droplets that are left there. I take the glass back to the living unit and put it on the chair.

Moving the metronome from the bedroom unit to the bathroom unit

I pick up the metronome and carry it from the bedroom unit to the bathroom unit. To balance myself I hold on to the upturned table leg as I walk past the table.

I put the metronome on the floor on the left-hand side of the toilet.

Peeing

I need to pee. I take the toilet paper from the shelf with my right hand. I keep my left hand behind my back. I take four steps over towards the toilet and turn my body round clockwise. When my back is to the audience I lean over and put the toilet roll on the left front corner of the shower tray. Then I lift the lid of the toilet with my right hand. I push it back until it is resting on the back of the unit. As I turn towards the front I lift up my shirt so I can unfasten my trousers. There are four buttons to unfasten. I tilt my head forward. When I have undone all the buttons I pull my trousers and my slip down to just above my knees and sit on the toilet.

I pick up the metronome and wind it up and put it down and set it ticking.

I put my feet close together in front of me and cup my hands together in my lap. My two index fingers and thumbs make a triangle shape. The tips of the fingers on my left hand touch the tips of the fingers on my right hand.

I look down. I sit still and wait for the pee to come.

The metronome stops ticking and I look at it.

Then the pee comes.

When I have finished peeing I lean over and take the toilet paper with my left hand. Holding it over my lap I unroll some paper and fold it precisely in half and then in half again and then in half again. I tear the bundle from the roll and place the roll back on the corner of the shower tray. I stand up and wipe myself with my right hand. Then I pull up my slip and my trousers and do up the four buttons. Then I straighten my shirt out.

I lean over and push down the handle of the bucket towards the front, then I turn on the tap on the wall with my left hand. The water falls into the bucket beneath. I stand still with my hands behind my back and listen to the sound.

When the bucket is half full I lift the bucket with both hands. I rest it on the edge of the toilet and then I pour the water down the toilet to flush it. Then I put the lid down. I place the bucket back where it was, underneath the tap, and pull the handle up so it is in the middle.

I pick up the toilet roll and put it back on the shelf where it was

before. Then I brush my hair back from my face with both hands.

I pick up the metronome and walk away.

Sitting on the bed

I sit on the bed at the quartz pillow end. The metronome is on my left-hand side and it is ticking. My feet are on the floor and my hands are together with my fingers interlaced. I stare at someone.

I swivel to the left to face someone else and I stare at them.

My head droops.

I brush the hair back from my face and stand up and walk away.

Filling the glass

I walk to the living unit and pick up the empty glass from the chair and take it to the sink in the bedroom unit. I sit down on the bed and twist round to face the sink. I hold the glass in my left hand and put it underneath the tap in the sink. I push the tap up and then twist it to the left with my right hand until water trickles out. I tilt my head down towards the tap and watch the water flow. I let the glass fill up slowly. My right hand rests on the tap. When the glass is full I turn off the tap by pushing it up and then twisting it to the right. Then I pass the glass from my left to my right hand.

Drinking water

I stand up and raise the glass to my mouth. My left arm is straight and motionless. I tip the water into my open mouth and gulp. To control the flow of water into my mouth, I open and close my lips slowly, and open and close them again. The water waves back and forth in the glass every time I swallow. My neck moves every time I swallow. I tilt my head back and drink until the glass is empty. I press my lips together to suck in the droplets that are left there. I take the glass back to the living unit and put it back on the chair.

Sitting on the bed

I sit on the bed on the left-hand side. I am pointing to the left. My hands are in my lap, my back is slouched, my shoulders hunched. My hands are together and they are in my lap. I stare at someone.

The metronome ticks.

I shift round so I am facing the front.

I shift round so I am facing the left.

The metronome ticks.

Lying on the floor

I put my hands on the edge of the bed, lift myself up and then lie on the floor. I lie on my front and rest my forehead against my arms.

Sitting on the bed

I get up again and sit on the bed.

Taking the hairband from the shelf

I get up and pick up the hairband from the shelf in the bedroom unit and hold it between my thumb and index finger. I carry it at chest height to the bathroom unit.

Showering

I walk back to the bathroom unit and put the hairband on the floor. I pick up the bath mat from inside the shower tray and unroll it on the floor in front of the shower. Then I lay the towel out on the toilet seat. I sit on the toilet seat and lean over and untie the laces of my right boot using my right hand. When the laces are loose enough, I take off the boot and then pull off the sock by grabbing the toe. I put the sock in the boot. Then I untie the laces of my left boot using my right hand. When the laces are loose enough I take off the boot and then pull off the sock by grabbing the toe. I put the sock in the boot. The boots are

next to each other by the wall.

Then I stand up and undo the buttons on my trousers. Then I pull them down. When I have sat down again, I finish pulling them off, starting with the right leg and finishing with the left leg. Then I fold them in half and then half again and then half again and put them on the floor next to the boots.

Then I undo the buttons of my shirt, starting at the bottom. There are seven buttons to undo. Then I take off my shirt and lay it across my legs and fold it up. Then I take off my undershirt and fold it up neatly. I put all my clothes on the floor next to my boots.

Then I pick up the hairband off the floor and put it on my knee. I pull my hair together behind my head, and tie it back with my hairband. I stand on the left of the shower, outside the tray, and turn on the taps. I test the temperature of the water by holding out my left hand under the trickle of water. I keep my hand there and wait for the water to warm up.

I step into the shower and face the audience. My hands are open, palms out and fingers straight, beside me. My eyes are closed.

I open my mouth very wide very quickly and hold it wide open for a long time. I let it fill up with water. Then I spit it out. I rock my head from side to side, slowly. Then I open my mouth wide again.

I rock my head from side to side.

Then I open my mouth wide again.

Then I reach behind me with both hands and turn off both taps.

I lean over to pick up the towel. I press the towel hard against my face for a long time, leaning forward. When I am ready, I move the towel away and then rub the towel over my arms, then my torso, then my legs. I do not dry myself very thoroughly. I lay the towel over the toilet seat and sit down on it.

Then I take off my hairband and put it on the floor.

Then I lean forward and touch my toes and stretch my back. Then I sit up and cover my face with my hands.

Then I put my slip back on. Then I put my undershirt back on by putting my head through the head hole and my arms through the armholes. I do the same with my shirt and do up the buttons on my cuffs. I do up the buttons starting at my neck and working my way downward. Then I brush my hair back from my face. Then I put my trousers on. I stand up and straighten out all of my clothes. I pick off a bit of fluff from my shirt. I sit back down and put my right sock on followed by my right boot. I tie the laces. Then I put my left sock on followed by my left boot. I tie the laces. I stand up.

I roll up the bath mat and put it in the shower tray. I pick up the towel and fold it and put it back on the shelf.

I pick up the hairband from the floor, gripping it between my thumb and index finger, and carry it away with me.

Putting the hairband back on the shelf

I walk to the bedroom unit with the hairband and put it back on the shelf.

Sitting inside the table

I sit on the floor next to the table and shuffle myself under the table legs. I have to duck my head. Then I sit inside the table. Two legs are on either side of my bottom. The other two legs are on either side of my head. My knees are hunched up against my chest. I stare at the eyes of someone in the audience.

I put my legs down and shuffle forward so my legs hang over the edge of the platform. My hands are in my lap. I stare at someone.

I put my face in my hands.

Then I shuffle back into the table and hunch my knees up to my chest.

Peeing

I need to pee. I put one foot in front of the other until I get to the bathroom unit. When I am in the unit I turn to my right and take the toilet paper from the shelf with my right hand. I keep my left hand behind my back. I take four steps over towards the toilet and turn my body round clockwise. When my back is to the audience I lean over and put the toilet roll on the left front corner of the shower tray. Then I lift the lid of the toilet with my right hand. I push it back until it is resting on the back of the unit. As I turn towards the front I lift up my shirt so I can unfasten my trousers. There are four buttons to unfasten. I tilt my head forward. When I have undone all the buttons I pull my trousers and my slip down to just above my knees and sit on the toilet. I put my feet close together in front of me and cup my hands together in my lap. My two index fingers and thumbs make a triangle shape. The tips of the fingers on my left hand touch the tips of the fingers on my right hand.

I look down. I sit still and wait for the pee to come. It takes a while and there is silence. I am motionless. Then the pee comes.

When I have finished peeing I lean over and take the toilet paper with my left hand. Holding it over my lap I unroll some paper and fold it precisely in half and then in half again and then in half again. I tear the bundle from the roll and place the roll back on the corner of the shower tray. I stand up and wipe myself with my right hand. Then I pull up my slip and my trousers and do up the four buttons. Then I straighten my shirt out.

I lean over and push down the handle of the bucket towards the front, then I turn on the tap on the wall with my left hand. The water falls into the bucket beneath. I stand still with my hands behind my back and listen to the sound. When the bucket is half full I lift the bucket with both hands. I rest it on the edge of the toilet and then I pour the water down the toilet to flush it. Then I put the lid down. I place the bucket back where it was, underneath the tap, and pull the handle up so it is in the middle.

I pick up the toilet roll and put it back on the shelf where it was before. Then I brush my hair back from my face with both hands.

Standing at the back

I move to the living unit and stand at the back leaning against the wall. My hands are clasped together behind my back. My feet are together. I look at someone in the audience.

Filling the glass

I pick up the empty glass from the chair and take it to the sink in the bedroom unit. I sit down on the bed and twist round to face the sink. I hold the glass in my left hand and put it underneath the tap in the sink. I push the tap up and then twist it to the left with my right hand until water trickles out. I tilt my head down towards the tap and watch the water flow. I let the glass fill up slowly. My right hand rests on the tap. When the glass is full I turn off the tap by pushing it up and then twisting it to the right. Then I pass the glass from my left to my right hand.

Drinking water

I stand up and raise the glass to my mouth. My left arm is straight and motionless. I tip the water into my open mouth and gulp. To control the flow of water into my mouth, I open and close my lips slowly, and open and close them again. The water waves back and forth in the glass every time I swallow. My neck moves every time I swallow. I tilt my head back and drink until the glass is empty. I press my lips together to suck in the droplets that are left there. I take the glass back to the living unit and put it on the side of the table leg.

Sitting on the bed

I sit on the bed at the quartz pillow end. The metronome is on my left-hand side and it is ticking. My feet are on the floor and my hands are together with my fingers interlaced. I stare at someone's eyes.

The metronome is ticking. I pick it up from the bed and put it on the floor.

Lying on the bed

I lie on my back on the bed. My feet are flat on the bed and my knees are hunched up. My hands are together, resting on my belly. My head is on the quartz pillow. I look at the ceiling.

The metronome has stopped. I lean over to start it ticking again.

Then I lie on my left-hand side and face the audience.

The metronome has stopped. I pick it up and wind it up. Then I put it on the floor and set it ticking.

It stops.

I set the ticker moving again with my right hand.

Lying on the bed

I lie on the bed on my left-hand side, facing the audience. My eyes are not closed. My head rests on my hands and my hands rest on the quartz pillow. My legs are on top of each other. The metronome is on the floor. It is ticking.

Sitting on the bed

I sit on the bed with my feet on the floor and my hands in my lap. I lean forward and stare.

Sitting on the edge

Before I kneel down I squat down and pick up hair and fluff and dirt from the floor and brush it down off the edge of the platform. Then I put my feet down and shuffle forward until my feet hang over the edge of the platform. I brush the hair from my face and stare. My hands are in my lap, linked together.

I stare at someone.

Then I fall asleep.

The metronome stops ticking.

I am still asleep.

My eyes are closed and I do not move.

I sleep.

Lying on the floor

I wake up, lean over and set the metronome ticking and then I stretch out on the floor on my front. My arms are out straight in front of me. My forehead rests on the floor.

Filling the glass

I walk to the living unit and pick up the empty glass from the side of the table leg and take it to the sink in the bedroom unit. I sit down on the bed and twist round to face the sink. I hold the glass in my left hand and put it underneath the tap in the sink. I push the tap up and then twist it to the left with my right hand until water trickles out. I tilt my head down towards the tap and watch the water flow. I let the glass fill up slowly. My right hand rests on the tap. When the glass is full I turn off the tap by pushing it up and then twisting it to the right. Then I pass the glass from my left to my right hand.

Drinking water

I stand up and raise the glass to my mouth. My left arm is straight and motionless. I tip the water into my open mouth and gulp. To control the flow of water into my mouth, I open and close my lips slowly, and open and close them again. The water waves back and forth in the glass every time I swallow. My neck moves every time I swallow. I tilt my head back and drink until the glass is empty. I press my lips together to suck in the droplets that are left there. I take the glass back to

the living unit and put it on the chair.

Peeing

I need to pee. I put one foot in front of the other until I get to the bathroom unit. When I am in the unit I turn to my right and take the toilet paper from the shelf with my right hand. I keep my left hand behind my back. I take four steps over towards the toilet and turn my body round clockwise. When my back is to the audience I lean over and put the toilet roll on the left front corner of the shower tray. Then I lift the lid of the toilet with my right hand. I push it back until it is resting on the back of the unit. As I turn towards the front I lift up my shirt so I can unfasten my trousers. There are four buttons to unfasten. I tilt my head forward. When I have undone all the buttons I pull my trousers and my slip down to just above my knees and sit on the toilet. I put my feet close together in front of me and cup my hands together in my lap. My two index fingers and thumbs make a triangle shape. The tips of the fingers on my left hand touch the tips of the fingers on my right hand.

I look down. I sit still and wait for the pee to come. It takes a while and there is silence. I am motionless. Then the pee comes.

When I have finished peeing I lean over and take the toilet paper with my left hand. Holding it over my lap I unroll some paper and fold it precisely in half and then in half again and then in half again. I tear the bundle from the roll and place the roll back on the corner of the shower tray. I stand up and wipe myself with my right hand. Then I pull up my slip and my trousers and do up the four buttons. Then I straighten my shirt out.

I lean over and push down the handle of the bucket towards the front, then I turn on the tap on the wall with my left hand. The water falls into the bucket beneath. I stand still with my hands behind my back and listen to the sound. When the bucket is half full I lift the bucket with both hands. I rest it on the edge of the toilet and then I pour the water down the toilet to flush it. Then I put the lid down. I place the bucket back where it was, underneath the tap, and pull the handle up so it is in the middle.

I pick up the toilet roll and put it back on the shelf where it was before. Then I brush my hair back from my face with both hands.

Sitting inside the table

I sit on the floor next to the table and shuffle myself under the table legs. I have to duck my head. Then I sit inside the table. Two legs are on either side of my bottom. The other two legs are on either side of my head. My knees are hunched up against my chest.

Sitting on the bed

I sit on the bed at the quartz pillow end. The metronome is on my left-hand side and it is ticking. My feet are on the floor and my hands are together with my fingers interlaced. My shoulders are hunched. I stare at someone.

Standing at the front

I get up and move to the front of the bedroom unit. I stand over the knife ladder. I brush the hair from my face and stare at someone's eyes. My wrists are tense and my hands flare out at my sides.

The metronome is on the floor and it is ticking.

I take a step closer to the edge.

Rearranging the furniture

I take the ends of the table leg and push the table away from the edge. Then I move round to the other side, grip the sides of the table and try to lift it up the right way again. The table falls to the ground. I lift it again and it goes all the way over. It is the right way up, with the ends of the four table legs on the ground. I shuffle it so it is straight. Then I take the glass from the chair and put it on the table, on the right-hand side.

Standing at the back

I move to the living unit and stand at the back leaning against the wall. My hands are clasped together behind my back. My feet are together. I look into someone's eyes.

Filling the glass

I pick up the empty glass from the side of the table and take it to the sink in the bedroom unit. I sit down on the bed and twist round to face the sink. I hold the glass in my left hand and put it underneath the tap in the sink. I push the tap up and then twist it to the left with my right hand until water trickles out. I tilt my head down towards the tap and watch the water flow. I let the glass fill up slowly. My right hand rests on the tap. When the glass is full I turn off the tap by pushing it up and then twisting it to the right. Then I pass the glass from my left to my right hand.

Drinking water

I stand up and raise the glass to my mouth. My left arm is straight and motionless. I tip the water into my open mouth and gulp. To control the flow of water into my mouth, I open and close my lips slowly, and open and close them again. The water waves back and forth in the glass every time I swallow. My neck moves every time I swallow. I tilt my head back and drink until the glass is empty. I press my lips together to suck in the droplets that are left there. I take the glass back to the living unit and put it on the table.

Sitting on the chair

I put my body in front of the chair and bend my knees until my bottom rests on the seat of the chair. I put my hands together in my lap. My fingers are interlaced. I look at the audience.

Standing between the units

I stand with one foot in the living unit and one foot in the bedroom unit, so that my body is over the gap. My legs make a triangle. I rest my arms on the back of the door frames. I look at the audience and remain still.

The metronome stops ticking.

Winding up the metronome

I pick up the metronome from the floor in the bedroom unit. I hold the metronome in my left hand and wind the winder with my right hand until it will not go round any more. Then I take the metronome to the living unit and put it on the floor on the left-hand side.

Showering

I walk back to the bathroom unit. I pick up the bath mat from inside the shower tray and unroll it on the floor in front of the shower. Then I lay the towel out on the toilet seat. I have forgotten the hairband.

Taking the hairband from the shelf

I walk to the bedroom unit and pick up the hairband from the shelf in the bedroom unit and hold it between my thumb and index finger. I carry it at chest height to the bathroom unit.

Showering

I sit on the toilet seat and lean over and untie the laces of my right boot using my right hand. When the laces are loose enough, I take off the boot and then pull off the sock by grabbing the toe. I put the sock in the boot. Then I untie the laces of my left boot using my right hand. When the laces are loose enough I take off the boot and then pull off the sock by grabbing the toe. I put the sock in the boot. The boots are next to each other by the wall.

Then I stand up and undo the buttons on my trousers. Then I pull them down. When I have sat down again, I finish pulling them off, starting with the right leg and finishing with the left leg. Then I fold them in half and then half again and then half again and put them on the floor next to the boots.

Then I undo the buttons of my shirt, starting at the bottom. There are seven buttons to undo. Then I take off my shirt and lay it across my legs and fold it up. Then I take off my undershirt and fold it up neatly. I put all my clothes on the floor next to my boots.

Then I pick up the hairband off the floor and put it on my knee. I pull my hair together behind my head and tie it back with my hairband. I stand on the left of the shower, outside the tray, and turn on the taps. I test the temperature of the water by holding out my left hand under the trickle of water. I keep my hand there and wait for the water to warm up.

I step into the shower and face the audience. My hands are open, palms out and fingers straight, beside me. My eyes are closed.

I open my mouth very wide very quickly and hold it wide open for a long time. I let it fill up with water. Then I spit it out. I rock my head from side to side, slowly. Then I open my mouth wide again.

I rock my head from side to side.

Then I open my mouth wide again.

Then I reach behind me with both hands and turn off both taps.

I lean over to pick up the towel. I press the towel hard against my face for a long time, leaning forward. When I am ready, I move the towel away and then rub the towel over my arms, then my torso, then my legs. I do not dry myself very thoroughly. I lay the towel over the toilet seat and sit down on it.

Then I take off my hairband and put it on the floor.

Then I lean forward and touch my toes and stretch my back. Then I sit up and cover my face with my hands.

Then I put my slip back on. Then I put my undershirt back on by putting my head through the head hole and my arms through the armholes. I do the same with my shirt and do up the buttons on my cuffs. I do up the buttons starting at my neck and working my way downward. Then I brush my hair back from my face. Then I put my trousers on. I stand up and straighten out all of my clothes. I pick off a bit of fluff from my shirt. I sit back down and put my right sock on followed by my right boot. I tie the laces. Then I put my left sock on followed by my left boot. I tie the laces. I stand up.

I roll up the bath mat and put it in the shower tray. I pick up the towel and fold it and put it back on the shelf.

I pick up the hairband from the floor, gripping it between my thumb and index finger, and carry it away with me.

Putting the hairband back on the shelf

I walk to the bedroom unit with the hairband and put it back on the shelf.

Winding the metronome

The metronome stops ticking. I pick it up from the floor in the living unit and wind it up. I twist the winder five times and put the metronome on the table. It starts ticking.

Filling the glass

I pick up the empty glass from the side of the table and take it to the sink in the bedroom unit. I sit down on the bed and twist round to face the sink. I hold the glass in my left hand and put it underneath the tap in the sink. I push the tap up and then twist it to the left with my right hand until water trickles out. I tilt my head down towards the tap and watch the water flow. I let the glass fill up slowly. My right hand rests on the tap. When the glass is full I turn off the tap by pushing it up and then twisting it to the right. Then I pass the glass from my left to my right hand.

Drinking water

I stand up and raise the glass to my mouth. I am under the light, pointing to the left. My left arm is straight and motionless. I tip the water into my open mouth and gulp. To control the flow of water into my mouth, I open and close my lips slowly, and open and close them again. The water waves back and forth in the glass every time I swallow. My neck moves every time I swallow. I tilt my head back and drink until the glass is empty. I press my lips together to suck in the droplets that are left there. I take the glass back to the living unit and put it on the table.

Rearranging the furniture

I rock the chair on its side. Then I twist it round. Then I go to the back, tilt it back and try to push it forward. It does not move and I make a sound. Then it moves and I lower the back of the chair onto the ground. I drop it and it makes a sound. Then I turn the chair on its left-hand side by gripping the top right leg. Then I turn it over again so it is lying on its front. The ends of the legs are facing the audience. Then I push the chair out the way with my left foot.

Standing at the back

I stand at the back of the living unit leaning against the wall. My hands are clasped together behind my back. My feet are together. I look at someone in the audience.

Standing at the front

I move to the front of the bedroom unit and stand over the knife ladder.

I stare at someone in the audience.

Standing at the back

I stand at the back of the living unit leaning against the wall. My hands are clasped together behind my back. My feet are together. I look at someone in the audience.

Starting the metronome

The metronome stops ticking. I step forward and pull the ticker down with the index finger of my right hand. It starts ticking again.

Standing between the units

I stand with one foot in the living unit and one foot in the bedroom unit, so that my body is over the gap. My legs make a triangle. I rest my arms on the back of the door frames. I look at the audience and remain still.

Kneeling

I walk to the edge, bend my knees and kneel down on the floor at the front of the living unit, over the knife ladder. I put my hands on either side of me and stare down at someone in the audience.

I lean over the knife ladder and let my arms hang down.

Standing at the front

I stand up. I stare at someone in the audience. My wrists tense and my hands flare at my sides.

I take a step back from the edge.

Rearranging the furniture

I pull the chair towards the center of the room and push the table back.

Stopping the metronome

I pinch the ticker between my thumb and forefingers and the metronome stops ticking.

Day 11

Monday, November 25th: Day 11

Wearing blue

Lying on the bed

I lie on the bed with my head resting on the quartz pillow. My eyes are closed. My hands are together on my belly. My knees are in the air and my feet are together, up near my bottom. The metronome is on the floor and it is ticking.

Sitting on the bed

I sit on the bed leaning against the back wall. My feet rest on the edge of the bed and my legs are hunched up.

Filling the glass

I move to the living unit and pick up the empty glass from the table and take it to the sink in the bedroom unit. I sit down on the bed and twist round to face the sink. I hold the glass in my left hand and put it underneath the tap in the sink. I push the tap up and then twist it to the left with my right hand until water trickles out. I tilt my head down towards the tap and watch the water flow. I let the glass fill up slowly. My right hand rests on the tap. When the glass is full I turn off the tap by pushing it up and then twisting it to the right. Then I pass the glass from my left to my right hand.

Drinking water

I stand up and raise the glass to my mouth. I am pointing to the left. My left arm is straight and motionless. I tip the water into my open mouth and gulp. To control the flow of water into my mouth, I open and close my lips slowly, and open and close them again. The water waves back and forth in the glass every time I swallow. My neck moves every time I swallow. I tilt my head back and drink until the glass is empty. I press my lips together to suck in the droplets that are left there. I take the glass back to the living unit and put it on the table.

Sitting on the chair

I put my body in front of the chair and bend my knees until my bottom rests on the seat of the chair. I put my hands together in my lap. My fingers are interlaced. I look at the audience.

Standing between the units

I stand with one foot in the living unit and one foot in the bedroom unit, so that my body is over the gap. My legs make a triangle. I rest my arms on the back of the door frames. I look at the audience and remain still.

Lying on the bed

I lie on the bed on my left side and look out. My head rests on the quartz pillow. My left arm hugs my right shoulder. My right hand rests on the bed.

The metronome ticks.

Filling the glass

I move to the living unit and pick up the empty glass from the table and take it to the sink in the bedroom unit. I sit down on the bed and twist round to face the sink. I hold the glass in my left hand and put it underneath the tap in the sink. I push the tap up and then twist it to the left with my right hand until water trickles out. I tilt my head down towards the tap and watch the water flow. I let the glass fill up slowly. My right hand rests on the tap. When the glass is full I turn off the tap by pushing it up and then twisting it to the right. Then I pass the glass from my left to my right hand.

Drinking water

I stand up and raise the glass to my mouth. I am pointing to the left. My left arm is straight and motionless. I tip the water into my open mouth and gulp. To control the flow of water into my mouth, I open and close my lips slowly, and open and close them again. The water waves back and forth in the glass every time I swallow. My neck moves every time I swallow. I tilt my head back and drink until the glass is empty. I press my lips together to suck in the droplets that are left there. I take the glass back to the living unit and put it on the table.

Lying on the bed

I lie on the bed on my left side and look out. My head rests on the quartz pillow. My left hand rests on the quartz pillow. My right hand hangs over the edge of the bed.

The metronome ticks.

A plane goes overhead and makes a sound.

Peeing

I need to pee. I put one foot in front of the other until I get to the bathroom unit. When I am in the unit I turn to my right and take the toilet paper from the shelf with my right hand. I keep my left hand behind my back. I take four steps over towards the toilet and turn my body round clockwise. When my back is to the audience I lean over and put the toilet roll on the left front corner of the shower tray. Then I lift the lid of the toilet with my right hand. I push it back until it is resting on the back of the unit. As I turn towards the front I lift up my shirt so I can unfasten my trousers. There are four buttons to unfasten. I tilt my head forward. When I have undone all the buttons I pull my trousers and my slip down to just above my knees and sit on the toilet. I put my feet close together in front of me and cup my hands together in my lap. My two index fingers and thumbs make a triangle shape. The tips of the fingers on my left hand touch the tips of the fingers on my right hand.

I look down. I sit still and wait for the pee to come. It takes a while and there is silence. Then there is a tinkling sound. I am motionless.

When I have finished peeing I lean over and take the toilet paper with my left hand. Holding it over my lap I unroll some paper and fold it precisely in half and then in half again and then in half again. I tear the bundle from the roll and place the roll back on the corner of the shower tray. I stand up and wipe myself with my right hand. Then I pull up my slip and my trousers and do up the four buttons. Then I straighten my shirt out.

I lean over and push down the handle of the bucket towards the front, then I turn on the tap on the wall with my left hand. The water falls into the bucket beneath. I stand still with my hands behind my back and listen to the sound.
The bucket overflows. The water spreads over the floor of the bathroom unit and falls over the edge. I look at the tap and then turn it off.

I lift the bucket with both hands. I make a sound. I rest it on the edge of the toilet and then I pour the water down the toilet to flush it. Then I put the lid down. I place the bucket back where it was, underneath the tap, and pull the handle up so it is in the middle.

I pick up the toilet roll and put it back on the shelf where it was before. Then I brush my hair back from my face with both hands.

Standing at the front

I move to the front of the living unit. I stand over the knife ladder. I brush the hair from my face and stare into someone's eyes. My wrists are tense and my hands flare out at my sides.

Lying on the bed

I lie on the bed on my left side and look out. My head rests on the quartz pillow. My left arm hugs my right shoulder. My right hand rests on the bed.

The metronome ticks.

Sitting on the bed

I sit up. I sit with my feet on the floor and my hands together in my lap. I look at someone in the audience.

The metronome is ticking.

Filling the glass

I move to the living unit and pick up the empty glass from the table and take it to the sink in the bedroom unit. I sit down on the bed and twist round to face the sink. I hold the glass in my left hand and put it underneath the tap in the sink. I push the tap up and then twist it to the left with my right hand until water trickles out. I tilt my head down towards the tap and watch the water flow. I let the glass fill up slowly. My right hand rests on the tap. When the glass is full I turn off the tap by pushing it up and then twisting it to the right. Then I pass the glass from my left to my right hand.

Drinking water

I stand up and take the glass to the living unit. I raise the glass to my mouth and tilt my head back. My left arm is straight and motionless. I tip the water into my open mouth and gulp. To control the flow of water into my mouth, I open and close my lips slowly, and open and close them again. The water waves back and forth in the glass every time I swallow. My neck moves every time I swallow. I tilt my head back and drink until the glass is empty. I press my lips together to suck in the droplets that are left there. I take the glass back to the living unit and put it on the table.

Sitting on the chair

I put my body in front of the chair and bend my knees until my bottom rests on the seat of the chair. I put my hands together in my lap. My fingers are interlaced. I look at the audience.

Standing at the back

I move to the living unit and stand at the back leaning against the wall. My hands are clasped together behind my back. My feet are together. I look at someone in the audience.

Peeing

I need to pee. I put one foot in front of the other until I get to the bathroom unit. When I am in the unit I turn to my right and take the toilet paper from the shelf with my right hand. I keep my left hand behind my back. I take four steps over towards the toilet and turn my body round clockwise. When my back is to the audience I lean over and put the toilet roll on the left front corner of the shower tray. Then I lift the lid of the toilet with my right hand. I push it back until it is resting on the back of the unit. As I turn towards the front I lift up my shirt so I can unfasten my trousers. There are four buttons to unfasten. I tilt my head forward. When I have undone all the buttons I pull my trousers and my slip down to just above my knees and sit on the toilet. I put my feet close together in front of me and cup my hands together in my lap. My two index fingers and thumbs make a triangle shape. The tips of the

fingers on my left hand touch the tips of the fingers on my right hand.

I look down. I sit still and wait for the pee to come. It takes a while and there is silence. Then there is a tinkling sound. I am motionless.

When I have finished peeing I lean over and take the toilet paper with my left hand. Holding it over my lap I unroll some paper and fold it precisely in half and then in half again and then in half again. I tear the bundle from the roll and place the roll back on the corner of the shower tray. I stand up and wipe myself with my right hand. Then I pull up my slip and my trousers and do up the four buttons. Then I straighten my shirt out.

I lean over and push down the handle of the bucket towards the front, then I turn on the tap on the wall with my left hand. The water falls into the bucket beneath. I stand still with my hands behind my back and listen to the sound.

When the bucket is half full I lift the bucket with both hands and then I pour the water down the toilet to flush it. Then I put the lid down. I place the bucket back where it was, underneath the tap, and pull the handle up so it is in the middle.

I pick up the toilet roll and put it back on the shelf where it was before. Then I brush my hair back from my face with both hands.

Standing at the back

I move to the living unit and stand at the back leaning against the wall. My hands are clasped together behind my back. My feet are together. I look at the audience.

Standing between the units

I stand with one foot in the living unit and one foot in the bedroom unit, so that my body is over the gap. My legs make a triangle. I rest my arms on the back of the door frames. I look at the audience and remain still.

The metronome is ticking.

Sitting on the edge

I sit on the edge of the bedroom unit, to the left of the knife ladder. My legs hang down. My hands are together in my lap. I look at someone.

I cover my face with my hands. I look at someone else.

Filling the glass

I move to the living unit and pick up the empty glass from the table and take it to the sink in the bedroom unit. I sit down on the bed and twist round to face the sink. I hold the glass in my left hand and put it underneath the tap in the sink. I push the tap up and then twist it to the left with my right hand until water trickles out. I tilt my head down towards the tap and watch the water flow. I let the glass fill up slowly. My right hand rests on the tap. When the glass is full I turn off the tap by pushing it up and then twisting it to the right. Then I pass the glass from my left to my right hand.

Drinking water

I stand up and raise the glass to my mouth. I am pointing to the left. My left arm is straight and motionless. I tip the water into my open mouth and gulp. To control the flow of water into my mouth, I open and close my lips slowly, and open and close them again. The water waves back and forth in the glass every time I swallow. My neck moves every time I swallow. I tilt my head back and drink until the glass is empty. I press my lips together to suck in the droplets that are left there. I take the glass back to the living unit and put it on the table.

Winding the metronome

The metronome has stopped ticking. I pick it up from the floor in the bedroom unit and hold it in my left hand and wind it with my right

hand. I wind it slowly until the winder will not wind round anymore. Then I put the metronome back on the floor and set the ticker ticking.

Sitting on the bed

I sit on the bed near the quartz pillow. My feet are on the floor. My hands are together in my lap. I look at the audience.

I shuffle down to the other end of the bed by putting my hands on the edge of the bed and pushing myself along. I stare at someone's eyes.

Filling the glass

I move to the living unit and pick up the empty glass from the table and take it to the sink in the bedroom unit. I sit down on the bed and twist round to face the sink. I hold the glass in my left hand and put it underneath the tap in the sink. I push the tap up and then twist it to the left with my right hand until water trickles out. I tilt my head down towards the tap and watch the water flow. I let the glass fill up slowly. My right hand rests on the tap. When the glass is full I turn off the tap by pushing it up and then twisting it to the right. Then I pass the glass from my left to my right hand.

Drinking water

I stand up and raise the glass to my mouth. I am pointing to the left. My left arm is straight and motionless. I tip the water into my open mouth and gulp. To control the flow of water into my mouth, I open and close my lips slowly, and open and close them again. The water waves back and forth in the glass every time I swallow. My neck moves every time I swallow. I tilt my head back and drink until the glass is empty. I press my lips together to suck in the droplets that are left there. I take the glass back to the living unit and put it on the table.

Lying on the bed

I lie on the bed on my left side and look out. My head rests on the quartz pillow. My left hand rests on the quartz pillow. My right hand hangs over the edge.

The metronome ticks.

My eyes are open. They are looking.

Then they are closed.

Then I roll over onto my back and sit up slowly.

Peeing

I need to pee. I put one foot in front of the other until I get to the bathroom unit. When I am in the unit I turn to my right and take the toilet paper from the shelf with my right hand. I keep my left hand behind my back. I take four steps over towards the toilet and turn my body round clockwise. When my back is to the audience I lean over and put the toilet roll on the left front corner of the shower tray. Then I lift the lid of the toilet with my right hand. I push it back until it is resting on the back of the unit. As I turn towards the front I lift up my shirt so I can unfasten my trousers. There are four buttons to unfasten. I tilt my head forward. When I have undone all the buttons I pull my trousers and my slip down to just above my knees and sit on the toilet. I put my feet close together in front of me and cup my hands together in my lap. My two index fingers and thumbs make a triangle shape. The tips of the fingers on my left hand touch the tips of the fingers on my right hand.

I look down. I sit still and wait for the pee to come. It takes a while and there is silence. Then there is a tinkling sound. I am motionless.

When I have finished peeing I lean over and take the toilet paper with my left hand. Holding it over my lap I unroll some paper and fold it precisely in half and then in half again and then in half again. I tear the bundle from the roll and place the roll back on the corner of the shower tray. I stand up and wipe myself with my right hand. Then I pull up my slip and my trousers and do up the four buttons. Then I straighten my shirt out.

I lean over and push down the handle of the bucket towards the front, then I turn on the tap on the wall with my left hand. The water falls into the bucket beneath. I stand still with my hands behind my back and listen to the sound.

When the bucket is half full I lift the bucket with both hands and then I pour the water down the toilet to flush it. Then I put the lid down. I place the bucket back where it was, underneath the tap, and pull the handle up so it is in the middle.

I pick up the toilet roll and put it back on the shelf where it was before. Then I brush my hair back from my face with both hands.

Lying on the bed

I lie on the bed on my left side and look out. My head rests on the quartz pillow. My left hand rests on the quartz pillow. My right hand hangs over the edge of the bed.

The metronome ticks.

Filling the glass

I move to the living unit and pick up the empty glass from the table and take it to the sink in the bedroom unit. I sit down on the bed and twist round to face the sink. I hold the glass in my left hand and put it underneath the tap in the sink. I push the tap up and then twist it to the left with my right hand until water trickles out. I tilt my head down towards the tap and watch the water flow. I let the glass fill up slowly. My right hand rests on the tap. When the glass is full I turn off the tap by pushing it up and then twisting it to the right. Then I pass the glass from my left to my right hand.

Drinking water

I stand up and walk to the living unit. When I am there I stop and raise the glass to my mouth. I am pointing to the left. My left arm is straight and motionless. I tip the water into my open mouth and gulp. To control the flow of water into my mouth, I open and close my lips slowly, and open and close them again. The water waves back and forth in the glass every time I swallow. My neck moves every time I swallow. I tilt my head back and drink until the glass is empty. I press my lips together to suck in the droplets that are left there. I take the glass back to the living unit and put it on the table.

Lying on the bed

I lie on the bed on my left side and look out. My head rests on the quartz pillow. My left hand rests on the quartz pillow. My right hand hangs over the edge of the bed.

The metronome ticks.

My eyes are open. I blink. I look at the audience.

Then my eyes close.

Then I sit up.

Filling the glass

I move to the living unit and pick up the empty glass from the table and take it to the sink in the bedroom unit. I sit down on the bed and twist round to face the sink. I hold the glass in my left hand and put it underneath the tap in the sink. I push the tap up and then twist it to the left with my right hand until water trickles out. I tilt my head down towards the tap and watch the water flow. I let the glass fill up slowly. My right hand rests on the tap. When the glass is full I turn off the tap by pushing it up and then twisting it to the right. Then I pass the glass from my left to my right hand.

Drinking water

I stand up and raise the glass to my mouth. I am pointing to the left. My left arm is straight and motionless. I tip the water into my open

mouth and gulp. To control the flow of water into my mouth, I open and close my lips slowly, and open and close them again. The water waves back and forth in the glass every time I swallow. My neck moves every time I swallow. I tilt my head back and drink until the glass is empty. I press my lips together to suck in the droplets that are left there. I take the glass back to the living unit and put it on the table.

Peeing

I need to pee. I put one foot in front of the other until I get to the bathroom unit. When I am in the unit I turn to my right and take the toilet paper from the shelf with my right hand. I keep my left hand behind my back. I take four steps over towards the toilet and turn my body round clockwise. When my back is to the audience I lean over and put the toilet roll on the left front corner of the shower tray. Then I lift the lid of the toilet with my right hand. I push it back until it is resting on the back of the unit. As I turn towards the front I lift up my shirt so I can unfasten my trousers. There are four buttons to unfasten. I tilt my head forward. When I have undone all the buttons I pull my trousers and my slip down to just above my knees and sit on the toilet. I put my feet close together in front of me and cup my hands together in my lap. My two index fingers and thumbs make a triangle shape. The tips of the fingers on my left hand touch the tips of the fingers on my right hand.

I look down. I sit still and wait for the pee to come. It takes a while and there is silence. Then there is a tinkling sound. I am motionless.

When I have finished peeing I lean over and take the toilet paper with my left hand. Holding it over my lap I unroll some paper and fold it precisely in half and then in half again and then in half again. I tear the bundle from the roll and place the roll back on the corner of the shower tray. I stand up and wipe myself with my right hand. Then I pull up my slip and trousers and do up the four buttons. Then I straighten my shirt out.

I lean over and push down the handle of the bucket towards the front, then I turn on the tap on the wall with my left hand. The water falls into the bucket beneath. I stand still with my hands behind my back and listen to the sound. I lean against the side wall.

The bucket overflows. The water spreads over the floor of the living unit. Then it falls off the edge.

I lift the bucket with both hands and then rest it on the edge of the toilet. Then I lift it again and pour the water down the toilet to flush it. Then I put the lid down. I place the bucket back where it was, underneath the tap, and pull the handle up so it is in the middle.

I pick up the toilet roll and put it back on the shelf where it was before. Then I brush my hair back from my face with both hands.

Lying on the bed

I lie on the bed on my left side and look out. My head rests on the quartz pillow. My left hand rests on the quartz pillow. My right hand hangs over the edge of the bed. My right leg rests on my left leg.

The metronome ticks.

I stare.

I hunch my legs up. My knees are bent at right angles.

I hug my right shoulder with my left hand.

I close my eyes. Then I get up.

Winding the metronome

The metronome has stopped ticking. I lean down and pick it up from the floor. I sit on the bed and hold the metronome in my left hand and wind it with my right hand. I wind it slowly until the winder will not wind round anymore. Then I carry the metronome to the living unit and put it on the floor on the left-hand side. I set the ticker ticking.

Showering

I walk to the bathroom unit and pick up the towel from the shelf and lay it out on the toilet seat. I have forgotten the hairband.

Taking the hairband from the shelf

I walk to the bedroom unit and pick up the hairband from the shelf in the bedroom unit and hold it between my thumb and index finger. I carry it at chest height to the bathroom unit.

Showering

I put the hairband on the floor. I take the bath mat from the shower tray and unroll it on the floor in front of the shower tray. I sit on the toilet seat and lean over and untie the laces of my right boot using my right hand. When the laces are loose enough, I take off the boot and then pull off the sock by grabbing the toe. I put the sock in the boot. Then I untie the laces of my left boot using my left hand. When the laces are loose enough I take off the boot and then pull off the sock by grabbing the toe. I put the sock in the boot. The boots are next to each other by the wall.

Then I stand up and undo the buttons on my trousers. Then I pull them down. When I have sat down again, I finish pulling them off, starting with the right leg and finishing with the left leg. Then I fold them in half and then half again and then half again and put them on the floor next to the boots.

Then I undo the buttons of my shirt, starting at the bottom. There are seven buttons to undo. Then I take off my shirt and lay it across my legs and fold it up. Then I take off my undershirt and fold it up neatly. Then I take off my slip. I put all my clothes on the floor next to my boots.

Then I pick up the hairband off the floor, pull my hair together behind my head, and tie it back with my hairband. I stand on the left of the shower, outside the tray, and turn on the taps. I test the temperature of the water by holding out my left hand under the trickle of water. I keep my hand there and wait for the water to warm up.

I step into the shower and face the audience. My hands are open, palms out and fingers straight, beside me. My eyes are closed.

I open my mouth very wide very quickly and hold it wide open for a long time. I let it fill up with water. Then I spit it out. I rock my head from side to side, slowly. Then I open my mouth wide again.

I rock my head from side to side.

Then I open my mouth wide again.

Then I reach behind me with both hands and turn off both taps.

I lean over to pick up the towel. I press the towel hard against my face for a long time, leaning forward. When I am ready, I move the towel away and then rub the towel over my arms, then my torso, then my legs. I do not dry myself very thoroughly. I lay the towel over the toilet seat and sit down on it.

Then I take off my hairband and put it on the floor.

Then I lean forward and touch my toes and stretch my back. Then I sit up and cover my face with my hands.

Then I put my slip back on. Then I put my undershirt back on by putting my head through the head hole and my arms through the armholes. I do the same with my shirt and do up the buttons on my cuffs. I do up the buttons starting at my neck and working my way downward. Then I brush my hair back from my face. Then I put my trousers on. I stand up and straighten out all of my clothes. I sit back down and put my right sock on followed by my right boot. I tie the laces. Then I put my left sock on followed by my left boot. I tie the laces. I stand up.

I roll up the bath mat and put it in the shower tray. I pick up the towel and fold it and put it back on the shelf.

I pick up the hairband from the floor, gripping it between my thumb and index finger, and carry it away with me.

Putting the hairband back on the shelf

I walk to the bedroom unit with the hairband and put it back on the shelf.

Standing at the back

On the way to standing at the back of the living unit I prod the metronome to make it tick again. Then I stand at the back leaning against the wall. My hands are clasped together behind my back. My feet are together. I look at someone in the audience.

Sitting on the edge

I sit on the edge of the living unit, between the metronome and the knife ladder. My legs hang down. My hands are together in my lap. I look at someone.

Lying underneath the table

I lie back so that my upper body is underneath the table. My legs still hang over the edge. I look up at the underside of the table.

Sitting underneath the table

I shuffle backwards and bring my legs up so that my whole upper body is underneath the table. Then I sit up and lean against the back wall. My legs are out straight and my feet reach the edge of the platform.

I stare at the audience.

The metronome ticks.

Sitting at the back

I slide out from underneath the table and sit leaning against the back wall. My legs are out straight and are far apart. My feet are splayed out. My hands are in my lap. I stare.

Sitting on the edge

I catch someone's eye and shuffle forward along the floor by pushing myself with my hands and hunching up my legs. I get to the edge of the platform and sit with my legs hanging over the edge. My hands are in my lap. I stare at the person.

Lying on the floor

I lift my legs up, swivel round on my bottom and lie on the floor on my back. My legs are hunched up, bent at the knee. My feet touch the door frame. My arms are flat on the floor and my palms face upwards.

Filling the glass

I get up and pick up the empty glass from the table and take it to the sink in the bedroom unit. I sit down on the bed and twist round to face the sink. I hold the glass in my left hand and put it underneath the tap in the sink. I push the tap up and then twist it to the left with my right hand until water trickles out. I tilt my head down towards the tap and watch the water flow. I let the glass fill up slowly. My right hand rests on the tap. When the glass is full I turn off the tap by pushing it up and then twisting it to the right. Then I pass the glass from my left to my right hand.

Drinking water

I stand up and raise the glass to my mouth. I am pointing to the left. My left arm is straight and motionless. I tip the water into my open mouth and gulp. To control the flow of water into my mouth, I open and close my lips slowly, and open and close them again. The water waves back and forth in the glass every time I swallow. My neck moves every time I swallow. I tilt my head back and drink until the glass is empty. I press my lips together to suck in the droplets that are left there. I take the glass back to the living unit and put it on the table.

Peeing

I need to pee. I put one foot in front of the other until I get to the bathroom unit. When I am in the unit I turn to my right and take the toilet paper from the shelf with my right hand. I keep my left hand behind my back. I take four steps over towards the toilet and turn my body round clockwise. When my back is to the audience I lean over and put the toilet roll on the left front corner of the shower tray. Then I lift the lid of the toilet with my right hand. I push it back until it is resting on the back of the unit. As I turn towards the front I lift up my shirt so I can unfasten my trousers. There are four buttons to unfasten. I tilt my head forward. When I have undone all the buttons I pull my trousers and my slip down to just above my knees and sit on the toilet. I put my feet close together in front of me and cup my hands together in my lap. My two index fingers and thumbs make a triangle shape. The tips of the fingers on my left hand touch the tips of the fingers on my right hand.

I look at the floor. I sit still and wait for the pee to come. It takes a while and there is silence. Then there is a tinkling sound. I am motionless.

When I have finished peeing I lean over and take the toilet paper with my left hand. Holding it over my lap I unroll some paper and fold it precisely in half and then in half again and then in half again. I tear the bundle from the roll and place the roll back on the corner of the shower tray. I stand up and wipe myself with my right hand. Then I pull up my slip and my trousers and do up the four buttons. Then I straighten my shirt out.

I lean over and push down the handle of the bucket towards the front, then I turn on the tap on the wall with my left hand. The water falls into the bucket beneath. I stand still with my hands behind my back and listen to the sound.

When the bucket is half full I lift the bucket with both hands and then I pour the water down the toilet to flush it. Then I put the lid down. I place the bucket back where it was, underneath the tap, and pull the handle up so it is in the middle. It falls to the front. I put it in the middle again.

I pick up the toilet roll and put it back on the shelf where it was before. Then I brush my hair back from my face with both hands.

Lying under the bed

I walk up to the bed and pause. Then I bend down and kneel. Then I lie down, stretching forward. I shuffle under the bed and lie on my left-hand side, facing the audience. I rest my head on my arms. I stare out from under the bed.

I blink.

Sitting on the edge

I shuffle out from under the bed and slide across the floor to the edge of the bedroom unit. I sit on the edge with my legs hanging over edge. My hands are in my lap. I stare at someone in the audience.

I close my eyes.

The metronome ticks.

Lying on the floor

I lie back and swivel round on my bottom so that my head is next to the door frame and my feet point to the side wall. My legs are hunched up. My hands are together, resting on my stomach.

The metronome stops ticking.

I sit up.

Filling the glass

I move to the living unit and pick up the empty glass from the table

and take it to the sink in the bedroom unit. I sit down on the bed and twist round to face the sink. I hold the glass in my left hand and put it underneath the tap in the sink. I push the tap up and then twist it to the left with my right hand until water trickles out. I tilt my head down towards the tap and watch the water flow. I let the glass fill up slowly. My right hand rests on the tap. When the glass is full I turn off the tap by pushing it up and then twisting it to the right. Then I pass the glass from my left to my right hand.

Drinking water

I stand up and raise the glass to my mouth. I am pointing to the left. My left arm is straight and motionless. I tip the water into my open mouth and gulp. To control the flow of water into my mouth, I open and close my lips slowly, and open and close them again. The water waves back and forth in the glass every time I swallow. My neck moves every time I swallow. I tilt my head back and drink until the glass is empty. I press my lips together to suck in the droplets that are left there. I take the glass back to the living unit and put it on the table.

Winding the metronome

The metronome has stopped ticking. I pick it up from the floor in the living unit and hold it in my left hand and wind it with my right hand. I wind it slowly until the winder will not wind round anymore. Then I put the metronome back on the floor and set the ticker ticking.

Standing at the back

I move to the back of the living unit and lean against the wall. My hands are clasped together behind my back. My feet are together. I look at someone in the audience.

Standing in the middle

I take a step to the middle of the living unit and stare at someone. My wrists are tense, my fingers are together.

Standing at the front

I move to the front of the living unit. I stand over the knife ladder. I stare at someone. My wrists are tense and my hands flare out at my sides. My arms lift a little.

Lying under the bed

I walk to the bed. Then I bend down and kneel. Then I lie down, stretching forward. I shuffle under the bed and lie on my left-hand side, facing the audience. I rest my head on my arms. I stare out from under the bed.

The metronome ticks.

I blink.

I breathe.

Showering

I walk to the bathroom unit, pick up the towel from the shelf and lay it out on the toilet seat. Then I take the bath mat from the shower tray and unroll it on the floor. I have forgotten the hairband.

Taking the hairband from the shelf

I walk to the bedroom unit and pick up the hairband from the shelf in the bedroom unit and hold it between my thumb and index finger. I carry it at chest height to the bathroom unit.

Showering

I put the hairband on the floor. I sit on the toilet seat and lean over and untie the laces of my right boot using my right hand. When the laces are loose enough, I take off the boot and then pull off the sock by grabbing the toe. I put the sock in the boot. Then I untie the laces of my left boot using my left hand. When the laces are loose enough I take off the boot and then pull off the sock by grabbing the toe. I put the sock in the boot. The boots are next to each other by the wall.

Then I stand up and undo the buttons on my trousers. Then I pull them down. When I have sat down again, I finish pulling them off, starting with the right leg and finishing with the left leg. Then I fold them in half and then half again and then half again and put them on the floor next to the boots.

Then I undo the buttons of my shirt, starting at the bottom. There are seven buttons to undo. Then I take off my shirt and lay it across my legs and fold it up. Then I take off my undershirt and fold it up neatly. Then I take off my slip. I put all my clothes on the floor next to my boots.

Then I pick up the hairband off the floor, pull my hair together behind my head, and tie it back with my hairband. I stand on the left of the shower, outside the tray, and turn on the taps. I test the temperature of the water by holding out my left hand under the trickle of water. I keep my hand there and wait for the water to warm up.

I step into the shower and face the audience. My hands are open, palms out and fingers straight, beside me. My eyes are closed.

I open my mouth very wide very quickly and hold it wide open for a long time. I let it fill up with water. Then I spit it out. I rock my head from side to side, slowly. Then I open my mouth wide again.

I rock my head from side to side.

Then I open my mouth wide again.

Then I reach behind me with both hands and turn off both taps.

I lean over to pick up the towel. I press the towel hard against my face for a long time, leaning forward. When I am ready, I move the towel away and then rub the towel over my arms, then my torso, then my legs. I do not dry myself very thoroughly. I lay the towel over the toilet seat and sit down on it.

Then I take off my hairband and put it on the floor.

Then I lean forward and touch my toes and stretch my back. Then I sit up.

Then I put my slip back on. Then I put my undershirt back on by putting my head through the head hole and my arms through the armholes. I do the same with my shirt and do up the buttons on my cuffs. I do up the buttons starting at my neck and working my way downward. Then I brush my hair back from my face. Then I put my trousers on. I stand up and straighten out all of my clothes. I sit back down and put my right sock on followed by my right boot. I tie the laces. Then I put my left sock on followed by my left boot. I tie the laces. I stand up.

I roll up the bath mat and put it in the shower tray. I pick up the towel and fold it and put it back on the shelf.

I pick up the hairband from the floor, gripping it between my thumb and index finger, and carry it away with me.

Sitting on the chair

I put my body in front of the chair and bend my knees until my bottom rests on the seat of the chair. I put my hands together in my lap. I look at the audience.

The metronome is ticking.

Sitting on the edge

I get down from the chair and sit on the edge of the living unit, with my legs hanging over the edge. My hands are together in my lap. I look at someone.

Lying on the floor

I lean back and swivel round on my bottom and lift my legs up and put them down flat so that my feet poke through the door frame. I lie on

my back with my head pointing towards the bathroom unit. My arms are flat on the floor, palm down. I look up at the ceiling.

Filling the glass

Then I get up and pick up the empty glass from the table and take it to the sink in the bedroom unit. I sit down on the bed and twist round to face the sink. I hold the glass in my left hand and put it underneath the tap in the sink. I push the tap up and then twist it to the left with my right hand until water trickles out. I tilt my head down towards the tap and watch the water flow. I let the glass fill up slowly. My right hand rests on the tap. When the glass is full I turn off the tap by pushing it up and then twisting it to the right. Then I pass the glass from my left to my right hand.

Drinking water

I stand up and raise the glass to my mouth. I am pointing to the left. My left arm is straight and motionless. I tip the water into my open mouth and gulp. To control the flow of water into my mouth, I open and close my lips slowly, and open and close them again. The water waves back and forth in the glass every time I swallow. My neck moves every time I swallow. I tilt my head back and drink until the glass is empty. I press my lips together to suck in the droplets that are left there. I take the glass back to the living unit and put it on the table.

Lying under the bed

I walk to the bed and pause. Then I bend down and kneel. Then I lie down, stretching forward. I shuffle under the bed and lie on my left-hand side, facing the audience. I rest my head on my arms. I stare out from under the bed.

Then I bend my arm at the elbow and rest my head on my hand. My right hand rests on the floor.

Then I put my arm down and rest my head on my arm, which is resting flat on the floor.

Sitting on the bed

I sit on the bed in front of the quartz pillow. My feet are on the floor. My hands are together in my lap. I look at the audience.

My shoulders are hunched.

I blink.

My head droops.

Wiping my nose

I am in the living unit. I take a tissue from my right hand pocket and wipe my nose with it. I put this tissue back in my pocket.

Standing at the front

I move to the front of the living unit. I stand over the knife ladder. I brush the hair from my face and stare at someone. My wrists are tense and my hands flare out at my sides.

The metronome ticks.

I take a deep breath and my arms lift at my sides. My hands point out.

Filling the glass

I pick up the empty glass from the table and take it to the sink in the bedroom unit. I sit down on the bed and twist round to face the sink. I hold the glass in my left hand and put it underneath the tap in the sink. I push the tap up and then twist it to the left with my right hand until water trickles out. I tilt my head down towards the tap and watch the water flow. I let the glass fill up slowly. My right hand rests on the tap. When the glass is full I turn off the tap by pushing it up and then twisting it to the right. Then I pass the glass from my left to my right hand.

Drinking water

I stand up and raise the glass to my mouth. My left arm is straight and motionless. I tip the water into my open mouth and gulp. To control the flow of water into my mouth, I open and close my lips slowly, and open and close them again. The water waves back and forth in the glass every time I swallow. My neck moves every time I swallow. I tilt my head back and drink until the glass is empty. I press my lips together to suck in the droplets that are left there. I take the glass back to the living unit and put it on the table.

Peeing

I need to pee. I put one foot in front of the other until I get to the bathroom unit. When I am in the unit I turn to my right and take the toilet paper from the shelf with my right hand. I keep my left hand behind my back. I take four steps over towards the toilet and turn my body round clockwise. When my back is to the audience I lean over and put the toilet roll on the left front corner of the shower tray. Then I lift the lid of the toilet with my right hand. I push it back until it is resting on the back of the unit. As I turn towards the front I lift up my shirt so I can unfasten my trousers. There are four buttons to unfasten. I tilt my head forward. When I have undone all the buttons I pull my trousers and my slip down to just above my knees and sit on the toilet. I put my feet close together in front of me and cup my hands together in my lap. My two index fingers and thumbs make a triangle shape. The tips of the fingers on my left hand touch the tips of the fingers on my right hand.

I look down. I sit still and wait for the pee to come. It takes a while and there is silence. Then there is a tinkling sound. I am motionless.

When I have finished peeing I lean over and take the toilet paper with my left hand. Holding it over my lap I unroll some paper and fold it precisely in half and then in half again and then in half again. I tear the bundle from the roll and place the roll back on the corner of the shower tray. I stand up and wipe myself with my right hand. Then I pull up my slip and my trousers and do up the four buttons. Then I straighten my shirt out.

I lean over and push down the handle of the bucket towards the front, then I turn on the tap on the wall with my left hand. The water falls into the bucket beneath. I stand still with my hands behind my back and listen to the sound.

The bucket overflows. Water spreads over the floor. Then it falls over the edge. I listen to the sound. I do not look at the water. Then I turn off the tap. I slide the bucket along the floor and then lift it with both hands. I rest the bucket on the edge of the toilet then pour the water down. Then I put the lid down. I put the bucket back where it was, underneath the tap, and pull the handle up so it is in the middle.

I pick up the toilet roll and put it back on the shelf where it was before. Then I brush my hair back from my face with both hands.

Standing at the back

I move to the living unit and stand at the back leaning against the wall. My hands are clasped together behind my back. My feet are together. I look into someone's eyes.

I take a step forward and stop leaning against the wall and stand up straight and stare at someone.

Standing at the front

I move to the front of the living unit, staring at the same person. I take one step too many and my right foot is half on and half off the platform. I take a step back from the edge. I stand over the knife ladder. I keep staring. My wrists are tense and my hands flare out at my sides. My arms rise.

I take another step back from the edge.

Winding the metronome

The metronome has stopped ticking. I pick it up from the floor and hold it in my left hand and wind it with my right hand. I wind it slowly until the winder will not wind round anymore. Then I put the metronome back on the floor. I crouch down and set the ticker ticking.

Filling the glass

I pick up the empty glass from the table and take it to the sink in the bedroom unit. I sit down on the bed and twist round to face the sink. I hold the glass in my left hand and put it underneath the tap in the sink. I push the tap up and then twist it to the left with my right hand until water trickles out. I tilt my head down towards the tap and watch the water flow. I let the glass fill up slowly. My right hand rests on the tap. When the glass is full I turn off the tap by pushing it up and then twisting it to the right. Then I pass the glass from my left to my right hand.

Drinking water

I stand up and raise the glass to my mouth. I am pointing to the left. My left arm is straight and motionless. I tip the water into my open mouth and gulp. To control the flow of water into my mouth, I open and close my lips slowly, and open and close them again. The water waves back and forth in the glass every time I swallow. My neck moves every time I swallow. I tilt my head back and drink until the glass is empty. I press my lips together to suck in the droplets that are left there. I take the glass back to the living unit and put it on the table.

Lying on the bed

I lie on the bed on my left side and look out. My head rests on my hands on the quartz pillow.

Wearing red

Sitting on the chair

I put my body in front of the chair and bend my knees until my bottom rests on the seat of the chair. I rub my face with my hands. I look out at people coming into the gallery.

I lean over and drag the metronome across the table closer to me.

I put my hands in my lap. My feet are wide apart. My hair is brushed back.

Winding the metronome

The metronome has stopped ticking. I stand up from the chair and pick up the metronome from the table. I hold it in my left hand and wind it with my right hand. I wind it slowly until the winder will not wind round anymore. Then I put the metronome back on the table and set the ticker ticking.

Filling the glass

I pick up the empty glass from the table and take it to the sink in the bedroom unit. I sit down on the bed and twist round to face the sink. I hold the glass in my left hand and put it underneath the tap in the sink. I push the tap up and then twist it to the left with my right hand until water trickles out. I tilt my head down towards the tap and watch the water flow. I let the glass fill up slowly. My right hand rests on the tap. When the glass is full I turn off the tap by pushing it up and then twisting it to the right. Then I pass the glass from my left to my right hand.

Drinking water

I stand up and raise the glass to my mouth. I am pointing to the left. My left arm is straight and motionless. I tip the water into my open mouth and gulp. To control the flow of water into my mouth, I open and close my lips slowly, and open and close them again. The water waves back and forth in the glass every time I swallow. My neck moves every time I swallow. I tilt my head back and drink until the glass is empty. I press my lips together to suck in the droplets that are left there. I take the glass back to the living unit and put it on the table.

Standing at the back

I move to the living unit and stand at the back leaning against the wall. My hands are clasped together behind my back. My feet are together. I look out.

I take a step forward and stop leaning on the wall and stand up straight and stare at someone. My hands are flat by my sides.

Standing in the middle

I take another step forward so I am in the middle of the living unit. I stand and stare.

Sitting on the bed

I sit on the bed in front of the quartz pillow. My feet are on the floor. My hands are together in my lap. I look at the eyes of someone in the audience.

Filling the glass

I move to the living unit and pick up the empty glass from the table and take it to the sink in the bedroom unit. I sit down on the bed and twist round to face the sink. I hold the glass in my left hand and put it underneath the tap in the sink. I push the tap up and then twist it to the left with my right hand until water trickles out. I tilt my head down towards the tap and watch the water flow. I let the glass fill up slowly. My right hand rests on the tap. When the glass is full I turn off the tap by pushing it up and then twisting it to the right. Then I pass the glass from my left to my right hand.

Drinking water

I stand up and raise the glass to my mouth. I am pointing to the left. My left arm is straight and motionless. I tip the water into my open mouth and gulp. To control the flow of water into my mouth, I open and close my lips slowly, and open and close them again. The water waves back and forth in the glass every time I swallow. My neck moves every time I swallow. I tilt my head back and drink until the glass is empty. I press my lips together to suck in the droplets that are left there. I take the glass back to the living unit and put it on the table.

Standing at the back

I stand at the back of the living unit and lean against the wall. My hands are clasped together behind my back. My feet are together. I look out.

I take a step forward and stop leaning on the wall and stand up straight and stare at someone. My hands are flat by my sides.

Standing in the middle

I take another step forward so I am in the middle of the living unit. I stand and stare.

Standing at the front

I take another step forward and one to the side so I stand at the front on the left. I stand and stare at someone.

Winding the metronome

The metronome has stopped ticking. I pick it up from the table. I sit down on the chair and hold the metronome in my left hand and wind it with my right hand. I wind it slowly until the winder will not wind round anymore. Then I put the metronome back on the floor and set the ticker ticking.

Standing at the front

I stand up and walk to the front. I stand over the knife ladder to stare at someone's eyes. My wrists tense and my hands flare at my sides.

The metronome ticks.

Lying on the bed

I lie on the bed on my left side and look out. My head rests on my hands on the quartz pillow.

Lying under the bed

I get up off the bed and lie on the floor. Then I shuffle backwards until I am under the bed. I lie on my left-hand side, facing the audience. I rest my head on my arms. I stare out from under the bed.

Sitting on the edge

I sit on the edge of the bedroom unit, to the right of the knife ladder.

My legs hang down. My hands are together in my lap. I look at someone.

Filling the glass

I move to the living unit and pick up the empty glass from the table and take it to the sink in the bedroom unit. I sit down on the bed and twist round to face the sink. I hold the glass in my left hand and put it underneath the tap in the sink. I push the tap up and then twist it to the left with my right hand until water trickles out. I tilt my head down towards the tap and watch the water flow. I let the glass fill up slowly. My right hand rests on the tap. When the glass is full I turn off the tap by pushing it up and then twisting it to the right. Then I pass the glass from my left to my right hand.

Drinking water

I walk to the living unit and stand in the middle, pointing to the left. I raise the glass to my mouth. I am pointing to the left. My left arm is straight and motionless. I tip the water into my open mouth and gulp. To control the flow of water into my mouth, I open and close my lips slowly, and open and close them again. The water waves back and forth in the glass every time I swallow. My neck moves every time I swallow. I tilt my head back and drink until the glass is empty. I press my lips together to suck in the droplets that are left there. I take the glass back to the living unit and put it on the table.

Sitting on the chair

I put my body in front of the chair and bend my knees until my bottom rests on the seat of the chair. My hands are in my lap. My feet are on the ground. My eyes are looking.

The metronome stops ticking. I bend down and flick the ticker to make it move again.

Sitting on the edge

I get down from the chair, sit on the floor and shuffle forward to the edge of the platform. I sit with my legs hanging over the edge. I stare at someone.

Standing between the units

I stand with one foot in the living unit and one foot in the bathroom unit, so that my body is over the gap. My legs make a triangle. I rest my arms on the back of the door frames. I look at the audience and remain still.

The metronome stops ticking.

Filling the glass

I pick up the empty glass from the table and take it to the sink in the bedroom unit. I sit down on the bed and twist round to face the sink. I hold the glass in my left hand and put it underneath the tap in the sink. I push the tap up and then twist it to the left with my right hand until water trickles out. I tilt my head down towards the tap and watch the water flow. I let the glass fill up slowly. My right hand rests on the tap. When the glass is full I turn off the tap by pushing it up and then twisting it to the right. Then I pass the glass from my left to my right hand.

Drinking water

I stand up and raise the glass to my mouth. I am pointing to the left. My left arm is straight and motionless. I tip the water into my open mouth and gulp. To control the flow of water into my mouth, I open and close my lips slowly, and open and close them again. The water waves back and forth in the glass every time I swallow. My neck moves every time I swallow. I tilt my head back and drink until the glass is empty. I press my lips together to suck in the droplets that are left there. I take the glass back to the living unit and put it on the table.

Peeing

I need to pee. I put one foot in front of the other until I get to the bathroom unit. When I am in the unit I turn to my right and take the toilet paper from the shelf with my right hand. I keep my left hand behind my back. I take four steps over towards the toilet and turn my body round clockwise. When my back is to the audience I lean over and put the toilet roll on the left front corner of the shower tray. Then I lift the lid of the toilet with my right hand. I push it back until it is resting on the back of the unit. As I turn towards the front I lift up my shirt so I can unfasten my trousers. There are four buttons to unfasten. I tilt my head forward. When I have undone all the buttons I pull my trousers and my slip down to just above my knees and sit on the toilet. I put my feet close together in front of me and cup my hands together in my lap. My two index fingers and thumbs make a triangle shape. The tips of the fingers on my right hand touch the tips of the fingers on my left hand.

I look down. I sit still and wait for the pee to come. It takes a while and there is silence. Then there is a tinkling sound. I am motionless.

When I have finished peeing I lean over and take the toilet paper with my left hand. Holding it over my lap I unroll some paper and fold it precisely in half and then in half again and then in half again. I tear the bundle from the roll and place the roll back on the corner of the shower tray. I stand up and wipe myself with my right hand. Then I pull up my slip and my trousers and do up the four buttons. Then I straighten my shirt out.

I lean over and push down the handle of the bucket towards the front. Then I turn on the tap on the wall with my left hand. The water falls into the bucket beneath. I stand still with my hands behind my back and listen to the sound.

When the bucket is half full I look at the tap then turn it off.

I lift the bucket and pour the water down the toilet to flush it. Then I put the lid down. I place the bucket back where it was, underneath the tap, and pull the handle up so it is in the middle.

I pick up the toilet roll and put it back on the shelf where it was before. Then I brush my hair back from my face with both hands.

Sitting and sleeping on the chair

I put my body in front of the chair and bend my knees until my bottom rests on the seat of the chair. My hands are in my lap. My feet are on the ground.

My head droops.

I look at the floor.

Then my eyes close.

The metronome stops ticking. I kick it with my left foot and it starts ticking again.

My eyes are still closed.

I take a deep breath and straighten up on the chair and open my eyes. Then I lean my head back on the quartz pillow and close my eyes. Then I bend all the way forward and touch the floor on either side of my feet.

Winding the metronome

The metronome has stopped ticking. I pick up the metronome from the floor. I hold it in my left hand and wind it with my right hand. I wind it slowly until the winder will not wind round anymore. Then I put the metronome on the table and set the ticker ticking.

Filling the glass

I pick up the empty glass from the table and take it to the sink in the bedroom unit. I sit down on the bed and twist round to face the sink. I hold the glass in my left hand and put it underneath the tap in the sink. I push the tap up and then twist it to the left with my right hand until water trickles out. I tilt my head down towards the tap and watch the

water flow. I let the glass fill up slowly. My right hand rests on the tap. When the glass is full I turn off the tap by pushing it up and then twisting it to the right. Then I pass the glass from my left to my right hand.

Drinking water

I stand up and raise the glass to my mouth. I am pointing to the left. My left arm is straight and motionless. I tip the water into my open mouth and gulp. To control the flow of water into my mouth, I open and close my lips slowly, and open and close them again. The water waves back and forth in the glass every time I swallow. My neck moves every time I swallow. I tilt my head back and drink until the glass is empty. I press my lips together to suck in the droplets that are left there. I take the glass back to the living unit and put it on the table.

Showering

I walk to the bathroom unit and pick up the towel from the shelf and lay it out on the toilet seat. Then I take the hairband from the shelf and put it on the floor. I take the bath mat from the shower tray and unroll it on the floor in front of the shower tray. I sit on the toilet seat and lean over and untie the laces of my right boot using my right hand. When the laces are loose enough, I take off the boot and then pull off the sock by grabbing the toe. I put the sock in the boot. Then I untie the laces of my left boot using my left hand. When the laces are loose enough I take off the boot and then pull off the sock by grabbing the toe. I put the sock in the boot. The boots are next to each other by the wall.

Then I stand up and undo the buttons on my trousers. Then I pull them down. When I have sat down again, I finish pulling them off, starting with the right leg and finishing with the left leg. Then I fold them in half and then half again and then half again and put them on the floor next to the boots.

Then I undo the buttons of my shirt, starting at the bottom. There are seven buttons to undo. Then I take off my shirt and lay it across my legs and fold it up. Then I take off my undershirt and fold it up neatly. I put all my clothes on the floor next to my boots.

Then I pick up the hairband off the floor, pull my hair together behind my head, and tie it back with my hairband. I stand on the left of the shower, outside the tray, and turn on the taps. I test the temperature of the water by holding out my left hand under the trickle of water. I keep my hand there and wait for the water to warm up.

I step into the shower and face the audience. My hands are open, palms out and fingers straight, beside me. My eyes are closed.

I open my mouth very wide very quickly and hold it wide open for a long time. I let it fill up with water. Then I spit it out. I rock my head from side to side, slowly. Then I open my mouth wide again.

I rock my head from side to side.

Then I open my mouth wide again.

Then I rock my head.

Then I scream without making a noise again.

Then I reach behind me with both hands and turn off both taps.

I lean over to pick up the towel. I press the towel hard against my face for a long time, leaning forward. When I am ready, I move the towel away and then rub the towel over my arms, then my torso, then my legs. I do not dry myself very thoroughly. I lay the towel over the toilet seat and sit down on it.

Then I take off my hairband and put it on the floor.

Then I lean forward and touch my toes and stretch my back. Then I sit up and cover my face with my hands.

Then I put my slip back on. Then I put my undershirt back on by put-

ting my head through the head hole and my arms through the armholes. I do the same with my shirt and do up the buttons on my cuffs. I do up the buttons starting at my neck and working my way downward. Then I brush my hair back from my face. Then I put my trousers on. I stand up and straighten out all of my clothes. I sit back down and put my right sock on followed by my right boot. I tie the laces. Then I put my left sock on followed by my left boot. I tie the laces. I stand up.

I roll up the bath mat and put it in the shower tray. I pick up the towel and fold it and put it back on the shelf.

I pick up the hairband from the floor and put it back on the shelf in the bathroom and then walk away.

Making the metronome tick

I prod the metronome with my finger to make it tick again.

Sitting on the chair

I put my body in front of the chair and bend my knees until my bottom rests on the seat of the chair. My hands are in my lap. My feet are on the ground. My eyes are looking at someone. Then they move and look at someone else. Then they move again and look at someone else.

Standing between the units

I stand with one foot in the living unit and one foot in the bathroom unit, so that my body is over the gap. My legs make a triangle. I rest my arms on the back of the door frames. I look at the audience and remain still.

Blowing my nose

I step into the bathroom unit and take the toilet roll from the shelf. I unroll some paper and tear it off, winding it around my hand. Then I press the bundle to my nose with both hands and blow out air and snot, hard, twice. Then I put the bundle of toilet paper in my pocket and walk away.

Lying under the bed

I walk to the bed and pause. I kneel, lean forward and lie down. Then I shuffle backwards until I am under the bed. I lie on my left-hand side, facing the audience. I rest my head on my arms. I stare out from under the bed.

The metronome stops ticking.

Winding the metronome

The metronome has stopped ticking. I pick it up from the table. I hold the metronome in my left hand and wind it with my right hand. I wind it slowly until the winder will not wind round anymore. Then I put the metronome on the floor to the right of the table and set the ticker ticking.

Rearranging the furniture

I take the glass off the table and put it on the chair. I grip the table with one hand on the far end and one on the near end and try to lift it. Then I move to the end of the table, hold both sides and tip it backwards. My hands shuffle further towards the legs and I lift it and tilt it further so it is nearly touching the floor. I make a sound. Then the table is on the floor, on its side, with the table legs pointing towards the audience.

Sitting in the table

I crouch down and climb into the gap between the four table legs. I sit between the bottom two, which touch the floor. The top two table legs are on either side of my head. My legs are hunched up and my hands are on my knees. I look at the audience.

Then my eyes close.

I hear someone's footsteps.

Then I shuffle forward so that my legs hang over the edge. I put my hands in my lap. My eyes are still closed.

My head rocks and I open my eyes.

Then I draw my legs in and sit back inside the table.

Winding the metronome

The metronome has stopped ticking. I get out from the table, walk over to the metronome and pick it up from the floor. I hold the metronome in my left hand and wind it with my right hand. I wind it slowly until the winder will not wind round anymore. Then I put the metronome back on the floor and set the ticker ticking.

Peeing

I need to pee. I put one foot in front of the other until I get to the bathroom unit. When I am in the unit I turn to my right and take the toilet paper from the shelf with my right hand. I keep my left hand behind my back. I take four steps over towards the toilet and turn my body round clockwise. When my back is to the audience I lean over and put the toilet roll on the left front corner of the shower tray. Then I lift the lid of the toilet with my right hand. I push it back until it is resting on the back of the unit. As I turn towards the front I lift up my shirt so I can unfasten my trousers. There are four buttons to unfasten. I tilt my head forward. When I have undone all the buttons I pull my trousers and my slip down to just above my knees and sit on the toilet. I put my feet close together in front of me and cup my hands together in my lap. My two index fingers and thumbs make a triangle shape. The tips of the fingers on my right hand touch the tips of the fingers on my left hand.

I look down. I sit still and wait for the pee to come. It takes a while and there is silence. Then there is a tinkling sound. I am motionless.

When I have finished peeing I lean over and take the toilet paper with my left hand. Holding it over my lap I unroll some paper and fold it precisely in half and then in half again and then in half again. I tear the bundle from the roll and place the roll back on the corner of the shower tray. I stand up and wipe myself with my right hand. Then I pull up my slip and my trousers and do up the four buttons. Then I straighten my shirt out.

I lean over and push down the handle of the bucket towards the front. Then I turn on the tap on the wall with my left hand. The water falls into the bucket beneath. I stand still with my hands behind my back and listen to the sound.

When the bucket is half full I look at the tap then turn it off.

I lift the bucket and pour the water down the toilet to flush it. Then I put the lid down. I place the bucket back where it was, underneath the tap, and pull the handle up so it is in the middle.

I pick up the toilet roll and put it back on the shelf where it was before. Then I brush my hair back from my face with both hands.

Sitting in the table

I move the metronome next to the table and I crouch down and climb into the gap between the four table legs. I sit in between the bottom two, which touch the floor. The top two table legs are either side of my head. My legs are hunched up and my hands are on my knees. I look at the audience.

Then I look down.

Then my eyes close.

I take a deep breath, tilt my head back and open my eyes.

Blowing my nose

I reach into my right pocket with my right hand and take the tissue from it. I hold it up to my nose with both hands, blow once into it and

then wipe my nose. Then I put the tissue back into the same pocket.

Sitting in the table

I crouch down and climb into the gap between the four table legs. I sit in between the bottom two, which touch the floor. The top two table legs are either side of my head. My legs hang over the edge. My hands are on my knees. I look at the audience.

Then I look down.

Then my eyes close.

The metronome stops ticking. I prod it with my left hand. It starts ticking again. My hand hovers over the metronome. My eyes stay closed. I put my hand on my leg.

Then the metronome stops again. I prod it with my left hand. It starts ticking again. My eyes stay closed.

I hunch my legs up and sit back in the table. I lean my head back against the top of the table.

Filling the glass

I pick up the empty glass from the chair and take it to the sink in the bedroom unit. I sit down on the bed and twist round to face the sink. I hold the glass in my left hand and put it underneath the tap in the sink. I push the tap up and then twist it to the left with my right hand until water trickles out. I tilt my head down towards the tap and watch the water flow. I let the glass fill up slowly.

The metronome stops ticking.

My right hand rests on the tap. When the glass is full I turn off the tap by pushing it up and then twisting it to the right. Then I pass the glass from my left to my right hand.

Drinking water

I stand up and raise the glass to my mouth. I am pointing to the left. My left arm is straight and motionless. I tip the water into my open mouth and gulp. To control the flow of water into my mouth, I open and close my lips slowly, and open and close them again. The water waves back and forth in the glass every time I swallow. My neck moves every time I swallow. I tilt my head back and drink until the glass is empty. I press my lips together to suck in the droplets that are left there. I take the glass back to the living unit and put it on the chair.

Peeing

I need to pee. I put one foot in front of the other until I get to the bathroom unit. When I am in the unit I turn to my right and take the toilet paper from the shelf with my right hand. I keep my left hand behind my back. I take four steps over towards the toilet and turn my body round clockwise. When my back is to the audience I lean over and put the toilet roll on the left front corner of the shower tray. Then I lift the lid of the toilet with my right hand. I push it back until it is resting on the back of the unit. As I turn towards the front I lift up my shirt so I can unfasten my trousers. There are four buttons to unfasten. I tilt my head forward. When I have undone all the buttons I pull my trousers and my slip down to just above my knees and sit on the toilet. I put my feet close together in front of me and cup my hands together in my lap. My two index fingers and thumbs make a triangle shape. The tips of the fingers on my right hand touch the tips of the fingers on my left hand.

I look down. I sit still and wait for the pee to come. It takes a while and there is silence. Then there is a tinkling sound. I am motionless.

When I have finished peeing I lean over and take the toilet paper with my left hand. Holding it over my lap I unroll some paper and fold it precisely in half and then in half again and then in half again. I tear the bundle from the roll and place the roll back on the corner of the shower tray. I stand up and wipe myself with my right hand. Then I pull up

my slip and my trousers and do up the four buttons. Then I straighten my shirt out.

I lean over and push down the handle of the bucket towards the front. Then I turn on the tap on the wall with my left hand. The water falls into the bucket beneath. I stand still with my hands behind my back and listen to the sound.

When the bucket is half full I look at the tap then turn it off.

I lift the bucket and pour the water down the toilet to flush it. Then I put the lid down. I place the bucket back where it was, underneath the tap, and pull the handle up so it is in the middle.

I pick up the toilet roll and put it back on the shelf where it was before. Then I tuck my hair back behind my ears and walk away.

Moving the metronome

I pick up the metronome from the floor of the living unit, carry it and put it down on the floor of the bedroom unit.

Sitting on the bed

I sit on the bed in front of the quartz pillow. I point to the left. My feet are on the floor. My hands are together in my lap. I look at someone in the audience.

Standing at the back

I move to the living unit. I take the glass from the chair and put it on the side of the table leg. I stand at the back leaning against the wall. My hands are clasped together behind my back. My feet are together. I look out.

I reach out and touch the glass. I lift it up and put it down again.

Then I return my hands behind my back.

I look at the glass.

I reach out and lift it up and put it down again.

Sitting on the chair

I put my body in front of the chair and bend my knees until my bottom rests on the seat of the chair. My hands are in my lap. My feet are on the ground. My eyes are looking. I point to the left.

I start singing. I sing the same song I always sing.

Filling the glass

I pick up the empty glass from the side of the table leg and take it to the sink in the bedroom unit. I sit down on the bed and twist round to face the sink. I hold the glass in my left hand and put it underneath the tap in the sink. I push the tap up and then twist it to the left with my right hand until water trickles out. I tilt my head down towards the tap and watch the water flow. I let the glass fill up slowly. My right hand rests on the tap. When the glass is full I turn off the tap by pushing it up and then twisting it to the right. Then I pass the glass from my left to my right hand.

Drinking water

I stand up and raise the glass to my mouth. I am pointing to the left. My left arm is straight and motionless. I tip the water into my open mouth and gulp. To control the flow of water into my mouth, I open and close my lips slowly, and open and close them again. The water waves back and forth in the glass every time I swallow. My neck moves every time I swallow. I tilt my head back and drink until the glass is empty. I press my lips together to suck in the droplets that are left there. I take the glass back to the living unit and put it on the chair.

Moving the metronome

The metronome has stopped ticking. I pick it up from the floor and

carry it to the bathroom unit.

Winding the metronome

I hold the metronome in my left hand and wind it with my right hand. I wind it slowly until the winder will not wind round anymore. Then I put the metronome on the floor by the wall and set the ticker ticking.

Showering

I walk to the bathroom unit and pick up the towel from the shelf and lay it out on the toilet seat. Then I take the hairband from the shelf and put it on the floor. I take the bath mat from the shower tray and unroll it on the floor in front of the shower tray. I sit on the toilet seat and lean over and untie the laces of my right boot using my right hand. When the laces are loose enough, I take off the boot and then pull off the sock by grabbing the toe. I put the sock in the boot. Then I untie the laces of my left boot using my left hand. When the laces are loose enough I take off the boot and then pull off the sock by grabbing the toe. I put the sock in the boot. The boots are next to each other by the wall.

Then I stand up and undo the buttons on my trousers. Then I pull them down. When I have sat down again, I finish pulling them off, starting with the right leg and finishing with the left leg. Then I fold them in half and then half again and then half again and put them on the floor next to the boots.

Then I undo the buttons of my shirt, starting at the bottom. There are seven buttons to undo. Then I take off my shirt and lay it across my legs and fold it up. Then I take off my undershirt and fold it up neatly. I put all my clothes on the floor next to my boots.

Then I pick up the hairband off the floor, pull my hair together behind my head, and tie it back with my hairband. I stand on the left of the shower, outside the tray, and turn on the taps. I test the temperature of the water by holding out my left hand under the trickle of water. I keep my hand there and wait for the water to warm up.

I step into the shower and face the audience. My hands are open, palms out and fingers straight, beside me. My eyes are closed.

I open my mouth very wide very quickly and hold it wide open for a long time. I let it fill up with water. Then I spit it out. I rock my head from side to side, slowly. Then I open my mouth wide again.

I rock my head from side to side.

Then I open my mouth wide again.

Then I rock my head.

Then I scream without making a noise again.

Then I reach behind me with both hands and turn off both taps.

I lean over to pick up the towel. I press the towel hard against my face for a long time, leaning forward. When I am ready, I move the towel away and then rub the towel over my arms, then my torso, then my legs. I do not dry myself very thoroughly. I lay the towel over the toilet seat and sit down on it.

Then I take off my hairband and put it on the floor.

Then I lean forward and touch my toes and stretch my back. Then I sit up and cover my face with my hands.

Then I put my slip back on. Then I put my undershirt back on by putting my head through the head hole and my arms through the armholes. I do the same with my shirt and do up the buttons on my cuffs. I do up the buttons starting at my neck and working my way downward. Then I brush my hair back from my face. Then I put my trousers on. I stand up and straighten out all of my clothes. I sit back down and put my right sock on followed by my right boot. I tie the laces. Then I put my left sock on followed by my left boot. I tie the laces. I stand up.

I roll up the bath mat and put it in the shower tray. I pick up the towel and fold it and put it back on the shelf.

I pick up the hairband from the floor and put it back on the shelf in the bathroom and then walk away.

Standing at the back

I move to the living unit and stand at the back leaning against the wall. My hands are clasped together behind my back. My feet are together. I look out.

Sitting in the table

I crouch down and climb into the gap between the four table legs. I sit in between the bottom two, which touch the floor. The top two table legs are on either side of my head. My legs are hunched up and my hands are on my knees. I look at the audience.

I flatten my legs on the ground. I put my hands in my lap.

Lying on the bed

I lie on the bed on my left side and look out. My head rests on my hands on the quartz pillow.

I wiggle lower down the bed and bend my arm at the elbow and rest my head on my hand. I rest my other hand flat on the bed.

I look at the audience.

Sitting on the bed

I sit up and stare.

Sitting on the edge

Then I sit on the edge of the bedroom unit, to the left of the knife ladder. My legs hang down. My hands are together in my lap. I keep looking at someone. I look them in the eye.

I smile, a little.

Then I brush the hair back from my forehead.

I continue staring.

The metronome keeps ticking.

Lying under the bed

I lift my legs up over the edge and lie on the floor. Then I shuffle backwards until I am under the bed. I lie on my left-hand side, facing the audience. I rest my head on my arms. I stare out from under the bed.

Filling the glass

I pick up the empty glass from the chair and take it to the sink in the bedroom unit. I sit down on the bed and twist round to face the sink. I hold the glass in my left hand and put it underneath the tap in the sink. I push the tap up and then twist it to the left with my right hand until water trickles out. I tilt my head down towards the tap and watch the water flow. I let the glass fill up slowly. My right hand rests on the tap. When the glass is full I turn off the tap by pushing it up and then twisting it to the right. Then I pass the glass from my left to my right hand.

Drinking water

I stand up and raise the glass to my mouth. I am pointing to the left. My left arm is straight and motionless. I tip the water into my open mouth and gulp. To control the flow of water into my mouth, I open and close my lips slowly, and open and close them again. The water waves back and forth in the glass every time I swallow. My neck moves every time I swallow. I tilt my head back and drink until the glass is empty. I press my lips together to suck in the droplets that are left there. I take the glass back to the living unit and put it on the chair.

Peeing

I need to pee. I put one foot in front of the other until I get to the bathroom unit. When I am in the unit I turn to my right and take the toilet paper from the shelf with my right hand. I keep my left hand behind my back. I take four steps over towards the toilet and turn my body round clockwise. When my back is to the audience I lean over and put the toilet roll on the left front corner of the shower tray. Then I lift the lid of the toilet with my right hand. I push it back until it is resting on the back of the unit. As I turn towards the front I lift up my shirt so I can unfasten my trousers. There are four buttons to unfasten. I tilt my head forward. When I have undone all the buttons I pull my trousers and my slip down to just above my knees and sit on the toilet. I put my feet close together in front of me and cup my hands together in my lap. My two index fingers and thumbs make a triangle shape. The tips of the fingers on my right hand touch the tips of the fingers on my left hand.

I look down. I sit still and wait for the pee to come. It takes a while and there is silence. Then there is a tinkling sound. I am motionless.

When I have finished peeing I lean over and take the toilet paper with my left hand. Holding it over my lap I unroll some paper and fold it precisely in half and then in half again and then in half again. I tear the bundle from the roll and place the roll back on the corner of the shower tray. I stand up and wipe myself with my right hand. Then I pull up my slip and my trousers and do up the four buttons. Then I straighten my shirt out.

I lean over and push down the handle of the bucket towards the front. Then I turn on the tap on the wall with my left hand. The water falls into the bucket beneath. I stand still with my hands behind my back and listen to the sound.

When the bucket is half full I look at the tap then turn it off.

I lift the bucket and pour the water down the toilet to flush it. Then I put the lid down. I place the bucket back where it was, underneath the tap, and pull the handle up so it is in the middle.

I pick up the toilet roll and put it back on the shelf where it was before. Then I brush my hair back from my face with both hands.

Sitting on the chair

I pick up the glass from the chair and put it on the side of the table leg. I put my body in front of the chair and bend my knees until my bottom rests on the seat of the chair. I look down at someone on my left-hand side.

Moving the metronome

The metronome has stopped ticking. I walk to the bathroom and pick up the metronome from the floor. I walk back to the living unit and sit in the chair. I hold the metronome in my left hand and hold the ticker in my right hand. I look at the metronome.

Then I put it on the floor and prod the ticker. It starts ticking again.

I look out at the audience.

Standing between the units

I stand with one foot in the living unit and one foot in the bedroom unit, so that my body is over the gap. My legs make a triangle. I rest my arms on the back of the door frames. I look at the audience and remain still.

Filling the glass

I pick up the empty glass from the side of the table leg and take it to the sink in the bedroom unit. I sit down on the bed and twist round to face the sink. I hold the glass in my left hand and put it underneath the tap in the sink. I push the tap up and then twist it to the left with my right hand until water trickles out. I tilt my head down towards the tap and watch the water flow. I let the glass fill up slowly. My right hand rests on the tap. When the glass is full I turn off the tap by push-

ing it up and then twisting it to the right. Then I pass the glass from my left to my right hand.

Drinking water

I stand up and raise the glass to my mouth. I am pointing to the left. My left arm is straight and motionless. I tip the water into my open mouth and gulp. To control the flow of water into my mouth, I open and close my lips slowly, and open and close them again. The water waves back and forth in the glass every time I swallow. My neck moves every time I swallow. I tilt my head back and drink until the glass is empty. I press my lips together to suck in the droplets that are left there. I take the glass back to the living unit and put it on the chair.

Sitting in the table

I push the table back from the edge. Then I crouch down and climb into the gap between the four table legs. I sit in between the bottom two, which touch the floor. The top two table legs are on either side of my head. My legs are hunched up and my hands are on my knees. I look at the audience.

Filling the glass

I pick up the empty glass from the chair and take it to the sink in the bedroom unit. I sit down on the bed and twist round to face the sink. I hold the glass in my left hand and put it underneath the tap in the sink. I push the tap up and then twist it to the left with my right hand until water trickles out. I tilt my head down towards the tap and watch the water flow. I let the glass fill up slowly. My right hand rests on the tap. When the glass is full I turn off the tap by pushing it up and then twisting it to the right. Then I pass the glass from my left to my right hand.

Drinking water

I stand up and raise the glass to my mouth. My left arm is straight and motionless. I tip the water into my open mouth and gulp. To control the flow of water into my mouth, I open and close my lips slowly, and open and close them again. The water waves back and forth in the glass every time I swallow. My neck moves every time I swallow. I tilt my head back and drink until the glass is empty. I press my lips together to suck in the droplets that are left there. I take the glass back to the living unit and put it on the chair.

Showering

I walk to the bathroom unit and pick up the towel from the shelf and lay it out on the toilet seat. Then I take the hairband from the shelf and put it on the floor. I take the bath mat from the shower tray and unroll it on the floor in front of the shower tray. I sit on the toilet seat and lean over and untie the laces of my right boot using my right hand. When the laces are loose enough, I take off the boot and then pull off the sock by grabbing the toe. I put the sock in the boot. Then I untie the laces of my left boot using my left hand. When the laces are loose enough I take off the boot and then pull off the sock by grabbing the toe. I put the sock in the boot. The boots are next to each other by the wall.

Then I stand up and undo the buttons on my trousers. Then I pull them down. When I have sat down again, I finish pulling them off, starting with the right leg and finishing with the left leg. Then I fold them in half and then half again and then half again and put them on the floor next to the boots.

Then I undo the buttons of my shirt, starting at the bottom. There are seven buttons to undo. Then I take off my shirt and lay it across my legs and fold it up. Then I take off my undershirt and fold it up neatly. I put all my clothes on the floor next to my boots.

Then I pick up the hairband off the floor, pull my hair together behind my head, and tie it back with my hairband. I stand on the left of the shower, outside the tray, and turn on the taps. I test the temperature

of the water by holding out my left hand under the trickle of water. I keep my hand there and wait for the water to warm up.

I step into the shower and face the audience. My hands are open, palms out and fingers straight, beside me. My eyes are closed.

I open my mouth very wide very quickly and hold it wide open for a long time. I let it fill up with water. Then I spit it out. I rock my head from side to side, slowly. Then I open my mouth wide again.

I rock my head from side to side.

Then I open my mouth wide again.

Then I reach behind me with both hands and turn off both taps.

I lean over to pick up the towel. I lean forward and I press the towel hard against my face for a long time. When I am ready, I move the towel away and then rub the towel over my arms, then my torso, then my legs. I do not dry myself very thoroughly. I lay the towel over the toilet seat and sit down on it.

Then I take off my hairband and put it on the floor.

Then I lean forward and touch my toes and stretch my back. Then I sit up and cover my face with my hands.

Then I put my slip back on. Then I put my undershirt back on by putting my head through the head hole and my arms through the armholes. I do the same with my shirt and do up the buttons on my cuffs. I do up the buttons starting at my neck and working my way downward. Then I brush my hair back from my face. Then I put my trousers on. I stand up and straighten out all of my clothes. I sit back down and put my right sock on followed by my right boot. I tie the laces. Then I put my left sock on followed by my left boot. I tie the laces. I stand up.

I roll up the bath mat and put it in the shower tray. I pick up the towel and fold it and put it back on the shelf.

I pick up the hairband from the floor and put it back on the shelf in the bathroom and then walk away.

Sitting on the chair

I put my body in front of the chair and bend my knees until my bottom rests on the seat of the chair. I put my hands in my lap. I look down and to the right at someone in the audience. Then I turn my head a little to the right.

Standing at the back, moving towards the front

I stand at the back of the living unit just in front of the wall. My hands are by my sides. My feet are hip-width apart. I look out.

My fingers twitch. Then my hands flare out a little.

I take a step forward.

Then I take another step forward. Now I am near the edge of the living unit. I lift my arms out even further from my waist. To steady myself I touch the end of the table leg on my right.

I straighten up my spine and stand taller.

I touch the table leg again.

I take another step forward so that I am right at the edge of the platform standing over the knife ladder.

I touch the table leg and take a step back from the edge.

Filling the glass

I pick up the empty glass from the side of the table leg and take it to the sink in the bedroom unit. I sit down on the bed and twist round to face the sink. I hold the glass in my left hand and put it underneath the tap in the sink. I push the tap up and then twist it to the left with my right hand until water trickles out. I tilt my head down towards the

tap and watch the water flow. I let the glass fill up slowly. My right hand rests on the tap. When the glass is full I turn off the tap by pushing it up and then twisting it to the right. Then I pass the glass from my left to my right hand.

Drinking water

I stand up and raise the glass to my mouth. I am pointing to the left. My left arm is straight and motionless. I tip the water into my open mouth and gulp. To control the flow of water into my mouth, I open and close my lips slowly, and open and close them again. The water waves back and forth in the glass every time I swallow. My neck moves every time I swallow. I tilt my head back and drink until the glass is empty. I press my lips together to suck in the droplets that are left there. I take the glass back to the living unit and put it on the side of the table leg. Then I pick it up again and put it on the chair.

Winding the metronome

The metronome has stopped ticking. I pick up the metronome from the floor. I hold it in my left hand and wind it with my right hand. I wind it slowly until the winder will not wind round anymore. Then I put the metronome back on the floor and set the ticker ticking.

Walking in the table

I step into the gap between the two table legs that are flat on the floor. The other two table legs are on either side of my hips. I put my hands on them and I shuffle sideways across the living unit until the table is in the middle.

Sitting in the table

I sit down in the gap between the four table legs. I sit between the bottom two, which touch the floor. The top two table legs are on either side of my head. My legs are hunched up and my hands are on my knees. I look at the audience.

I sing. I sing the same song I always sing.

I crawl out of the table.

Wiping my nose

I walk to the bathroom unit and reach for the roll of toilet paper. I tear of a few sheets, make a bundle and wipe my nose. I put the bundle in my pocket. Push the hair back from my face and walk away.

Rearranging the furniture

I pull the table away from the edge and leave it pointing diagonally toward the left. Then I take the glass off the chair, put the glass on the floor and then tilt the chair backwards on one leg. I move to the back of the chair and tilt it again. Then I move to the other side of the chair, tilt it back and hold the front of the chair. Then I move to the back of the chair and tilt it all the way down until it rests on the floor. I crouch down as the chair gets closer to the floor. Now the chair points to the back left-hand corner of the living unit. I pick up the glass and put it on the side of the table leg that points to the back corner of the gallery.

Sitting on the bed

I sit on the bed in front of the quartz pillow. My feet are on the floor. My hands are together in my lap. I look at the eyes of someone in the audience.

Someone in the audience stands in front of me and shows me a painting he has made. First I smile and then I start crying.

Then I cover my face with my hands.

Filling the glass

I pick up the empty glass from the side of the table leg and take it to the sink in the bedroom unit. I sit down on the bed and twist round to face the sink. I hold the glass in my left hand and put it underneath

the tap in the sink. I push the tap up and then twist it to the left with my right hand until water trickles out. I tilt my head down towards the tap and watch the water flow. I let the glass fill up slowly. My right hand rests on the tap. When the glass is full I turn off the tap by pushing it up and then twisting it to the right. Then I pass the glass from my left to my right hand.

Drinking water

I stand up and raise the glass to my mouth. I am pointing to the left. My left arm is straight and motionless. I tip the water into my open mouth and gulp. To control the flow of water into my mouth, I open and close my lips slowly, and open and close them again. The water waves back and forth in the glass every time I swallow. My neck moves every time I swallow. I tilt my head back and drink until the glass is empty. I press my lips together to suck in the droplets that are left there. I take the glass back to the living unit and put it on the corner of the right hand table leg where it meets the tabletop.

Peeing

I need to pee. I put one foot in front of the other until I get to the bathroom unit. When I am in the unit I turn to my right and take the toilet paper from the shelf with my right hand. I keep my left hand behind my back. I take four steps over towards the toilet and turn my body round clockwise. When my back is to the audience I lean over and put the toilet roll on the left front corner of the shower tray. Then I lift the lid of the toilet with my right hand. I push it back until it is resting on the back of the unit. As I turn towards the front I lift up my shirt so I can unfasten my trousers. There are four buttons to unfasten. I tilt my head forward. When I have undone all the buttons I pull my trousers and my slip down to just above my knees and sit on the toilet. I put my feet close together in front of me and cup my hands together in my lap. My two index fingers and thumbs make a triangle shape. The tips of the fingers on my right hand touch the tips of the fingers on my left hand.

I look down. I sit still and wait for the pee to come. It takes a while and there is silence. Then there is a tinkling sound. I am motionless.

When I have finished peeing I lean over and take the toilet paper with my left hand. Holding it over my lap I unroll some paper and fold it precisely in half and then in half again and then in half again. I tear the bundle from the roll and place the roll back on the corner of the shower tray. I stand up and wipe myself with my right hand. Then I pull up my slip and my trousers and do up the four buttons. Then I straighten my shirt out.

I lean over and push down the handle of the bucket towards the front, then I turn on the tap on the wall with my left hand. The water falls into the bucket beneath. I stand still with my hands behind my back and listen to the sound.

When the bucket is half full I look at the tap then turn it off.

I lift the bucket and pour the water down the toilet to flush it. Then I put the lid down. I place the bucket back where it was, underneath the tap, and pull the handle up so it is in the middle.

I pick up the toilet roll and put it back on the shelf where it was before. Then I brush my hair back from my face with both hands.

Standing in the middle

Everyone in the audience stands up.

I stand in the middle of the living unit. My hands are by my sides. My feet are hip-width apart. I look at the audience.

I take a step to the left and stare at someone.

Then I step back to the middle.

Then I take a step closer to the edge.

My hands flare out as I stare at someone's eyes.

The gallery staff carry a stepladder to the front of the bedroom unit.

I keep staring. I lift my arms out from my sides, like wings.

Stopping the metronome

I walk over to the metronome, crouch down and stop it ticking.

Undressing

I sit on the bed and untie my laces. I take my right shoe off first, then my right sock. I put my right sock in my right shoe. Then I take off my left shoe, then my left sock. I put my left sock in my left shoe.

I stand up and undo the buttons on my trousers. Then I pull them off, fold them up and put them on the bed.

Then I sit down and unbutton my shirt, starting at the bottom. I take it off, fold it up and put it on my trousers. Then I put the bundle on top of my shoes.

Then I put on the slippers that the gallery staff have placed on the floor of the bedroom unit. Then I read a note that they have given me and I laugh. Then I put on the robe they have given me. I tie up the cord.

Leaving

I step to the edge.

I pause for a second.

Then I walk down the stepladder and onto the ground.

Texts

The Twelve Days of Marina Abramović

Cindy Carr

DAY ONE

Friday, November 15, 2002

10:10 A.M.

It's a typical gallery opening, but with coffee instead of wine. Marina is dressed in the usual black, including an Issey Miyake skirt. Hugs me. Hugs many others. Hints of giddiness, but perhaps it's nerves. On the phone from Germany, she told me this would be the hardest work she's ever done. But this morning she jokes about it: "Now I will have time." I look at the clothing shelf in her "bedroom." There is a white quilt along with the different colored clothes. She says she can't wait to wear the green. The ladders in front of each platform have six knife rungs each. She keeps telling people that she has done nothing to prepare, but AA Bronson says to me that he thinks she is already withdrawing. He can see it in her eyes. At **10:40** I notice that Marina has gone to change. A few minutes later, everyone else is herded out of the space.

11:00 A.M.

Marina is dressed in white pants and white shirt buttoned to the neck, seated on the oak chair, hands on knees, staring into the distance. She is working to sink in to it. She's set the metronome to tick once every second. I think it is there to slow down time. People who came for the opening are still buzzing. They have not made the big transition she just made, and there's lots of hub-bub. Then I notice her feet. Just as she told me, the boots from the Chinese wall!! She regards this piece as similar to that. At **11:28** she stands up and takes a step forward. This seems to draw more people into the room, and by **11:30** it's quieter. When I leave at **11:45** she's still standing there.

DAY TWO

Saturday, November 16, 2002

5:05 P.M.

She is standing where I left her yesterday, but dressed all in purple. A woman walks forward almost to the white line on the floor about a foot in front of the knife ladders. Marina appears to look at her, or in that direction. Rain is audible on the roof. The metronome seems a bit slower today, maybe because the energy in the space is now slower. About twenty people observe. At **5:10** she goes into the "bedroom" with a glass, sits on the bed and gets water from the tap. She takes it back to the center room to drink, while standing, very slowly. At **5:12** she goes into the bathroom to pee. Has to fill a bucket with water to flush it down. At **5:15** she goes back to the center room and puts the metronome on again. When did it turn off? This piece is about becoming aware of very small things. Marina goes to "the abyss" between the living room and the bedroom and stands with one foot in each space, hands on the wall. I count 23 spectators. By **5:17** the metronome has turned off again. At **5:20** she goes back to the center and rewinds it, placing it precisely on the northeast corner of the table. She sits on the chair. At **5:25** she stands up and goes directly behind the knife ladder. The metronome is off. I hear loud men in another room. At **5:31** she winds the metronome again and sits down. I look at her through the telescope, notice the eyes pulled in. Ten to twelve people are standing in the hall right outside the room. Are they afraid to come in? There are definitely different ways of watching. Some go right to the tele-

scope and soon leave. Others look like they've been planted there for hours. One of these, a bearded man, has now gone to the east wall up close to the white line. At **5:40** Marina takes the glass into the bedroom, again for water, and returns to the center room to drink very slowly, emptying the glass. At **5:45** she enters the bathroom again, puts one towel on the floor and another towel over the toilet. She sits there and takes her clothes off in a particular order: shoes, socks, pants, shirt, both undershirts, then underpants. Stands naked next to the shower with her hand under the water until it warms up. When she gets under the water, she just stands there. No soaping. I count 23 people watching. At **5:50** she coughs for a bit. At **5:55** she turns off the water. It's a long shower, but perhaps her only moments of sensual pleasure in this day. She dresses in reverse order of her undressing, then wipes water off the floor, puts the bathmat in the shower and the towel back on the shelf. Very monastic. Everything is ritualized. I leave at **6:00** as she stands back in the center behind the knife ladder.

DAY THREE

Sunday, November 17, 2002

3:25 P.M.

Marina's in yellow gold today. As I enter, she's on the center platform, drinking slowly from a glass of water. It's raining outside, very audible on the roof. As Marina puts the glass down, she sees me. A flicker of recognition. The metronome ticks. There are three other people in the room. At **3:40** she begins the shower ritual, same as yesterday, undressing in the same order. Steps under the water at **3:47**. Again there's no soaping. She holds her mouth open and drinks as she stands. She turns the water off at **3:52**. I am trying to figure out the paradox. Is she more trapped in time—her twelve days—or more free of it? Here I am, writing down the precise minute she does everything, but she probably gives no thought to time apart from the gallery's opening and closing time and the passage of each day. By chance, I have been reading Coetzee's *Life and Times of Michael K*, a novel about apartheid, but also a novel about time and about hunger. Michael K is a hunger artist, as Kafka meant it, since he cannot find a food he really wants to eat except the pumpkins he grows for himself out in the veld. He also realizes there, in his period of freedom, that he lives "beyond the reach of calendar and clock." Could it be the moral of the story, he wonders near the end of the book: "that there is time enough for everything?" At **3:57** Marina comes back to the center room and stands behind the knife ladder, arms at her sides. I worry about her falling. Already! She seems unsteady. Already! I sense that she is tired and not completely alert. When someone gets up to look through the telescope, I wonder if it helps her. To see that people are spectating. The heavy rain on the roof, combined with the metronome, is too hypnotic. She seems to wobble and just catch herself. She goes to the bedroom for water at **4:07**. At **4:09** she's drinking it slowly in the center room. Then she sits. I flash on portraits of nineteenth-century women, confined to inactivity by their gender. At **4:15** she stands between bedroom and living room. Ten people present. At **4:20** I look through the telescope. She seems sad today. Distressed. Already! At **4:23** she moves back to the center and stands in front of the chair. At **4:25** she goes to the bedroom for water, comes to the center room to drink it empty. At **4:26** she sits on the chair again. Ten people are present. I leave at **4:30** as she's sitting down in the bathroom to pee.

DAY FOUR

Monday, November 18, 2002

2:28 P.M.

Today, some changes. When I arrive she's in grayish blue, standing between the chair and the table, where she's never stood before. The metronome is now on the bed, behind the quartz pillow. I am the only spectator. Probably because there's no rain, I'm more aware of hearing the video in the front gallery, muted voices in the office, trucks or machines rumbling in adjacent buildings. At **2:40** two women and a man enter, and I'm distracted by the man's energy. He keeps whispering to his friends or popping up to leave the room or approaching Marina's space. Or maybe I'm more aware of other people's energy here. At **2:44** Marina walks into the bathroom, to the far wall, and turns, begins pacing across the front of all three rooms then back. She takes six deliberate steps in each of the rooms, turns, repeats. Until **2:48** when she gets the glass from the table and fills it in the bedroom. Back in the center room, she drinks it slowly, as always. All of it. At **2:50** she goes to the use the bathroom. The man seems startled. I keep wanting to ask him: What are you doing here? I notice that Marina is folding the toilet paper very deliberately as though it was origami. As she fills the bucket to flush the toilet, she stands almost at attention. At **2:55** she goes back to the center space and sits on the chair. The man keeps getting up, now to advise someone on how to use the telescope. Apart from him and me, there are now six other women watching. I go to look through the telescope. I wonder if

her eyes are changing color. I feel something—but what?—is being communicated. It's too deep. She blinks once. At **3:07** she goes to stand between the bathroom and living room, one foot in each. At **3:10** the metronome stops. At **3:14** she goes to the bedroom, sits on the bed and winds the metronome, then lies down. Looking at the clothes on her shelf, I wonder if they're Tibetan colors. I mean prayer flag colors. She sits back up at **3:20** and takes the metronome to the bathroom, placing it on the floor in front of the shower. At **3:22** she begins the shower ritual. Does this exactly as before. When I leave at **3:30** she's just stepped in under the water.

DAY FIVE
Tuesday, November 19, 2002

10:24 A.M.

Marina is pacing along the front of the rooms, dressed today in an orangey-red. At **10:26** she goes into the bedroom to fill her glass, drinks it in the center room as usual, then goes back to pacing. Sean Kelly sits next to me briefly and says he's worried she'll fall while doing this. The space between rooms is about 18 inches. It's a walking meditation, six paces in the side rooms and seven through the center. At **10:32** she sits in the chair. There is one other spectator. At **10:37** she goes to stand between the chair and table at the back of the center room. There are three other spectators. One of them, a man, paces along the white line. At **10:44** she goes for more water, drinks it again slowly in the center room. At **10:46** she is back to standing between table and chair, hands behind her. Nine or ten students (I'm guessing) arrive all at once at **10:50**. By the time she goes to pee at **11:01**, all but four or five people have left. At **11:04** she runs water in the bucket to flush the toilet and returns at **11:05** to stand between the table and chair in the center room. Apart from me, three spectators remain. It's a big thing to submit yourself to "nothing," to waiting. Are we waiting? Today I took two subways and a bus, then walked for six blocks. *That* involved waiting. Marina's energy has changed. The mental strength she needs to do this has taken over and pushed away her vivacity. When I look through the telescope at **11:14** she seems focused and serious. She is putting energy out into the space. Do I send any back? At **11:15** she gets another drink of water, then rewinds the metronome. I didn't notice it going off this time. At **11:17** she stands just behind the knife ladder. She's still there when I leave.

DAY SIX
Wednesday, November 20, 2002

3:40 P.M.

She's in lime green, sitting on the chair. What does it mean that she's turned the table upside down? The glass sits on the end of one of the legs. At **3:42** she begins the shower ritual, taking clothes off in the order she established, pushing socks into the boots, then folding each item of clothing and stacking it on the boots. The metronome stops at **3:45**. Today when she stands with her hand in the water, waiting for it to warm up, she looks out at the spectators. Usually she does not. She steps in at **3:49**, standing as usual, with palms out, no soaping. There are ten men watching and two women. Two of the men look through the telescope. She turns the water off at **3:53** and holds the towel to her face for almost two minutes before drying off. She unfolds each garment in order and puts it back on. At **3:59** she re-enters the center room, rewinds the metronome and places it on the other front leg of the upturned table. At **4:00** she goes to stand directly behind the knife ladder, right at the edge so the top of the ladder touches her pants leg. She begins to stare at one young man who stood up from where he was sitting on the floor. I worry. She seems wobbly, almost leaving her body. At **4:10** she puts her palms out from her side as if to steady herself. She's still looking at the guy. There is some kind of drama here. At **4:12** she lets her palms drop down again and looks straight ahead. Two minutes later, the guy sits back down. At **4:18** the metronome stops and she finally leaves the ladder position to rewind it. She wipes her nose. A cold? At **4:20** she goes to the bedroom for water, then back to the center room to drink slowly as usual. There are 17 people present. She goes to sit in the chair, this time with hands folded in her lap. She seems somewhat slumped. I look through the telescope at **4:22**. She looks very tired today. I sit back on the bench and watch her with undivided attention. I think I see little balloons of light moving up from her head. A trick of the light? Actually it's just an outline of her head that moves up, like a balloon, one after another, usually drifting to my right. Then I realize that it's an afterimage. It's what happens if you look at a light bulb, then look away. The imprint of the bulb stays on your eye. The afterimages stop at **4:26** when she gets up to rewind the metronome, this time bringing it to the chair and holding it on her lap. Then I begin to see them again. At **4:35** she carries the metronome into the bedroom, puts it behind the quartz pillow and lies down.

DAY SEVEN

Thursday, November 21, 2002

10:16 A.M.

She's in yellow today, standing behind the knife ladder. The table is upright again. The metronome's sitting on the bed, towards the east end, not behind the pillow. There is one other spectator. At **10:20** she gets water and drinks it in the bedroom for the first time (that I've seen). These small details become the big chance for variety. At **10:22** she begins standing in the center of the room, between the table and the chair, hands behind her. At **10:26** she squats on her haunches, fists under her chin. It's a bit noisy—people are talking in the other galleries. At **10:34** the metronome stops and she goes to the bed to rewind it and get water. She sits on the bed drinking. There are five spectators now, all women. At **10:35** she goes to the bathroom to pee. At **10:38** she fills the bucket, standing at attention, hands behind her. After emptying the water into the commode and putting the bucket back down, she places the bucket handle up. The handle falls and she goes back to correct it. It's a controlled environment. At **10:40** she sits in the chair, hands in her lap. The metronome stops at **10:44**. Marina gets up. A woman comes forward. Marina looks at her and comes to the front of the center room, leaning against the side (the "door jamb"). The woman goes a step closer. At **10:49** Marina puts her palms out, away from her body. The woman steps out of her shoes and stands behind them. It seems very dramatic. I wonder what is being communicated. Only two other spectators are present besides me. At **10:55** Marina steps back, ending it. The woman goes back to sit on a bench. Marina goes to the bathroom for a Kleenex, then to the bedroom to start the metronome. She sits on the bed. I am seeing some afterimages again. A man comes in and walks up near the front line. She stares. He wanders back out and she leans forward, elbows on knees. She begins singing at **10:59** and as she begins I'm seeing big afterimages of her whole seated body, lifting back and up towards the ceiling. I can't tell what she's singing. Can't make out the words. I suspect they are not English, but it begins to sound like: "They must guard their message to you." At **11:08** she goes to the center room for the glass, still singing under her breath. She gets water, drinks it while sitting on her bed. At **11:10** she returns the glass and goes to the bathroom to pee, still singing a bit. Sits on the commode with hands covering her face.

As I write this down, I think how much my writing choice is like Gertrude Stein's *Three Lives*. "And then and then and then" until you get through a whole lifetime.

DAY EIGHT

Friday, November 22, 2002

6:22 P.M.

She's in white, walking into the bedroom to start the metronome. A minute later she laughs, then again. The metronome's on the floor. She's sitting in the middle of the bed. I count 22 people at **6:29**. I have finally figured out why I write down the minutes. Because the piece is about each minute. Today she looks tired, but beatific. The table in the center room is on its side, legs sticking out over the edge. I notice some people who've been here before. One young man along the west wall appears to be meditating. At **6:31** she goes to stand with one foot in the bedroom, one in the center room. At **6:34** I notice afterimages again. Today they're milky or cloudlike and they take different courses this way and that, but always up. At **6:42** she sits on the chair, takes off her shoes and socks. There are 29 people here. She sits down behind the knife ladder in the center room and rests her feet on the second rung, on the cutting edge of the knife. At **6:45** she begins her sing-song, hands gripping the top of the ladder. I realize after a couple of minutes that she is singing the same words as before. At least I think I hear the words "message to you" as before. Thirty people are present. At **6:50** she stops singing, goes back to the chair and puts her shoes and socks back on. At **6:52** she takes the glass in for water, fills it, and stands up, taking a step towards us away from the bed. She drinks the water. There are 27 people present. At **6:54** she takes the glass back to the center room and goes to pee. Folds the toilet paper slowly. At **6:57** she puts the bucket handle down and turns the water on. Nothing happens. No water. She puts the handle back up and goes to the center room, leaning against the back wall at the center. At **6:59** the young meditator goes to the center of the room, dropping onto his knees, looking at her. She comes forward and kneels in the center room, hands over the edge, looking at him. At **7:05** she pulls back and goes to sit on the bed, looking at others who sit on the floor, hands folded in her lap. There's a kind of nimbus around her today. At **7:15** she looks away and another man comes to stand near the white line. She stares at him, a bright afterimage rising. That is, hair and eyes bright. At **7:19** the metronome goes off. At **7:24** it's so quiet I can hear the surf pounding from the video in the front room. When I leave at **7:25** she's still staring. The gallery will be open till midnight.

DAY NINE
Saturday, November 23, 2002

3:44 P.M.

A big crowd—44 in the space, with more in the hall and lobby. She's wearing purple today, standing at the center behind the knife ladder with palms extended out from her sides. Both the table and chair are turned over. The metronome is under the bed. I notice Tom McEvilley with his personal chair, seated along the west wall. I stand along the back wall until a couple of people on the west bench leave. She looks at me after I sit down. I notice an afterimage. She seems unsteady. At **3:54** she turns away. She has to step carefully around the chair legs to reach the bedroom with her water glass. She drinks in the bedroom, takes the glass back to the center room and returns to stand behind the knife ladder at **3:56**. At **4:00** she goes to lean against the back wall. Afterimages move sideways towards the bedroom, but disappear at the wall. There's a pointed one. Tom walks to the center and nods, as if to a guru, then picks up his chair and leaves. At **4:03** she goes to sit on the bed. At **4:05** she scoots down closer to the pillow. Afterimages here move away, then come back as if elastic. I have been thinking all these days that my eyes are playing tricks on me. I look at other people in the room to see if I notice anything around them. Maybe something faint here and there. So maybe it is just a trick of the light. There's a lot of chattering and milling out in the hallway. At **4:17** she stands behind the knife ladder in the bedroom. All her movements today look heavy, even turning the head. At **4:20** she starts looking at a woman standing against the west wall, moving her palms out again as if to steady herself. The woman smiles; Marina smiles. Occasionally today I see her stop to take deep breaths. At **4:29** some man who isn't paying attention to anything drifts in and takes up a spot between Marina and the woman she's been looking at. Another man gets up and goes to the white line in front of the bathroom, looks at the ladder and the furnishings and moves along the white line until he's near Marina. She looks at him. He moves away after 30 seconds or so. At **4:31** she goes to the bathroom to pee. The room gets the quietest that it's been today. At **4:34** she opens the tap over the bucket of water, moving the handle down first as usual. She stands at attention, looking at the woman along the wall, the one she was looking at before the men imposed themselves. She is not paying attention to the bucket and at **4:36** it overflows. Water trickles over the edge of her room onto the gallery floor. She turns the water off, has to work now to pick up a bucket filled to the brim. At **4:40** a sudden influx of new people seems to arrive all at once. Must be 70 in the room now. I decide to leave. Sean Kelly tells me they've had about 1000 people today.

DAY TEN
Sunday, November 24, 2002

3:35 P.M.

She's in the yellow suit again, sitting on the edge of the bedroom, legs over the side, staring at Tom McEvilley. He's placed his personal chair near the center of the room. The chair is upright, but the table is on its side. Another man is standing in front of the bedroom, staring at the west wall, his side to her, his hands folded in front. Then he turns his back to her, eyes closed. I suppose he's meditating. There are 20 people present. Marina looks exhausted, really drained, and she's totally focused on Tom to the point of seeming unaware of anything or anyone else in the room. At **3:40** the meditating man walks toward the audience, then turns his other side to her and begins shifting his weight back and forth from one foot to the other. He's into his own little trip. At **3:45** he begins to creep east, an inch at a time. I don't think Marina has moved a muscle or even blinked this whole time. At **3:50** the meditating man jumps as he turns back towards Marina's rooms. He weaves around like a junkie. Marina still hasn't moved. I look through the telescope for the first time in days. She actually seems the same, just more closed in. People seem to feel freer today to move up to the white line. I think it's because she's so inert, like a statue. I am seeing none of the "afterimages" today. Susan Sontag comes in and sits on the floor. There are 27 people present. At **4:05** she turns away from Tom and stretches flat out on her stomach, arms in front of her. She starts the metronome, which is under the bed. She's only there for a minute, getting up at **4:06** to go to the center room for the glass. She fills it in the bedroom and stands there, drinking slowly. At **4:07** she takes a deep breath and walks to the center room, where she puts the glass on the chair. She has to climb around the table legs, which extend to the front of the room, in order to get to the bathroom. She goes in to pee. There are 36 people present. At **4:09** she begins to fill the bucket, then pours water down the commode. At **4:11** she returns to the center room and crouches down between the table legs with her knees up. The meditating man is up at the white line near the west end of the bathroom. She's ignoring him as he raises his arms up and out. It seems to me that someone's spiritual practice can take up a lot of space, can be a way of showing off. Marina has definitely perked up. At **4:16** she crawls out the side of the table, nearly falls as she stands up, then goes to the bedroom and sits on the bed. At **4:20** Tom comes up to the white line to do his good-bye gesture.

153

She's looking around the room now. She goes to stand behind the knife ladder in the bedroom. There are 28 people present. At **4:22** she begins taking deep breaths, extending palms out as if to balance. The woman next to me is sitting there with her palms up, a secret meditator. A man walks right to the white line at the bedroom at **4:25**. She looks at him. He backs away at **4:29**. The meditating man is now at ease, standing with his back to the east wall. At **4:30** she steps back from the knife ladder, almost hyperventilating. I keep wishing she'd just sit down, but after a few moments she steps up again to her position behind the knife ladder. I wish to transmit the message telepathically: *sit down*. Finally, at **4:37**, she steps back very unsteady, catching herself. She goes to the center room and lifts the table up with great effort. She puts the glass on it. At **4:40** she goes to stand between the table and chair. At the front desk, Sean Kelly tells me that he talks to her at night when he's closing the gallery and he's been asking her not to place the furniture in front of the doors to block her own path. She does it anyway.

DAY ELEVEN
Monday, November 25, 2002

4 P.M.
Marina is seated in the center room, dangling her legs over the edge, looking at a man who's come right up to the white line. She wears the grayish blue outfit. About 25 people are there. The metronome is on the floor at the other end of the center room. The furniture is upright today. I see an afterimage around not just her but the whole chair behind her. Tom McEvilley arrives and places his chair towards the west wall, a couple of yards in front of the bench. At **4:15** there are 15 people present. Marina has not moved. At **4:22** Marina leans back until her head touches the chair, then turns to lay out flat on her back. At **4:23** she gets up slowly and takes the glass from the table. Walking to the bedroom now, she steps carefully, puts her hand on the doorway. She drinks, standing in front of the bed. She seems unsteady. She puts the glass back on the table, then crosses to the bedroom again. She gets down and sweeps the floor clean with her hand. Some piece of fuzz floats down. At **4:25** she crawls under the bed, lying on her side looking out. Tom shifts his chair to face her. A woman comes up closer, along the west wall. Marina looks at her, then at a man who comes to stand near the white line. I have been content to just sit on a bench all these days, but now I begin to feel that I should go forward, just as a gesture of support. She really seems to be in distress today. I gather my things but still don't move. I noticed a small man with weird energy scooting in. He ends up standing along the west wall, either writing or drawing in a little book. The Sketch Artist. There are 33 people present at **4:35**. At **4:36** she lies back down under the bed. At **4:40** she gets up and sits on the bed, right by the quartz pillow. Finally, at **4:45**, I go up near the front and stand for a while. She doesn't seem to recognize me. I sit down on my coat. Afterimages move back. It's a cowl shape—her hair and clothes—with the face lighter. Sometimes the whole thing is solid. She seems unable to focus. There's a constant white light around her but it moves. At **4:58** I think I see a tear. I see Leon Golub come in at **5:00**. Thirty people are present, many sitting on the floor. This is a day when I think many, like me, feel that they should move forward towards her. At **5:05** I count 36 people. Nancy Spero comes in and sits behind Leon on the bench. An afterimage moves quickly east. Then there's nothing. At **5:15** Marina stands and goes to the center room, blows her nose, then stands behind the knife ladder, palms out to her side. She is like a person on a tightrope. I count 44 people. I feel it is taking her great effort just to stand there. The Sketch Artist goes to stand directly in front of her, imitating her, palms out. She only looks at him for a moment. She seems to be smiling. At **5:24** there are 40 present. At **5:25** she steps back unsteadily and takes the glass in to get water. Drinks it in front of the bed. A woman comes forward and places a single rose at the base of the knife ladder, then walks out. Marina hasn't noticed. She goes to pee. At **5:27** she begins to run water into the bucket as she stares across the room. Water runs onto the floor before she turns it off at **5:30**. At **5:34** she goes to stand between the table and the chair at the back of the center room.
In the room next door, where people can lie on the Dream Bed for an hour wearing Dream Clothing, I see someone all in purple lying in what seems more box than bed. Over 80 people have signed pledges taped to the wall, pledges to lie there for the full hour. Out in the lobby I copy a quote from her book *Public Body*. "The desert reduces you to yourself. That's all that happens."

DAY 12
Tuesday, November 26, 2002

3:10 P.M.
The table's on its side and she's sitting between the legs in her orange-red outfit. The metronome is in the bathroom, near the east wall. At **3:14** she goes to the bedroom and lies on the bed, facing us. A minute later she pushes herself down the bed, resting her elbow against the pillow. The audience is back around the benches, except for the Sketch Artist who is up front along the west wall,

drawing. More stand in the hallway, as if afraid to enter. A **3:18** a couple of people come forward. She gets down from the bed and puts her legs over the side, looking at a man in watch cap and leather jacket who is up near the white line. At **3:20** this man walks away and stands along the west wall. Marina looks out and settles on the pale man she's watched before. The man is on the bench. At **3:22** Tom enters and places his chair within a yard of the white line near the center. She smiles and begins to look at him. At **3:27** a woman moves forward. Except for her and Tom, people aren't filling the middle area yet. Then, at **3:30**, people suddenly begin to move into the middle, including a young woman who lies prone on her stomach. There are 36 present. Marina breaks off looking at Tom at **3:38**, pulls back from the edge and lies down under the bed on her side. At **3:40** she emerges from under the bed, collects herself on her haunches before getting up, goes to the chair in the center room to get the glass, returns to the bedroom to fill it, and stands in front of the bed drinking slowly. At **3:43** she goes to pee. There are 44 people in the room, including Salman Rushdie. More stand in the hall. At **3:45** she's running water into the bucket, fills it half full to flush the toilet. She really seems more lucid today than she was yesterday. At **3:47** she places the glass on the turned-over table's leg, moves the chair forward a bit, and sits down. She resumes looking at Tom. He gets up and leaves the room at **3:50**, but his chair remains. She looks at a man along the west wall. I see afterimages. Maybe I'm looking too hard. At **3:55** she goes to rewind the metronome and brings it to the center space. At **3:58** a man sits down in Tom's chair. Marina goes to stand between rooms and stares at him. About 50 people are present. At **4:09** she smiles and steps into the center room to get the glass, gets water in the bedroom, and stands drinking in front of the bed. The man on Tom's chair leaves. At **4:10** she pushes the table out to the front of the sitting room and gets inside to sit, knees up. She's looking happy today for the first time. Soon it's over. Tom returns at **4:20**, but someone else is in his chair. Marina crawls out from between the table legs at **4:27** and takes the glass into the bedroom. Tom returns to his chair. At **4:30**, after drinking, she takes something from the bedroom shelf. A hairband. She places the glass on the chair in the center room and goes to the bathroom to begin the shower ritual. About 64 people are here, including Kim Jones. Shoes off. Socks into shoes. Clothes folded and placed on top of shoes. And so on. This will be her last shower. Marina steps under the water at **4:35**, holding her palms out. About 70 are present. When she steps out at **4:40**, 75 are present. She holds the towel to her face for two to three minutes. Then, sitting on the toilet, she leans over with her hair over her head and puts her hands on the floor. She begins to dress at **4:45**, leaves the bathroom at **4:48**, crawling around the table legs in the center room. About 82 people are present. She takes the glass into the bedroom for water. This is the most active she's been in days. At **4:50** she returns to the center room, puts the glass on the table leg and sits in the chair. I see a moment of white glow around her, even around the chair. At **4:52** she goes to stand at the back of the center room between the table and the chair. Someone from the gallery directs everyone on the floor to move forward. About 90 are here at **4:55**. At **4:58** I briefly see a green light around her. At **5:00** she takes a couple of steps forward. About 95 people are there. At **5:03** she steps closer to the edge. At **5:04** she goes closer to stand right behind the knife ladder. She's unsteady, touches the table leg right next to her, then takes a step back, breathing hard. How can someone "just standing there" be so excruciating to watch? At **5:12** she begins to look at Tom again, smiles, touches the table leg to steady herself and moves up again behind the knife ladder, then steps back again. At **5:14** she steps up again, stomping her feet as if to plant herself firmly behind the knife ladder. This is drama. She takes another step back. She pants. About 120 people are present. At **5:20** she steps back for the water glass, goes to the bedroom for water then back to the center and places the glass on the chair. She rewinds the metronome. At **5:22** she climbs between the table legs and scoots it to the center. She sits down between the legs, knees up. At **5:24** she begins to sing the same song—I recognize those words that sound like "message to you." The room is now packed. I'm guessing 150 people. At **5:31** she climbs out sideways from between the table legs, stands and goes into the bathroom where she blows her nose. Back in the center room, she moves the table back and angles it sideways. She puts the glass on the floor near the front, then moves the chair forward and laboriously tips it onto its back. She places the glass on the top east leg of the table. At **5:35** she goes to sit on the bed, on the crystal pillow. The Sketch Artist is sitting there along the wall. He stands up to stare and she looks back, smiling. He starts fussing with his papers on the floor and pulls one out to show her. At **5:37** he is holding it in front of his face. She starts to cry. At **5:40** he turns it sideways and she smiles. She returns to the center room for the glass and drinks in the bedroom. At **5:41** she returns to the center room, puts the glass on the table and goes to pee. Someone from the gallery brings a microphone forward at **5:44** and sets it up in front of the center room. At **5:45** she fills the bucket. At **5:46** she returns to the center room and stands between the fallen table and chair. Someone directs us to stand up at **5:50**. She's come up behind the knife ladder. At **5:54** gallery workers bring a real ladder in and place it in front of the bedroom knife ladder. She looks out over the crowd, breathing heavy. Silence. We are all just waiting for the minutes to pass. She is smiling. At **6:00** she stops the metronome and goes to the bedroom where she takes off her shoes, socks, and the orange-red outfit. She folds it, placing it atop the shoes. She puts on Chinese slippers and a white bathrobe, slipping something small and flat into her pocket from the clothing shelf. A framed photo. Then she climbs down the ladder.

The Theater of the Body

RoseLee Goldberg

The House with the Ocean View is without a doubt one of the most important live art works in decades. Not because it is a work of extraordinary elegance, which it is, nor because it continues potent themes of Abramović's thirty-year career, which it does, but because *House*, above all, is a work of visual theater in the most powerful and heroic sense. It is the staging of emotion, without recourse to a single word, and of high drama, with barely a contrived effect. It is a wholly physical manifestation of thoughts, memories and desires, so dense that the courage to present it verges on a form of recklessness. It stems from a personal challenge so unlikely, to make her world a stage, and is constructed with such restraint, the artist installed on a suspended platform only six feet deep on one wall of a gallery, that its success is almost uncanny, especially given the broad sweep of audience members who were moved, some to tears, to sit with Abramović for a large part of her twelve-day vigil.

House was simple in its parameters. Its motions were the rituals of daily life—sleeping, drinking, showering—slowed down in time to a series of stiffly executed gestures which transformed ordinary activities into somber ceremonies. Her costume was a uniform of tunic and pants, a new color worn each day (a reference to Alexander Rodchenko's Constructivist designs). The 'stage' was a triptych of domestic essentials—bedroom, bathroom, living room—of equal measure and furnished with solid wooden furniture built to a diagrammatic design. Yet, even the smallest embellishment—a large bath towel draped across the artist's body, her long, dark hair falling forward as she bent to dry a foot following a shower—triggered associations, in this instance with painted bathers from art history, while associative words, "house" and "ocean view" from the title, metamorphosed a simple elevation into an architectural alcazar of the imagination. A vision of dunes below and of a windswept beach beyond provided a narrative that was not really there. Furthermore, the fact that Abramović remained quite alone in the space the entire night, made palpable the fullness of an empty building. How do the unlit spaces of empty galleries fare between closing time and the morning hours? What layered yarns, of ghostly inhabitants with past lives and a myriad of purposes, remain between walls and ceiling? How did Abramović continue her private theater with nobody there?

None could tell. No real meaning could be deduced from Abramović's silent gaze, when she would begin, again, less fresh each day for being further deprived of food, more somber and concentrated for being speechless and alone. There was no question though, that an ongoing argumentative dialogue, a continuous commentary, was the busyness in each separate onlooker's brain. While the performer followed no script—there was none, only a set of restrictions—random members of the crowd became spontaneous players in this work. One young woman mimicked Abramović's movements with the precision of an understudy. A man held up a small drawing he had made of her, tinted gold, as in an offering to a saint. Another man stood and stared, legs astride, arms akimbo, at Abramović and she down at him, for a full quarter of an hour. Only the tick-tock of a metronome punctuated the intimate communion between two strangers that was the subtext to this scene. In each colloquy, artist and viewer locked eyes for an unblinking period of time, longer than one ever does with even the most intimate partner, with revelatory effect; if the eyes are indeed windows to the soul, then connecting two pairs in a two-way exchange as the centerpiece of a work made it clear, as though for the first time, that it is through them that we convey our humanity towards one another. Such was the thrust of Abramović's dramatic aspirations: to connect. With this goal in mind, she discovered eye contact as dramaturgy's secret weapon in breaking through the intractable fourth wall of theatrical tradition.

The finale on the twelfth day could only be described as a stroke of directorial brilliance, more so given the fact that the artist,

now completely weakened by her fast (although energized by its imminent end) continued to direct the work from the stage. How would it end? How would she puncture the devout aura of the crowd that had grown thicker all afternoon? What would happen at 6 P.M.? At ten minutes to the hour, assistants gestured the audience to stand and two hundred people stood, eyes fixed on Abramović. At 6:05 P.M., she changed out of her clothes and, in pristine bathrobe and slippers, slowly descended the ladder, which had been brought to her. "This work is as much you as it is me," she announced when she reached the gallery floor. The audience applauded, in wonder it seemed, for the way in which she had unaccountably frozen an interval of time for them amidst their hurried lives, while keeping them in a state of thoughtful, and reassuringly communal, meditation.

What had occurred during those days of watching and waiting? Why did so many people return to the gallery day after day to witness the unfolding of Abramović's stoical plan, and why did so many leave having apparently been transformed by the encounter, even those familiar with the artist's work and who thought they knew what to expect? After all, there was nothing in the space or wall text to suggest an emotional exercise—no overt clues as to meaning, unlike her earlier performances which had a clear political or feminist undertone, or those with former partner Ulay, which referred to their own complicated relationship as much as to relationships in general. Yet, once inside the hushed white space, viewers were quickly absorbed by a standing or seated figure within an invisible frame, whose body language conjured hours of silent storytelling. Whether a viewer stayed fifteen minutes or fifty, Abramović's presence acted as a stimulus to the nervous system. Fleeting changes in her facial expressions provided a mental map for viewers to follow, while each set of slow-motion gestures, each steady sweep of her eyes over the crowd, registered a response. When she cried, absorbed probably in a nostalgic flashback, a few cried with her, when she sang melancholy Serbian songs, the mood lifted. Even so, the intensity of emotion was out of proportion to her rather mundane and repetitive activities enacted on a minimal stage of quotidian props.

In many ways these responses were involuntary, as though a reflex point had received a direct hit. They seemed to have more to do with what recent neurophysiological research calls "the feeling brain" than with conscious empathy. Distinguishing between emotions and feelings, the former being visible, while the latter are hidden, these studies point out that "the content of feelings" (according to leading neuroscientist Antonio Damasio) are represented in "a particular state of the body." Abramović's gestures, being the visible expression of her feelings, stimulated the viewer's emotions. "Emotions play out in the theater of the body," Damasio writes. "Feelings...are the language of the mind."[1]

Scene by scene, this theatrical work of waiting was as suspenseful as any production by Samuel Beckett. Yet Abramović's state of mind was not directed towards an endgame but returned again and again to its starting point: September 11, 2001. *The House with the Ocean View* began, she said, with a desire to provide a place of contemplation for the aftermath of the disaster and for the dramatic changes it had wrought in the psyche of a wounded New York City. Inevitably for this artist, however, such meditation covered autobiographical terrain as well: a childhood in Tito's Yugoslavia, years of apprenticeship in Eastern Philosophy in India, and a period spent living with Aborigines in the Australian desert. For this purpose, she constructed a pristine, perfectly lit reverent place, hard edged and unambiguous in its composition. Her actions were placed dead center and fully frontal on each of the three platforms, while the triptych itself was cleverly set at a distance, directly opposite the entrance to the space, like that of an overarching altarpiece at one end of a church nave. This arrangement, as well as references to figurative painting and sculpture, gave the work an additional art-historical, and religious, aura. Even the positioning of a high-powered telescope, through which viewers could investigate the smallest details of Abramović's wall relief, suggested the methods of an art historian's close examination of an artwork. Indeed, the mix of an aesthetic experience with an emotional one, of producing a work both visually seductive and ethically informative, could have been achieved by none other than a visual artist with an acute awareness of the formal properties of picture making and a history of creating vivid and compelling live performance. Such was Abramović's success in accomplishing all of the above.

1. The nature of bodily representations of the brain (and the affects of emotion) has been developed in several books by Antonio Damasio, including his latest, *Looking for Spinoza: Joy, Sorrow and the Feeling Brain* (New York, 2003). Gilles Deleuze has written extensively on "the notion of art directly affecting the nervous system" in *The Logic of Sense* (1969). Johathan Crary also uses neuroscience as a key starting point for his book *Suspensions of Perception* (1999).

Marina Abramović: Staring at the Ocean

Chrissie Iles

On October 14th, 1984, Rémy Zaugg sat in silence for several hours, watching Marina Abramović and Ulay sitting opposite each other across a table. Zaugg's triangulation of Abramović and Ulay's performance *Night Sea Crossing* in Forum, Middelburg,[1] was titled *The Observer*. Zaugg, invited by the two artists to sit at his own table at a silent distance, described his observation of Abramović and Ulay as an unsettling hybrid of passive observer and active participant. Behind him, viewers came and went, watching the artists, and watching him watching the artists. Zaugg found his attention as an observer shifting between the viewers, their perception of him in relation to the artists, and Abramović and Ulay. Who, then, was the subject of the performance?

The act of self-reflexive looking formed one of the defining perceptual enquiries of 1970s artmaking. The relationship between artist and viewer, and between the viewers themselves, was explored primarily through the mirror, performative action, and instant feedback of the video camera. Of all the artists making radical performative actions with the body and viewer during the 1970s, only Marina Abramović has carried forward this perceptual self-reflexiveness into her current work through live action. *The House with the Ocean View* (2002) is her most recent, and perhaps most metaphysical, performance.

The House with the Ocean View emerges out of both the durational performance work Abramović made in the 1970s, alone and with Ulay, and its continuation into the definitive performance series *Night Sea Crossing*, made with Ulay between 1981 and 1986. Each performance of *Night Sea Crossing*, in which Abramović and Ulay sat silently opposite each other at a table for eight hours without moving, lasted for between one and sixteen days. *Night Sea Crossing* was structured as a tableau, in which the two artists appeared as objects, sitting motionlessly in the museum near other, inert artworks. Abramović and Ulay's paradoxical undermining of the object through ephemeral action in object form proved to be one of the most radical works of the 1980s, a decade in which the values of the previous decade—process, time, immateriality, and a rejection of the artwork as tangible commodity—were being overturned and rendered invisible.

Several elements from *Night Sea Crossing*, as well as from Abramović's earlier works, form the core of *The House with the Ocean View*. For twelve days, Abramović lived in the Sean Kelly Gallery, fasting, making slow, deliberate actions, sleeping, performing ablutions, and sitting motionless for long periods of time. Viewers were allowed into the gallery during regular opening hours, from 10 A.M. to 6 P.M. each day.

As in *Rhythm 0* in Naples in 1974, Abramović took all responsibility in advance for whatever might occur during the performance. At the artist's insistence, a legal agreement waived the gallery of all responsibility for her fate during the performance. Abramović's acceptance of whatever might occur as a result of her actions, rooted in both the strategies of chance in the work of John Cage and the philosophical and spiritual practices of Zen, was a challenge to the limits of both her own practice, and the viewer's collective responsibility.

All of Abramović's activity during the twelve days of the performance was confined to a large platform several feet above the floor, divided into a tableau of three pared-down, open spaces representing, through sparely designed wooden furniture, a bathroom, a sitting room, and a bedroom. The impossibility of descent was underlined by the presence of three ladders made of razor-sharp knives, leaning against the edge of the platform in front of each room. The time was measured by the perpetual slow ticking of a metronome.[2]

During the twelve-day period of *The House with the Ocean View*, viewers came into the gallery and stood or sat in silence for considerable periods of time, looking at the artist who, in turn, looked intently at them. Each new visitor was acknowledged by her body language or eye movements. As each day progressed, the atmosphere in the gallery became infused with the unspoken dialogue that occurred between the artist and the viewers, and the viewers' reactions to each other. Abramović extended the relationship between artist and viewer, which had formed the basis of so many earlier works, into an unprecedentedly direct form of energy exchange.

The arduous mutual contemplation that had taken place between Abramović and Ulay during each performance of *Night Sea Crossing* formed an energy circuit into which Rémy Zaugg, removed at a table to the side, did not intrude. When Abramović and Ulay extended the performance to include a Tibetan llama, Ngawang Soepa Lueyar, and an Aboriginal holy man, Watuma Tarruru Tjungarrayi, in a performance of *Night Sea Crossing* in Amsterdam in 1983, on four axes of a round table covered in gold leaf, the energy field was extended from a dual to a circular form, to include two highly respected spiritual practitioners from different cultures. Yet in both cases, the viewers entered the same space as the artists and additional participants, but never engaged in any form of direct communication with them.

By contrast, the palpable, often intense silent emotion that filled the room during the twelve days of *The House with the Ocean View* marked a dramatic shift in the energy exchange between artist and viewer. The closed circuit of previous performances had been broken, replaced by a direct interaction between artist and audience. From her earliest performances, Abramović has always attempted to break the invisible barrier between performer and viewer, and tried to include the viewer in the performance as participant. As Jane Blocker has observed,[3] this impulse, born out of the 1970s and articulated in the work of Abramović, Vito Acconci, Ana Mendieta and others, was partly influenced by the arguments regarding the death of the author by the French philosopher Roland Barthes.

Barthes' dispersal of the authorial voice was echoed in Frank Popper's observation in 1975 that "the 'work of art' itself has more or less disappeared by gradual stages. The artist has taken upon himself new functions which are more like those of an intermediary rather than a creator, and has begun to enunciate open-ended environmental propositions and hypotheses. Finally the spectator has been impelled to intervene in the aesthetic process in an unprecedented way."[4]

In *The House with the Ocean View*, Abramović transformed the discrete artwork into Popper's "open-ended environmental proposition." The object had been replaced by a 'field,' created by the artist and viewer in equal measure. A charge occurred between artist and viewers, intensified by Abramović's silent acknowledgement of each visitor as they settled down and became part of the mutual contemplation. Unlike tangible religious or spiritual practices in which people are brought together for predetermined meditative purposes, *The House with the Ocean View* created an open-ended public space of non-commodified exchange.

In this space of exchange, the private, domestic space is collapsed into the public white cube of the gallery. Abramović moved around the three 'rooms' of the tableau as though inhabiting an interior private space to which the viewer had unlimited access. Abramović's relinquishment of privacy allowed the viewers to consider giving up some of their own. Just as the artist undressed, showered, sat deep in thought and slept in full view, she, in turn, observed viewers as they came and went, often staying for hours on end. Many became palpably emotional; some openly wept. Most arrived in a hurried state that dissipated over time as they sat. Each reaction was heightened by the contemplative atmosphere, which deepened as each new visitor arrived and became part of the collective performance.

The intimacy created by Abramović's folding of private space into public counteracts the prevailing sense of alienation that pervades the urban city, whose expansion in the nineteenth century triggered what Anthony Vidler describes as an estrangement, or "transcendental homelessness," brought about by the social conditions of modernity.[5] Vidler cites the sociologist Georg Simmel's argument, written in 1903, that space forms the primary catalyst for social behavior: "…the jostling crowdedness and the motley disorder of metropolitan communication would simply be unbearable without…psychological distance… The peculiar characteristic of relationships…places an invisible functional distance between people that is an interior protection and neutralization against the overcrowded proximity and friction of our cultural life."[6]

The House with the Ocean View deliberately challenges the protective mechanism of this psychological removal, the need for which, a century after Simmel's observations, has arguably increased tenfold. Where the cacaphonic urban environment engenders anonymity and 'non-existence,' *The House with the Ocean View* brings strangers into a contemplative engagement with each other's existence, through the presence of Abramović as intermediary. The rigid frontality and spatial inaccessibility of

Abramović's tableau ensures that the silent interaction between artist and viewers takes place within a clear structure, in which a tangible physical distance anticipates, and takes care of, the need to delineate physical and psychological boundaries. Viewers need not engage in mutual eye contact, or a direct acknowledgement of each other's presence; the artist does so for them. The subject of *The House with the Ocean View* is, thus, not the actions of the artist, but the way in which the artist's actions break down the armature of functional distance.

Abramović's challenge to the neurotic space of the urban environment is rooted in the radical experimental artistic climate of the 1960s and 1970s, in which Abramović was a key participant. The dissipation of the object into time-based actions, and a process-based use of ephemeral materials, took place through an engagement with the streets, derelict urban sites, alternative spaces, institutional and corporate spaces, doorways, storefronts, restaurants and lobbies, in an attempt to overturn their inbuilt codes of social alienation.

As Vidler observes, the modern urban environment which artists were seeking to irritate was, as Walter Benjamin argued, defined by increasing levels of physical and psychological transparency. Benjamin described the emergent modernist architectural language of interpenetration, in which the separation of interior and exterior, and between public and private space, became dissolved, as "the substitution of the void for the home."[7] The open structure of Abramović's tableau both underlines this substitution and undermines it. The tableau's frontal orientation is that of a proscenium stage, but the visible edges of the constructed scenery evoke the artificiality of a film set. Abramović's intimate domestic activities and the wooden furniture suggest the home; yet there is no privacy. Every action by the artist can, furthermore, be scrutinized through a telescope, positioned in the center of the gallery, evoking the voyeuristic spying on domestic interiors epitomized in films like *Rear Window*.

Like *Night Sea Crossing*, *The House with the Ocean View* presents a further paradox: a tableau involving live action adopts the language of the static object, housed within—and in this case literally attached to—the walls of the gallery, locating *The House with the Ocean View* somewhere between theater, home, art object, and cinematic tableau.

Within this paradoxical image, the symbolic space of 'home' occupies a central role. Abramović literalizes the dissolution of privacy in the transparency of modernist space, moving between one domestic 'room' and another, carrying out personal activities, from showering and urinating to undressing and sleeping, in full view of the visitors gathered in the gallery. The irrational, psychologically charged spaces of the private home are replaced by three rational, hygienic white rooms, whose spatial language is that of the gallery.

If the house is synonymous with the body, this 'rational' space could be read as a visual manifestation of Abramović's physical and psychic state during the performance. The gap between the extreme conditions informing her physical and mental state and the quotidian sensibility of the viewers is thus actualized, not only by the rigor of her performative actions, but by the stripped-down symbolic space of her body/house. Only the three ladders of gleaming knives, which she approached at various moments during the day, sometimes closely enough to trigger alarm amongst the viewers, suggest another, darker space, full of the danger and suffering expressed in past performances.

In art-historical terms, this darkness, implying inner turmoil, pain, and a loss of control, was most fully articulated in the Baroque. The title of a deeply personal performance Abramović made in 1997, *Balkan Baroque*, indicates her connection to the underlying psychological symbolism of the Baroque, which reached its apogee in Bernini's sculpture *The Ecstasy of St. Theresa* (1645-52), which John Rupert Martin describes as embodying "the mystic's sense of withdrawing from the world, the alternating states of pleasure and pain, the expansion of the self that comes through union with the divine…which transports them beyond the world of mortal suffering and enables them to bear their torments unflinchingly."[8]

In her early solo performances Abramović symbolically removed herself from the world, undergoing a transformation through the endurance of extreme physical pain (*Lips of Thomas*, 1975), drug-induced euphoria (*Rhythm 2*, 1974) and a trance-like repetitious dance performed naked (*Freeing the Body*, 1976). Abramović made all these performances at a critical moment in the history of her native Yugoslavia, just at the moment where the Communist regime under Tito was about to collapse. Benjamin Buchloh draws our attention to the source of "allegorical modes of internalized retrospection"[9] in political repression, citing George Steiner's observation of Walter Benjamin's analysis of Weimar German theater: "Eras of decline resemble each other not only in their vices but also in their strange climate of rhetorical and aesthetic vehemens…thus a study of the Baroque is no mere antiquarian hobby, it mirrors, it anticipates and helps grasp the dark presence."

The House with the Ocean View appeared at, and in response to, another turning point in modern history, one of its most traumatic. Abramović's extreme physical endurance induced a deep state of mutually experienced transformation. Twelve days of fasting, a practice historically adopted by all religious denominations as a method of achieving a heightened spiritual consciousness, palpably altered the artist's physical and mental state, and that of the viewers who entered what could be read as a Baroque 'field.'

Abramović's fusion of spiritual symbolism with an almost clinical stripping down of the body to its bare bones is rooted in that moment in the seventeenth century when allegorical mysticism collided with the emerging 'rational' disciplines of science, anatomy and medicine. The isolated fasting (evoking the piety of the hermit St. Jerome) and the knife ladders in *The House with the Ocean View* suggest an art-historical symbolism similar to that of the skeleton, which Abramović has often used in direct superimposition with her own body, evoking mortality, suffering, and the inescapable ravaging of the flesh by time.

The razor-sharp edges of each ladder also made clear the uncrossable physical boundary between artist and viewer; the dissolution of boundaries occurred invisibly. Abramović's actions, observable across time all day, every day, were all slow and deliberate. As in *Night Sea Crossing*, she wore different colored clothing each day, each corresponding to Indian Vedic color symbolism. At all times she wore the sturdy hiking boots she had worn during her three month walk across the Great Wall of China, as though to ground herself as she became physically weaker. Confined inside the three rooms inside the gallery, the boots transported her back to the long, arduous journey she had taken across an unknown territory fifteen years previously.

The longer visitors spent in the gallery with Abramović as the days passed, the more evident the transformation of the artist became. At once physically weak and emotionally opened, Abramović demonstrated an acute sensitivity to the shifting moods that took place in the room, punctuated by the arrival and departure of each person. She spoke later of being able to smell people's emotions, and see their auras. Most striking of all, she sensed a collective sense of trauma and grieving, as people struggling to process their feelings only a year after the catastrophic events of September 11th found an unexpected sense of release in witnessing the artist's own suffering and endurance in public.

Abramović's palpable awareness of people's moods was returned by the viewers' awareness of hers, often intensified by a concern for her well-being. Abramović's silent, passive presence in the gallery drew a range of reactions from visitors, just as all her performances, in particular her most provocative performance, *Rhythm 0*, had done. In *The House with the Ocean View*, Abramović shifted the responsibility she had handed to the public from physical intervention to contemplative exchange. As in *Rhythm 0*, the attitude of certain male viewers encountering Abramović was confrontational. Their stance, which tended to dissipate over time, partly through the permeation of its opposite by the group, suggested an anxiety towards both the vulnerability the piece invited, and the power demonstrated by a female's discipline of physical stamina over brute force.

Such individual reactions formed part of a larger, complex expression of group dynamics that evolved over the twelve days of Abramović's performance. During the 1970s, new psychological theories of social behavior influenced artists exploring the breaking down of the boundaries between artist and viewer. One of the most basic components of social interaction is spatial. *The House with the Ocean View* comprises three interlocking spatial structures: the horizontal linear arrangement of three 'domestic' rooms, which Abramović traversed back and forth; the frontal relationship between artist and viewers, experienced at a distance; and the organic relationship between viewers, sitting in close proximity to one another on the floor or standing against the walls, all contained within, and almost covering, the floor area of the gallery.

The separation of Abramović from the viewers, through both distance and height, underlined the triangulation of the viewers' relationship with the artist by their experiences with each other. Prominently evident at the same time each afternoon was the scholar Thomas McEvilley, an old friend and colleague of both Abramović and her ex-partner and collaborator Ulay, who sat for a long period on a fold-out stool in the center of the room, directly in front of the artist, in an empathetic meditative state.

McEvilley, experienced in Eastern meditation practices, became a feature of the performance each day, and provided an unanticipated constant for Abramović, who had no means of measuring time. His role as an 'insider,' deeply familiar with Abramović's performance history, echoed that of Rémy Zaugg in *Night Sea Crossing*. But in this case, McEvilley had appeared of his own accord, and sat not as an observer of a closed-circuit meditation between two artists, but as a participant in an open structure, within which each viewer had the same direct access to the artist.

This contribution to the performance was repeated in different ways by viewers throughout the twelve days. One older man came each day and drew a picture of Abramović and the architectural structure. Towards the end, when Abramović was at her faintest, he held up the completed drawing in front of her; she turned slowly to look at it and began to weep.

The accumulated collective experience of, and contribution to, the performance was witnessed in its entirety only by Abramović herself. As much as we had access to the artist, she had ongoing access to us. The conventional gathering of an audience in front of an artist follows a specific trajectory of performance, climax, conclusion, applause, and dispersion. Abramović's observation of, and exchange with, viewers over a prolonged period refused the conventions of theatrical performance, elongating time until the line between artist and viewer disappeared, its trace detectable only in the sharp blades of the knife ladders and the edge of the 'stage.'

This elongation of time, from a strictly punctuated linear structure to a serpentine, almost Mannerist extension of form, folded the viewer and the artist together into a psychologically and architecturally transparent space, within which an emotional and spiritual osmosis occurred. This osmosis took place through the symbolic transplanting of the home into a public space. Abramović's public performance of intimate, private activity suggests the intimacy of home, which symbolizes, in microcosm, the individual's whole world.

The anxiety and alienation engendered by the contemporary urban metropolitan environment is calmed by this re-formation of a protective space, akin to Aby Warburg's "denkraum." As Vidler observes, Warburg "critique[ed] … the way in which space-conquering techniques—flight, wireless, telephones—seemed to him to be eroding any possibility for a stable distance of reflection, the…denkraum." As Warburg stated on the eve of the Second World War, in notes for one of his final lectures on the effects of modernity on traditional culture: "So the Indian establishes the rational element in his cosmology by depicting the world like his own house, which he enters by means of a ladder…"[10]

Warburg goes on to say that "Telegram and telephone destroy the cosmos. Mythopœic and symbolic thought, in their struggle to spiritualize man's relation with his environment, have created space as a zone of contemplation or of reasoning, that space which the instantaneous connection of electricity destroys unless a disciplined humanity restores the inhibitions of conscience."

In *The House with the Ocean View*, Abramović creates the kind of zone of contemplation that Warburg felt it was so urgent to preserve, stating that she wanted to "create time in a place where people have no time." If the home, or house, represents the body and the cosmos, Abramović's zone of contemplation reunites the body with home, restoring to it its cosmological meaning. In *The House with the Ocean View*, Abramović connected with the viewer in a mutual exchange of trust, deeply received and given, by a group of New Yorkers whose belief in the stability of their surroundings, and of each other, had been profoundly and perhaps irrevocably shaken.

1. Forum, a gallery space in Middelburg, The Netherlands, was the site of the 80th performance of *Night Sea Crossing*.
2. Abramović first used the metronome in *Spaces*, an installation in the Museum of Contemporary Art Zagreb (1973), in which she set a metronome in seven rooms of the museum, each at a pace that she felt corresponded to the energy of he room, ending with silence.
3. Jane Blocker, *Where is Ana Mendieta? Identity, Performativity and Exile*, Duke University Press, 1999, pp. 9–10.
4. ibid., p. 9.
5. Anthony Vidler, *Warped Space: Art, Architecture and Anxiety on Modern Culture*, MIT Press, 2000, pp. 65–66.
6. ibid., p. 70.
7. ibid., pp. 77–78.
8. John Rupert Martin, *Baroque*, Westview Press, 1977, pp. 104–112.
9. Benjamin Buchloh, "Figures of Authority, Cyphers of Regression: Notes on the Return of Representation in European Painting," in *Art After Modernism: Rethinking Representation*, Brian Wallis, ed., The New Museum of Contemporary Art, New York and David R. Godine, New York, p. 109.
10. Vidler, pp. 49–50.

P e r f o r m i n g t h e P r e s e n t T e n s e

Thomas McEvilley

For nearly two weeks in November 2002, Marina Abramović lived on a kind of stage set at New York's Sean Kelly Gallery. The elegantly minimalist structure of drywall and wood, attached to the rear wall of the main space, was like three adjacent balconies of a hotel overlooking the seaside. (The piece was called *The House with the Ocean View*.) These balconies were partly open on the sides and separated from one another by about 18 inches, so Abramović could step from one to the next, through it was a slightly long step. The balcony on the viewer's left was a bathroom, with a shower, a toilet and a bucket used to flush the toilet—none of which was curtained off from the audience's gaze. The balcony in the middle was a living room, with a table, a chair and a water glass. To the right was a bedroom, including a wooden-box bed with no mattress, over which a water faucet and a basin hung from the wall. On the left-hand setback to this balcony architecture, on some shelves recessed into the wall, Abramović kept her simple solid-colored outfits, a blanket, a sleeping roll that could be spread out as a rather ascetic mattress, and a hairband, which, at least some of the time, was replaced there after a shower; these shelves were angled and could be seen from the right side of the audience space only. A telescope was installed in the gallery to facilitate the audience's intimate inspection of these activities and to underline the fact that Abramović was hiding nothing. In front of the balcony rooms were ladders leading down to the gallery floor where the viewers stood; but this apparent invitation for Abramović to descend into the ordinary world was negated by the fact that the rungs of the ladder were large knives with their blade edges upward. Occasionally Abramović sat on the edge of the platform with her feet resting lightly on one of the knife-edges, but she apparently never ventured father down.

Here Abramović stayed for 12 days and nights, during which she neither ate, nor spoke, nor performed cognitive transactions such as reading or writing. She remained on the set for 271 consecutive hours; of this time, she was on display to the public for 118 hours, for 20 of which I was there. The passage of time was ticked off, at about one beat a second, by a metronome that she occasionally moved from room to room, as if to keep it in the flow of the action.

This was the action: Abramović would walk, stand, sit and lie down; draw a glass of water from the faucet installed over her bed and drink it, standing in a particular place and angled in a particular way to the light; urinate and wipe herself with toilet paper; take the hairband from the shelf, walk into the bathroom, put on the hairband, remove her clothes, take a shower, get out of the shower, dry her body with a large white towel, put her clothes back on, remove the hairband, walk back to the bedroom and replace the hairband on the hidden shelf. If you stayed for two or three hours, you'd probably see all this. Other events that happened somewhat less often included rearranging the furniture in the living room; rewinding the metronome and setting it going; gazing at a particular audience member for a long time or sweeping the whole audience more briefly with her gaze; noticeably blinking; sometimes singing; occasionally smiling slightly; closing her eyes; covering her face with her hands and, every now and then, crying. That was it.

The piece could be situated in several genres of Conceptual and performance art; perhaps the most obvious linkage is to the thematic area that includes the gallery critique and the related art-life project. Both these persistent themes gained ascendancy in the generations of artists who matured after World War II, arising from a feeling not unlike Theodor Adorno's when he asserted that to write poetry after Auschwitz would be barbaric. It seemed that the aesthetic dimension of society had been discredited by the horrors of history, and that art had to somehow move closer to life—closer to the ethical dimension—in order to be useful in a world characterized by such traumas. Abramović, who was born in 1946 in Zagreb to a Serbian general and a Croatian museum director, is part of that lineage. She was 14 years old when the principle was laid down uncompromisingly by the French artist Yves Klein: "The artist only has to produce one work, himself, constantly."

Soon after that remark, as the foundations of performance art were established, artists did in fact begin to present themselves as art works, living in galleries or museums or spending ordinary time there in an attempt to narrow or close the breach between art

and life. This has been done in various ways by James Lee Byars, Linda Montano, Tehching Hsieh, Tom Marioni, Chris Burden, Gerhard Richter, Gilbert and George, Vito Acconci, Joseph Beuys, Lucas Samaras and others. It was usually understood, by those who did it and by those for whose observation it was done, as an ethical statement. This was the first generation of modern performance art. The artists wanted to make their point by putting themselves, or their wills, or their bodies, on the line rather than simulating or representing something. Body art, Ordeal art and Endurance art were parts of that moment. Abramović, who explored that area of performance deeply in her collaborations with Ulay in the '70s and '80s, is among the few keeping that conviction alive today.

The approach has been described as universal appropriation: the artist asserts that art contains all of life, not just some of it. The theme goes back to the lineage of Duchamp, who, in his dialogues with Pierre Cabanne, remarked that one could designate one's every breath as an artwork.[1] After World War II, the theme recurred with a hidden ethical agenda: that somehow absorbing life into art, or merging the two, might restore the sanity that modernism was seen at that time as having lost.

Behind Duchamp, the theme has earlier precedents that are ethically more ambiguous in intent, such as the generally European tradition of the Dandy. Benjamin Disraeli defined the Dandy as the prince of an imaginary kingdom. In the Romantic era, the role of the Dandy drifted into the realm of art, and that was when it acquired a special ethical dimension. The German poet Schiller, in the nineteenth century, said the artist innately lives, and deserves to live, by different rules from others, because he is a kind of perfected human being.[2] This princely claim applies to some of the artists who have worked on the art-life project, especially Klein and Byars.

Before the Romantic era, the tradition of infusing life with the rules of art opens into even broader panoramas of cultural history that begin to verge on the domain of shamanism. Examples are found around the world, but less in the tradition of art than in those of religion and philosophy. In the Shinto tradition of Japan, for example, it is said that there is a certain priest who rises from strict seclusion once a year to walk about 60 yards before his fellows because he has the Perfect Walk; this is how they can learn.[3] Several of the pre-Socratic philosophers in ancient Greece are recorded as having had elaborate costumes and mannerisms that amounted to designating their personal presence and manner as art works. Diogenes was a kind of "performance philosopher," executing outrageous and shocking gestures in public in order to make philosophical points.[4] He also lived in pubic, in the streets, under constant inspection by his fellows—as Abramović was in *The House with the Ocean View*. In the pre-Socratic period, Anaximander, Pythagoras, Empedocles and others adopted outlandish personas. Even father back, behind such gestures, lie the animal imitations and shamanic performances of Neolithic and Paleolithic cultures.

It would seem that this is a difficult tradition to insert oneself into. There is, after all, a lot of tension and self-doubt involved in presenting oneself as a model or ideal. But Abramović, rather than doing that, seemed to be collaborating with her audience in an attempt at seeing and confronting the shared problems of consciousness and time.

But there was something else going on in *The House with the Ocean View*, too. In a sense, what was actually on display was a quality of mind or a state of concentration associated with certain types of meditation retreats. Abramović has undertaken retreats from time to time and has repeatedly incorporated such experiences into her performance work. *The House with the Ocean View* could be described as a meditation retreat made public. Specifically, it seems to have been based on what in the Pali tradition of Theravadin Buddhism is called a *vipassana* retreat. These retreats (which are given here and there around the world) usually last 10 to 12 days (Abramović chose 12), with no talking, reading or writing, and very limited eating; one can fast, as Abramović chose to do, or eat one meal at about noon every day.

In the Southern Buddhist *Mahasatiptthana Sutta*, where this oldest known form of meditation is described, the Buddha says that the primary point is to remain carefully aware of four postures: walking, standing, sitting and lying down. Abramović's posted rules for her publicly performed retreat adhered to this formula. Within this framework, the central *vipassana* practice involves trying to keep your mind constantly focused on the present moment. The moment is defined primarily by sense impressions, conceptual overlays on them being regarded as coming after and thus not a part of the immediacy of experience. So *vipassana* involves a constant moment-to-moment attention to one's sensory experience, no matter how trivial or ordinary it might be—like an itch or passing-car sound or, especially, the natural sensations of one's uncontrolled breathing, which is the most continuous and accessible and hence easiest act to keep centered on. The practice, according to ancient texts, is like carrying a bowl of water, full to the brim, and trying not to spill a drop.

In addition to the *vipassana* practice, other factors may have been involved in Abramović's public retreat. In *pranayama*, for example, a Hindu yogic practice, the subject controls the breath in ways that might be counted by a metronome. Abramović had the metronome turned on most of the time. Occasionally after it wound down (which took about two hours) she would leave it off for a while. It was usually a relief when it came back on; it was hard to imagine enduring the long empty times without the resonant tick-tocking, which echoed slightly off the hollow balcony structures. Rather than the simple attention of *vipassana*, *pranayama* involves counting and controlling; the breathing is a useful device for restoring one's concentration when the water has begun to

spill from the bowl. In *trataka*, another Hindu practice, one gazes resolutely at a point and, as the concentration gathers at that point, the surround fades, and a visible aura pops out of the subject. This was the feeling conveyed when, frequently, Abramović would engage a specific viewer (always someone who seemed to be asking for it) in a prolonged stare-down.

The one activity that Abramović introduced from outside the tradition of these retreats was gazing at the viewers. In *vipassana* retreat, one is not supposed to have eye contact with anyone. She introduced this subversive element in order to break the performance out of the ashram and make it a social sculpture.

Abramović is from the '70s generation of artists who thought they didn't want to sell anything. They had a contempt for the market which many of them, now saddled with mortgages and dependents, have come to regret. But Abramović has pretty much stuck with the immaterialist values of that idealistic age. Some years ago she said to me that she wanted to do a kind of performance that didn't involve any mediation;[5] there would be no objects, such as artworks or props, nor anything else, such as words or ideologies or a scenario, to get between her and her "viewers." Instead, the viewers would be invited to enter into an "energy relationship" with her, which would have no external visual component. I asked her how this might transpire. What would you do, without sets or scenarios, when you walked into the performance space and there was the audience? She referred to a dinner with a prominent guru in India where everyone roundabout felt a strong auratic or vibrational or tangibly ethical presence. She wanted to seduce an audience in this way.

At that moment it seemed to me an old-fashioned and unlikely Blavatsky-ite dream. Yet here, I think I saw Abramović significantly accomplish her goal, although it is true she used a few props. It did, in fact, seem that a relationship had developed about halfway through; the audience was, like the performer, respectful and dignified. Not, it seemed, naively cultish, the onlookers nevertheless honored the earnest and considered efforts of the artist. Abramović was meticulous, and her audience was meticulously appreciative. Only on the eighth day of the event, a Friday when the gallery stayed open until midnight, did things get a little ugly during the last half hour or so, as seemingly drunk people entered the room and neglected to take the event seriously.

Something about Abramović's performance reminded me of Alice Neel's paintings of herself naked. Neel famously attained a degree of objectivity that forestalled the preconceptions of the male gaze. Similarly, at the gallery we watched this stately woman dress and undress, shower and pee. Her simple human—or animal—decency deterred any lascivious reactions. One watched with sympathy as she strove to maintain her bodily rightness.[6]

Kant said that ethics and aesthetics were separate. Each has its own imperatives, and neither could comment meaningfully on the other. As the Romantic era wore on, this became one of the dogmas of the Enlightenment that was deeply compromised. At the culmination of the Romantic period, the view was that ethics and aesthetics were the same thing; this attitude survived into the time of, say, Wittgenstein. Belief in the artist as a higher being (as in the works of Schiller referred to above) grew to the point where it was possible to believe that the artist was somehow essentially good. The long connection of art with religion helped to support this belief. "Beauty is truth, truth beauty," said Keats—meaning that Kant's distinction between cognition and aesthetics was rejected. The aesthetic grew to a dominant position and more or less absorbed the ethical.

That view is not in the forefront of art discourse anymore, but many cling silently to it. Abramović is one of those for whom the practice of art would not hold any attraction if it didn't seem to have a moral dimension. The same could be said of many artists whose works have been socially directed, from Joseph Beuys to Hans Haacke, although she differs in her interiorized expression of it.

When Abramović descended from her stage set on the last day, by means of an aluminum ladder without knife blades, the room was full; perhaps 150 people were there. She spoke briefly and with a becoming modesty, dedicating the piece to "the people of New York City," and then went into a back room to have some carrot juice.

1. Pierre Cabanne, *Dialogues with Marcel Duchamp*, English translation by Ron Padgett, New York, Da Capo Press, 1979, p. 72.

2. See, for example, Wilhelm Windelband, *A History of Philosophy*, vol. 2, New York, Harper and Brothers, 1958, pp. 600-02.

3. James Lee Byars told me this story; I have no other source for it. He spent several years in Japan engrossed in Shinto rituals.

4. See Thomas McEvilley, "Diogenes of Sinope, Selected Performances Pieces," *Artforum*, March 1983, pp. 58-59, and *Diogenes, Defictions*, Berkeley, Peter Koch, 1994.

5. See Thomas McEvilley, "Stadien der Energie: Performance-kunst am Nullpunkt?" in *Marina Abramović, Artist Body*, Milan, Charta, 1998, pp. 14-27.

6. Abramović had set up a kind of support system in another room of the gallery, where, in a bed that looked like a coffin, various individuals lay completely still for an hour, at a time each of them had scheduled beforehand. The coffin-like design may have signified a loss or temporary abandonment of self in an energy transfer. It may have been arranged as a kind of spiritual insurance policy for Abramović, but as it turned out she didn't need it, and it remained peripheral to what was going on in the main gallery space.

On Seeing the Invisible: Marina Abramović's *The House with the Ocean View*

Peggy Phelan

Marina Abramović came of age as a performance artist in the 1970s.[1] During this decade, performance art undertook a radical examination of the mind/body problem, attempting to link ancient, inherited knowledge of the body with a newly expanded interest in alternative modes of consciousness as a medium for art. The exploration of alternative modes of consciousness was reflected in drug culture and in the establishment of what has come to be called "new age philosophy." Performance art, drug culture, and new age investigations were motivated to explore alternative modes of consciousness by a recognition that much of Western thought and culture was insufficiently sensitive to the psychic and political force of embodiment. Descartes' famous proclamation, "I think therefore I am," central to post-Enlightenment thought, ignored modes of being not dependent upon rationality. Body artists of the '70s, especially feminist artists, saw in performance an opportunity to explore questions that had been systematically repressed and ignored in Western thought. With a combination of courage and recklessness, performance artists of the '70s focused particularly on what happens to the body and mind when thinking is a secondary response, if not an impossible response, to the enacted event. Much of this work explored acute physical pain, and some touched on the elusive horizon separating life from death.

The Australian artist Stelarc pursued a series of spectacular suspension pieces throughout the decade. He inserted large fishhooks into his skin and hung from walls and ceilings to demonstrate the porous nature of the body, open to the world, and the controlling energy of consciousness, mediating the pain of the penetrating hooks. Suspending his body in the center of a gallery, Stelarc vividly exposed the surface of the body as a horizon for drama and for artistic and philosophical meditation and change. Vibrating with the sense of a future body, one infused with the mechanical, the electronic, and the prosthetic, Stelarc's work pointed to a new conception of the human body, one in which the traditional philosophical category of existence would be replaced by the concept of the operational. This transformation would necessitate a revision of the place of human death in Western thought, for if the human body were to be defined as that which operates, then fixing parts and repairing mechanical failures would do away with the inevitability of permanent death. Chris Burden, working in Southern California, did a provocative piece entitled *Shoot* in 1971. Standing against the white wall of a Santa Monica art gallery, Burden was shot in the arm by his friend, a marksman who stood about 20 feet in front of Burden, raised his rifle and shot the artist in the upper arm. Burden had invited a small group of friends to watch the performance and he also had it filmed. The footage shows Burden calmly waiting for the shot, and then, stunned by the force of the bullet, springing off the wall. The speed of Burden's transformation from calm and relaxed young man to frantic, hopping body is part of what remains haunting about the piece today, thirty years on. While Stelarc was urging his spectators to dream of a cyborgic body capable of outlasting death, Burden was reminding us that life gains meaning and substance, indeed energy itself, from physical and mental encounters with death.

At issue for body artists of the '70s was an investigation of the body as medium for art and for life: What are its political possibilities and limits? How does the certainty of death challenge and/or sustain the all-too-fragile purposes of life? How can the relationship between the artist and her own body serve as a mirror for the larger drama of the relationship between the individual and the social body more broadly? The best body art of the '70s employed endurance and physical pain as primary tools for the exploration of a new practice predicated on exploring bodily limits. Body artists claimed their own bodies as a medium and a metaphor for the relationship between self and other, performer and spectator, art and life, and life and death.

Also fueling this work was a persistent question about what kind of art performance actually was. Working in the United States, artists such as Linda Montano, Allan Kaprow and Tehching Hsieh explored the structure, and sometimes the content, of ritual as a way to create their work. Often summarized as work about "art in everyday life," sometimes shortened to "art/life performances," this work also represents a systematic investigation of ritual practice.[2]

The traditional understanding of the origin of theater is that it emerged from ritual practices. Ritual practices are understood to be per-

formances designed to respond, indeed to manage, transformations in the life cycle. Thus, anthropologists have cataloged the ways in which various societies created ritual processes—often walkabouts or other kinds of acts that require physical endurance—to frame the rite of passage that transforms, for example, a boy into a man. This transformation in social and biological identity requires that the initiate be suspended in an in-between or liminal state during the ritual practice itself. That is, for the period of time in which the rite of passage is being performed, the initiate is neither fully a boy nor fully a man—rather, he is in the liminal stage between these two modes of being.[3] Anthropologists speculate that most ritual practice was prompted by life transformations, and more particularly, from life's encounter with death. But I have sometimes wondered if perhaps the anthropologists have gotten it the wrong way around. While it is perfectly logical to assume that life began before ritual, theater, and performance—and therefore that these practices respond to life—perhaps it is useful to entertain the possibility that life was "invented" in order to respond to art, theater, ritual, and performance. I mean this in the spirit of Michel Foucault's contention that sexuality was invented in the nineteenth century.[4] Within this understanding of "invention," while sexual activity occurred prior to the nineteenth century, consciousness of the importance of the relationship between these acts and one's identity did not emerge until that time. Similarly, "life" only becomes meaningful as a conceptual and biological category after a significant non-life force throws it into relief—this non-life force is often summarily understood to be (biological) death. But death is not quite so easy to understand and grasp; indeed, its meaning extends well beyond the historical and technological meaning of biological cessation.[5] Therefore, perhaps it makes sense to say that insofar as early ritual, theater, and performance were devoted to managing the meaning of death, that management itself involved the invention of another conceptual, biological and experiential field that came to be called life. This kind of speculation helps clarify why live art emerges as a specific art form most energetically in the years after World War II. The technologies of the concentration camps and the atom bomb rendered death a mechanical and impersonal event. Artists attempted to respond to these catastrophes by developing an art form predicated on the value of the singular, intensely personal, *life*. From Body Art to the solo monologue, performance artists made vivid the drama of the artist's own life in relation to the life of the other, be that the life of the distant witness or the life of the intimate partner.

It is against this background that we can start to assess the work of Marina Abramović. Beginning in the '70s working in Belgrade, Abramović has spent the last thirty plus years traveling the world, studying ancient and contemporary thought, and developing an unsurpassed body of performance work. The trajectory of her work mirrors and extends the achievements of performance art as a whole. But while Abramović has been absolutely central to the development of this form, she has also stood somewhat to the side of its main contentions. While much performance art, especially solo art, has worked to consolidate the value of individual subjectivity and life, Abramović has insisted that the force of life (and therefore of live art) extends beyond the individual, and indeed beyond consciousness as such. Insisting that life requires and seeks periods of unconsciousness, Abramović has composed performances in which she sleeps and in which she passes out. She has also invited her spectators to use her performances as a way to become attached to their own dream cycles, inviting audiences to contract to sleep and dream for an agreed upon time in the space of Abramović's installations. While a shorthand way of expressing this aspect of the artist's work might be to say something along these lines—"Abramović's art insists that the only subjectivity worth celebrating is an intersubjective and profoundly social and collective one"—such a statement would not do justice to the more disturbing aspects of her art. In her early solo work, Abramović routinely placed her body in situations of extreme danger. To list just a few elements of those early pieces: in the 1974 performance *Rhythm 5*, she constructed a five-pointed star from wood shavings soaked in gasoline. She lit the star and then walked around it, cutting her hair and nails and throwing them into each end of the star. She then lay down inside the star. When the flames consumed all of the oxygen in the inner area of the star, she lost consciousness. In *Rhythm 2* (1974), she took drugs designed for treatment of catatonia and schizophrenia, passing out from the latter. In *Lips of Thomas* (1975) she cut a star into her belly with a razor blade and, while she bled, whipped herself.[6] While some of this work may seem, in retrospect, more sensational than illuminating, performing these extreme acts gave Abramović a measure of all that art might contain, and gave her audience a view of her seemingly limitless passion to achieve what she set out to do. In *Rhythm 5*, for example, spectators who realized that her clothes were on fire and that she was not moving, pulled her out of the burning star. Rather than being chastened by the need for rescue, however, Abramović dedicated herself to designing performances in which her own individual consciousness was not necessary for the completion of the event itself. She said, "After this performance, I ask[ed] myself how to use my body in and out of consciousness without interrupting the performance."[7] This disturbing ambition was not laid to rest until an interruption did occur that was itself more dramatic than her original conception of the performance: *Rhythm 0*.

Performed in Naples in 1974, *Rhythm 0* remains one of the most compelling performances of that fecund decade. Assembling 72 items on a table in a gallery with a window open to the street, and agreeing "to take the full responsibility" for the event, Abramović invited the audience to use the objects on the table in any way they desired. These items included a feather, a gun, a razor blade, a bullet, a perfume bottle, lipstick, a Polaroid camera, a rose.[8] RoseLee Goldberg vividly describes the scene: "As she stood passively beside the table, viewers turned her around, moved her limbs, stuck a thorny rose stem in her hand. By the third hour they had cut all her clothes from her body with razor blades and nicked bits of flesh from her neck. Later, someone put a loaded gun in her hand and pushed its nozzle against her head."[9] In this phase of the performance, the audience divided into two distinct groups, characterized by Paul

Schimmel as "protectors" and "instigators."[10] Abramović had contracted to do the piece from 8p.m. to 2 a.m., but the protective members of the audience, seeing the violent trajectory of the crowd, insisted that the performance be stopped. In the extensive photographic documentation of the piece, Abramović's eyes are filled with tears and her face conveys a resigned melancholy, to which part of her audience seems indifferent. Disconcerting and sad, these photographs remind us how easy it is to lose sight of those with whom we are close. The photographer sees Abramović clearly but those touching her seem blind. While this performance has often been discussed in feminist terms—that is, Abramović's performance reveals, once more, the woman as passive object of desire and the largely male audience as the active and violent agents of power—I think this reading overlooks something more singular in the event. While failing to continue the performance until the designated time, Abramović responded to the ethics of communal care expressed by one part of her audience, an ethics that summoned the will and wisdom to break the contractual code of performance and intervene. Her protectors' response to the unfolding event, and Abramović's response to their response, helped clarify the central promise of performance art. While countless performances, both prior to and after *Rhythm O*, have called for "audience participation," these have tended to script the role and options for the audience in advance. *Rhythm O* demonstrated that what makes live performance a significant art form is that it opens the possibility for mutual transformation on the part of the audience and the performer/s. What distinguishes performance art from other arts, both mediated and live, is precisely the promise of this possibility of mutual transformation during the enactment of the event. By yielding to part of her audience's care for her safety and surrendering her prepared performance structure, Abramović transformed her relationship to the event. She was as moved by the performance as was any of her audience. Or, to put it differently, Abramović had the capacity to allow her spectators to transform her intended performance to such a degree that they became co-creators of the event itself. Abramović's decision to allow the piece to be stopped reminds me once more of the enigmatic nature of the social act, a nature that rarely can be completely anticipated in advance. *Rhythm O* placed performance art squarely in the ongoing post-war conversation about the ethics of the act: what does it mean to act when full knowledge of the consequence of your act cannot be known in advance? What are the costs of refusing to act without such foreknowledge? What keeps us blind to the consequences of our actions and our passivity?

Abramović is the rare artist willing to be surprised by her own nature, as well as by ours. What surprises most of us is the finality of death. Faced with an angry and increasingly violent crowd, Abramović ceased her performance and later declared that *Rhythm O* marked "the conclusion of her research on the body."[11] The possibility that the performance might result in her death exposed, once more, how thin the line between life and death truly is.

Abramović, who has been deeply influenced by Tibetan Buddhism and shamanic wisdom from disparate traditions, learned during the early '70s that the border crossing traversed within performances that work on the art/life divide might be seen as a kind of rehearsal for that other crossing, the one between life and death. In this sense, performances that occur on the art/life divide can serve as a kind of laboratory dedicated to exploring art's deepest mysteries, mysteries at the core of the encounter between self and other, love and bodies, life and death.

In 1976, Abramović began her twelve-year collaborative relationship with the German-born Uwe Laysiepen, known as Ulay. They began working and living together while rejecting the certainties of spatial locations—they had no fixed address—and energetically examining the nature of the heterosexual couple. Crucial to all of these performances was an investigation of a deep love and trust, and the concrete limits of the mortal body. In one of their more haunting pieces, *Rest Energy* (1980), they stood facing each other with a taut bow and arrow between them, the arrow aimed directly at Abramović's heart. Small microphones resting on their chests amplified the rapidly rising rates of their heartbeats as the piece went on. The performance, which lasted four minutes and 10 seconds, made vivid the line between life and death and the fragility of that line as it quivered there between Ulay and Abramović for those intense 250 seconds.

> *Dear Marina,*
>
> *You and Ulay spent a year living with the Aborigines of Australia. You walked with them in the bush, sat with them in the desert sun, tasted the dead air, dreamt of water. You made yourself parched. After China and the Great Wall Walk, you felt a different thirst, one for beauty, glamour, and lipstick. On the cover of* Artist Body *you are on a beach, holding a beach ball, looking seductive. But my eye is drawn to the sea beyond you. The place where humans tie themselves to the sea's beautiful promise is called The Marina.*
>
> *In New York, you called your piece* The House with the Ocean View. *We met there on the island and we each watched the other. As I looked, my eyes burned, laughed, cried. I became untied. You asked us to enter the performance, to engage in an "energy dialogue" with you. You asked me, a writer and a teacher, to give up talking, to meet you in silence, to become wordless. You yourself were singing. I want to give you something of the melody of our encounter for it still hums in my mouth.*
> *Love,*
> *Peggy*

One of the achievements of body art in the '70s was that its embodiments and navigations made it impossible, even now, to discuss live performance without also talking about death. The entwined relationship between live performance and death has been at the core of the most radical art practice of the post-war period. In her more recent work, Abramović has also employed performance art as a way

to respond to some of the bloodiest events in recent geopolitics. Indeed, her 1995 performance, *Cleaning the Mirror*, in which she sits placidly on a stool while washing a filthy skeleton for three hours, stands behind her haunting piece, *Balkan Baroque*, for which she won the Golden Lion at the Venice Biennale in 1997. *Balkan Baroque* constitutes her response to the massive deaths in the former Yugoslavia. In Venice, she installed two large copper sinks and one copper bath filled with water in the main gallery space, and had slides projected of her mother, her father, and herself on the walls. These slides were accompanied by a soundtrack describing ways to kill rats in the Balkans.[12] For four days, six hours a day, Abramović washed 1,500 beef bones, while singing folksongs from her native land. She wore a white dress and sat on top of the immense heap of bones. As she washed, the blood from the bones stained her dress. In both *Cleaning the Mirror* and *Balkan Baroque*, Abramović reminds us that contemporary war always involves an encounter with the treachery of the document, of the trace we call numbers, and a repression of the trance we call love. In contemporary war, those who decide when intervention is necessary often look at death counts before acting. These numerical documents, the calculus of how many die before, during, and after the fighting, comprise the record that will be cited and recited in historical and official accounts of war, intervention, and recuperation. What is lost in such calculations is the weight, the very blood and bone, of each dead person's hope, struggle, and life. Abramović's methodical scrubbing of each of the 1,500 bones touches something of the weight of that loss. While she cannot and we cannot retrieve those who are dead, *Balkan Baroque* gives the public a place to acknowledge that loss and to take measure of the grief often forgotten as the world shifts attention from one war to the next. Given the situation in Iraq today, it is impossible not to notice the repetitious return of the story of numbers and the history of destruction and buried grief central to these catastrophic events. But perhaps Abramović's most stunning use of performance art as a response to the politics of death and war is *The House with the Ocean View*. Characteristically, her performance responds to war and terrorism via a demonstration of love and trust. At once a performance of extraordinary vulnerability and astonishing strength, *The House with the Ocean View* asks us to revise our own relation to the tasks of everyday life. In my own case, that means the task of writing about performance.

> Dear Marina,
> I don't really know you, but I feel as if I do. I have seen your traces: videos, photographs, catalogs. I have seen you perform live. I met you once in a crowd. You were wearing perfume and your lipstick was smudged from kissing people. You shook my hand but there was no connection.... We both moved on. I saw you once alone in Paris, but I did not say anything to you. I have lectured about your work, read wonderful books and essays about your art, and some friends even gave me an Illy espresso cup and saucer with your photo from the cover of Artist Body on it. From these bits and pieces, I have assembled some kind of history with you, but I am aware you don't have one with me—at least not one you are aware of.
> I know you well enough to know you don't like to discuss the politics of your work. But these days, well.... Look, I don't want to fight with you. Please trust me just a little bit. It is tempting to say it won't hurt, but it might. Besides, we both respect pain enough to avoid making predictions about anything in its realm.
> Love,
> Peggy

Performance art can be said to derive from three different historical traditions.[13] The three narratives describing that history are:
1) Performance emerges from the history of theater and begins as a counterpoint to realism.
2) Performance emerges from the history of painting and gains its force and focus after Jackson Pollock's "action painting."
3) Performance represents a return to investigations of the body most fully explored by shamans, yogis, and practitioners of alternative healing arts.

All three of these modes of understanding the history of performance art are helpful to some degree. But since they each understand performance as a kind of add-on to their primary interest (theater, painting, or anthropology/healing/spiritual practice) they also tend to give short shrift to the larger intellectual and aesthetic achievements (and failures) of performance in an expanded field. The most significant aspects of performance art's specific contribution to the history of art and the history of thought in the twentieth century extend well beyond the fields of theater, painting, and anthropology. Commenting on these three narratives of the history of performance art, Thomas McEvilley argues that Abramović's work "is dedicated to preserving the traditional shamanic/yogic combination of ordeal, inspiration, therapy and trance." Moreover, he astutely claims, "that this approach to performance art is both the most radically advanced—in its complete rejection of modernism and Eurocentrism—and most primitive—in its continuance of the otherwise discredited association of art with religion."[14] Geopolitical events since 9/11 have combined to make the connection between radical postmodernism and fundamental religiosity ever more urgent. In his prescient 1999 essay, Paul Virilio warned: "The new technologies convey a certain kind of accident, one that is no longer local and precisely situated, like the sinking of the *Titanic* or the derailment of a train, but *general*, an act that immediately affects the entire world."[15] This immediacy is precisely what happened on 9/11, when the local crash of the planes into the World Trade Center, the Pentagon, and a field in Pennsylvania, set off a general set of consequences that resonated around the entire world.

Among the many consequences of this event is the need to revise our understanding of the ethical act, and of live performance's role in such an ethics. The exploration of this ethics has been at the heart of Abramović's practice for more than 30 years. As she

puts it: "We are always in the space in-between, like airports, or hotel rooms, waiting rooms or lobbies, gyms, swimming pools… all the spaces where you are not actually at home. You haven't arrived yet. You have left home but you still haven't arrived to a new home. So you are in-between. This is where our mind is the most open. We are alert, we are sensitive, and destiny can happen. We do not have any barriers and we are vulnerable. Vulnerability is important. It means we are completely alive and that is an extremely important space. This is for me the space from which my work generates."[16]

Dear Marina,

I have just quoted you. Your words, your funny English, have just come through my fingers, out of my mouth. It feels intimate to quote you. I notice our differences. You say, "this is where our mind is most open." I would have said, "this is where our minds are most open." The plural, though, despite its generosity, curiously isolates us as well. I am trying to approach something closer to your sense of connection. "Our mind is" conjures up an image of a shared mind, and if this is what we are after then I should probably confess that when I typed your words, I kept mistyping the word "destiny." You said, "We are alert, we are sensitive, and destiny can happen" but I kept typing "density can happen." The word destiny is too dense for me. I prefer Irish mystics to Greek oracles. Why am I confessing this? Perhaps as a way of repeating the lessons from Breathing In/ Breathing Out, *in which you and Ulay blocked your nostrils and kissed until the carbon dioxide passing between your bodies made you faint. Liminality is the space between breaths, the tiny pause when one is neither breathing in nor breathing out, neither kissing nor killing, neither writing nor reading, neither speaking nor listening, neither Peggy nor Marina. In the space of the mistake, before consciousness of the mistake emerges, something lives, vibrates, shakes. Perhaps it is in the mistake, the place of vulnerability, that we are completely alive.*

More mundanely, my mistaken typing is no doubt a resistance to your confidence about connection and sharing. We do not have the same mind. I want both intimacy and separation. I want to acknowledge certain points of contact and certain points of non-connection between us. I would like to develop a way to write and respond to your work, and to you, with a sincere honesty that is neither judging nor indifferent. Such honesty might bring us closer to a sustained liminality in critical thought and in the ethics of the approach to the other. Contemporary critical writing is severely resistant to the undecided and the shaded. Increasingly, criticism is reduced to the thumbs up or thumbs down gesture. But I need to find a richer means of response if I am to remain a writer of nonfiction, a task I am less and less sure makes much sense. You might think this is my problem, but I am afraid it is yours too. Harold Rosenberg, writing in 1952, pointed out that in order to form a new school, one needs both a new consciousness and a new consciousness of that consciousness. You have dedicated yourself to performing a new consciousness, but we still need a way to write about it. I know you have gifted, brilliant commentators in several languages already. Nonetheless, maybe I can help articulate something that remains muted in the writing about your work thus far. Something to do with the heart of a woman and the thought that takes and makes no home. Am I being essentialist? Is there such a thing as "the heart of a woman?" Probably not. But sometimes your emotional courage, the game of chicken you play with yourself, with us, seems to me to be possible only because you love, and are loved, as a woman.

Love,

Pcggy

The liminal state Abramović has dedicated herself to exploring via performance is familiar to anyone who is, or who has spent any time with, a saint, mystic, or sleight-of-hand artist. For the rest of us, such suspension tends to be more emotional, ethical, intellectual. The inability to discern what position one should take, how one "ought" to feel, and what one "should" do, often leads to a paralyzing sense of indecision. As the saying gets said, often with a kind of subdued rage, "don't just leave things hanging." But we are often hung up, and that is because we can't seem to see what it is we are between: land and sky, sea and stone, life and death. Abramović's performances invite us to join her in a liminal space, rather than demanding we choose one side or the other. For Abramović, the architecture of liminality is fundamentally temporary, suspended, provisional.

Dear Marina,

You had an idea that claimed all my attention. Indeed, it was the vastness of your idea that made me begin to want to know your story, to know your heart, to know your art. The intimacy I felt with you was rooted in my understanding of your idea of intimacy. I don't remember how I first encountered your idea. Before that, I felt you were somehow beyond my capacity to understand. I did not know your language, and the history of Yugoslavia was too dense to become my critical or creative destiny. I had been very drawn to your piece Lips of Thomas, *especially when you took a razor blade and inscribed an upside down Communist star on your belly. I thought of it as a way of putting a map of the sky on your belly, so that later you could trace a scarred star anytime you needed a map. And I liked it because I thought of it in relation to Doubting Thomas, my favorite apostle. He was my favorite because at first he insisted that the skin was truthful and the tale was not, but then he got caught and was taught to see the truth in the skin and the truth in the dream of love. I liked the idea that you had transformed his doubt into lips. Lips that kiss and lips that eat. Lips that cut and lips that join.*

I was not in love with the idea of the crowds you drew, suspected they were there for the wrong reasons—after all, our varied

cultural histories display a consistent attraction to the idea of watching women bleed or whip themselves. I wondered a little bit about your psyche, too, wondered if you were a bit like some of my students, reckless with your own capacity to create. So I was interested in what you were doing, but content to hear things as they came to me, and not inspired to seek you out. But then when I heard, or read, or however it was that I grasped the idea of the Great Wall Walk I was immediately riveted and then—well, I guess we can say I have been riveted ever since. The Walk was what drew me to you. Initially the title of the performance was The Lovers. It was going to be a wedding; you and Ulay were going to meet in the middle and get married. Ha. Isn't it odd how the heart works? All that planning and then the unraveling of the impetus for the plan. I know the surprise deep in the heart that betrays our deepest breath. No wonder when we kiss we give each other carbon monoxide. But you and Ulay kept your vow to the performance, if not to each other, and from March to June of 1988 you marched up and down the wall. Photographs show you clinging at times to the precipice, adding stones to your pockets for ballast against the sweeping winds, reversing Virginia Woolf's suicide, which she secured by adding stones to her pockets to keep her underwater. Marina, you wanted to be tied to the land, but you climbed toward the sky, already inscribed by your own star. You were alone from Ulay, but translators, drivers, photographers, aids of various sorts surrounded you. In the end, you and Ulay met in the middle, each having walked 1,200 miles, to embrace goodbye. The death of a twelve-year relationship and the birth of something, someone, else. For three years after that, you did not perform publicly with your body.

You went to Brazil to dream in the mines. Crystals. Gems. The stones beneath the sea. And then from the caves of Mina Girais, back to the air. You built An Impossible Chair, and sent it teetering against the suspense of an immense sky. You crafted crystal Shoes for Departure, enormous shoes too heavy to move. It was your time of study and repair, nesting and gestation. Then came Biography, in which you told us your art/life story with slides and music. The photos of your performances with Ulay were projected on split screens, his story and your story, in a history told and sung by you. There were snakes and dogs. Then there was Cleaning the House, and Balkan Baroque. But having said all this I have not yet arrived in the House, the one you called The House with the Ocean View.

Between Balkan Baroque and The House with the Ocean View, as the journalists like to say, everything changed. Journalists like to puff things up and bloat their own utterances—but even so, something had shifted. It called you back; it helped me leave. But first: our encounter there, where the journalists said everything had shifted. New York, the island of Manhattan. It took you a year and two months to respond to that awful day, a day when there was no time, a day that was at once deeply personal and somehow not at all about us or for us. I came to see you. I wonder if you remember.... Dear Marina, what do you remember?

Love,

Peggy

From November 15–26, 2002, Marina Abramović performed *The House with the Ocean View* at the Sean Kelly Gallery in New York. During that twelve-day period, she did not eat, read, write, or speak. She did allow herself to hum and sing. She drank as much water as she wanted; she urinated as needed. She took at least three showers a day. Each day she wore a suit of different colors; magnets were sewn inside the suits. She slept in the gallery every night. During the 12 days, the public was invited to the gallery to participate in what was called "an energy dialogue" with the artist. In two other rooms, a video of Abramović's face at the lip of an ocean played on an extended loop. One could hear the lapping of the water on the tape in the room in which Abramović performed. In another room, the public was invited to contract to sleep in the dream room for one hour. The hours were quickly contracted.

In the main space of the gallery, three small stages were built. On the first stage there was a toilet and a shower, on the second, a wooden table and chair with an enormous crystal built into its back, and on the third stage, there was a simple bed and Abramović's clothes and mattress. These three stages were about six feet off the ground, and they were buttressed in the center by three ladders with butcher knives serving as rungs. The side of each stage had an opening, allowing the artist to walk horizontally between the three rooms. In addition to the glass and water pitcher, there was also a metronome tapping out the passage of time, and sometimes pacing Abramović's breathing. In the back of the gallery, a telescope was set up and focused to a magnification that made it possible to discern each hair of her eyebrows.

Dear Marina,

It was you and I knew it was going to be you, but I did not know which you you would make me become. Yes—make me. I did not want to change. I rarely want to change. You stood there, daring me, inviting me, commanding me. You. You. A double you. "W" is for women, for witness, for wind, for weight, for waiting.

You. Me. The crowded room. The energy in that space. The weight of you changing right there in front of my eyes. Herb Blau wrote that in theater, as in life, someone is always dying in front of your eyes. My eyes are fading. You kept me waiting. There I was, feeling the mounting energy, seeing that energy, molecule cells dancing in a petri dish dyed and cast so that I could see them grow like stars in the night sky, like the light I feel—even now I feel—fading.

Should we have faded then and there and left it at that? You are very dramatic, and I will do in a pinch. You don't go in for

subtlety or the slipping away of things. You like grand gestures. Heroic scenes. You walked for three months along lengths of the Great Wall of China and you told everyone that you did it in order to say goodbye to your lover. I did not believe you. There were too many cameras, too many negotiations with too many governments, too much money, too many steps—I still hear them: one crunch, two crunch, breath breath breath—for me to call that walk a goodbye. You walked across the Great Wall of China, becoming at last the daughter of your soldier father. And now here we are and still the soldiers are marching and dying in a theater of war in which everyone is dying in front of our eyes.

But I am long blind.

I waited there that day—day eight for you, day one for me. The previous seven days I was not in the city. I was teaching in Massachusetts. Looking for a new home in California. I had not yet arrived.

 It was raining out. I was exhausted. When I entered the gallery, you were doing your theatrical stuff, humming songs, looking dramatic, although also a little bit vacant, distracted. Hungry but not in an active, growling way. We both knew it was not so difficult, not really, not in relation to the monks of Tibet who sit in caves for ten years, not in relation to the truly starving, not in relation to other situations of intense and unchosen suffering and pain. But you did it anyway and I came anyway, because we knew things had changed.

I sat on the floor in the back. You sat in the middle of the second stage, your bare feet draped casually over the second rung of the butcher knife ladder, staring into space, a little dull-eyed. You looked a bit like an animal in a cage. I thought of Kafka's hunger artist. Then a group of children came in and rushed right to the front of the room and lined up across a white stripe I had not seen before. You seemed immediately happier, hosting your young and vibrant guests. I was worried that you would stand up and your feet would bleed with the pain of the butcher knife. I watched you closely and in one gesture you were on your feet, back on the stage, your feet unharmed. I could not work out how you had done that. Levitation? A quick transfer of weight from foot to arms? The children looked at you, and you looked at them one by one. It was quite beautiful to watch. Some of the children were scared and left quickly, but one girl, a plump girl on the cusp of adolescence, was transfixed, and I watched your eyes will a kind of strong love into her. She met your gaze with confidence and also open curiosity, claiming your steady attention and easily returning it. Soon though her teacher came and took her by the arm to pull her away.

After she left, you looked depleted. I waited for someone else to take the girl's place at the white line. You moved to the back of the second stage and leaned against the wall. No one came forward. You drank some water, had a pee, and then took a shower. You put on your clothes, and this time you put on your boots. I recognized those boots from the photographs of the Great Wall Walk. I thought about the nature of distance. There you walked across vast geographical terrain. Here you were attempting another kind of ambitious performance, but this was not across geographical space. It was into the interior of your own muscle, skin, bone. We were invited to help shape that walk, but in the end it was yours. You had turned our faces into the ocean from which you would drink, bathe, float away.

You went back to the second stage and leaned against the wall. I felt a little bit sorry for you. I looked at my watch and saw it was 5:50. Since the gallery closed at 6, I trusted myself to have an energy dialogue with you for 10 minutes. I wanted to help you through the last minutes so you could be rested before your long night alone in the gallery. I slowly walked up to the white line the girl had left. Immediately, our eyes met, locked. I was taken aback by the intensity, the density of your eyes. It was a different gaze from the loving one you had given the young girl. It felt aggressive. Before long, I was sweating. You slowly came off the wall and began to walk toward me. As you walked, my body began to shake. My left buttock began to tremble. I became extremely self-conscious. The gallery was crowded and I was worried everyone was staring at my one jiggling buttock. But you kept coming closer and the closer you came the more I shook. I had entered the space of yet another mistake. Then I saw that you were shaking too. You came right to the edge of the stage and you were shaking so hard I thought you might fall off. I began to panic. I began to imagine being blamed by the whole international performance art world for making you fall off the stage before the 12 days were up. I decided to focus all my mental energy on getting you to return to the back wall. Mentally, I was very strong—I was startled by the force of my focus. My head was burning. My body was a mess. I could not stop shaking or sweating. I felt weak and disgusted to be so weak, when you had not eaten for eight days and I had eaten just before I arrived. I wondered if maybe you were so hungry that you were determined to turn my body into liquid, some kind of high-energy drink that would get you through the next days of your performance. At first I resisted the idea of being converted but then I began to think it would really be quite a spectacular destiny and maybe that was part of your point—that this performance I had just declared your interior walk was actually a complicated kind of alchemy, whereby I would be emptied and you would be filled. All of this was running through my head, as were theories of aggressiveness, narcissism, exhibitionism, voyeurism, questions about love and sacrifice, surprise about how what I thought was a fairly dull and passive waiting had turned into a genuine drama. And against the music of these thoughts the dull hum of self-consciousness because others are seeing me falling to pieces. But you would not budge from the edge of the stage, even as you trembled on the lip. Lips of Thomas. Would we betray each other? Whose skin would be opened in this encounter? Who would be saved? Who would be hurt?

I was beginning to feel irritated with you. Couldn't you see it would be better not to stand there shaking? Better to walk back and lean against the wall, as I willed you to do? And then I was stupid and angry with myself—after all you had been training

for this sort of thing for years, and I had not trained for one minute. You knew your limits much more intimately than I knew mine. How could I have imagined that I could help you, since you were a master and I a novice at these feats? I remembered all my failed attempts to meditate. If I could not do it alone in private, how could I attempt to try to do it with you in this hot, crowded, public gallery? I felt embarrassed. I wanted to offer you something but I could not find anything to give you. The postures and positions in my head were exhausting me, but even so I felt I could not look away from the density of your eyes. They were not quite as aggressive as when I first approached, but they were still boring into me. I decided to try just to watch and trust that you would not fall. I decided to let my mind run and not to focus on guiding you back to the wall.

Almost immediately you surprised me and lay down on the stage, your whole body now supported by the wooden floor, but your face suddenly very close to mine. Our eyes remained locked for what felt to me like a very long time.

In our look what passed between us? Stories. Images. A kind of hallucination, real facts and real fictions. But not narratives so much, more like photographs of memories. My dead lover. My saved brother. The building heaving up before it crashed down. The telephone calling. The widow's walk. Gradually the whole day came flooding back to me, the feeling of drowning in an event whose density still cannot be fully taken in. I remember walking, going to give blood in the morning with all the other lost New Yorkers. I waited on line for what seemed forever, the ashy smoke and acrid smell floating over the city. Finally when I reached the beginning of the line, my blood was rejected. I had been in London a few months before and they were worried about mad cow disease. Hurt they would not let me bleed, I walked the city blind. I went to the river, looked way west, saw New Jersey in the smoke. Wondered if there was enough water to put those fires out.

In the thick of my recollection I began to wonder what was prompting it? Were these thoughts yours or mine? They were the details of my day but why had you summoned them without a word on this day? Or were these the things lying in wait for me once I stopped talking and writing and reading? Were these images somehow something I was trying to give you? A gift of a day you missed in the city, even though I was sure that wherever you had been that day you had also somehow been present. "The new technologies convey a certain kind of accident, one that is no longer local and precisely situated, like the sinking of the Titanic or the derailment of a train, but general, an act that immediately affects the entire world." In this condition of generality, time and space begin to flow into one another. I was drifting away from my own consciousness. There was a kind of reversal occurring between us, in which I was giving you what you missed and you were giving me the chance to be absent from what I had experienced. I was not sure who I was becoming standing there, looking at you vibrating right in the center of what I could see, but looking at you as if from your own eyes, blind again in my own. It was a strange metaphor for the situation of the couple, the ways in which we insist we can be intimate with strangers, those we sleep next to and those we do not recognize in the mirror. Insisting on intimacy sometimes blinds us to the utter otherness of our very selves. Who was Marina? Who was I? Were we some consolidated ciphers for the more dramatic encounters that occurred on 9/11? Or was I, once more, mistaking my own tears for rain? Was I trying to inflate something into an ethical drama that was really not "in" the event, but rather imposed upon the event by my will to interpret? After all there is almost always more difference at play than we can acknowledge. Maybe this constant doubt and questioning is what makes love love. The fantastic energy released by love might actually be motivated by a kind of terror that we will have to know each other, when in fact we much prefer our fantasy of one another. Even when those fantasies lead to a kind of annihilation of one another.

All of this and much more passed between us. You looked and I saw, saw it all again. There was more too—but much of it still resists words. More than that, there are some things that should perhaps remain unsaid, because they are dangerous secrets and because they are truly mysteries. I repeat: something passed between us. Also other things. I was still sweating but my body was no longer shaking. I was sort of floating now, in the ocean that flowed between our eyes. I kept waiting for the gallery staff to come and announce that the gallery was closing. But no one came.

Just when I thought my body might just give out entirely, you smiled at me. A smile that was deeply personal and also liberatingly impersonal. I kept my eyes locked on yours, still waiting, but now without an expectation of a "for." I looked at you and your head fell forward, over the edge of the stage, to the right of the ladder. This was the first time you looked away from my eyes. Our exchange had ended. I quickly turned away and went to the rear of the gallery. I collected my coat and went out into the rain. When I looked at my watch it was a few minutes before 7 P.M. I later learned that was the one evening the gallery was open until midnight. I walked for a long time, grateful for the rain.

Love,

Peggy

There was no object. There was a kind of fused subjectivity, a condensation of the main themes of psychic, emotional, and perhaps spiritual, development. It passed through and touched on aggression, surprise, trust, fear of betrayal, fear of annihilation, acceptance, connection, beauty, exhaustion, transformation. The strength of it still surprises me, not only because I remember it so vividly, all these months later, but also because at the heart of the performance was an embrace of simplicity. Stripped of plot, object, and verbal dialogue, the performance nonetheless produced a potent ethics, a drama of the relation between self and other unaffected by the usual rhythms that help us maintain the distinction between strangers and intimates. Such a drama poses considerable risks, for both the artist and the

viewer. Faced with the choice of looking away or looking back, one realized there was a cost for each choice. Moreover, accompanying this realization was the recognition that this is precisely the economy in which we often try to live and love. Endlessly weighing what to let in and what to ignore, we measure and are measured by these everyday calculations. But phrasing it in this way risks making Abramović's performance more conscious, indeed more calculating, than it was. It was not, in the end, a narrative performance, and in that sense, *The House with the Ocean View* resists critical commentary even as it begs for more words after all that silence.

Jacques Lacan famously claimed that love is a giving of what one does not have.[17] On the last day of the performance, Abramović came down from the stage and told the gathered crowd that she wanted to come to New York to give the busy island time. Time to heal, time to think, time to love, and time to live, despite death, with death. It is not that people have not died elsewhere, or that people have not died before and since 9/11. But that act, that falling of so many, has made it hard for so many people to walk. To climb up stairs is to remember the firefighters burdened with their hoses and axes; to walk down stairs is to remember those fleeing the towers; to look out the window is to see them flying, already ash before they landed. *The House with the Ocean View* was an invitation to look at things from another perspective. To think about other wars, other attacks, to think about love in the face of hate, to feel time in the history of the eyes of those still living.

This performance reminded me that I want to live so I might have time to think about, to write about, to give time to, our performances, rituals, theaters. This essay is one fruit of that giving, written about an hour when there was no time, spoken now in this moment, wordless but flowing. My sweat an ocean, her eyes a kind of terrain. From this a history, from that a world. A world in which architecture does not seek permanence, and art objects are not valued exclusively for their price. A world in which what is made between our efforts to see and our inevitable blindness counts as art. We can call it performance, we can call it presence, or we can call it time. But in the end it is life. If live performance is to have a future in the electronic age, artists, viewers and writers must commit themselves to exploring the trance we call love. It begins with a look, a glance, an exchange between eyes. It takes place face to face. It is intimate and it occurs in public. It breathes, it sweats, it ends. It begins again. It passes from you to me and I hope back again to you. It asks strangers to become witnesses. It trusts. It builds. It rests. It tries. It might be happening now right in front of our eyes.

1. A version of this paper was given at the Tate Modern in London, March 2003. In that presentation, each of the italic sections in this text were prefaced by excerpts from Philip Glass's score for the movie *The Hours*. Additionally, the talk was accompanied by slides of Abramović's work, many of which were projected repeatedly and often with the orientation reversed. A webcast of this talk with the sound and slides can be found at www.tatemodern/liveculture.

2. For a fuller discussion see Allan Kaprow, *Essays on the Blurring of Art and Life*, ed. Jeff Kelley (Los Angeles and Berkeley: University of California Press, 1993) and Linda Montano, *Art in Everyday Life* (Barrytown, New York and Los Angeles: Astro Artz and Eighteenth Street Arts Complex, 1981).

3. The central texts in this argument are Arnold van Gennep's *The Rites of Passage*, translated by Monika B. Vizedom and Gabrielle L. Caffee (Chicago: University of Chicago Press, 1960), and Victor Turner, *The Ritual Process: Structure and Anti-Structure* (Chicago: Aldine Publishing Company, 1969).

4. Michel Foucault, *The History of Sexuality: Volume 1: An Introduction*, translated by Robert Hurley, (New York: Random House, 1980).

5. See Jacques Derrida, *Aporias*, translated by Thomas Dutoit (Stanford: Stanford University Press, 1993) for a fuller discussion of death as a social and cultural event, as well as a biological one.

6. All of this work, which is more complicated than these brief descriptions suggest, has been documented in the remarkable catalog *Marina Abramović: Artist Body, Performances 1968–1998* (Milan: Charta, 1998).

7. Ibid, p. 69.

8. The other items were: blue paint, comb, bell, whip, pocket knife, spoon, cotton, matches, flowers, candle, water, glass, scarf, mirror, chains, nails, needle, safety pin, hair pin, brush, bandage, red paint, white paint, scissors, pen, book, hat, handkerchief, sheet of white paper, kitchen knife, hammer, saw, piece of wood, a stick, bone of lamb, newspaper, bread, wine, honey, salt, sugar, soap, cake, metal pipe, scalpel, metal spear, bell, dish, flute, band aid, alcohol, medal, coat, shoes, chair, leather strings, yarn, wire, sulfur, grapes, olive oil, rosemary branch and an apple.

9. RoseLee Goldberg, "Here and Now," reprinted in *The Artist's Body*, edited by Tracy Warr with a Survey essay by Amelia Jones (London: Phaidon, 2000, p. 246).

10. Paul Schimmel, "Leap Into the Void: Performance and the Object" in *Out of actions: Between Performance and the Object, 1949–1979* (Los Angeles: Museum of Contemporary Art Los Angeles, 1998, p. 101).

11. *The Artist's Body*, edited by Tracy Warr with a Survey essay by Amelia Jones (London: Phaidon, 2000, p. 125).

12. The complete soundtrack and further documentation of *Balkan Baroque* can be found in *Marina Abramović: Artist Body, Performances 1968–1998* (Milan: Charta, 1998, pp. 364–370).

13. See Thomas McEvilley, "Stages of Energy: Performance Art Ground Zero?" in *Marina Abramović: Artist Body, Performances 1968–1998* (Milan: Charta, 1998, pp. 23–25) for a superb discussion of these three narratives.

14. Ibid, p. 25.

15. Paul Virilio, *Politics of the Very Worst, An Interview by Philippe Petit*, translated by Michael Cavaliere, from the original French edition published by Les Editions Textuel: Paris 1996. Edited by Sylvère Lotringer. (New York: Semiotexte, 1999, p. 12).

16. "On Bridges, Traveling, Mirrors and Silence: An Interview with Marina Abramović, (April, 1998)" Pablo J. Rico, *The Bridge/El Puente* (Milan: Charta, 1998, p. 50).

17. Jacques Lacan, "The Signification of the Phallus," *Écrits: A Selection*, translated from the French by Alan Schneider (New York and London: W.W. Norton & Company, 1977, pp. 281–292).

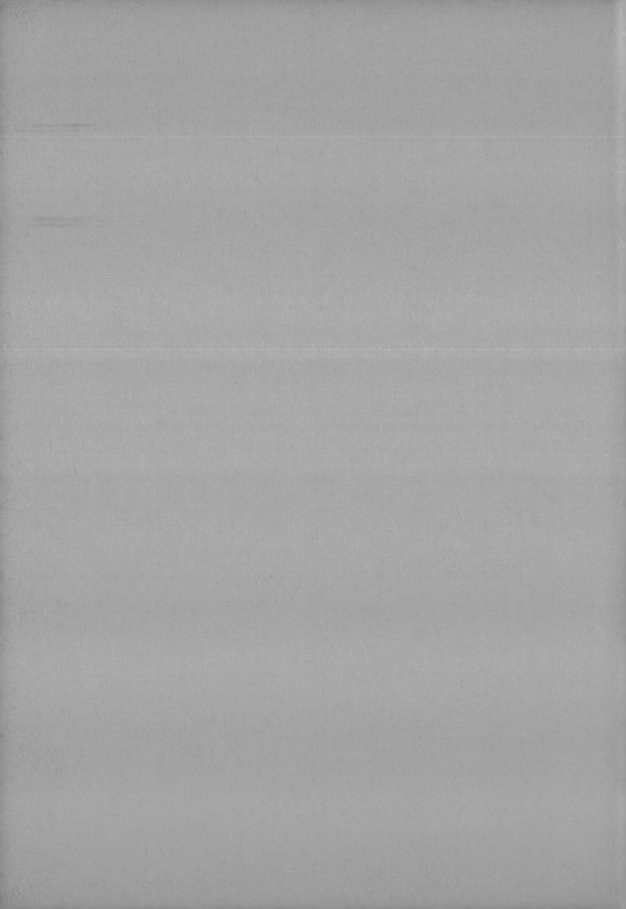

Photo album

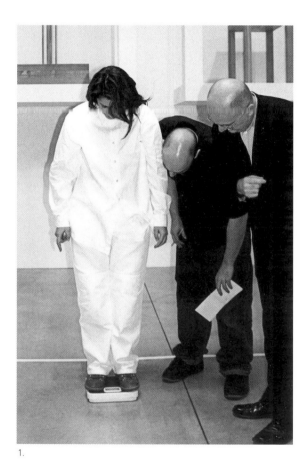

1.

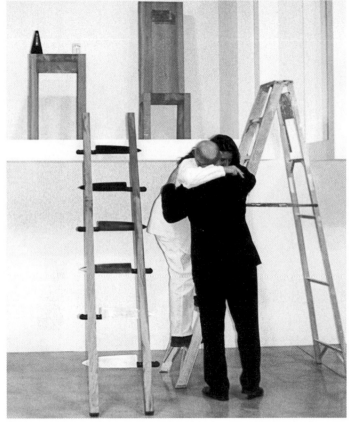

2.

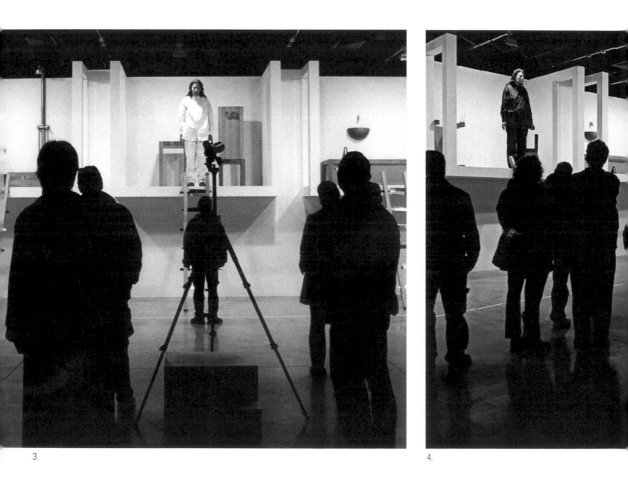

3.

4.

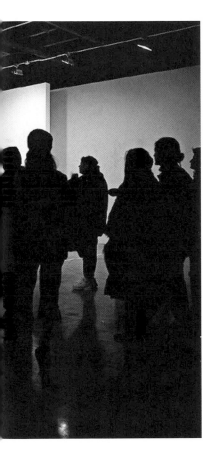

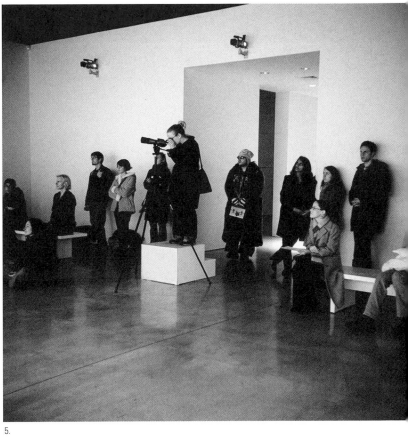

5.

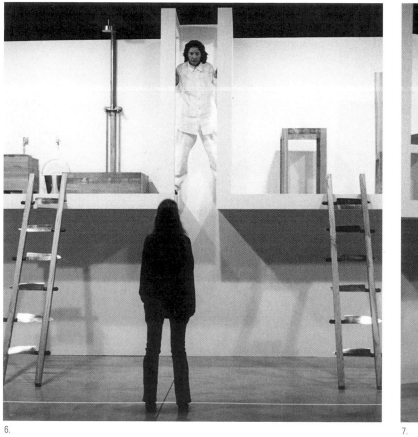

6.

7.

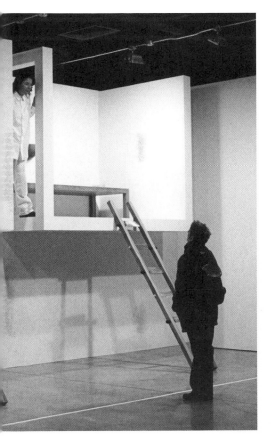 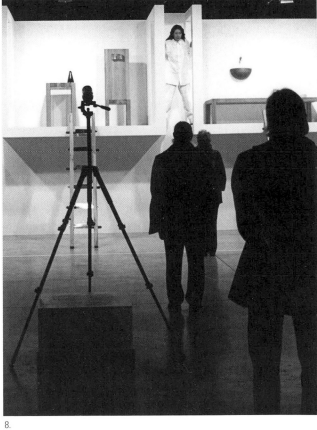

8.

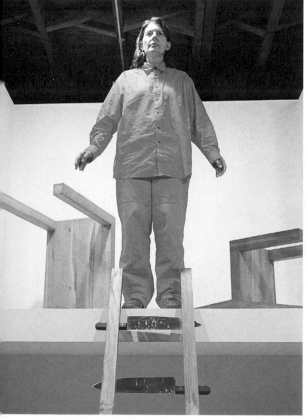

9.

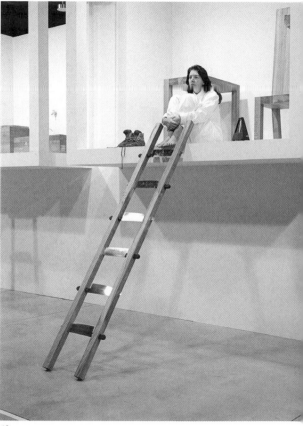

10.

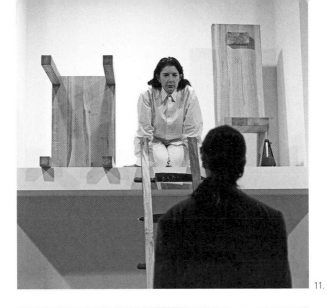

11.

12.

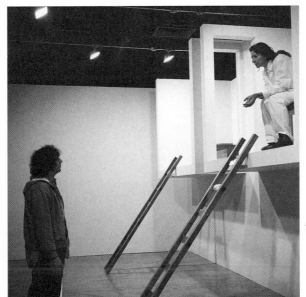

13.

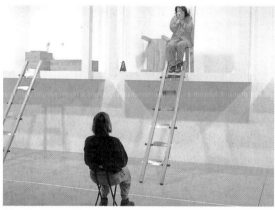

14.

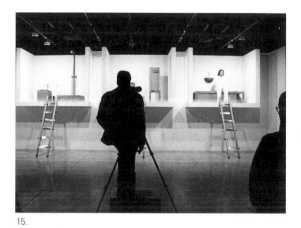

15.

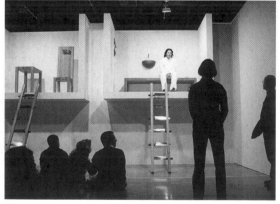

16.

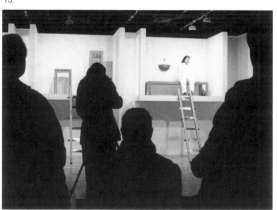

17.

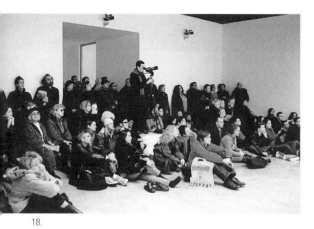

18.

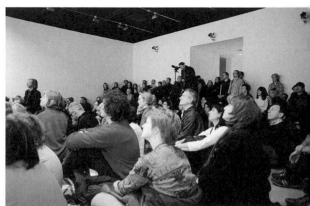

19.

20.

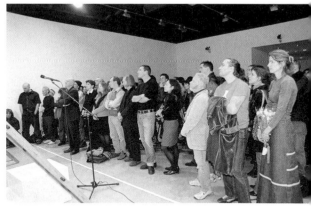

21.

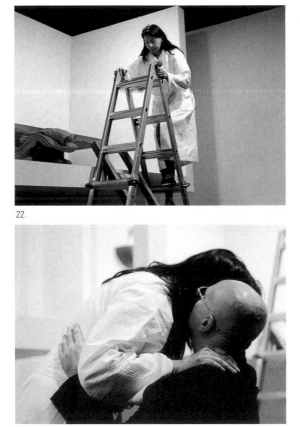

22.

23.

24.

194

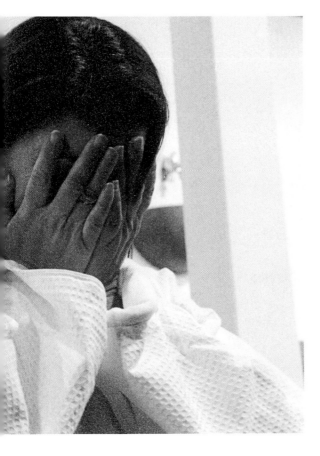

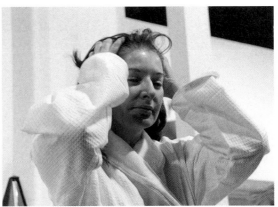

25.

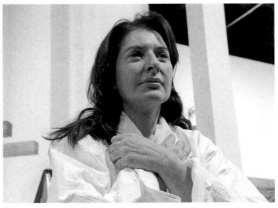

26.

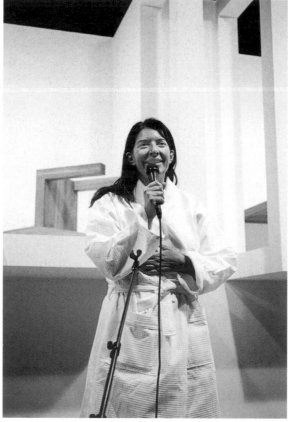

27.

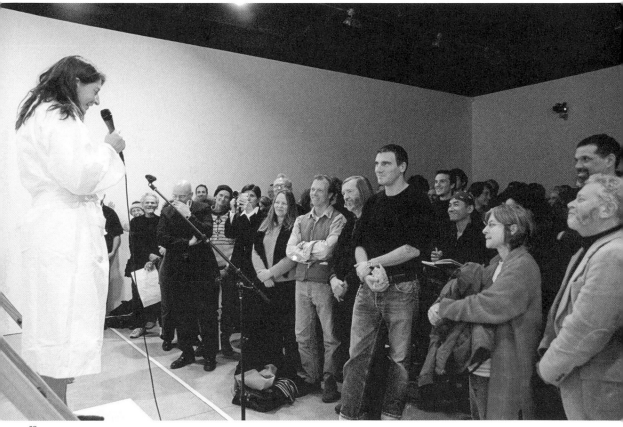

28.

1. Marina Abramović on the scale while Matt Dawson and Sean Kelly look on. Marina will lose 27 pounds during the performance.

2. Marina Abramović receives her last hug from Sean Kelly before entering the Installation.

3. Visitors during the first hour of the first day of *The House with the Ocean View.*

4.–5. Gallery visitors during the first days of *The House with the Ocean View.*

6. A regular visitor interacts with Marina Abramović.

7. A visitor interacts with Marina Abramović.

8. Gallery visitors.

9. Marina Abramović in the last hour of the performance.

10. Marina Abramović sits with her feet on the knife blade rung of one of the ladders and sings a Serbian folk song.

11. Marina Abramović interacts with a visitor.

12. Marina Abramović in the living room space surrounded by the furniture that she has rearranged.

13. A visitor interacts with Marina Abramović.

14. Thomas McEvilley interacts with Marina Abramović.

15. A visitor observes Marina Abramović through the telescope.

16. Gallery visitors.

17. Gallery visitors.

18. The crowd grows daily as the performance draws to its conclusion.

19. The main gallery fills up during the final phase of the performance.

20. Marina Abramović in the last minutes of the performance.

21. The viewers stand as the performance culminates.

22. Marina Abramović descends a ladder, leaving *The House with the Ocean View* at 6:00 p.m. on November 26, 2002.

23. Sean Kelly welcomes Marina Abramović's descent from *The House with the Ocean View.*

24.–26. Marina Abramović responds to a standing ovation from the visitors.

27.–28. Marina Abramović thanks the visitors for their extraordinary support.

Appendix

Marina Abramović

Born November 30, 1946, in Belgrade,
Yugoslavia.
Lives in Amsterdam and New York.

Selected Biography

1960–68
Paintings and drawings.

1965–70
Academy of Fine Arts, Belgrade, Yugoslavia.

1968–70
Projects, texts and drawings.

1970–72
Graduate Studies, Radionica Krsta
Hegedusica, Academy of Fine Arts, Zagreb,
Croatia.

1970–73
Sound environments, exhibitions at Student
Cultural Centre with Rasa Todosijevic,
Zoran Popovic, Gergelj Urkom, Slobodan
Milivojevic and Nesa Paripovic.

1973–75
Teaches at the Academy of Fine Arts, Novi
Sad, Yugoslavia.

1973–76
Performances, videos, films.

1975
Meets Ulay in Amsterdam.

1976
Starts relation works with Ulay. Decides to
make permanent movements and detours.

1980–83
Travels in Central Australian, Sahara, Thar
and Gobi Deserts.

1988
The Great Wall Walk: April 30 – June 27.
Afterwards begins to work and exhibit
individually.

1990–91
Visiting professor at the Hochschule der
Kunst, Berlin, Germany.

Visiting professor at the Académie des
Beaux-Arts, Paris, France.

1992–96
Professor at the Hochschule für Bildende
Kunst, Hamburg, Germany.
Completes two major theater performances;
Biography and *Delusional*.

1997
Professor at the Hochschule für Bildende
Kunst in Braunschweig, Germany.
Winner of the Golden Lion Award, XLVII
Biennale de Venezia, Venice, Italy.

1998
Board Member of the Contemporary Art
Museum, Kitakyushu, Japan.

2001
Artist in Residence at the Atelier Calder,
Saché, France.

2003
Winner of the Niedersächsicher Kunstpreis
2003.
Winner of the New York Dance and
Performance Award (The Bessies) for *The
House with the Ocean View*.
Winner of the Best Show in a Commercial
Gallery in New York from the International
Association of Art Critics for *The House
with the Ocean View*.

Selected Bibliography

Beeren, Wim, et al. *The Lovers*.
Amsterdam: Stedelijk Museum, 1989.

Iles, Chrissie, ed. *Marina Abramović:
objects performance video sound*. Oxford:
Museum of Modern Art, 1995.

Pijnapple, Johan, ed. *Marina Abramović:
Cleaning the House*. London: Art and Design
Monographs, 1995.

Iles, Chrissie. *Ulay/Abramović:
Performances 1976–1988*. Eindhoven:
Stedelijk Van Abbemuseum, 1997.

Rico, Pablo J. and Thomas Wulffen. *The
Bridge/El Puente*. Valencia: Consorci de
Museus de la Comunitat Valenciana, 1998.

Stooss, Toni, et al. *Marina Abramović:
Artist Body, Performances 1969–1998*.
Milan: Edizioni Charta, 1998

Celant, Germano. *Marina Abramović: Public
Body, Installations and Objects 1965–2001*.
Milan: Edizioni Charta, 2001.

Abramović, Marina, et al. *Marina
Abramović: Student Body, Workshops
1979–2003 Performances 1993–2003*.
Milan: Edizioni Charta, 2003.

Abramović, Marina, et al. *Marina
Abramović: The House with the Ocean
View*. Milan: Edizioni Charta, 2003.

About the Authors

Cindy Carr is the author of *On Edge: Performance at the End of the Twentieth Century* (Wesleyan University Press/ University Press of New England), which includes an account of her journey on The Great Wall of China with Marina Abramović and Ulay.

RoseLee Goldberg pioneered the study of performance art with her seminal book *Performance Art: From Futurism to the Present*. A frequent contributor to *Artforum* and other magazines, she is author of *Performance: Live Art Since 1960* and *Laurie Anderson*. She is Associate Adjunct Professor of Art History at New York University.

Chrissie Iles is a curator at the Whitney Museum of American Art, New York. Her most recent exhibitions include *Into the Light: The Projected Image in American Art 1964–1977*. She is co-curator of the *2004 Whitney Biennial*. As Head of Exhibitions at the Museum of Modern Art Oxford from 1988–1997, she curated exhibitions of Marina Abramović, Donald Judd, Sol LeWitt, Louise Bourgeois and Gary Hill.

Scholar and critic **Thomas McEvilley** has written numerous books and essays on both ancient and modern art and culture. He has received various awards including the College Art Association's Mather Award for Distinction in Art Criticism. His new book, *The Triumph of Anti-Art*, will be published by McPherson and Company at the end of 2003.

Peggy Phelan is the Ann O'Day Maples Chair in the Arts, Stanford University. She is the author of *Unmarked: The Politics of Performance* and *Mourning Sex: Performing Public Memories*. Currently she is writing a book about twentieth-century performance for Routledge.

Contents

Design
Gabriele Nason
with Daniela Meda

Editing and Editorial Coordination
Amy Gotzler

Editing Supervisors
Emanuela Belloni
Elena Carotti

Proofreading
Charles Gute

Copywriting and Press Office
Silvia Palombi Arte&Mostre, Milano

Web Design and On line Promotion
Barbara Bonacina

Photo credits
Amy Gotzler. Photo album n. 1–3, 6–8,
15–17, 18
Steven P. Harris. Cover and Photo album n. 5,
13, 14, 19–21, 24–26, 28
Attilio Maranzano. *The House with the Ocean
View* p. 12–35 and Photo album n. 4, 11, 12
Dobra Vilon. Photo album n. 9, 10, 22, 23, 27

The cover image has been intentionally
reversed at the request of the artist.

ISBN 88-8158-436-0

Edizioni Charta
via della Moscova, 27
20121 Milano
Tel. +39-026598098/026598200
Fax +39-026598577
e-mail: edcharta@tin.it
www.chartaartbooks.it

Printed in Italy

This book is dedicated by Marina Abramović and Sean Kelly to Paolo Canevari and Mary Kelly.

In addition Marina Abramović and Sean Kelly would like to thank:

Till Steinbrenner, Claudia Krug, and Nan Bress, who helped to prepare materials for inclusion in the installation *The House with the Ocean View*.

The staff of Sean Kelly Gallery, New York: Gallery Director Cécile Panzieri, Associate Director Amy Gotzler, Registrar Debra Vilen, Art Handler Matt Dawson, and Gallery Assistants Julia Bloch and Anna Gray, all of whom went above and beyond the call of duty in their dedication to the presentation of *The House with the Ocean View*.

Steven P. Harris and Attilio Maranzano, who documented the installation photographically, and James Westcott, who edited Marina's transcript of the twelve days of *The House with the Ocean View*.

The authors Cindy Carr, RoseLee Goldberg, Chrissie Iles, Thomas McEvilley, and Peggy Phelan, who spent considerable time in *The House with the Ocean View* and produced such wonderful and informative essays. Giuseppe Liverani and everyone at Charta, who worked with great dedication to ensure that this publication accurately reflects the installation *The House with the Ocean View*.

Finally, *The House with the Ocean View* could not have been realized without the energy and commitment of the many visitors who came to the gallery, several of them on a regular basis, to be with Marina throughout the twelve days of the piece; the support of the people of the extraordinary City of New York made the piece more than the sum of its parts.

To find out more about Charta, and to learn
about our most recent publications, visit
www.chartaartbooks.it

Printed in January 2004
by Leva spa, Milano
for Edizioni Charta